ARTIST'S PAINTING TECHNIQUES

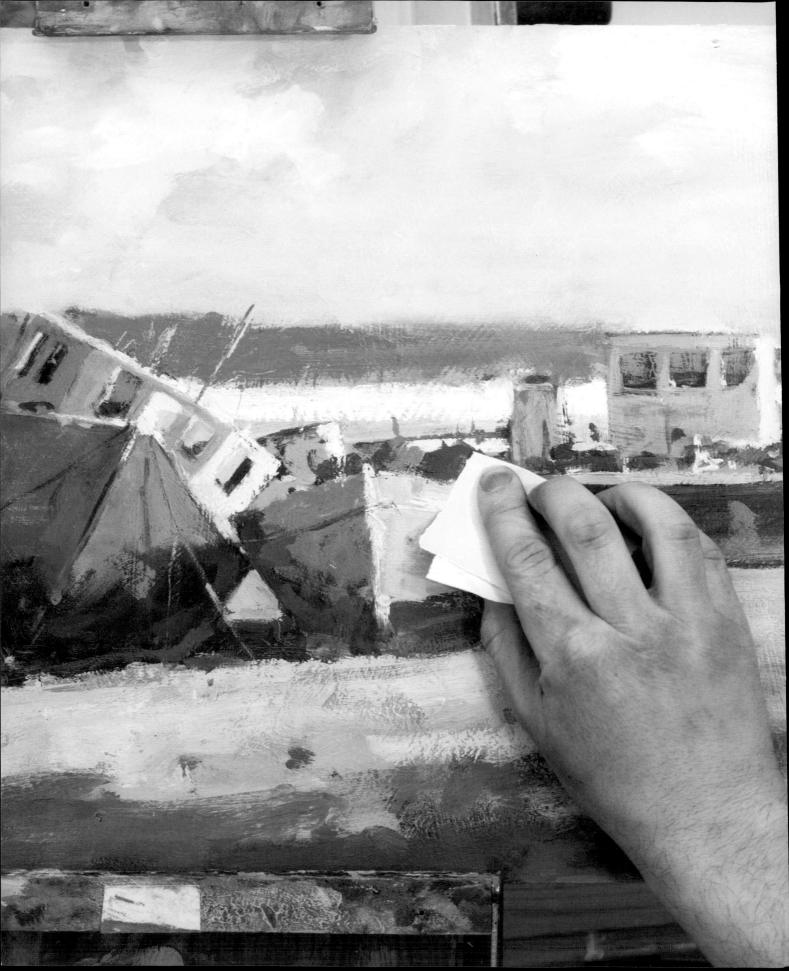

ARTIST'S PAINTING TECHNIQUES

Senior Editor Senior Art Editor Project Editors

Bob Bridle Alison Gardner Shashwati Tia Sarkar.

Alison Sturgeon. Allie Collins

Project Designers

Simon Murrell, Helen Garvey

Senior Jacket Creative Jackets Assistant Nicola Powling Libby Brown

Producer (Pre-production) Senior Producer Ché Creasev

Andy Hilliard

Creative Technical Support Sonia Charbonnier Managing Art Editor Marianne Markham

Managing Editors Angela Wilkes, Lisa Dyer

Publishing Director Mary-Clare Jerram

Art Director Maxine Pedliham

First published in Great Britain in 2016 by Dorling Kindersley Limited 80 Strand, London WC2R ORL

A Penguin Random House Company

681097 008-286834-Aug/2016

Copyright © 2016 Dorling Kindersley Limited

All rights reserved. No part of this publication may be reproduced, stored in a retrieval system, or transmitted in any form or by any means, electronic, mechanical, photocopying, recording, or otherwise, without the prior written permission of the copyright owner.

A CIP catalogue record for this book is available from the British Library.

ISBN 978-0-2412-2945-3

Printed and bound in China

All images © Dorling Kindersley Limited For further information see: www.dkimages.com

> A WORLD OF IDEAS: SEE ALL THERE IS TO KNOW

> > www.dk.com

The basics

Getting started	10
Observational skills	12
Colour theory	14
Perspective and composition	16
Pencil-drawing basics	18
Using a pencil to create tone	20
Choosing a medium	22
Choosing a subject	24
Working outdoors	26
Mounting and displaying work	28

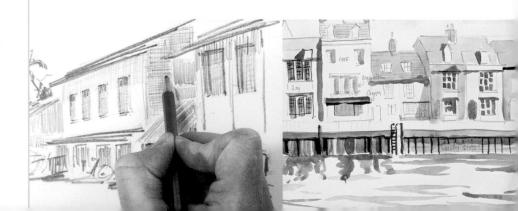

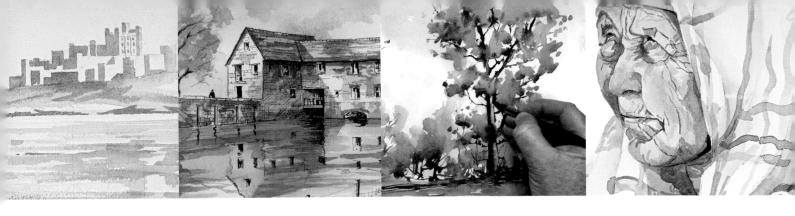

Watercolours

Painting with watercolours 32
Watercolour paints 34
Brushes 36
Supports and other materials 38

Beginner techniques

Colour mixing	40
Colour charts	44
Tone exercises	46
Warm and cool colours	48
Brushstrokes	50
Laying paint	52
Using runs	54
Modelling form	56
Simplifying a scene	58
Showcase painting	60

2 Intermediate techniques

Laying a flat wash	62
Laying a graduated wash	64
Lively darks	66
Aerial perspective	68
Edges	70
Highlights	72
Adding texture	14
Paper surfaces	76
Correcting errors	78
Reserving whites	82
Line and wash	84
Experimental techniques	86
Showcase painting	88

3 Advanced techniques

Planning a painting	90
Mood	94
Laying a double	
graduated wash	98
Laying a granulated wash	100
Monochrome	102
Glazing	104
Building layers	106
Adding details	108
Reflections	110
Opaque whites	112
Skin tones	114
Showcase painting	116

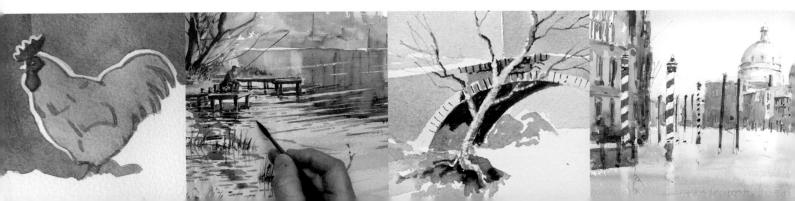

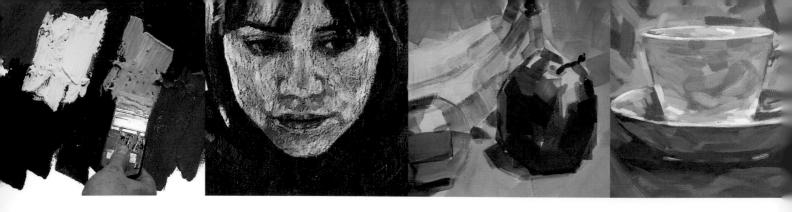

Acrylics

Painting with acrylics 120
Acrylic paints 122
Brushes and palette knives 124
Supports and other materials 126

Beginner techniques

Colour mixing	128
Using a limited palette	132
Drawing with a brush	134
Tints, tones, and shades	138
Acrylic washes	140
Neat acrylics	142
Painting shapes	144
White subjects	146
Aerial perspective	148
Showcase painting	150

2 Intermediate techniques

Adding texture	152
Using ground colours	156
Blending	158
Glazing	162
Warm colours	164
Cool colours	166
Painting with warm and	
cool colours	168
Negative space	172
Reflections	176
Showcase painting	178

3 Advanced techniques

Creating focal points	180
Optical colour mixing	182
Painting rain	186
Painting fur	190
Dramatic skies	192
Painting people simply	194
Skin tones	196
Painting movement	200
Showcase painting	204

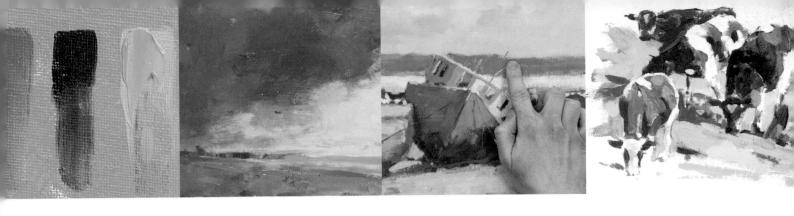

Oils

Painting with oils 208
Oil paints 210
Brushes and palette knives 212
Supports and other materials 214

1 Beginner techniques

Colour mixing	216
Mark-making	220
Palette knives	222
Fat over lean	224
Layering	226
Drawing and	
underpainting	228
Decreasing stages	232
Alla prima	234
Creating forms	238
Showcase painting	240

2 Intermediate techniques

Aerial perspective	242
Blending	244
Impasto	246
Sgraffito	250
Scumbling	252
Broken colour	254
Wiping and scraping back	256
Wet-in-wet	258
Texture	260
Tonking	262
Showcase painting	264

3 Advanced techniques

l		
_	Ground colour	266
-	Skin tones	268
and other party of the last of	Colour harmony	272
	Tonal values	276
	Using mediums	280
	Oiling out	282
	Glazing	284
	Re-evaluating and	
	correcting	286
	Finding your style	288
	Varnishing	290
	Showcase painting	292

Glossary 294 | Index 296 | About the artists 304

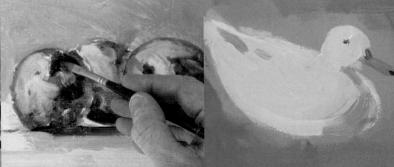

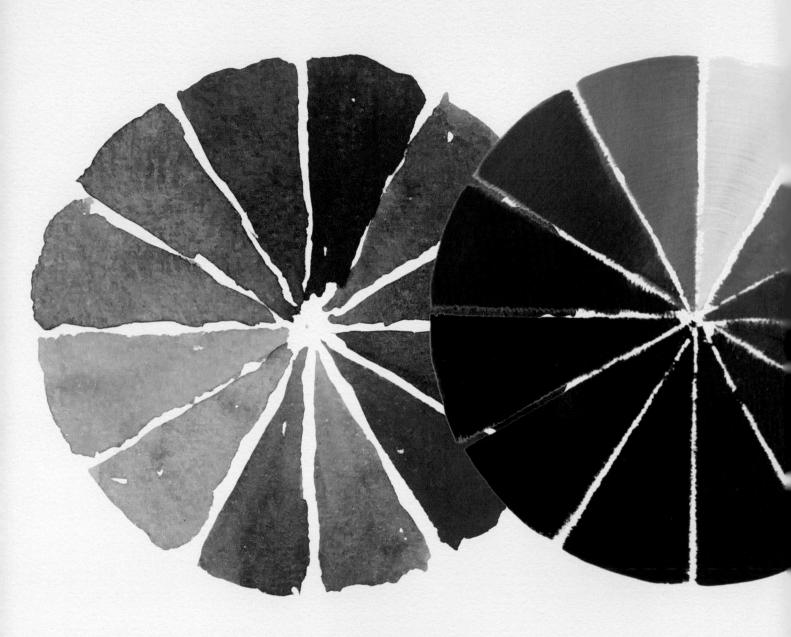

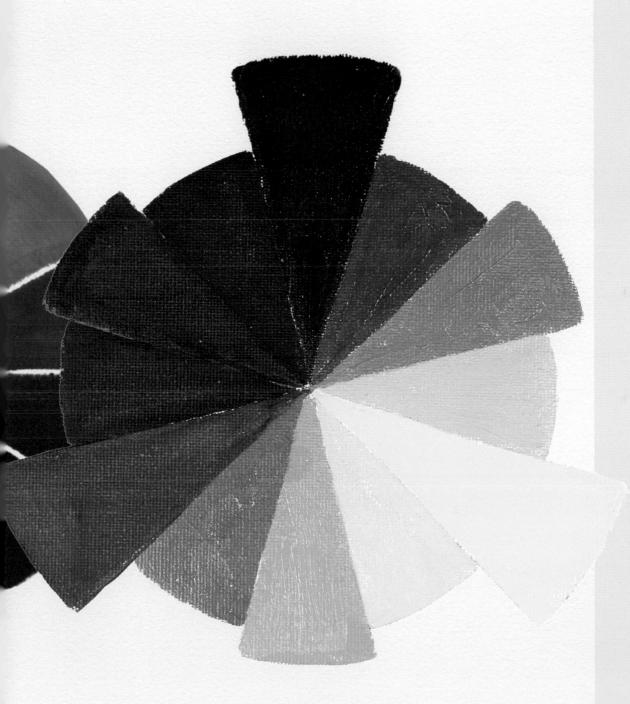

he basics

Getting started

THE ELEMENTS OF A PAINTING

If you are new to painting or haven't painted for several years, it can be difficult to know where to start. One of the best ways to overcome any hesitancy in tackling a new painting is to choose a subject that excites and inspires you. That way, you are likely to feel impelled to express yourself, and your painting will be authentic and heartfelt.

If a scene, such as a breathtaking sunset or grand building, attracts your attention, your excitement will come across in the work. Paintings that are charged with feeling and that are personal to the artist often have the most impact on the viewer.

Exploring different techniques

Apart from the emotional impact of your subject, there are also technical considerations to take into account.

Familiarize yourself with the tonal relationships between various elements in your scene, and learn how to balance colour to create harmonious paintings. Considered use of shape and composition will help to structure your painting, establishing a strong base on which to add layers of colour.

Choosing a medium that appeals to you (see pp.22–23), along with the correct brushes and supports, are important factors in creating the effect

you are seeking. An understanding of the medium, a feeling for your subject, and good planning will help you to create the best work you can.

Making a connection

Paintings that have an emotional impact often need to be handled differently to those in which the subject is paramount. Emotionally charged works may rely more heavily on, for example, the texture of the paint or the types of brushstrokes used. For works that prioritize subject matter above all else, the stylistic qualities of the painting are perhaps less important than conveying the essence of the subject simply and accurately. Either way, the possibilities across the three painting media are limitless.

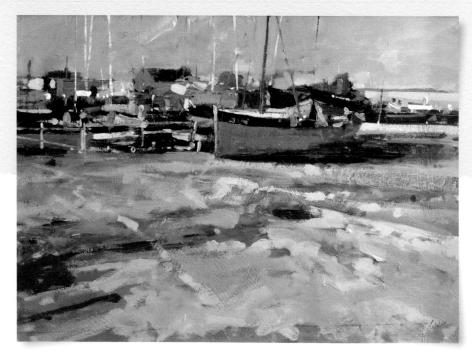

Technical considerations

This work in oils uses the lines of the track, dark tones, and bright colours to draw the eye to the blue boat, and then beyond. The masts balance the horizontal lines of the boats and fence.

Imparting emotion

This scene, painted with acrylics, is filled with movement and feeling, conveyed by dynamic brushstrokes, the use of pure pigments, and strong contrasts. The artist imparts a sense of awe at the castle's monumental form shining in the sun.

Strong brushwork conveys emotion

A successful painting connects with the viewer and holds their interest. It may provoke discussion or represent a familiar subject in a new way. If the viewer is moved to re-evaluate something familiar, then you have made a positive impact with your work. However, try not to be swayed by what other people think - after all, everyone has a different idea of what makes a good painting. The most important thing is to create work that inspires you. If you can convey your own feeling in a work, then the painting will be a success.

"If you have been able to convey your own feeling in a work, then the painting will be a success."

Observational skills

THE ART OF SEEING

Observation is about more than simply replicating a subject with photographic accuracy. As an artist, you have licence to move, alter, emphasize, or exclude elements of your choosing. For example, you might decide to exaggerate scale or experiment with perspective to create a more dynamic arrangement. The art of seeing is not only about capturing what is in front of you, but also interpreting it in your own way.

Honing your observational skills is the first step to creating a successful painting. With a good understanding of your subject matter, you will be able to depict it more convincingly.

Take your time

Spend time with a subject before you start to paint. Try to dispel any preconceptions you may have about how you *think* something looks. Instead, learn to concentrate on what you can actually *see* in front of you.

Notice where the light falls and which areas are in shadow. Look at the edges: are they crisp and well-defined, or blurred and indistinct? What shapes can you see? (Both the positive shapes of the object itself and the negative spaces between and around it.) Make sure you are viewing the subject from the best vantage point and that you have a strong composition (see pp.16–17). Look for a good range of tones (see p.20) and think about where to place the main focal points.

Objects are given form by light, so producing a painting is really a matter of rendering light, with the objects taking shape as a result.

Base measurement

Where accuracy is important, take a measurement from an element in the scene, such as the width of a house or the height of a tree. Then, compare other elements to this base measure to keep the proportions true. Another tip is to squint your eyes at the subject to

In the photograph, there is relatively little detail in the sky

> The vibrant yellow looks fine in the photograph, but it would advance too much in a painting

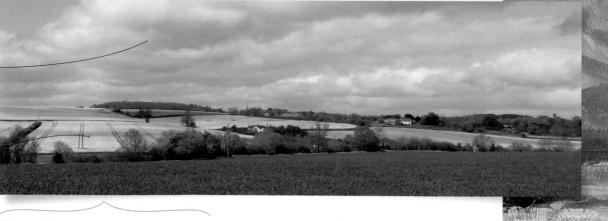

Observation

Studying the landscape helps to identify key features and areas of interest, as well as which elements to omit or change, such as the colour saturation of the background fields.

Interpretation

Artistic licence was used to create a more dynamic painting. There is a greater sense of drama in the sky, and tones have been balanced across the work.

Measuring from life

Hold a pencil upright at arm's length and at eye level. Close one eye and look along your arm, lining up the top of the pencil with the top of the subject. Then use your thumb to mark off on your pencil the area measured. Transfer this measurement to your page.

Mark the measurement using your thumb

1 - Take measurement from life

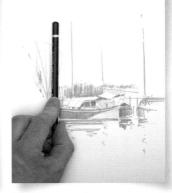

2 - Check proportions on page

Use simple geometric

"Spend time with your subject. Focus on what you can see in front of you rather than what you think is there."

block out the detail. This will help you differentiate areas of light and shadow as you plan and get started on your painting.

You don't always need to copy a subject exactly or include every element. Keep sight of the final goal: conveying the scene in your own way. Remember that successful paintings are often the result of an artist's personal interpretation of a subject.

Expressive brushstrokes give the painting energy and personality

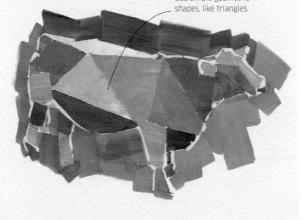

Shape and tone

Try to identify basic shapes within the subject. Use triangles, circles, and rectangles to construct form and establish proportion. This image also indicates tonal areas.

More cloud movement has been suggested in the sky, making it a key feature of the painting

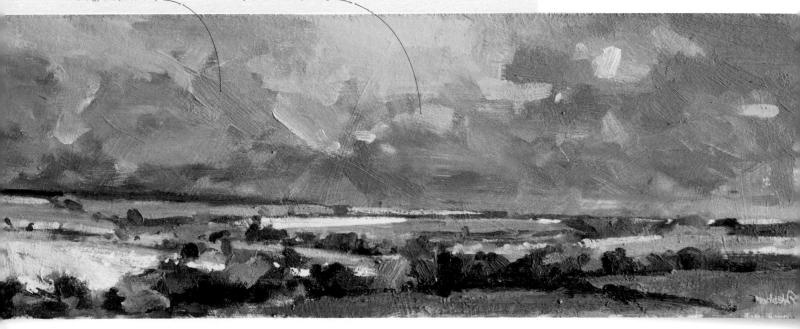

Colour theory

MIXING AND COMBINING COLOURS

Exploring colour is one of the most exciting aspects of painting. Understanding the relationships between colours will help you to create harmony, contrast, depth, and mood in your paintings, as well as mix paints.

The colour wheel

The colour wheel shows the relationships between colours. These diagrams demonstrate how primary colours can be combined to create the whole colour wheel.

Primary colours

Red, yellow, and blue are primary colours. You can't create primary colours using other paint colours, but you can combine the primaries to create a huge range of other colours.

RED Green

PIGMENTS AND HUE

Paints are made from finely ground. insoluble pigments that are suspended in a base such as water or oil. Qualities such as opacity, lightfastness, and granulation vary from pigment to pigment.

Natural pigments are either organic (from animal or plant sources) or inorganic (from rocks and metals). They can be rare or expensive to process, so synthetic pigments have been developed to match them. Many popular colours, such as cobalt blue and cerulean blue, are made from synthetic mineral pigments introduced centuries ago. "Hue" usually means the same as colour, but on a tube of paint, hue means that the paint colour is a blend or imitation of the

original pigment. Paints with "hue" in the name are usually cheaper and may "muddy" quicker than a pure pigment, but they offer other qualities. such as lightfastness.

Cerulean blue pigment

Secondary colours

Orange, green, and violet are secondary colours; they can be made by mixing two primary colours. On the colour wheel, each secondary colour is shown between the two primary colours that create it - for example, the wheel shows that red and yellow make orange.

Tertiary colours

Tints

You can create tertiary colours by mixing a secondary colour with one of its primaries, for example adding red (a primary) to orange (a secondary) creates red-orange. The tertiary colour therefore has a higher proportion of one primary, which is shown on the wheel by its position next to that primary.

Colours lightened with white are

called tints. Adding white changes

the saturation of the original colour,

Saturation

The intensity or strength of a colour is referred to as its saturation. A colour straight from the tube will be more saturated than when it is diluted or mixed.

Pure cobalt blue

Cobalt blue mixed with a little white

creating a pastel hue.

Cobalt blue mixed with more white

Watercolour swatches

Acrylic swatches

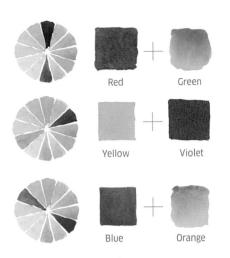

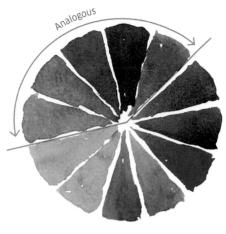

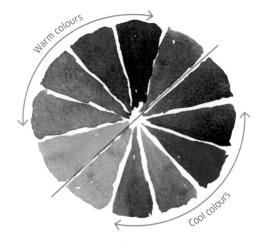

Complementary colours

Opposite colours on the colour wheel, such as red and green, are complementary. They brighten each other when placed side by side but dull and darken each other when you mix them, which creates interesting neutrals.

Analogous colours

Groups of three to five colours that sit next to each other on the colour wheel are known as analogous. The close relationship between analogous colours means you can use them to create harmonious colour schemes.

Colour temperature

Colours have qualities that we associate with temperature. In general, the yellow-orangered half of the wheel is considered to be warm, while the violet-blue-green half is considered to be cool.

"A little knowledge of colour theory helps you create the effects you are aiming for in your paintings."

Cool (blue bias)

Cadmium red Warm

(yellow bias)

Cool

Lemon yellow

(blue bias)

Warm (red bias)

Cool (vellow bias)

French ultramarine

Warm (red bias)

Colour bias

There are warm and cool versions of every colour because paints often have an undertone of another colour - for example, you can buy a warm yellow with a red bias or a cool yellow with a blue bias. Bias affects how you use and mix a colour.

Shades

Colours darkened with black are called shades. Blacks with colour biases can affect hue; here, vellow mixed with blue-black creates greens.

Pure lemon yellow

Lemon yellow mixed with a little black

Lemon yellow mixed with more black

Oil swatches

Tonal value

The relative lightness or darkness of a colour is its tonal value. Establishing tonal relationships in a painting is important for creating the shape and form of the subject.

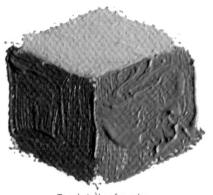

Tonal study of a cube

Perspective and composition

PORTRAYING THREE-DIMENSIONAL SPACE

Understanding linear perspective – whereby parallel lines appear to converge in the distance – is an important part of painting and drawing. It is key to portraying distance and three-dimensional space. Your distance from the ground determines your viewpoint and the position of the horizon line, which will be at your eye level. The point at which parallel lines in an artwork converge on the horizon is known as the vanishing point.

Some key points to remember regarding perspective are that all parallel lines appear to converge at the same vanishing point on the horizon, and that objects closer to you look larger than those further away. An object's relationship to the horizon will depend on your location when viewing it.

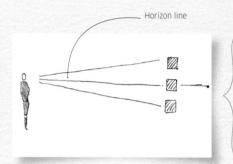

Viewpoint

An object you look down on appears to sit below the horizon line, while an object you look up at appears to sit above the horizon line.

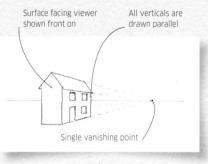

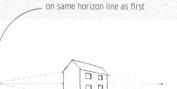

Second vanishing point

Object shown at an angle to the viewer

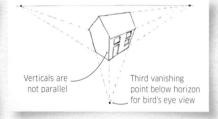

One-point perspective

The surface facing the viewer is seen front on, without distortion. The object's lines should converge on one vanishing point.

Two-point perspective

Two vanishing points give a more realistic aspect. As the object is at an angle, both sides are distorted by perspective.

Three-point perspective

Use a third vanishing point for very high or low viewpoints. The closer it is to the work's centre, the more dramatic the effect.

Large foreground object

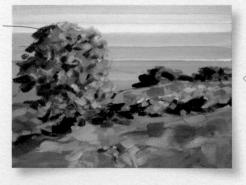

Aerial perspective

Where there are few parallel lines to show perspective, such as in landscapes, use other techniques instead. For example, use scaling (making objects in the foreground larger than those in the background) and aerial perspective (see pp.68–69, 148–49, and 242–43).

"Linear perspective is key to depicting distance in your work."

COMPOSITION

The placement of the horizon determines your viewpoint and shapes the composition. Patterns in compositions can highlight aspects of a scene and help lead the eye to the focal point. Try sketching different compositions before deciding on one.

S-shaped

This composition leads the viewer from the start of the "S" in the foreground to the main focal point – the distant church. This shape is very effective in landscapes.

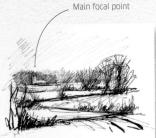

V-shaped Exaggerating a sense of perspective and creating composition lines that lead to a single point are good ways to create a strong dynamic image.

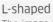

Grass and tree form the "L"

The image is framed on two sides by a horizontal and a vertical element. This directs the viewer's attention to the opposite side of the picture.

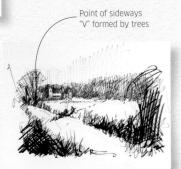

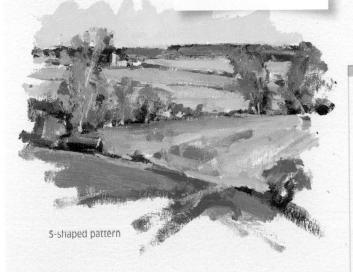

Horizon line is a third down from the top

Main focal point placed where lines intersect

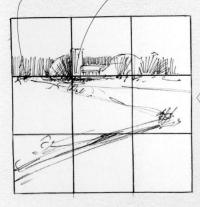

Rule of thirds

This is a popular technique for producing a balanced image. Divide the surface into thirds horizontally and vertically to create a nine-square grid. Place the horizon either a third up from the bottom or a third down from the top, and create focal points where the lines intersect.

SCALING UP

When transferring initial sketches for a composition to the final surface, you can maintain the proportions by scaling up. Make a grid on your sketch and choose a support with the same proportions. Scale up the grid to fit your final surface and copy the detail of each square onto the new grid.

Use the proportions within each square to guide you

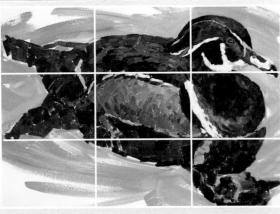

Pencildrawing basics

TYPES OF PENCILS AND MARKS

Pencils offer a great way to create tonal images. There are different grades ranging from soft, dark pencils to hard, light ones, which can be used in many different ways. Pencils are perfect for sketching any subject matter.

TYPES OF PENCILS

Pencils are graded from hard "H" to soft "B", with "HB" and "F" between the two. Harder pencils create a lighter tone and are good for fine detail, whereas softer pencils create a darker tone and are great for shading. Although pencils from 9H to 9B are available, a 6B offers a dark enough tone, and a 5H offers a light enough tone for everyday sketching.

HARD

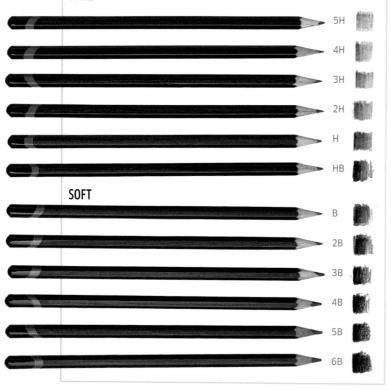

MARK-MAKING

Pencils are versatile tools for working on small to mid-size areas, but they can be difficult to use over large areas as the tip is so small. There are, however, several techniques for overcoming this problem.

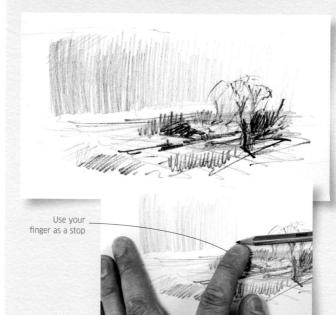

Broad shading

To block in large areas of tone, move the pencil back and forth without lifting it from the page. Keep the pencil tip flat against the paper to create a broader line. For accuracy, use the finger of your other hand as a stop, allowing the pencil to hit your finger as you move the pencil across the area.

Hatching and cross-hatching

Hatching, in which many parallel lines visually blend with the white paper, is a good way to create tone. Crossing the lines (cross-hatching) creates a denser look and a darker tone.

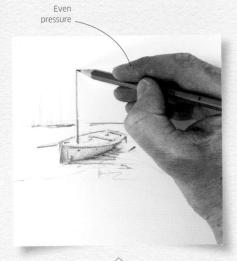

Hold pencil near the tip

shallow angle

Fine line

To create hard lines, draw the mark in one go, keeping the pressure even. Make sure you sharpen the pencil if it starts to become too blunt for the line you want to create.

Curved line - small

With your wrist resting on the paper, hold the pencil near the tip and keep it at a steep angle to the paper. Keeping your hand still, curve the line around using just your fingers.

Curved line - large

Keep pencil at a

Hold the pencil further away from the tip and keep it at a shallow angle to the paper. With your wrist resting on the paper, swing the rest of your hand around to create a large curve.

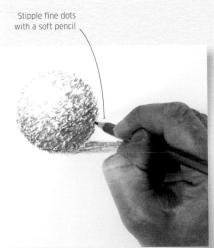

Go over areas for denser tones

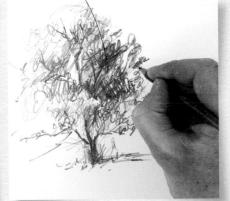

Stinnling

Using the point of the pencil, stipple fine dots and marks onto the surface. The closer together they are, the darker the tone. Softer pencils are more effective for stippling.

Scribbling

Multi-directional scribbles create an interesting look and allow for subtle changes in tone. Use circular motions and darken the tone by going over an area several times.

ADDITIONAL EQUIPMENT

- Pencil sharpener whether you're using pencils for preliminary sketches or finished pieces, you will need a pencil sharpener or knife to keep the points fine. Pencil sharpeners that collect the shavings will help keep your work area clean, while a knife will give you control over the length of graphite you wish to expose.
- Blending stump and eraser use a paper blending stump or a tissue to soften pencil marks, and either a hard or soft eraser to remove unwanted areas of tone.
- Paper use medium-weight cartridge paper for general work, and coloured papers, watercolour paper, or tissue paper to experiment with texture and transparency in your final drawing.
- Fixative a spray fixative will bond pencil marks to the paper, allowing you to work over areas without smudging.

"Painting is an extension of drawing, so pencils are the best place to start."

Using a pencil to create tone

CREATING SHADING AND HIGHLIGHTS

You can create a range of tones with a single pencil just by varying the amount of pressure you apply – use a light touch to cover an area with soft shading, or apply more pressure to create a harder, darker mark. You can also create a range of tonal effects using an eraser, a blade, or through blending.

Tonal study

Creating a tonal sketch from a photograph or from life will help you plan your final painting. Identifying deep shadows and highlights early on in the process means you can pitch the painting in a suitable tonal key. Use a pencil to experiment with tone, making decisions about where to use strong contrast and so create focal points, and where to use tone more subtly.

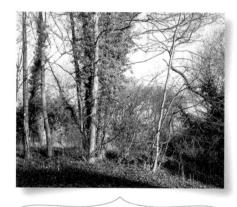

Reference photograph
There is a wide range of tones in this woodland scene, with the light sky providing a good backdrop for the foreground trees.

2 Pencil sketch
This initial reference sketch establishes the key tones, with areas of high contrast at the base of the tree.

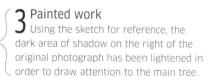

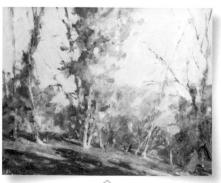

A Black-and-white image
Looking at an image of the painting in black and white will help you to assess the tonal balance of the finished piece.

CREATING TONAL EFFECTS

With these simple techniques you can create a range of tonal effects in your drawings. Starting with a simple pencil drawing, try using erasers, blades, or paper blending stumps to adjust the tone and create highlights. This will help you get the most out of your sketches and finished drawings.

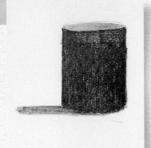

Tone too dark and flat Use erasers to blend and lighten the tone of an area of pencil shading, particularly if the tone is too heavy.

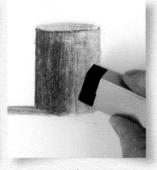

Using a hard eraser A hard eraser will create clean lines and can be used to wipe complete sections back to paper.

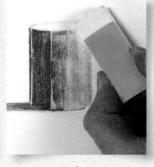

Using a soft eraser A soft eraser will lighten tone while blending the surface. Keep the eraser clean to avoid smudging.

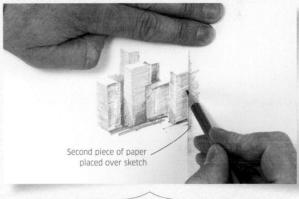

High contrast paper mask

To achieve a crisp edge between tones, use a piece of paper to mask between the two areas. Shading over the paper will leave a definite line where the two tones meet.

Using a blade

Scratching the surface to create white marks in an area of pencil shading is a good way to achieve crisp lines in a dark tone. The blade will alter the smoothness of the paper, so use this technique sparingly.

Blending

You can use your finger to soften edges or blend tones. However, natural oils from your skin can affect the pencil marks, bonding them to the surface and making them harder to erase. For finer detail, use a paper blending stump or piece of tissue paper instead.

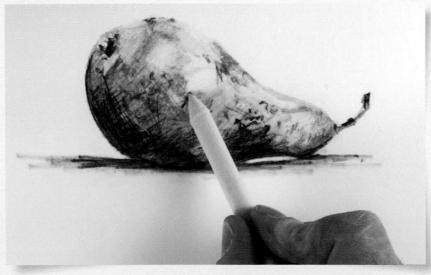

Choosing a medium

WATERCOLOURS, ACRYLICS, OR OILS?

When you are choosing a medium, it can help to look at other artists' work – you may be inspired by their use of a particular type of paint. Some artists use mixed media, while others are known for their paintings in one medium. Their choice often depends on factors such as drying time, how easy the paint is to use, and scale. If you are interested in work with a certain feel, identify whether the medium has played a part in creating the image.

WATERCOLOURS

Watercolour paints are diluted with water, making them easy to clean up and use. They remain dilutable even after the paint has dried, meaning fresh colours can be blended into dried colour. Washes can be used to cover large areas quickly.

Watercolours - pros and cons

PROS

- Relatively inexpensive to buy
- Very quick to dry
- Techniques such as washes, splashing, and dripping can create expressive paintings

CONS

- Watercolour techniques can be difficult to master
- It is harder to correct mistakes
- Fragile just one drop of water can damage a painting

ACRYLICS

Acrylic paints combine many of the advantages of oils and watercolours, such as a fast drying time and the fact that you can build up multiple layers quickly. They can be mixed with water, so there is no concern about paint fumes or special cleaning materials.

Acrylics - pros and cons

PROS

- Can be applied in thick layers or thin washes
- Dries in minutes
- Can be used on a range of materials including canvas, paper, wood, plastic, and metal

CONS

- Fast drying time means you must work quickly to blend colours
- Colours can change as they dry
- Can be tricky to work with over a large area

OILS

Oil paints have a long tradition and are popular due to the richness of colours available. They have a thick, sculptural quality and techniques such as glazing, impasto, and layering can be used to produce work from dynamic abstract paintings to hyperrealistic depictions.

Oils - pros and cons

PROS

- Longer drying time means oils are more flexible to work with
- Colours blend together smoothly
- Can be used in thick layers to build texture

CONS

- Canvases must be primed before use
- Special cleaning materials such as turpentine are needed
- It can be more difficult to create clean lines as the paint stays wet for longer

"Subject matter and where you paint may influence your choice of medium. An outdoor landscape painter and an indoor portrait painter may have different requirements."

Watercolour washes

This painting shows the range of techniques that can be achieved using watercolours, from delicate washes in the sky to clean lines and white highlights in the foreground.

Bright acrylics

Acrylic paints can be used to build up vibrant layers of colour, with rich tones giving depth to a painting. This striking image features small, even brushstrokes and dabs of colour to build up the layers.

Oil techniques

In this painting, softly blended oil colours create the sky, while the detail on the boats showcases the richness and texture that oil paints can offer. Rougher brushstrokes and layers of colour add depth and interest.

Choosing a subject

HOW TO DECIDE WHAT TO PAINT

Getting to know your subject will help enormously when trying to paint it. For example, if you know how something behaves, how heavy it is, or how fast it moves, you will have a better chance of being able to portray it accurately. The best way to get to know a subject is to spend time observing and drawing it. Then, once you have a good understanding of perspective, colour, and tone, you can begin to experiment with your paintings.

Different subjects can suit different styles. Large, geometric subjects may demand a bold approach, while fine, detailed paintings will suit more intricate subjects. Start by identifying what interests you in both style and subject. Try to pick appropriate subjects to match your style and medium, then

get to know your subject by sketching it. This will give your work a solid foundation.

Refining your painting

To help discover how finely detailed you want your work to be, it is a good idea to develop a painting through gradual refinement. This means starting from an impressionistic, even abstract, starting point, and then adding more and more detail. The process is an easy one with acrylics and oils, as you can add layers to adjust tone and colour, but it is still possible with watercolours. Use opaque white paint to add light areas

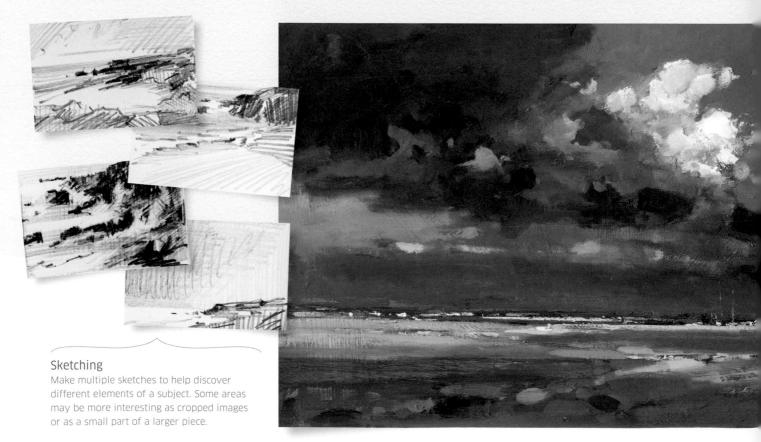

Still life

Still life paintings can be easily set up at home. You can adjust the lighting and choose a subject matter that suits the technique you want to practise. It is a great way to refine your tone and brushwork in the comfort of the studio.

back in, or plan ahead and use lighter initial washes so that you can achieve a layered approach.

Knowing when to stop

Working around the whole painting, rather than concentrating on one area at a time, will mean you can stop at any

point and the painting can be considered "finished". Artists often find it difficult to know when to stop painting, and it can be tempting to keep on adding more to your work. It is important to take a few steps back from the painting from time to time to assess your progress. Putting too much into a painting can spoil its impact and leave it looking overworked. If you find yourself struggling to decide whether you have finished, take a break and come back to it later with fresh eyes. You could even do a little more research about your subject, perhaps with some more sketching and studies, to help you analyse the work you have already done. Then you can decide whether any areas of your painting would benefit from further refinement.

The vastness of a dramatic landscape can lift spirits and emphasize power and scale. Landscapes offer a huge variety of subject matter, and time restraints and changing light can provide an exhilarating challenge.

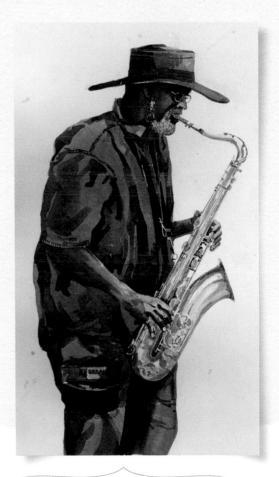

People

Portraits, figures, and crowds offer a great chance for the viewer to interact with a painting. We recognize emotion in faces, and a portrait can trigger different reactions in people. Figure drawing is a useful way of developing techniques to give objects a sense of identity, weight, and balance.

Working outdoors

THE RIGHT MATERIALS FOR THE ENVIRONMENT

If your main sources of inspiration are nature and the world around you, then drawing or painting from life is the best place to start. Working outdoors, also known as plein air painting, is particularly good for small landscapes and capturing quick impressions of a subject. Studio work, on the other hand, is better for larger paintings or those created over several sessions. There are pluses and minuses to working both outside and in the studio.

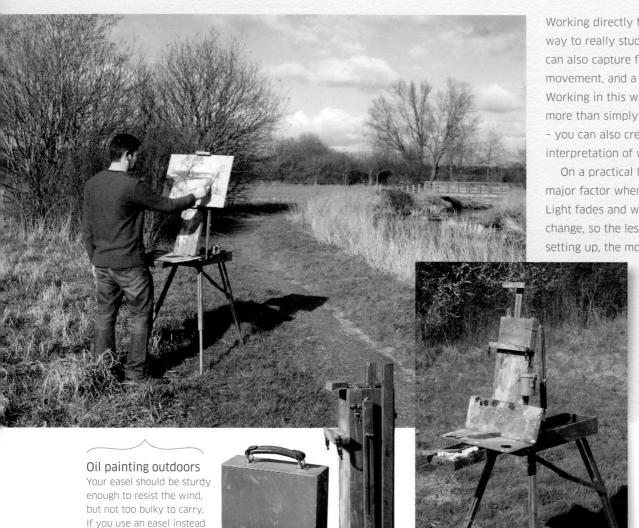

Working directly from life is the best way to really study your subject. You can also capture fleeting light effects, movement, and a sense of energy. Working in this way helps you to do more than simply replicate a subject - you can also create an emotional interpretation of what you see.

On a practical level, time is a major factor when painting outdoors. Light fades and weather conditions change, so the less time you spend setting up, the more time you have

> to sketch and paint. Travel light: use a limited palette of colours and restrict yourself to just a few key brushes.

of a pochade, you will also need a wet panel carrier - a box in which to carry wet paintings.

Wet panel

carrier and

folded box easel

This portable easel has a compartment for storing art supplies and folds down to a compact box, making it ideal for outdoor painting.

"Travel light when working outdoors, and consider what you can realistically achieve with the equipment and time you have available."

Camera backpack

A camera backpack is useful for stowing a tripod (see right) and other supplies. Carry half-empty paints to reduce the weight.

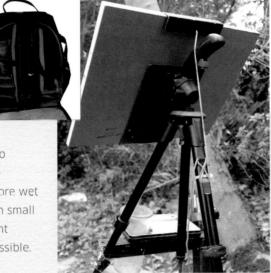

Camera tripod easel

You can convert a camera tripod into an outdoor easel by attaching a bracket to hold a board or sketch pad, and a metal shelf for the paints and water holder.

Working outside can be messy, so squeeze paint sparingly onto the palette and carry hand wipes. Store wet rags or discarded paper towels in small plastic bags, keep your equipment clean, and be as organized as possible.

> Try packing your supplies into a specialist camera or fishing backpack, ideally with an attached stool. A pochade - a box with a lid hinged at an angle that acts as an easel - is also very useful. It has storage for your wel works of art and a compartment for paints and brushes. Place the pochade on your lap or attach it to a tripod. Alternatively, you can use a portable easel that includes a storage area.

WORKING IN THE STUDIO

Apart from the convenience of having heat, shelter, and your materials to hand, working in the studio has other advantages. It makes it easier to work on large paintings, you can revisit a painting over several sessions, and the lighting is consistent. Being in a studio may also allow your imagination to flow - without being restricted by what you see in front of you, your work may become more personal and exploratory. However, it is still useful to have access to multiple sources when painting in the studio, such as photographs, notes, colour sketches, and preliminary drawings made on location.

Outdoor easel for watercolour

Use a portable easel and a field palette with plenty of mixing space, a water reservoir, and pan colours (rather than tubes). Secure the pad with elastic bands.

Watercolour field palette

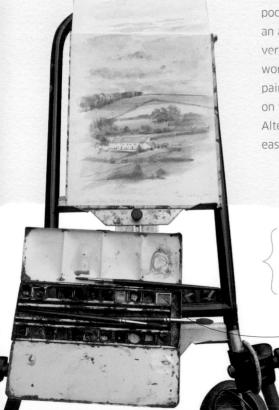

Mounting and displaying work

SHOWING YOUR ART

If you want to display your artworks in public, they will benefit from being properly mounted and framed. Take them to a professional framer, or create frames yourself using specialist equipment. Once your artwork is well presented, and you have some experience of exhibiting in local or national shows, you might consider approaching galleries.

One approach for oil paintings and unglazed acrylic paintings is to frame smaller works in wider frames and larger works in narrower frames. Watercolour paintings are usually best presented in a mount behind glass, surrounded by a slender frame.

Inner frames and mounts

Although fashions change, it is usual to include an inner frame, or slip, of a lighter colour than the frame, which will help balance and enhance the painting. Use gold with caution as it can be overbearing, although a little gold around the moulding of a frame can be effective. There is a wide range

of colours available, but it is usually best to choose subtle, light colours that complement and lift your work. Avoid frames or mounts that distract from – or even conflict with – your work. You can also use more than one mount, leaving a small gap between them to lead the viewer's eye into the painting.

Framing practicalities

You can frame your work at home, although you will need to invest in some specialist equipment. For example, you will need a mitre cutter to create smooth, accurate corners at 45-degree angles, V-nails to join the frame corners, and an underpinner for fixing the nails.

Alternatively, you can instruct a professional framer to make up finished frames to your specification, or ask them to create barefaced (untreated) wooden frames, which you can finish at home using a good emulsion and furniture wax, a matt or satin varnish, or even gold leaf.

Displaying your work

Look for opportunities to show your work at local art societies, and both regional and national open shows. For more consistent exposure, consider approaching a gallery. Always do your research and prepare your artwork first (see below).

APPROACHING GALLERIES

First, assess and prepare your work. For example, does it have a recognizable style? Galleries usually want consistency and a unique selling point. List your exhibitions, open shows, and experience, and assemble a small portfolio of original, well-presented, "ready-for-sale" pieces.

Choosing a gallery

- Do you have a similar experience and ability as other artists at the gallery?
- Will your work fit in without being too similar to other artists on its books?
- Are your prices in line with the paintings displayed at the gallery?
- Be consistent when setting your own prices and find out how much commission they charge.

Negotiating with a gallery

- Don't cold call make an appointment and find out what the gallery would like you to bring.
- Listen to the staff they know their business.
- Clarify terms before committing to work.
- Discuss their requirements and decide whether you could keep up with the work.
- Understand that the commission they take pays for running the gallery, publicity, client lists, and their reputation.

Exhibiting work You will need to demonstrate a consistent and stylistically coherent body of work to appeal to galleries.

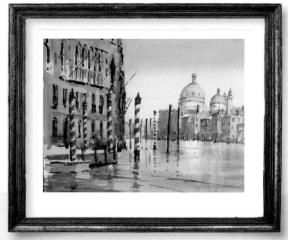

Venice in the sunshine (see pp.96-97)

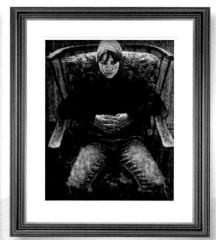

Marie, seated (see p.199)

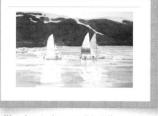

Sailing boats (see pp.72-73)

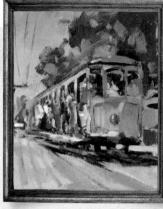

Yellow tram (see p.273)

Still life with fruit (see pp.266-67)

Peppers (see p.182)

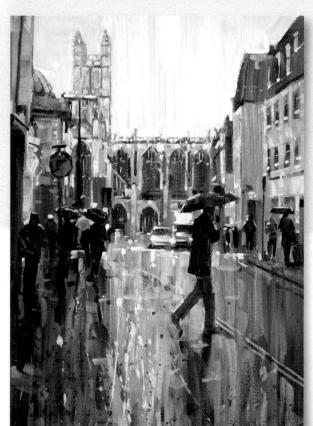

Rainy day (see pp.188-89)

St Michael's Mount

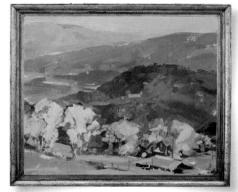

Mountain scene (see pp.242-43)

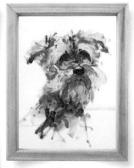

Miniature Schnauzer (see pp.280-81)

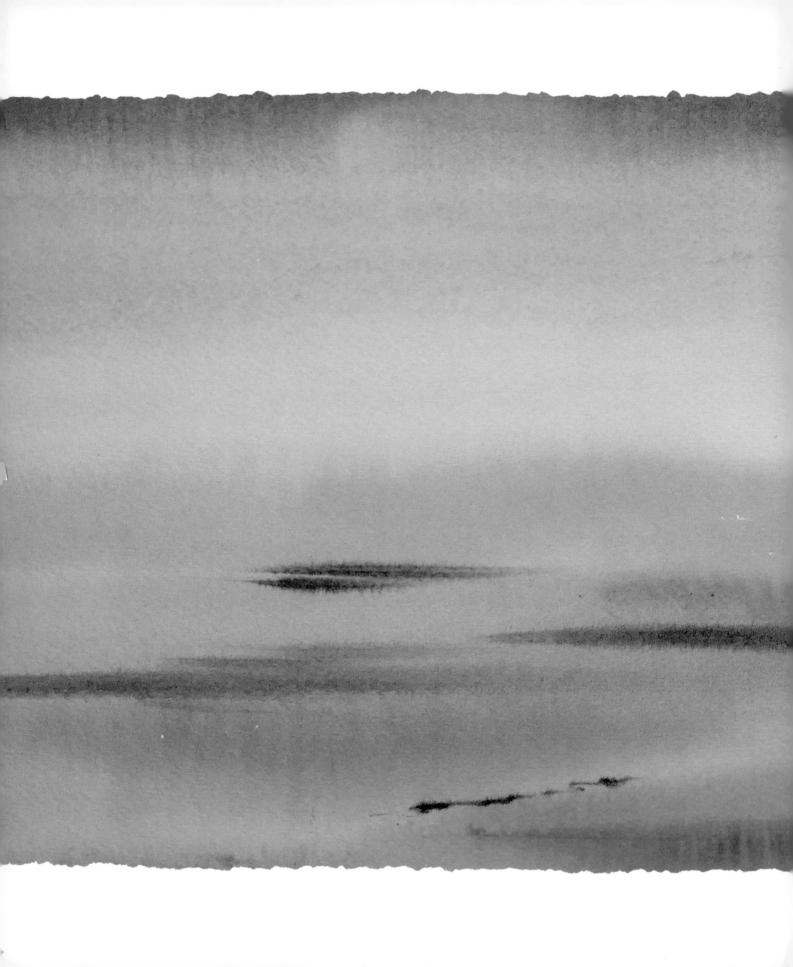

Watercolours

Painting with watercolours

Watercolours are popular with artists of all abilities because they are versatile, easy to use, portable, and affordable. With a translucency that allows the white of the paper to show through, they have a luminosity that imbues paintings with a sense of light. The spontaneous, fluid nature of the paint allows you to create a range of expressive strokes and textures.

On the following pages, you can find out about the paints and materials needed to get started. Then, practise and develop your skills with more than 30 watercolour techniques, grouped into three sections of increasing sophistication – beginner, intermediate, and advanced. A showcase painting at the end of each section brings all the techniques together.

1 Beginner techniques

■ See pp.40-61

In the first section, find out about colour mixing and warm and cool colours, experiment with brushstrokes, produce a range of tones, paint three-dimensional objects, and learn about wet and dry applications.

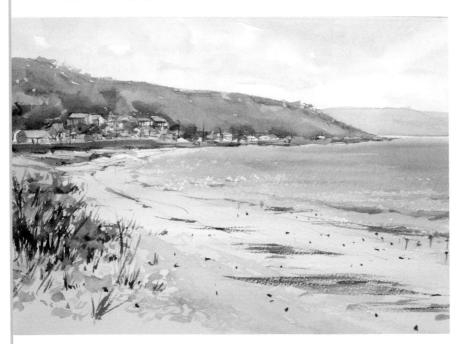

Beginner showcase painting (see pp.60-61)

2 Intermediate techniques

■ See pp.62-89

In the second section, see how to lay flat and graduated washes – core watercolour skills – use aerial perspective to create depth, and find out how to correct minor errors or incorporate them into your painting.

Intermediate showcase painting (see pp.88-89)

Although water-based paints have been used for millennia, watercolours as we know them were first used during the 14th century. At the time, oils and tempera were the predominant media, but watercolours grew in popularity during the 17th century, mainly in England where the landed gentry commissioned paintings of their country estates. As a portable medium suited to outside work, watercolours came to the fore during the Romantic period of the 19th century, when there was a growing love of landscapes and the natural world.

Water-based pigments

Watercolour paints comprise pigments bound with water-soluble binders. The pigments are either dyes that dissolve, or minute particles that form a suspension in water. Paints may also include other additives to prevent them drying out, improve colour, and add body. Natural pigments are usually easier to remove from your paper with a wet brush, while dyes tend to stain.

As watercolours are transparent, the colour and surface of your paper will have an effect on the final painting.

White paper is traditionally used to maximize the luminosity of the paint, although creams and other off-whites are also popular choices.

Watercolours are easy to apply, but as they are unpredictable and difficult to correct, they require practice to perfect. They are best applied quickly and boldly, with economy, to bring out their clarity. With this fluid medium, you can make subtle blends when working "wet-in-wet", or work "wet-on-dry" to create shimmering layers and precise detail.

3

Advanced techniques

■ See pp.90-117

In the final section, find out about granulation, glazing, painting skin lones, and the value of gathering source material and trying different compositions and tonal studies before committing to a final painting.

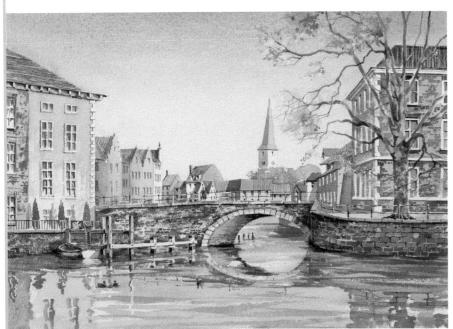

Advanced showcase painting (see pp.116-17)

Watercolour paints

CHOOSING WATERCOLOUR PAINTS

There are two main forms of watercolour: wet tube paints and dry pan paints. You can also buy watercolour "sticks", which are dry and can be used to draw and sketch as well as with a brush. These paints are available in two qualities: student quality, which is recommended for beginners, and more expensive artist-quality paints for more advanced artists.

Tube paints

Usually available in 5ml or 14ml tubes, these have a semi-liquid consistency and are quick and easy to mix. As you can squeeze out as much paint as you need, tube watercolours are ideal for mixing large batches of colour for

washes and large-scale paintings. For the same reason, it is easy to achieve intense colour saturation (see opposite) with tube paints. You can even use them neat for the most vibrant colour. Tube watercolours will dry out if left on a palette, but can be used again if wetted. They can also be used to replenish a pan paint (see below) if left to dry.

Pan paints

Dry, cake-like pan paints are convenient and portable - perfect for working en plein air. As you pick up the colour a

little at a time using a wet brush. they are great for small paintings and sketches. Use a damp cloth to wipe the pans clean after use to prevent contamination. Pans tend to absorb colours from a dirty brush.

Whole pans

Pan paints are available in two sizes: half pans and whole pans. Buy whole pans for the colours you use most frequently. For example, if you specialize in landscapes, you might decide to buy whole pans for blues (skies) and earthy colours such as burnt sienna and burnt umber. Buy individual pans to customize a set.

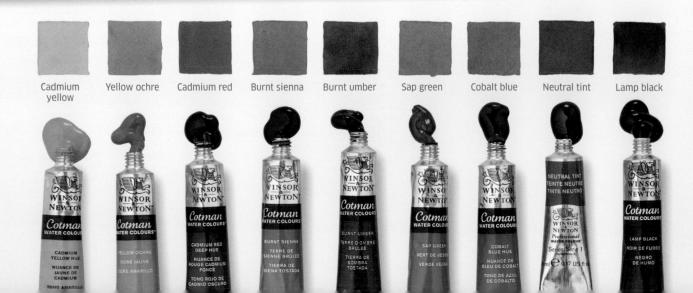

Quality and saturation

Artist-quality paints have a higher proportion of pigment to filler than the more affordable student-quality versions. The pigments are more finely ground, which results in a richer paint, and they are more lightfast and consistent from tube to tube or pan to pan. However, as a beginner you should stick to student-quality paints (the same goes for other materials) until you gain confidence with the basic techniques and are sure that you want to continue with watercolours. As you progress, buy the best-quality paints you can afford.

Watercolour paints offer a range of effects in terms of saturation and transparency. Tube paints can give an intense effect because you can apply lots of pigment, whereas pan paints will create a relatively transparent effect unless they are built up in layers.

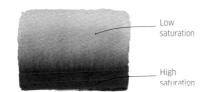

Tube paint swatch

"As you develop your skills as a watercolour artist, tailor your palette of colours to suit your own style."

Basic palette

This sample selection of colours (shown here in tube form) is a good basic palette for the beginner. Add or substitute colours as you become more familiar with the medium.

Additional colours

Explore the range of paints available as you progress. For example, all of these colours are used in the techniques in this chapter.

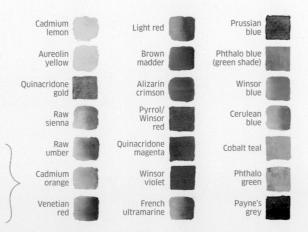

Opaque white

Although it is usual to allow the white of the paper to show through, white watercolour paint is also available for a more opaque colour.

Chinese white

Brushes

HOW TO CHOOSE YOUR BRUSHES

There is a wide range of brushes on offer, but round, soft-hair brushes are the mainstay of watercolour painting. You can create a wide range of brushstrokes with a small selection of round brushes. Other brush types, on the whole, lend themselves to specific tasks, such as washes or fine details. Add them to your collection as you need them.

Brushes are available in various materials, qualities, shapes, and sizes. High-quality brushes can be very expensive, but you don't need to spend a great deal. Whichever fibre you choose, a round brush should be supple, have a pointed shape, and be able to carry plenty of paint in its belly.

Brush fibres

Sable brushes are the traditional choice of watercolour painters, as the hairs are springy, keep their shape, and hold plenty of water and

paint. However, they are expensive (especially the larger sizes) and do wear out. The best quality are those made of kolinsky sable (a member of the weasel family); pure sable and red sable are less good, but still of high quality. When buying in a retail shop, ask for some water, wet the brush, and ensure that it comes to a perfect point before purchasing. If you buy online you run the risk of buying an imperfect brush.

Squirrel and goat fibres are very soft and suitable for large washes, but won't give you enough control

for detailed work. Ox hair is suitable for flat brushes, and hog hair, or a synthetic equivalent, is stiff and good for scrubbing out mistakes.

There are also blends of sable and synthetic fibres, which can be a good compromise. Synthetic brushes are cheaper than sable, will last a lot longer, and are perfectly good for just about all watercolour work.

Types of brush

8 round sable and synthetic blend brush

Brushes are available in numerous shapes, each suited to its purpose. For most brushstrokes, a round

Round brushes

For watercolour painting, round brushes are the most frequently used type of brush. Their shape makes them versatile, suitable for detail and delicate lines, but also for applying washes and broader strokes. It is worth investing in a good-quality round brush as you will use it the most.

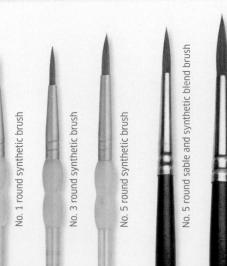

Wash brushes

Natural bristle brushes hold and distribute paint very well, so are ideal for applying washes. The square, mop, and hake (an oriental-style wash brush) are all good for laying large areas of colour, as well as absorbing excess paint. The mop is also suitable for blending.

Holding a brush

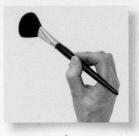

Mid-handle hold
To paint washes, hold your brush in the middle of the handle and move your entire lower arm.

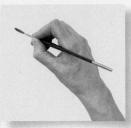

Close pencil hold
To paint details, hold the
brush like a pencil. Place
your little finger on the
paper to steady your hand.

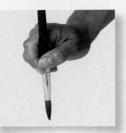

Upright hold
Paint sweeping lines with
the brush tip, keeping your
wrist fixed and moving
your arm from the shoulder.

Flexible pencil hold Hold the brush like a pencil halfway down the handle to increase your range of movement for flowing lines.

End-of-handle hold Grip the brush at the end so that you can flick your wrist - perfect for fine, delicate lines.

shape that comes to a fine point is best. Large square brushes or large oval mop brushes are good for applying washes to larger areas. A flat brush, also known as a "one stroke", is suitable for strong lines and linear strokes. Wash brushes are simply larger versions of these.

Liners and riggers are long and narrow, with long hairs and pointed tips. These are ideal for painting very fine lines. Swordliners – very tapered brushes – are also good for fine detail. For blending, fan-shaped brushes are useful.

Sizes

Brush sizes are designated by numbers from 000 (the smallest or finest) upwards. If you are a beginner, start with three round brushes in sizes 03, 05, and 08. Intermediates and advanced artists can extend their collection to suit their personal style and needs.

Brushmarks

You can use the tip, side, or edges of your brushes to make marks. Square, flat brushes produce strong, angular lines. Round brushes create loose, expressive lines when used on their side, and fine lines using their lips.

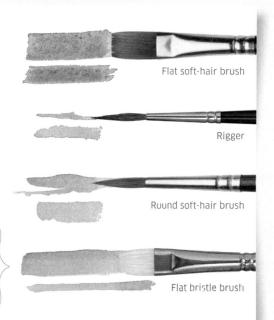

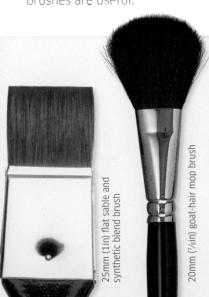

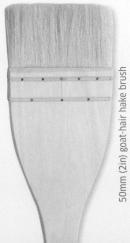

Other brushes
Use the right brush

for the job.
Fan-shaped brushes are suitable for blending, while riggers are ideal for adding fine detail and outlines. Flat brushes are good for creating strong lines and straight edges.

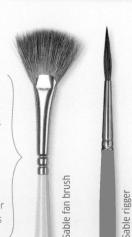

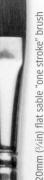

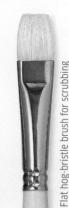

Supports and other materials

CHOOSING A SURFACE TO PAINT ON

The primary support, or painting surface, for watercolours is paper. It is manufactured in many different ways and has many different properties, colours, sizes, and weights (thicknesses). You can buy paper in several forms including individual sheets, rolls, bound sketch books, and pre-stretched watercolour blocks.

Different textures and weights of paper will create different effects in your finished paintings. It is advisable to experiment and think about the effect you want before choosing your paper. Buy single sheets of paper until you have decided which type you prefer.

Sketch books

Sketch books are essential for all artists and are bound in various ways. Spiral-bound sketch books are the most useful as the pages lie flat. Sizes vary. If you are using them for outdoor work, A3 is probably the largest manageable size.

The type and quality of paper in sketch books also vary. Choose a medium to heavyweight paper that won't cockle (buckle) when wet. Lighter papers are suitable for pencil or pen work, as is robust cartridge paper. Sketch books made from watercolour paper will take washes better than cartridge paper.

Watercolour papers

Watercolour papers come with different surfaces: rough, NOT-pressed (also known as cold-pressed) and hot-pressed. Rough paper has a very textured finish, while NOT paper has a relatively smooth surface. Hot-pressed paper is run through rollers to make the surface very smooth. Although watercolour papers are generally white, the tone of the paper can vary according to the manufacturer, ranging from brilliant white to nearly cream. The whiteness will affect the luminosity of the painting. Watercolour paper has a "right" and a "wrong" side. The right side is the side from which you can read the watermark the right way up, but you can paint on both sides of most good papers. Paper is also treated with size when it is made, to control its absorbency. Manufacturers

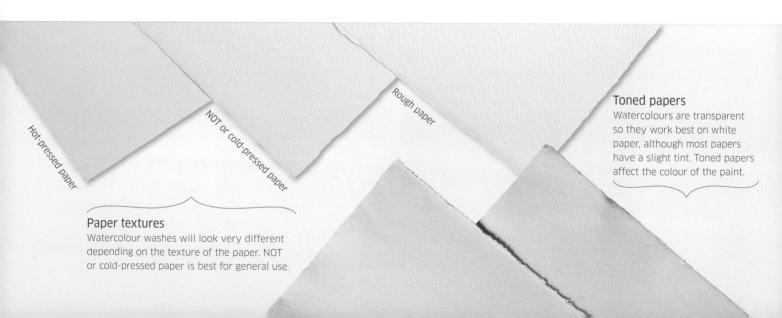

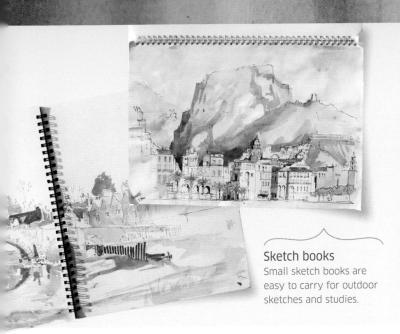

Palettes

Palettes should be white and preferably ceramic. Plastic palettes tend to stain over time. You will need at least one palette with several wells for different colours, and one larger palette for mixing washes.

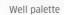

Ceramic palette

create different surface qualities in their sizing processes, which affect how paint behaves. Paint will not be absorbed by a highly sized paper. Instead, it will "slide" across the surface. Less sized papers will absorb paint washes quickly and the paint will sink into the surface. If paper is too highly

Paper sizes and weights

sized for your needs, stretch it to

remove some of the size (see below).

Individual sheets of paper come in various sizes, the largest of which is 76 x 56cm (30 x 22in) and sometimes

called a "full imperial". Half and quarter imperial sheets are also available. Should you require larger sizes, you can buy paper on the roll. Weights of paper are generally 200 grams per square metre (90lb), 300gsm (140lb), and 640gsm (300lb). You can use the heaviest-weight papers without stretching them, but they are expensive. It is also difficult to roll heavier papers, for example if you want to send a painting to be framed. It is much easier to roll 200gsm and 300gsm papers to store them or send them in a cardboard tube. However, you will need

to stretch these weights of paper before use or they will cockle when washes are applied.

Watercolour blocks

Watercolour blocks are made up of smaller sheets of paper that are glued down. The top layer of the block acts as the painting surface. When your painting is complete, you can simply lift it off the block, exposing the next layer. Blocks are good for use outdoors, as they provide a sturdy surface for you to work on and you don't need a separate drawing board.

Stretching paper

Step 1
Soak the paper thoroughly with water on both sides using a sponge.

Lay right-side up on a strong board.

Step 2
Stick one edge of the paper down with gum strip and gently pull the paper to remove cockles.

Step 3
Glue the remaining edges of the paper down with the gum strip.

Step 4
Leave the paper to dry (this will take several hours). Keep the paper on the board while painting.

Colour mixing

USING COLOUR THEORY TO MIX WATERCOLOUR PAINTS

Exploring colour theory will help you learn how to mix your own colours and create the hues, tones, and shades that bring your work to life. However, watercolours dry noticeably lighter than the wet colour you see on the paper, so you'll need to practise making your mixes stronger to compensate for this.

WET MIXING METHODS

You can mix wet paints together in a palette or combine them "wet-in-wet" directly on the paper, as shown in these examples with French ultramarine and aureolin. Don't rinse your brush between picking up colours - rinsing adds water and dilutes the mix, making it impossible to achieve strong colours.

Traditional versus modern colour wheels

The primary colours - traditionally red, yellow, and blue - are capable of creating many other hues (see pp.14-15). There are warm and cool variations of every colour, however, so your colour mixes will vary depending on which versions of blue, red, and yellow you choose. A modern approach is to use magenta, yellow, and cyan as primaries. These are cooler than the traditional primaries, and create vibrant secondary and tertiary mixes.

As the studies opposite show. neither traditional nor modern colour wheels create a fully comprehensive range of colours. However, using colours from both systems will allow you to mix warm and cool primaries to create a huge range of colours, both muted and bright.

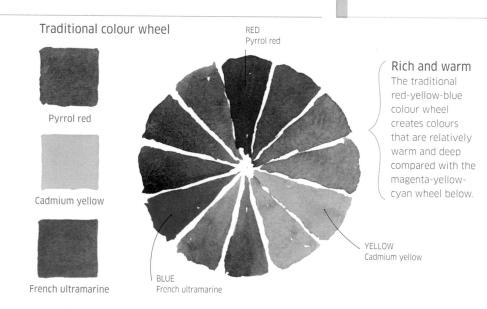

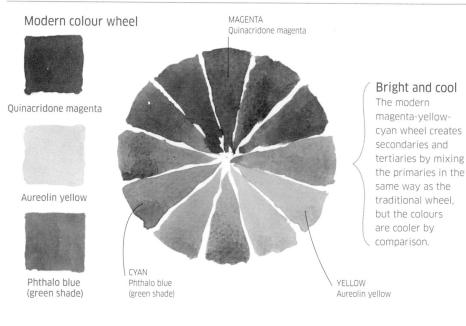

Mixing in a palette Using your brush, place some water in the palette then pick up the first colour and blend it with the water. Without rinsing your brush, pick up the second colour and blend it with the first. This creates an evenly mixed colour.

Mixing wet-in-wet onto the paper Apply a wash of the first colour to the paper. Add the second colour while the first wash is still wet. The result will be a partially mixed colour with a variegated appearance.

1 - Blend paint with water

2 - Add second colour

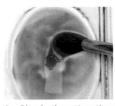

3 - Blend colours together

Produces even colour

1 - Apply first colour

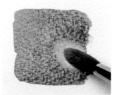

2 - Add second colour

3 - Blend wet colours

Produces variegated colour

Mixing traditional primaries

This study of a house was painted only with the traditional primary colours of red, yellow, and blue. The secondary colour mixes made with the traditional primaries look quite earthy and muted compared to those created by the modern primaries (see below).

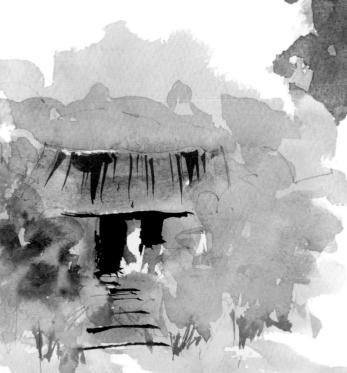

Study using modern primaries

Mixing modern primaries

Study using traditional primaries

A trio of modern primaries were used for this study – magenta, yellow (aureolin yellow), and cyan (phthalo blue – green shade). The resulting secondary colour mixes are vibrant but a little brash and unnatural compared with the secondaries created by the traditional primaries (see above).

Mixing three primary colours to create darks

Combining all three primaries together creates dark colours. The results are close to black, rather than pure black, and usually look less jarring in your painting than black paint. You can vary your choice of primary colours and the proportions in which you mix them to create a range of useful darks.

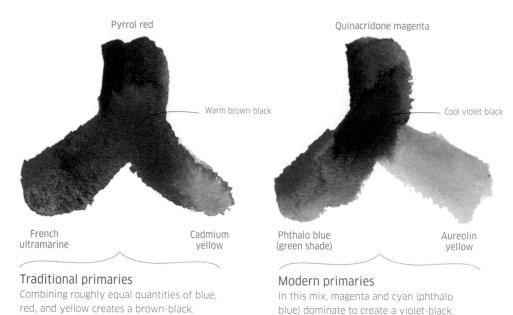

Mixing complementary colours to create darks

Complementary colours sit opposite each other on the colour wheel. When they are mixed together, they create a wide range of dark colours: brown, blue, grey, black. Many painters find this a better method of mixing darks than using primaries.

Combining complementaries

French ultramarine and its complementary burnt sienna (a dull orange) create a very wide range of darks. Phthalo green and magenta (substituting red) create cooler darks. The yellow and violet create a duller neutral that is less successful.

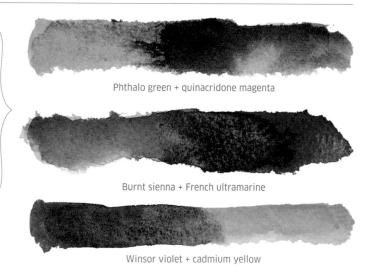

Lightening colours

In watercolour, colours are lightened by adding water to make them more transparent. Adding white paint creates pastel tones but also makes the colour more opaque. Adding too much white can make colours look chalky.

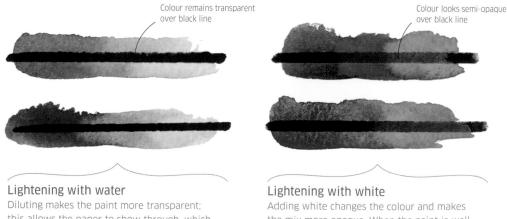

Diluting makes the paint more transparent; this allows the paper to show through, which lightens the colour optically.

Adding white changes the colour and makes the mix more opaque. When the paint is well diluted, the opacity is not very noticeable.

Pigment staining and transparency

All pigments are staining or non-staining; and either transparent, semi-transparent, semi-opaque, or opaque. Manufacturers may classify similar pigments differently, so check when you buy. Staining pigments leave some colour on the paper if you remove them. Opaque pigments become transparent when diluted, so you can mix them without fear of creating muddy colours.

French ultramarine (non-staining)

French ultramarine (non-staining)

Phthalo blue (staining)

Dry paint swatches were wetted

and scrubbed to lift out the paint.

The staining pigment does lift out

but leaves a little more colour.

Staining - dry colour

Phthalo blue (staining)

Staining - wet colour

Wet paint was lifted from these swatches with a tissue. There is a a slight difference between the staining and non-staining results.

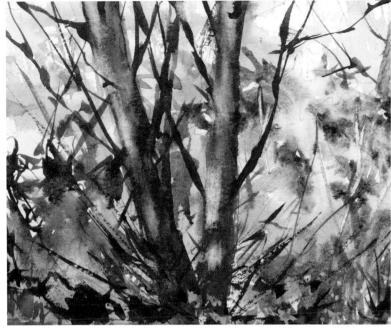

Lifting out staining pigments

Staining pigments can be removed enough to create highlights, as seen on the trunks of these trees.

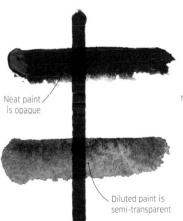

Cadmium red (opaque)

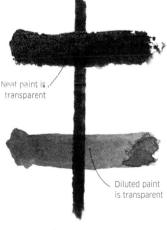

Alizarin crimson (transparent)

Opaque pigment

This colour is opaque enough to cover black when it is neat but is almost fully transparent when diluted for washes.

Transparent pigment

Some colours are transparent even when they are neat. Transparent pigments remain bright when they are layered.

Using opaque pigments

One of the benefits of opaque pigments is that you can apply them over a dark background, as with the neat cadmium yellow used here to paint daffodils.

Colour charts

PRACTISING COLOUR MIXES

Making colour charts is a great way to practise colour mixing, and you can keep them as a reference for subsequent projects. You can mix watercolours by painting washes of colour over dry layers (wet-on-dry), adding one wet wash to another on the paper (wet-in-wet), or mixing paints in your palette. Try making colour charts using each of these methods so that you can observe the different results.

WET-ON-DRY COLOUR CHART

In this exercise, let the first layer of colours dry before adding the second. Use all the colours in your collection; the chart below uses the colours recommended in the basic palette (see pp.34–35).

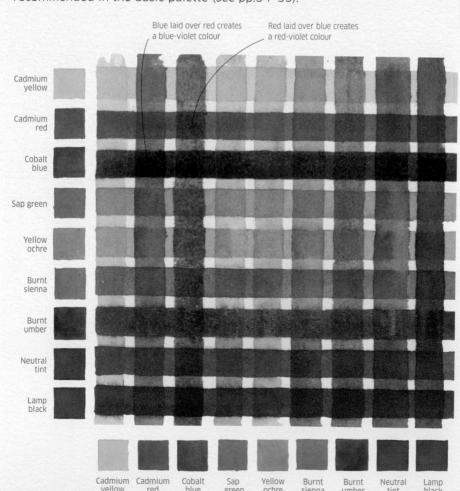

You will need

- All the colours in your collection
- Medium-size round soft-hair brush
- Jar of water for rinsing
- NOT watercolour paper
 - Making a grid
 Draw a grid on your paper in pencil, labelling all the columns and rows so that each of your colours is listed both horizontally and vertically.
 - 2 Painting the lines
 Paint the columns first. Once the columns are completely dry, paint the rows over the top. Aim for the same saturation level for each colour.
 - 3 Observing the effects
 When the chart is dry,
 observe how the colours have
 been modified by layering.
 The effect depends on the hue,
 density of pigment, and order in
 which the colours were painted.

CHART OF COLOURS MIXED IN YOUR PALETTE

This exercise involves mixing two wet colours together in your palette and painting them on a grid to record the result. Use all the colours in your collection. These charts show 50:50 and 70:30 ratio colour mixes, respectively.

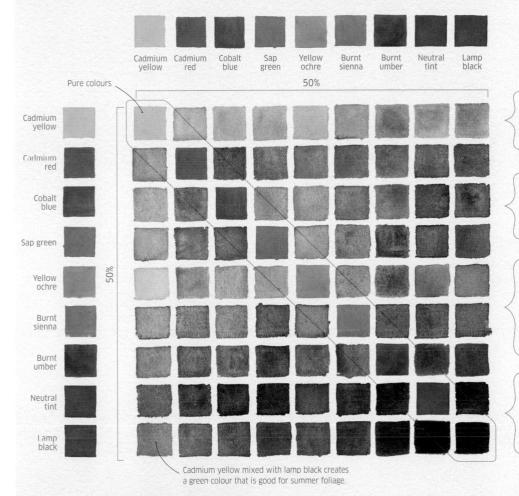

You will need

- All the colours in your collection
- Medium-size round soft-hair brush
- Jar of water for rinsing; jar of clean water for mixing
- NOT watercolour paper

Making a grid Draw a grid with spaces to list each of your colours along the top and down the side of the grid.

2 Plotting unmixed colours
Before you begin mixing, paint
pure colours on the diagonal axis,
where the horizontal and vertical
lines for each colour intersect.

Mixing colours 50:50

Add equal amounts of two colours to your mixing well for a 50:50 ratio. Don't rinse your brush before picking up the second colour, otherwise your mix could be too weak and diluted.

4 Plotting mixed colours
Paint the mixes in their
corresponding squares on the
chart. Rinse your brush before
creating each new mix. Let the
chart dry and keep it for reference.

Pure colours 70%

5 Mixing colours 70:30

Create other charts to see how changing the ratio of one colour to another extends the range of hues you can mix. The chart on the left was created with 70:30 colour mixes.

30% cobalt blue mixed with 70% sap green

70% cobalt blue mixed with 30% sap green

GREENS

Green can be a difficult colour to mix successfully. For this reason, you may want to include several bought greens in your palette so that you always have a suitable green to hand.

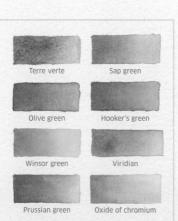

Tone exercises

CREATING ATMOSPHERE AND FORM

Tone describes the lightness or darkness of a colour. With watercolours, this relates to the density of paint. Paint straight from the pan or tube is as dense as it can be and the darkest tone for that hue. By adding more and more water, you can create lighter and lighter tones. You can use variations in tone to create form (see pp.56–57), and to suggest an overall atmosphere for your painting.

Form and mood

You can use graduations of tone to convey the form of a three-dimensional object by creating shadows, highlights, and a range of tones in between. You can also use tone to create atmosphere, and so evoke an emotional response in the viewer. For example, paintings with a narrow tonal range tend to suggest a soft or subdued atmosphere, while paintings with high tonal contrast are generally more vibrant and upbeat.

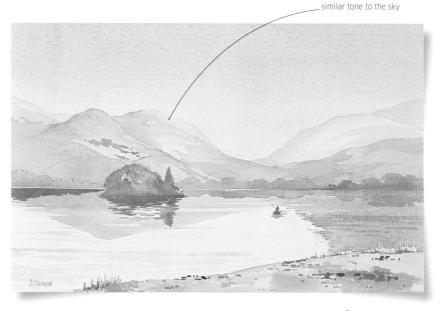

Narrow tonal range

In this landscape, there is very little tonal difference between the different elements. The painting aims to evoke a quiet, reflective response in the viewer, which suits the peaceful scene.

Wide tonal range

This painting of a fishing village bathed in sunshine has a wide tonal range. There are strong contrasts in tone between the dark shadows and bright highlights.

PUTTING IT INTO PRACTICE

These exercises, the first in black and white and the second in colour, are a great way to get to grips with tone. By starting off with simple tone charts, you can practise creating individual swatches of tone before blending them in a simple still life.

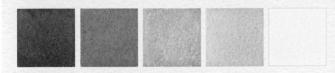

1 Black-and-white tone chart
Draw a grid comprising five squares. Paint the darkest
tone first, using black paint straight from the tube or pan. Next,
dilute the paint to create the middle box. It will then be easier
to judge the tone for the adjacent squares. For the final, lightest
tone, leave the paper white.

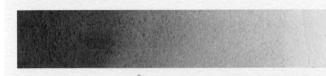

2 Graduated tone chart

This time, draw a long bar with no segments. Load a no. 2 soft-hair brush with undiluted paint and block in one end. Apply water, a little at a time, and blend the paint from dark to light in a gradual transition.

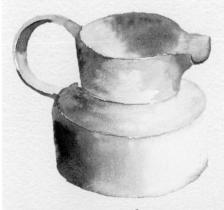

Black-and-white jug
Sketch a simple, curved object, such as a jug. Look at how the light falls on it, then, using a no. 4 soft-hair brush, apply tones to create a three-dimensional effect. Use the darkest tones for the shadows, gradually blending lighter tones towards the highlights.

4 Colour tone chart
Repeat steps one to three but with a range of colours
to test the density of different pigments. Here, brown madder
was used.

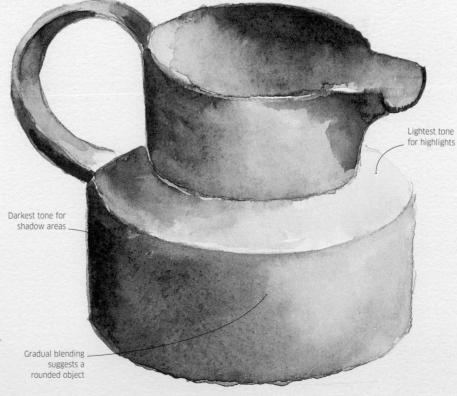

Warm and cool colours

BALANCING COLOUR TEMPERATURE

Colours have qualities that we associate with temperature. Some colours, such as red, are considered to be warm, while other colours, such as blue, are cool. Using these traits can be a powerful way of conveying mood, depth, and harmony in your work.

Characteristics of colour temperature

Visually, warm colours appear to come forward in paintings whereas cool colours appear to recede. This illusion is very useful for creating a sense of depth. Warm and cool colours are also associated with certain emotions, which you can use to convey mood.

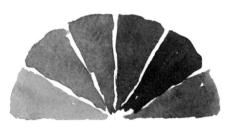

Warm colours

Reds, oranges, and yellows are generally grouped in the warm half of the colour wheel (see pp.14-15). A picture painted mostly with warm colours suggests a happy or energetic mood.

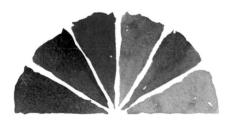

Cool colours

Violets, blues, and greens are generally grouped in the cool half of the colour wheel. Including a lot of cool colours in a picture suggests a calm or subdued mood.

Creating colour harmony

Colour harmony helps you to create visually satisfying pictures. Limiting your palette to a small range of colours, or using analogous colours, is one way to achieve a unified scheme. You can also use a common, or "atmosphere", colour throughout a painting to tie elements together. Balancing colours doesn't necessarily mean using equal amounts of warm and cool – one can dominate while the other provides a pleasing contrast.

Atmosphere colour

You can use one colour as a unifying theme throughout a painting. In this painting, burnt sienna is used in various tones in the background, middle ground, and foreground to create a harmonized colour scheme.

This snowy scene calls for a cool, blue-toned palette, but the brown-gold trees and building in the background, and the bright pheasant in the foreground, provide some warmth for balance.

An equal amount of warm and cool is generally unsatisfying, so in this painting the figures are mostly wearing warm yellows, oranges, and reds with only one or two cooler blues and violets.

PUTTING IT INTO PRACTICE

In this painting, the cool background colours appear to recede while the warm colours of the foreground objects seem to advance. This creates an overall sense of depth.

Still life with wine and fruit

You will need

- No. 5 and no. 2 round soft-hair brushes
- 25 x 30cm (10 x 12in) rough watercolour paper

Background

L Sketch your composition in pencil, then mix a cool, dark blue wash for the backround. Paint the wash with a no. 5 round soft-hair brush, turning the paper upside down to make it easier to paint around the bottle and other objects.

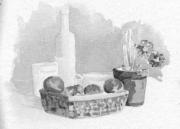

Warm colours
When the background is dry,
paint the oranges, basket, and
plant in the foreground with
warm colours to help them stand
out. Allow to dry.

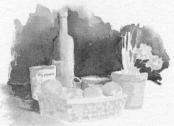

3 Cool colours

Paint the bottle, glass tumbler, and cup with cool colours. This helps to indicate that they are behind the fruit and flowers

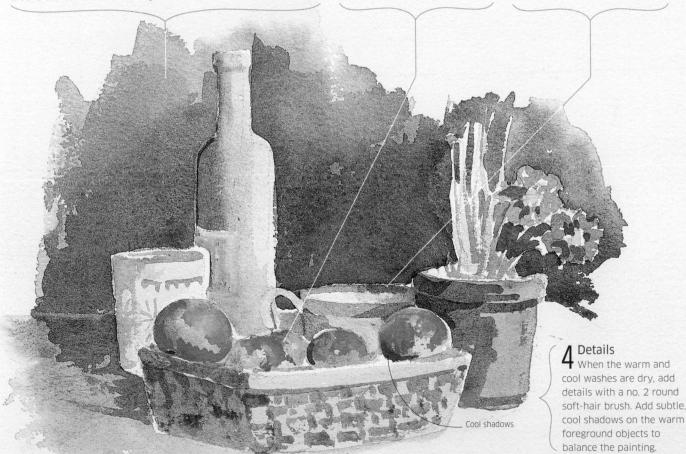

Brushstrokes

TYPES OF BRUSHES AND STROKES

There are many sizes and types of brush, from tiny riggers to large mop wash brushes. Soft-hair brushes made from sable are the best material, as they are absorbent and retain the finest point – but they are also the most expensive. There are, however, many more affordable, synthetic brushes that are also of good quality.

19mm (¾in) flat brush

No. 10 round soft-hair brush

No. 3 rigger brush

Choosing the right brush

A no. 10 round soft-hair brush is one of the most useful and versatile brushes. You can use it for both broad washes and fine, detailed line work. For larger washes, use a large, flat brush – you can also use it to create square-edged marks. The rigger, so called because it was used by painters to describe the intricate rigging on ships, is used for more delicate lines.

Square edges with flat brush

Large wash with round brush

Applying washes

Hold the brush close to the end of the handle when laying broad washes. This allows your hand and arm to move more easily, keeping the work loose.

Scumbling with flat brush

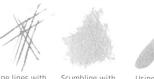

Fine lines with Scumbling with rigger brush round brush

Using tip of round brush

Drier strokes and detail

For fine details, hold the brush as you would a pen, for greater control. Familiarize yourself with each brush by making a variety of marks, using paint at different strengths.

PUTTING IT INTO PRACTICE

This landscape of winter trees was created using several brushstroke techniques. For example, a dry brush was used to suggest the tree canopies, while individual branches were picked out in fine detail.

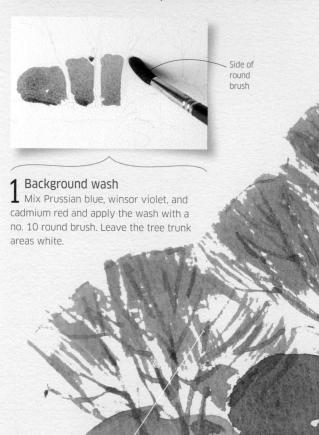

Dry mix of yellow

ochre and winsor

) Dry brush

Luse the dry-brush technique to create the effect of a mass of twigs in the canopy. Drag a flat brush across the surface using downward strokes.

You will need

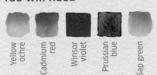

- No. 10 round soft-hair, 19mm (3/4in) flat soft-hair, and no. 3 rigger brushes
- = 28 x 38cm (11 x 15in) NOT watercolour paper

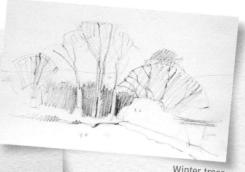

Winter trees

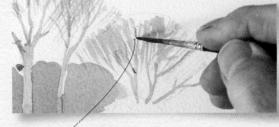

Add fine detail with a rigger brush

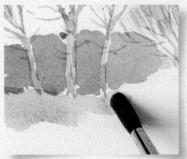

Foreground area Mix sap green and yellow ochre for the foreground area. Use the side of a no. 10 round brush to add broad strokes of paint.

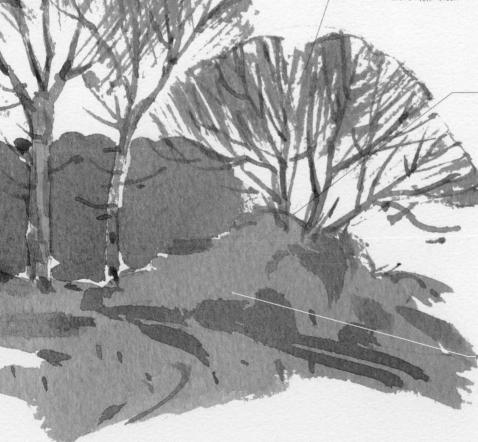

"Familiarize yourself with brushes by making a variety of marks, using the paint at different strengths and dilutions."

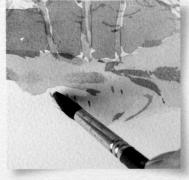

5 Foreground details
Use a darker mix of sap green and yellow ochre to add detail and texture to the grassy foreground area. Use the tip of a no. 10 round brush for these finer details.

Laying paint

WET-IN-WET AND WET-ON-DRY

Applying paint on wet paper is called "wetin-wet" and it allows the paint to spread and blend with other colours. This creates soft colours and lines, but doesn't give you much control. If you lay paint on dry paper, called "wet-on-dry", the pigment won't spread as easily, allowing you to make crisp, precise marks and apply strong colour.

Diffusion and definition

If your paper dries out during a wet-in-wet wash the paint won't spread easily, so prepare your mixes and water in advance. Once the paper is dry, you can re-wet it to apply further wet-in-wet washes, or apply a wet-on-dry wash for stronger colour and detail.

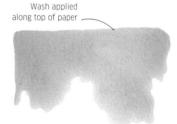

Wash applied here when paper was upside down

Wet-in-wet

Paint applied to wet paper will spread because the surface water disperses the pigment. Tilt the support so the paint runs down.

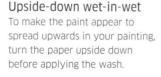

Wet-on-dry

Paint applied on dry paper is easier to control, which is perfect for sharp lines and details.

Blended wet-in-wet

Laying multiple colours on wet paper will make them blend into each other.

PUTTING IT INTO PRACTICE

Try a cloud study to practise the different methods of laying paint. Before you start, prepare one jar of water to clean your brush, another jar to keep as clean water, and mix generous amounts of colour.

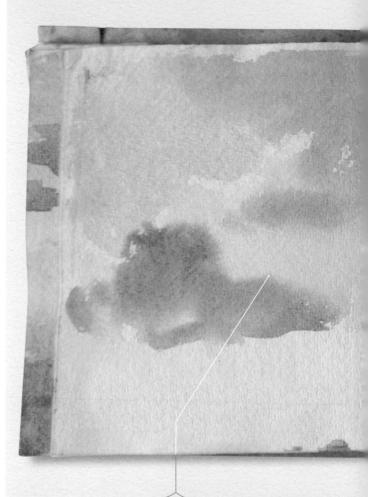

Wet-in-wet wash L Use a clean brush to wet the paper with clean

water. Working quickly, apply a cerulean blue wash to one part of your paper. Rinse your brush immediately, then apply an ochre wash next to the blue, allowing the two colours to touch and merge at their edges.

You will need

Winsor violet erulean

- No. 10 round soft-hair brush
- Clean water

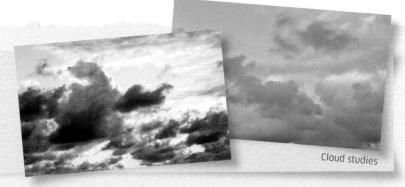

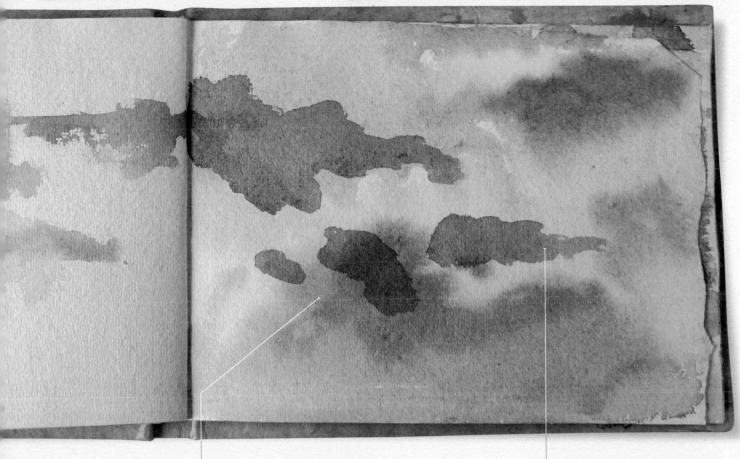

2 Re-wetting the paper
Let the first washes dry
completely. Rinse your brush
and use clean water to re-wet
the paper (using dirty water
will taint the previous
colours). Quickly apply a
third wash to the wet paper,
allowing it to blend with the
previous washes. Use a
stronger colour (such as
violet) so that the layered
wash shows up.

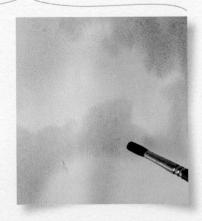

Wet-on-dry wash
Let the previous washes
dry completely before you
add more defined cloud
shapes. Apply a stronger
colour (so that it shows
up against the previous
washes) on the dry paper.
The wet-on-dry method
will give your shapes
defined edges.

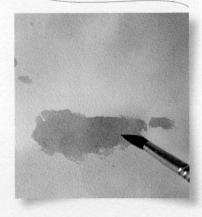

Using runs

CREATING EFFECTS WITH WATER

When used in a conventional way. watercolour has one particular quality that no other medium can match - it runs Instead of trying to blot your work dry when this happens - or even abandoning it - why not make it a feature of your painting? Runs can create some unexpected yet beautiful effects in their own right.

Manipulating runs in washes

Many watercolour techniques are based on manipulating washes of diluted colour. It is inevitable that at some point these washes will run together. As the outcome of a run is reasonably easy to predict. you can either exploit the results or prevent the run from happening in the first place.

Runback or "cauliflower"

Be careful not to let drops of water from the brush land in a wet wash. The drip immediately spreads out. leading to this common but undesirable phenomenon.

Strong into weak

To avoid runbacks, always apply strong washes into weak ones. That way, any drops will retain their shape and colour and can be incorporated into your work.

Blotting

You can blot excess colour from a damp wash using a tissue. The resulting texture can create a desirable effect in its own right.

Controlling movement

Use washes of a similar strength to prevent adjacent washes moving into one another. A weak wash will move into a strong one - the greater the disparity, the stronger the effect.

PUTTING IT INTO PRACTICE

Runs can create some interesting effects. Although you can never completely control the results, with practice you will find it easier to make the best of them. The effect is useful when you want to paint a subject with a natural blend of colour or tone, such as on an old stone wall.

Hillside buildings

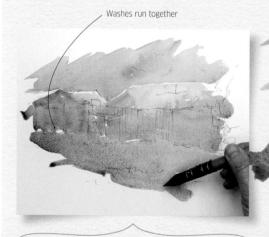

Background with run

f L Block in the hillside with a wash of ultramarine and burnt sienna using a soft-hair mop. Allow it to dry, then paint the buildings with the same mix and paint the grass with a mix of ultramarine and gold. Allow the last two washes to run together.

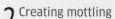

L Flick water onto the washes while they are still damp. Then, with your mop, apply stronger varieties of the same mixes created in the first step. This produces a mottled effect.

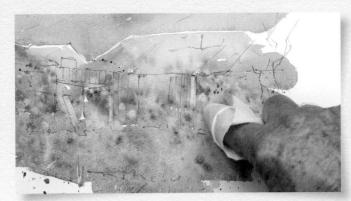

3 Blotting out
As the applications of paint from the previous step are drying, blot parts of the wash using a tissue wrapped around your finger. When the wash has just dried, paint blobs of water onto other areas, such as the planks of wood on the right-hand side of the wall, then blot after about 20 seconds.

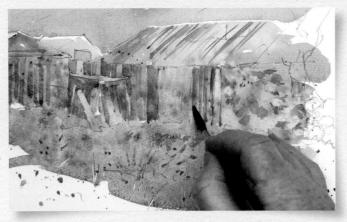

4 Adding detail
Add details to the barn - such as the corrugated roof and wooden walls and doors - using a rigger brush. Flick paint onto the foreground and then blow on it through a straw to suggest blades of grass.

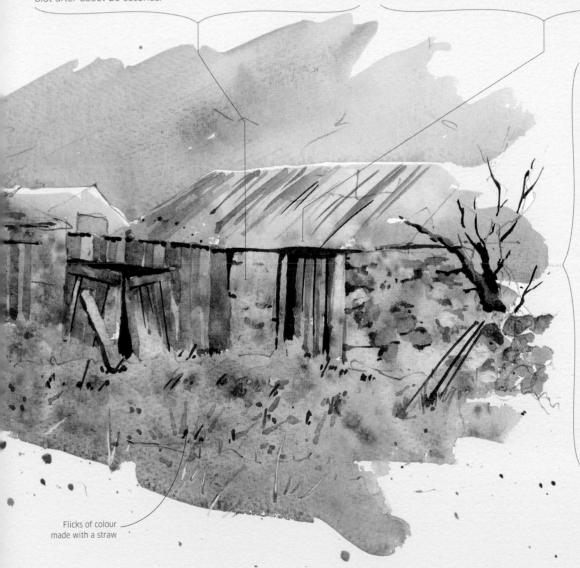

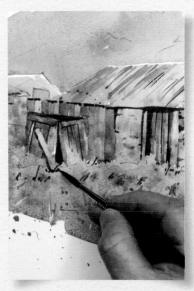

5 Final touches Finally, apply a mix of

French ultramarine and burnt sienna with a rigger to further define the structure of the buildings and to suggest the branches of a sapling behind the wall.

Modelling form

CREATING THREE-DIMENSIONAL SHAPES

A simple line drawing can convey a subject's two-dimensional shape, but it will lack a sense of solidity or form. By adding tone, colour, and texture, you can create the illusion of volume – that your subject is a three-dimensional object. The way in which light falls on a subject, and the shape and direction of its shadow, also reveal its shape. Using warm and cool colours can add depth, too, as cool colours appear to recede while warm colours seem to advance

Turning shape into form

When creating form, it is important to show where the light is falling by varying the tone between brightly lit areas and areas of shadow. The background tone is also important, as it provides context, emphasizes the shape of the object, and helps separate the object from its surroundings.

Flat shape

Two-dimensional shape

This simple line drawing shows the two-dimensional shape of the bucket, but it does not have substance or depth. The sketch reveals nothing about the nature of the background or where the light is falling.

Three-dimensional object

By adding shadow, we can see that strong light is falling on the right side of the bucket, which reveals its rounded shape. The contrast between the dark background and bright foreground places the bucket firmly on the ground.

Background shadow

PUTTING IT INTO PRACTICE

This sequence shows how to give a small group of sacks of grain form. The sacks sit on hay bales, which add substance and context, while light seems to flood in from one side, as if from a nearby door.

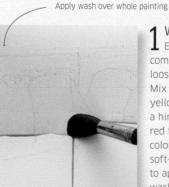

1 Weak wash
Establish the
composition with a
loose pencil sketch.
Mix a wash of
yellow ochre, with
a hint of cadmium
red to enrich the
colour. Use a large
soft-hair mop
to apply a weak
wash across the
whole painting.

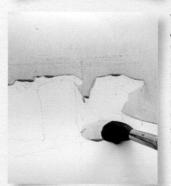

2 Strong wash
Using the same
colours, but in a
more concentrated
mix, apply a second
wash. This time,
paint around the
sacks to make them
stand out from
the background.

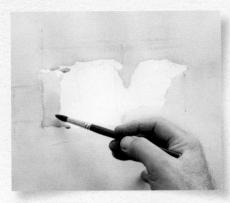

3 Shadow tone
Using a no. 6 soft-hair brush and a mix
of blue and violet, add shadows to the sacks.
This establishes the direction of the light and
conveys the sacks' rounded shapes.

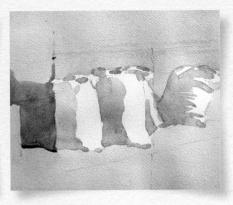

4 Background tone
Add the background tone using a mix of violet and yellow ochre. This sets the sacks in context, further reveals their shape, and emphasizes the light falling on them.

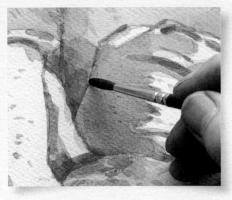

5 Final details
Refine and strengthen the shadows, warming them slightly with yellow ochre.
Finally, add the details of the folds and textures of the sacks to finish the painting.

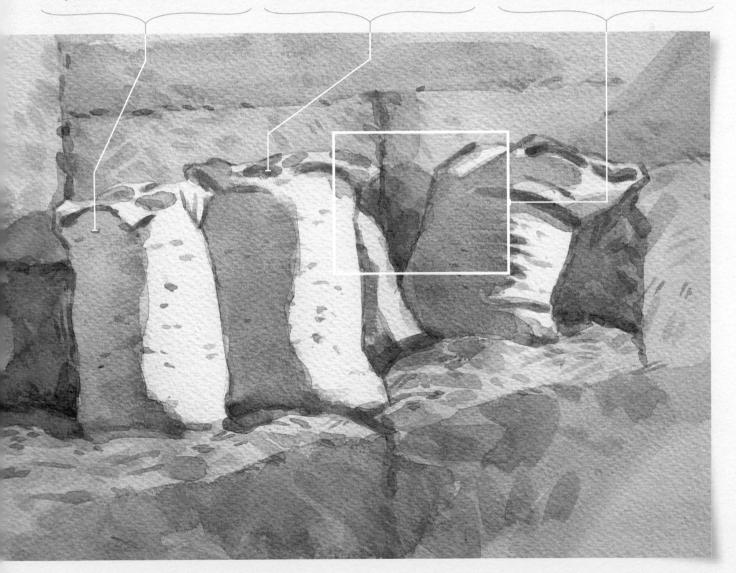

Simplifying a scene

HOW TO APPROACH A PAINTING

Always spend time planning each painting before you start. As a general rule, aim for a ratio of ten minutes' planning to one minute's painting. Use this planning time to find ways of breaking down a potentially complex subject into manageable sections. Look for one main focal point and don't be afraid to rearrange elements of the scene if it improves the composition.

Creating a composition

A good composition consists of a few distinct shapes – some light, some dark. Link several small shapes to create a few large ones, and then create a tonal contrast between them. Don't try to paint everything you see, instead choose one focal point and remove or subdue anything that doesn't enhance it. Keep the foreground simple to provide a restful space before the main subject.

Isolated shapes

The space around these simple shapes isolates them. Several disconnected elements can be distracting, as the eye jumps from one to another.

Combined shapes

Connecting the shapes promotes harmony, and we see them as a single entity. This is useful when planning the background.

PUTTING IT INTO PRACTICE

The clock tower makes a strong focal point, so simplify the scene by ignoring everything to the far right and left, making the painting portrait-shaped. The car is distracting so that can go, too. Finally, connect the figures and shadows to make one interesting shape.

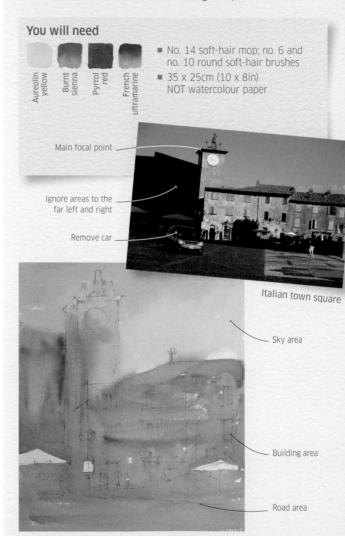

1 Three main areas

Loosely sketch the scene, then paint the sky, buildings, and road as if there were no shadows. Use a no. 14 mop and apply as few strokes as possible. Start at the top and work steadily down. Begin with ultramarine, then add burnt sienna for the buildings and a little more ultramarine for the road.

"A ratio of ten minutes of planning for every minute of painting will give you a chance to find ways of simplifying the composition."

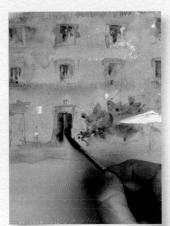

2 Initial details
When the first washes
are dry, add detail to the
windows and doors using a
no. 6 round brush. They will
look more natural if you don't
paint the whole shapes. Add
more detail to the tops of the
objects than the bottoms.

3 Shadow areas
Paint the shadows as one shape with a wash of red and ultramarine over the buildings and road. Start at the top and work down in one go.

4 Simple figures
Loosely indicate the shapes of the people, without painting them as separate figures.

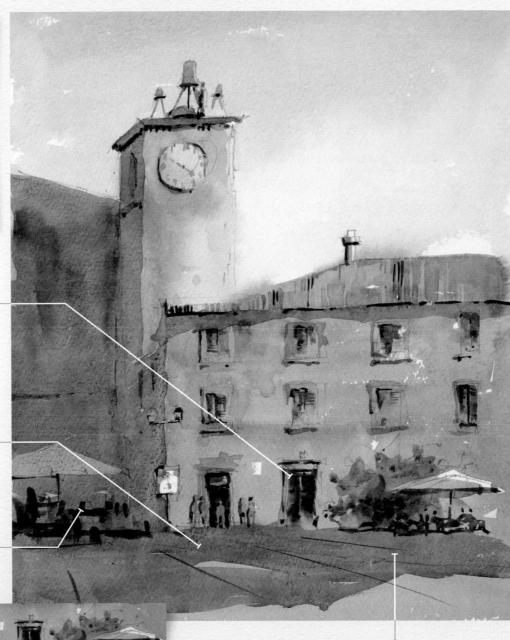

5 Finishing off
Add finer details using a dark mix of
ultramarine and burnt sienna. This will suggest
an animated scene underneath the parasols.

Artist Grahame Booth Title Glenarm, Antrim Coast Medium Watercolour Support NOT watercolour paper

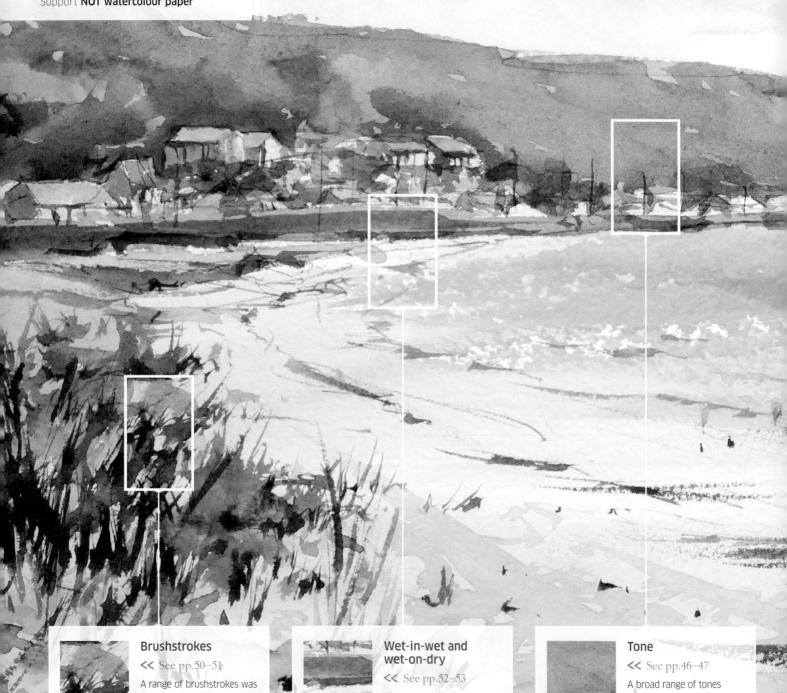

used to paint the grass in the foreground. The tip and side of a round brush were used to suggest single blades and larger clumps.

The sea and sand were painted wet-in-wet so they blend together, while the distant wall and grass were picked out using wet-on-dry.

and hues were used to create contrast and structure throughout the painting.

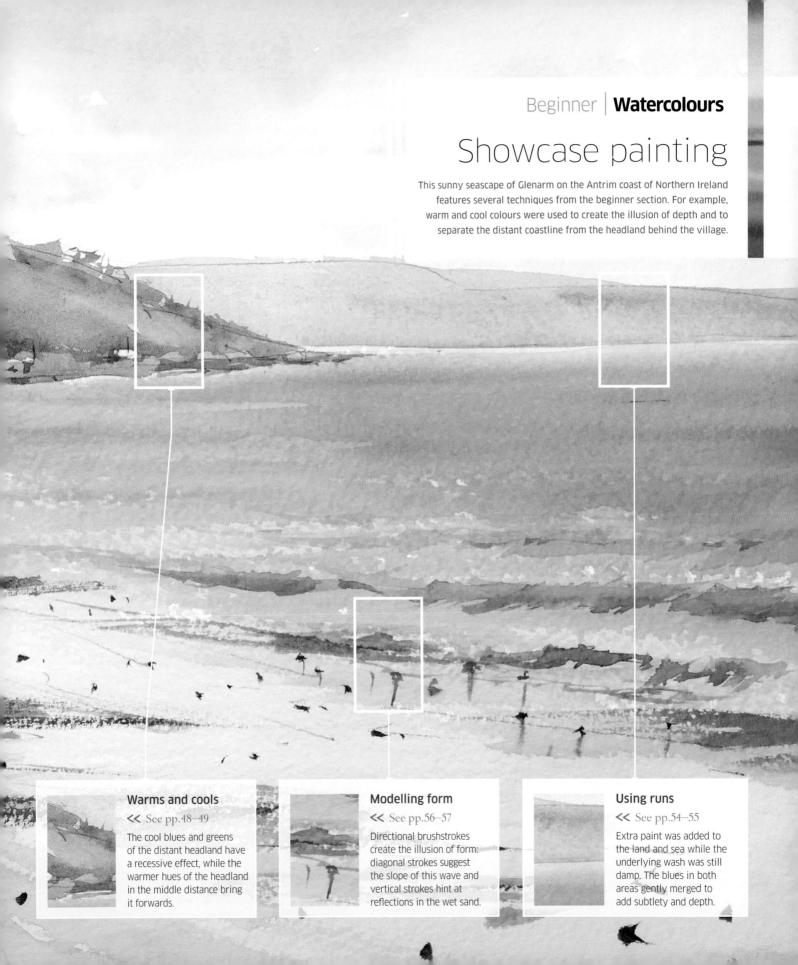

Laying a flat wash

APPLYING EVEN COLOUR

Laying a flat wash is a key watercolour skill. Although the idea is a simple one – applying a wash of paint so that it dries to an even tone throughout – the technique can be surprisingly difficult to perfect. Flat washes are useful for backgrounds and skies.

Mix and lay a wash

Mix a darker wash than you think you'll need, as watercolour dries lighter. Mix plenty of paint so you don't run out halfway through. Set the board at a shallow angle to allow the paint to run down the paper.

Paint at a slight angle

One continuous stroke

Choose a brush size commensurate with the size of the wash area. Load the brush fully, then, starting at the top, paint across the paper in one continuous stroke.

Pick up the bead

Immediately re-load the brush and repeat the process, picking up the bead of colour left by the previous brushstroke. This helps the strokes to blend.

Bead runs along bottom of stroke

Repeat the process

Continue until you have covered the whole area. Mop up any surplus moisture at the bottom of the wash using a dry brush or piece of paper towel. Lay the board flat and allow the wash to dry thoroughly.

PUTTING IT INTO PRACTICE

In this tabletop still life with apples and a vase, a flat wash was used to create the green background. The wash was painted around the outlines of the objects with the paper turned upside down.

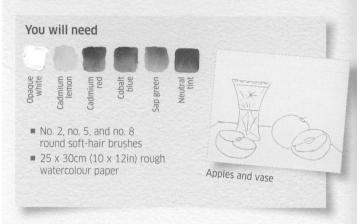

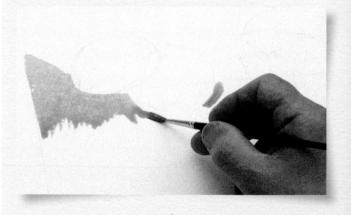

Turn paper upside down

■ Lightly sketch the scene, then turn the paper upside down.
 This will allow the wash to run away from the outlines of the objects. Set the board at a slight angle and mix a wash of sap green. Using a no. 5 round brush, carefully work the wash around the edges of the apples.

"Raise the board slightly so the wash runs down, then work from top to bottom in one sitting."

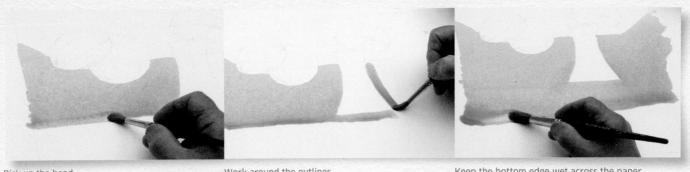

Pick up the bead

Work around the outlines

Keep the bottom edge wet across the paper

7 Work around the outlines Continue laying the wash from top to

bottom, carefully working up to and around the edges of the vase and tabletop. Once you are clear of the objects, work across the paper using continuous strokes, always keeping the bottom edge of the wash wet.

Tablecloth and vase
When the background wash is completely dry, repeat the process for the tablecloth using cobalt blue and neutral tint. When that's dry, add the detail on the vase using cobalt blue. neutral tint, sap green, and opaque white.

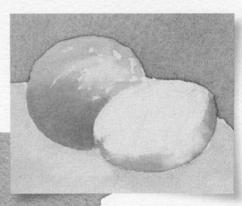

4 Apples
Apply a pale wash of cadmium lemon for the flesh of the cut apple and a darker wash of mainly cadmium red for the skins.

washes on the apples to dry, then add streaks of cadmium red, sap green, and opaque white to the skins. Finally, paint the pips and stalk in neutral tint.

Laying a graduated wash

APPLYING GRADUATED COLOUR

A graduated wash fades smoothly from a strong tone to a weak tone. It is achieved by adding water to your wash little by little as you paint.

Laying the wash

Set up your board at an angle of 30 degrees so that the wash will spread downwards. Mix more paint for the wash than you think you'll need, and keep some clean water to hand.

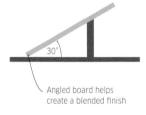

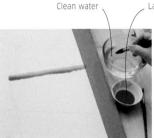

Large quantity of paint mix

1 First line of wash Dampen the area to be painted. Lay the first line of wash along the top at full strength. Dip the brush in clean water, then immediately recharge it with paint.

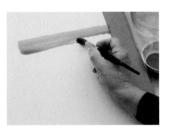

1 Subsequent lines Pick up the bead of paint from the first line as you lay the second line of wash. Dip your brush in clean water before you pick up paint for each subsequent stroke.

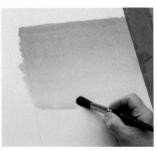

7 Finishing the wash ${f j}$ Continue working down the paper, diluting the wash a little more with each line you paint until it fades out. Mop up excess moisture at the bottom, lay the paper flat, and allow it to dry.

PUTTING IT INTO PRACTICE

A blue, graduated sky sets the mood in this atmospheric landscape. Don't pause while laying your wash - it could dry unevenly, leaving unwanted marks. Work quickly and with confidence.

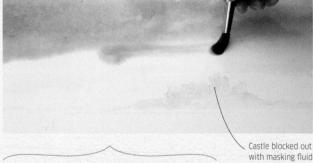

Beginning the wash

L Sketch your composition and apply masking fluid over the castle using an old brush. Mix plenty of cobalt blue for the wash. Dampen the paper in the sky area, then apply the wash along the top with a large synthetic-soft-hair brush.

2 Completing the wash
Apply continuous strokes from one side to the other, dipping your brush in clean water before recharging it with paint for each stroke. Lay the wash down to the horizon, painting over the masked castle.

"A graduated sky that reaches down to the horizon creates a feeling of wide, open space."

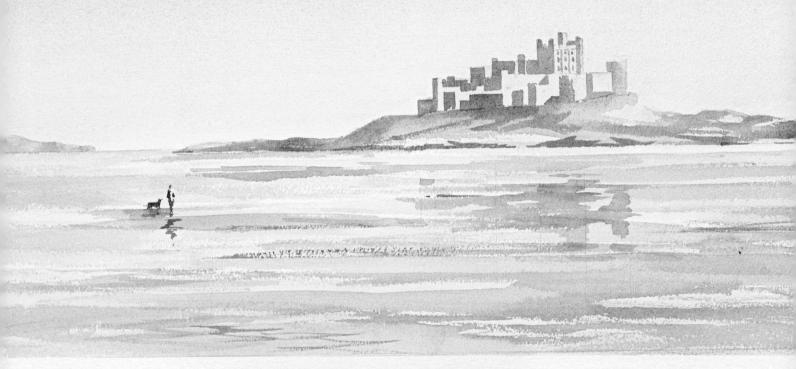

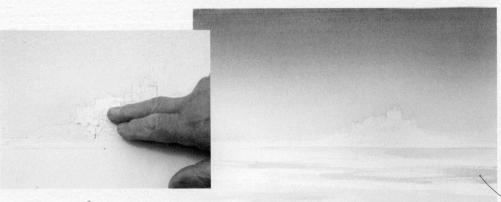

5 Completing the scene
When the foreground sand
colours are dry, paint in the sea.
Paint the castle simply to keep
the focus on the sea and sky.
Finally, add the figures of the
man and dog, which give
the painting a sense of scale.

Textured dry brushstrokes

Removing the mask
When the wash is completely
dry, rub off the masking fluid from
the castle.

4 Foreground
Paint the sand bars in yellow ochre. When the ochre is dry, apply raw umber and burnt umber over the top using dry brushstrokes for texture (see pp.50-51 and 74-75).

Lively darks

AVOIDING FLAT, DULL COLOUR

One of the most appealing qualities of watercolour is its transparency. Solid dark colours, however, do not have the same transparency as lighter colours and can sometimes look flat and dull. Applying darks quickly and simply will make them look fresh and lively.

Creating depth and contrast

Try not to overwork darks when you apply them, as using too many brushstrokes, or "scrubbing", can lead to a muddy look. Create tonal contrast in adjacent areas to lift flat-looking darks, and punctuate a dark wash by leaving areas of white paper or applying opaque white paint on top.

Flat wash

This swatch was applied correctly with just four brushstrokes, a loaded brush, and without scrubbing. However, you will need to add tonal contrast in adjacent areas to add interest.

Scrubbed paint

This swatch has been scrubbed on with a brush that is too dry, using too many brushstrokes. It looks flat and muddy.

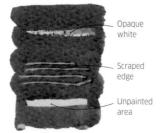

Adding white

Either leave some white areas of paper as you apply darks, or scrape off areas of paint using your fingernail or the edge of a credit card. On dry paint, you can apply opaque white or gouache.

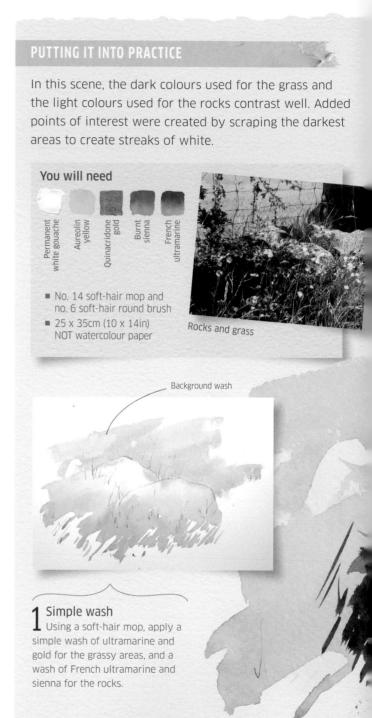

"Aim to apply dark watercolour quickly and simply, without overworking."

2 Dark areas Build up the grass behind the rocks with quick strokes of your round brush to suggest individual blades of grass. Darken the area with French ultramarine and burnt sienna to contrast with the tops of the rocks. Lift the darks by scraping areas with a credit card. This breaks up the dark tone and suggests grass-like stalks. Dampen the tops of the rocks and add a little darker wash of ultramarine and sienna to suggest their roundness.

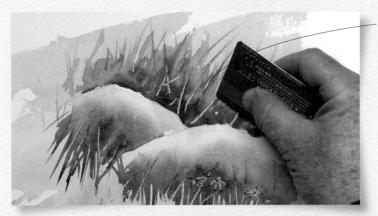

Scrape darks to create highlights

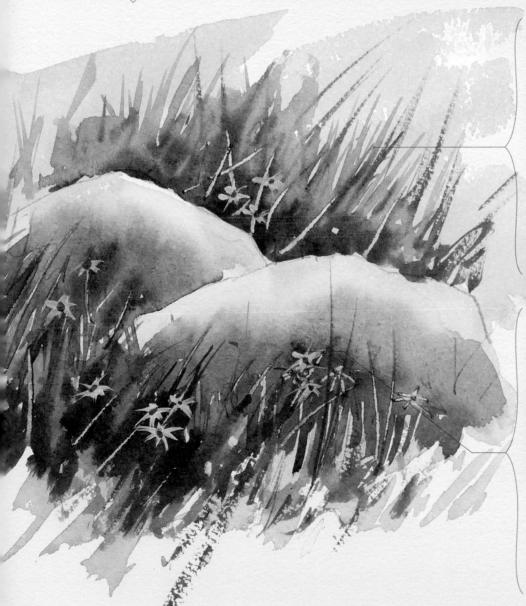

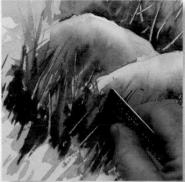

Foreground grasses
Repeat the technique to create the grassy area in the foreground. Again, scrape dark areas with a credit card to create white strokes.

Flower details 4 Finally, still using a round brush, apply an opaque mix of aureolin yellow and permanent white to the darkest areas to suggest the flower petals. Add a darker dot of paint for the centre of each flower.

Aerial perspective

EVOKING DEPTH AND DISTANCE

Aerial (or atmospheric) perspective enables you to suggest depth by simulating the effect of the atmosphere on distant objects. The further light has to travel, the more diffused it becomes. This makes colours look softer and details less defined, the further they are from the viewer.

Portraying distant objects

Atmosphere affects objects in proportion to their distance from the viewer – colours become cooler and graduate to blue-grey, light and dark tones gradually lose contrast, details diminish, and sharp edges look softer. Divide your subject into background, middle ground, and foreground to portray these effects. Apply little or no detail to the background, then add more detail and stronger colour as you work towards the foreground of your painting.

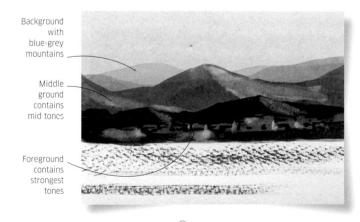

Distant mountains

You may have noticed aerial perspective when looking at a mountain range. The furthest mountains appear faint and bluish, and there are distinct changes of colour with each layer of hills.

PUTTING IT INTO PRACTICE

Aerial perspective can create the illusion of depth even when it may not be obvious to the naked eye in real life, as you can see in this painting of a nearby group of trees.

You will need

- No. 14 soft-hair mop, no. 10 and no. 8 round soft-hair brushes, and a small soft-hair sword liner
- 35 x 25cm (14 x 10in) NOT watercolour paper

Group of trees

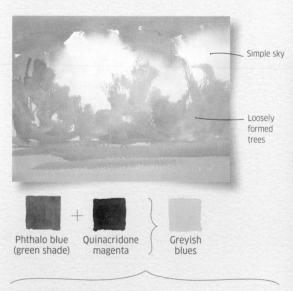

1 Background

■ Paint a simple sky and allow it to dry. Mix a pale greyish blue for the trees in the background, then paint them as a flat wash with a mop brush. Don't include details such as leaves and branches at this point – the background shapes will make sense when you add trees in front.

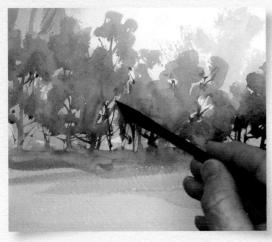

Quinacridone gold

Burnt sienna

Phthalo blue (green shade)

Phthalo blue

(green shade)

sienna

7 Middle ground

A Paint the trees in the middle ground with various tones of green, to distinguish them from the flat background. Use light strokes with a fine brush, such as a sword liner, to suggest trunks and branches, but don't add too much detail.

Greens

Quinacridone

magenta

3 First foreground tree
Make the tonal differences between light and shade more obvious in the foreground. Paint the leaves with lots of tonal variety to show which areas are in sunlight and which are in shade. Add dark branches that stand out from the leaves.

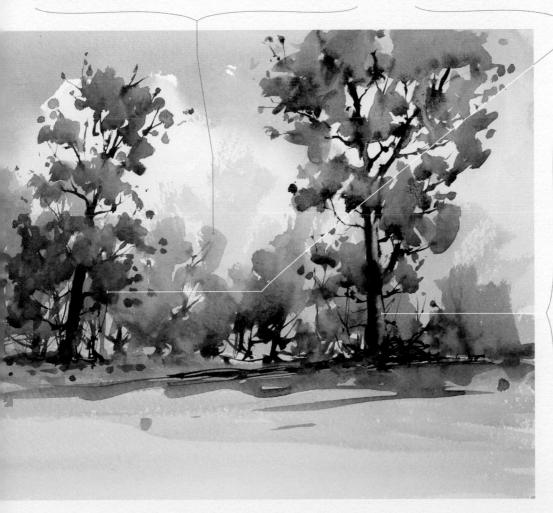

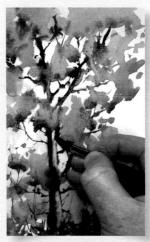

Closest foreground 4 tree

The tree closest to the viewer needs the most detail, colour, and tonal variety. Lift out some dark colour from the right side of the trunk using a damp round soft-hair brush to give the trunk more form.

Edges

HARD AND SOFT OUTLINES

Controlling the hardness or softness of edges is the main way to focus the eye on an object or shape. Hard edges are crisp, well defined, and draw the eye in, whereas soft edges blend into one another and seem to disappear. Being able to create hard and soft edges is one of the fundamental skills of watercolour painting.

Relationships between objects

In general, use hard edges to define two objects that are *not* physically connected, such as a building against the sky. Use soft edges, on the other hand, to link two objects that *are* physically connected, such as a building and the ground on which it stands. In practice, it is best to convey objects with a variety of edges, both hard and soft. Avoid giving an object hard edges on all sides, as this separates it entirely from the rest of the painting.

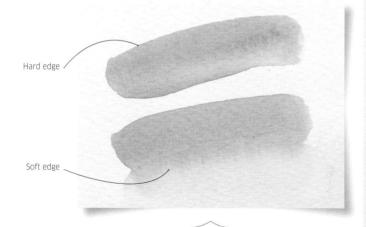

Creating hard and soft edges

Make a hard edge by simply painting wet onto dry. You can soften a wet edge with a gentle touch of a damp, but not wet, brush, or paint a second wash alongside the first, allowing the wet edges to touch.

PUTTING IT INTO PRACTICE

This study of a window with shutters makes use of both hard and soft edges. It starts with softer edges that are then worked into. Hard edges have been added for definition and detail.

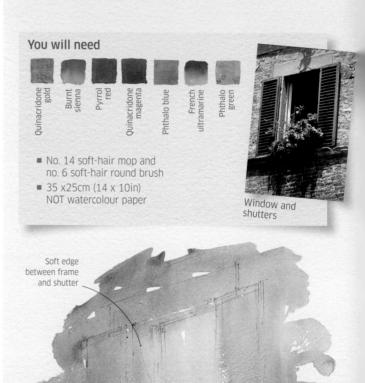

1 Soft edges

■ Begin by creating soft edges between the frame, shutters, plants, and wall. To achieve this, apply a soft wet wash against another wet wash and then allow it to dry.

Soft-edged plants

Soft edge between shutter and wall

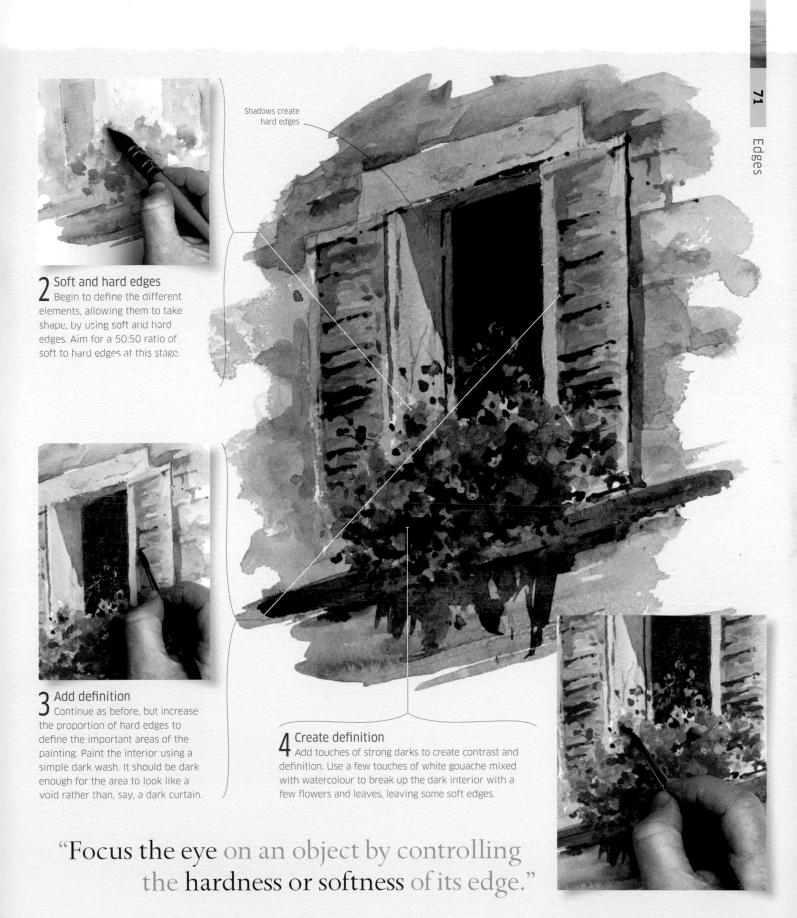

Highlights

SHOWING THE DIRECTION OF LIGHT

Highlights show how light falls on the illuminated or prominent forms in your composition, and are therefore the lightest tones in your painting. They are essential for creating a three-dimensional effect. In watercolour painting, the lightest tone is usually the paper, so you can create highlights by leaving some paper unpainted, or use opaque white paint to add highlights on top of painted areas.

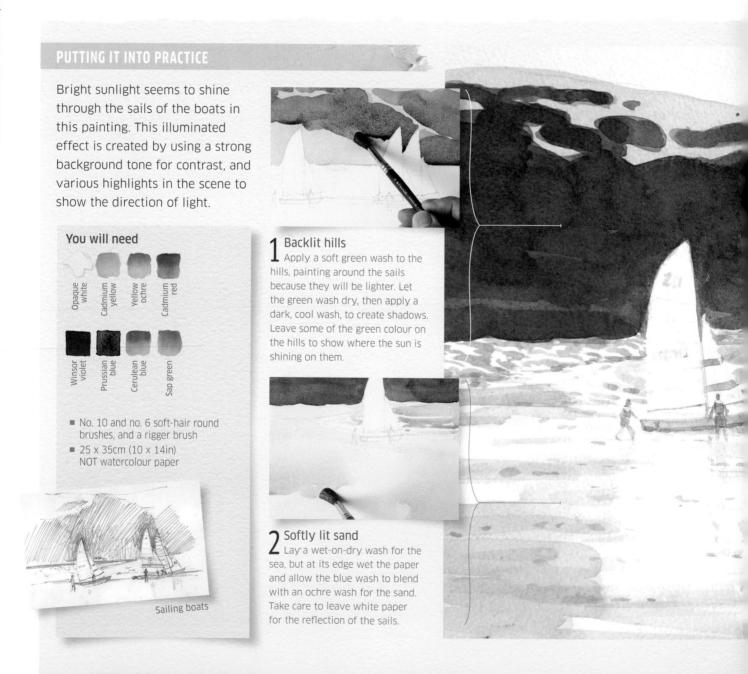

Highlights and contrast

A white highlight will not show up against a pale tone, so your highlights need to be contrasted with stronger tones. This will ensure that the highlights "read" as light falling on a subject. Using a good range of tones to indicate light and dark is the key to painting highlights successfully.

Opaque white highlights

Here, an opaque white highlight gives the chicken shape and form. The dark background suggests that the highlight is a light source behind the chicken.

Painting around highlights

This blue wash leaves some of the pale wash below exposed, evoking light sparkling on water. Plan which areas to paint around if you use this method.

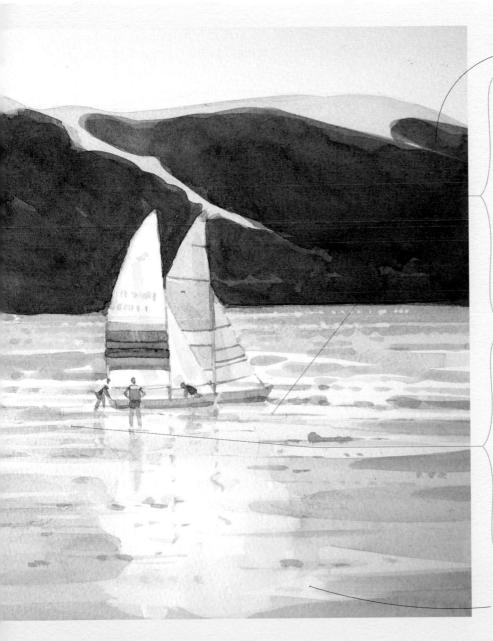

Contrast of soft green with deep blue indicates strong light behind the hills

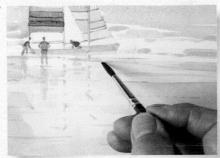

3 Strong colours
Paint in the figures and add strong colour on the sails to show that they are in full sun. Apply very light shadows to show the backlighting on the sails. Strengthen the tone of the reflections on the sand.

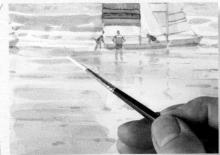

Final highlights

4 Use a rigger brush to apply final, bright highlights in opaque white paint on the sea, sails, and figures.

White paper indicates the reflection of the sails

Adding texture

USING BRUSHES AND PENS

By using different brushstrokes and pen marks, you can build up layers of texture. For example, use the side of an almost-dry brush to create a scratchy effect or the tip of the brush for fine detail. For more experimental textural effects, see pp.86-87.

Smooth and rough textures

Round brushes are the most versatile for adding texture. Use the side of the brush with washes of various dilutions to build up initial layers, the side of an almost dry brush for a scratchy look, and the tip for fine lines. For precise details, use a dip pen or fibre-tip pen, and for highlights, use opaque white paint, white pastel, or gently scratch out the area with a sharp blade.

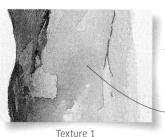

Smooth trunk

This smooth-looking section of tree trunk was created using wet washes. Various light and dark tones were used to create form.

Wet wash gives a smooth finish

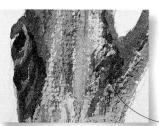

Semi-rough trunk

Once the initial washes had dried, the side of an almost-dry brush was dragged across the surface to develop the texture of the bark. Darker tones were also used.

Undiluted paint for the darkest tones

Texture 2

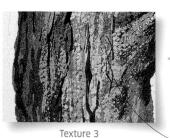

Rough trunk

Details were picked out in black paint using a dip pen with a steel nib. Excess paint was shaken off the nib to prevent blots. Highlights were added in white pastel.

White pastel highlights

PUTTING IT INTO PRACTICE

In this study of a country church and churchyard, the viewer's eye is drawn to the large tree in the foreground. The tree, which was painted first, includes multiple layers of texture on its trunk.

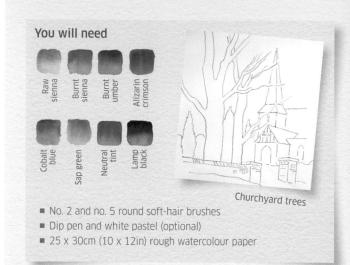

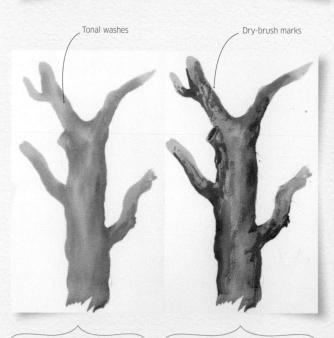

Initial washes

Loosely sketch the scene in pencil, paying particular attention to the foreground tree. Apply pale washes of burnt sienna, burnt umber, and neutral tint to establish the basic colour and form.

3 Building texture

When the initial washes are dry, start adding texture. Load a no. 5 round brush with a darker mix than the background, and squeeze out most of the moisture. Drag the side of the almost-dry brush over parts of the trunk.

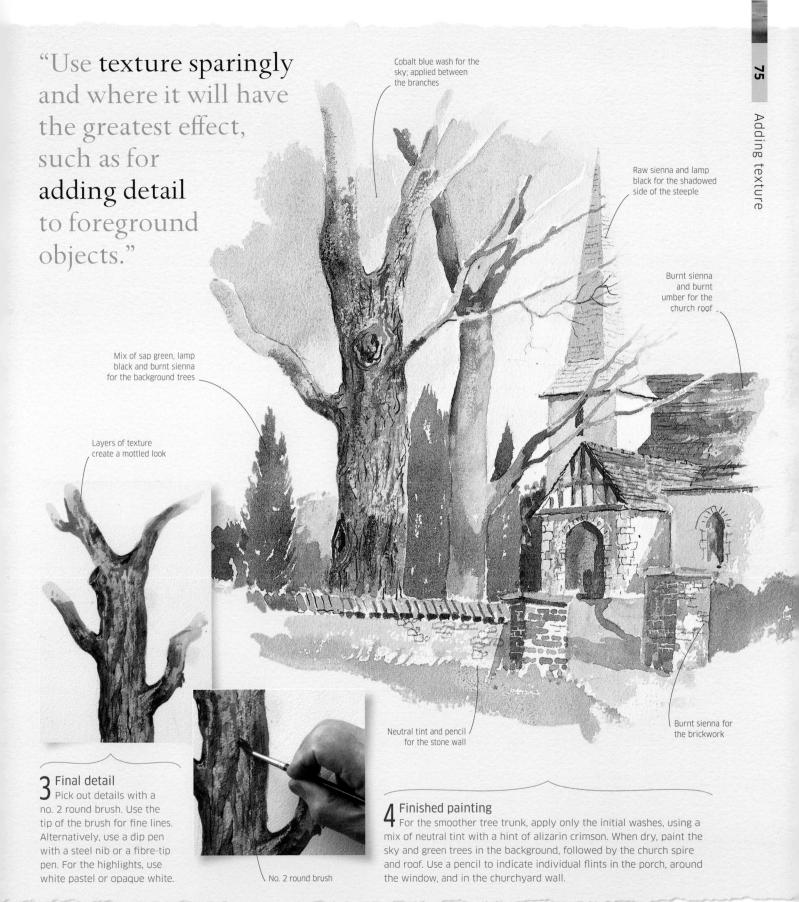

Paper surfaces

THE EFFECTS OF TEXTURE AND WETNESS

Rough paper creates a broken wash because the paint sits on the "peaks" of the paper.

NOT, or cold-pressed, paper is smoother, which allows you to create flatter, even washes. The wetness of your surface also has a bearing: use wet paper for soft, luminous washes, and dry paper for strong colour and detail.

Wet, damp, and dry paper

Practise working on wet and dry surfaces to help you see what effects they have. If your paint mix is too watery, when you put it on damp paper it may disturb the pigment and create watermarks. You must judge whether your paint mix is correct, or whether the paper is too wet to take the paint.

Wet paper

Prepare your colour mix first. Wet the paper, then brush on the colour. Avoid reworking, to prevent marks. You won't be able to fully control how the wash disperses.

Damp paper

Apply a wash when the paper has dried a little but is still damp. The wash will bleed but it won't disperse as much as on wet paper, resulting in a stronger colour.

Dry paper

Lay a wash of colour on dry paper. It will create a crisp, hard edge, and you'll have more control over the wash. For adding detail, the paper must be dry.

PUTTING IT INTO PRACTICE

NOT paper was ideal for laying the soft, even washes in this painting. Wet- and damp-paper washes suggest a view of distant hills through rain, while dry-paper washes sharpen the foreground for contrast.

You will need

- Large flat soft-hair, no. 10 round soft-hair, and no. 10 round synthetic-soft-hair mix brushes
- 25 x 35cm (10 x 14in) NOT watercolour paper

1 Wet-paper wash

Mix your washes first. Wet the paper with clean water, then apply a bluegrey wash to the hills, working from the top downwards so you can better control the line of the hills. Apply a yellow wash in the foreground.

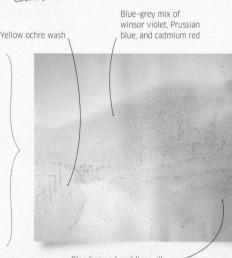

Bleeding and puddles will be painted over later

2 Damp-paper wash

While the paper is still damp, add a darker tone of grey to show the nearer hills and trees. The soft edges suggest aerial perspective (see pp.68-69).

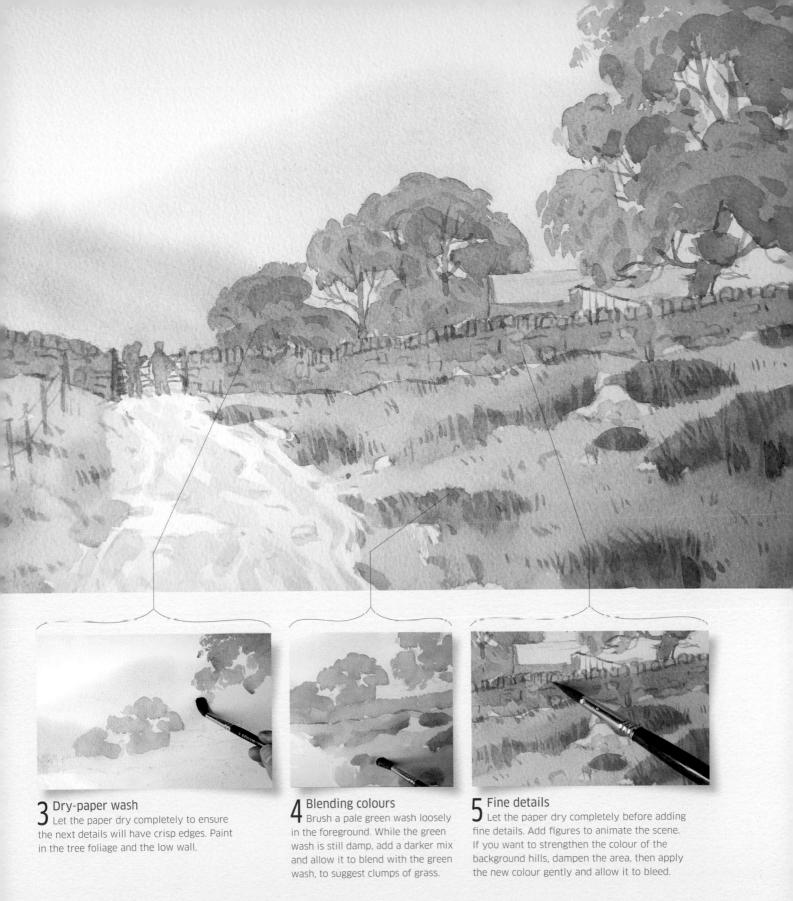

Correcting errors

IN WET OR DRY PAINT

Despite watercolour's reputation for being difficult. you can correct small mistakes. Your options depend on the scale of the error (extensive mistakes may be too hard to rescue), the type of pigment, and type of paper you are working with.

Five ways to correct errors

You can tackle errors by incorporating them into the painting. removing them, painting over them or, for forgotten elements, adding them in later. You will need a sponge, paper towels, a scalpel, a stiff bristle brush, and opaque white (gouache) in your "correction kit".

Incorporating errors Instead of removing errors, such as runbacks. try incorporating them by changing a colour, painting over it, or adding extra details around it.

Lifting out Mistakes in wet paint can be lifted out (blotted) straight away using absorbent material. such as a damp sponge or a paper towel.

Small patches of dry paint can be removed by scrubbing with a damp. stiff brush. This method is slightly abrasive, so take care with the paper.

Hard-edged runbacks incorporated by adding hard-edged dark clouds

INCORPORATING ERRORS

Runbacks, blobs, or bleeds don't have to be disastrous. If the error hasn't ruined your composition, consider adding an extra element - such as a tree - to disguise the area, or change the colour or mood of the piece.

You will need

Paints and brushes

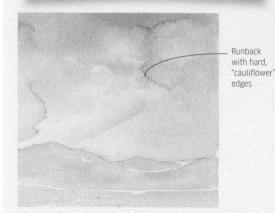

Problem

Runbacks in the wash for the sky have dried unevenly. leaving unsightly "cauliflower" edges.

Solution

Leave the error to dry completely. Change the mood from light and sunny to cloudy and breezy to disguise the mistake in the sky.

Scraping with a blade On heavyweight paper. you can remove small details or make additions by gently scraping off dry paint with a fine blade or scalpel.

Using opaque white You can add forgotten details with opaque white body colour then paint over it. This method is best for details rather than areas of wash.

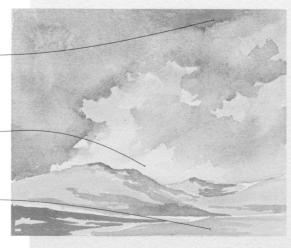

LIFTING OUT

If you spot the error while the paint is still wet, deal with it immediately. Use a damp sponge or a paper towel to lift it out. If you apply more water to the offending area, the pigment will loosen and become easier to blot. Let the paper dry before painting over the area.

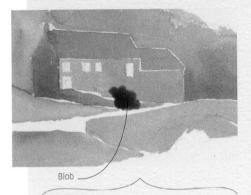

Problem

A blob of paint fell onto the painting from a wet brush. The dropped paint has not yet dried.

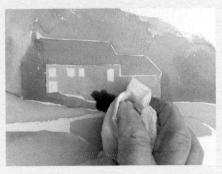

Solution

Wet the area immediately with water to loosen the pigment, then blot the error with a paper towel to lift it out.

You will need

- Sponge or paper towel
- Clean water

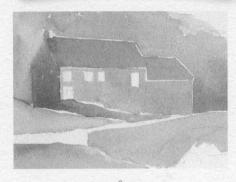

Result

Once the paper is dry, repaint the whole front of the house and the wall to cover the blotted area seamlessly.

SCRUBBING

If an error dries before you can remove it, try dampening the area and gently scrubbing it with a stiff brush. Let the paper dry completely before repainting.

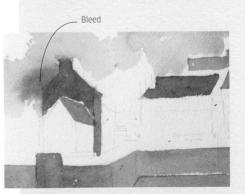

Problem

Two damp washes were placed side by side, and one bled into the other. The error wasn't dealt with before it dried.

Solution - step 1

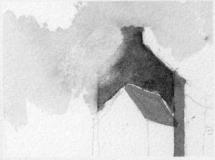

Solution - step 2

Solution

Wet the area with water to loosen the pigment, then gently scrub off the paint with a damp bristle brush.

You will need

- Clean stiff bristle brush
- Clean water

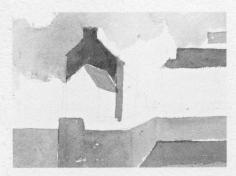

Result

Once the paper is dry, repaint the side of the house and the sky to cover the scrubbed areas.

SCRAPING WITH A BLADE

You can use a sharp blade or scalpel to remove dry paint when you need a more precise tool than a brush. This method is only suitable for robust, heavyweight paper – never use a blade on a delicate surface.

You will need

Sharp blade or scalpel

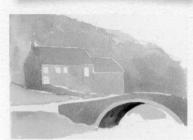

Problem

A tree is missing from the foreground because it was forgotten at an earlier stage.

Solution

When the paper is dry, gently scrape the surface with a blade, teasing away the dry pigment to create the shape of the tree and branches.

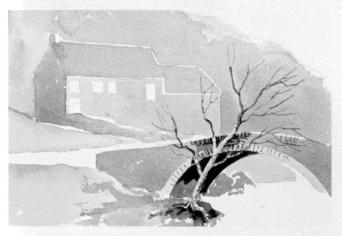

Result

Paint the tree over the scraped area using a small rigger brush. You can create highlights by leaving some of the scraped paper unpainted.

USING OPAQUE WHITE

If you need to amend or add a detail, you can cover the error with opaque white body colour (gouache) or white acrylic ink, then repaint it. You may need to apply several layers of opaque white to obscure the error successfully.

You will need

- Opaque white body colour (gouache) or white acrylic ink
- Round soft-hair brush

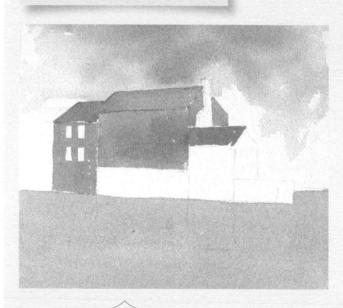

Problem

The dark flat washes on the house and water were painted without remembering to reserve white paper for the windows and boat. Now lighter colours need to be added on top.

"This method is best for areas where you can use details to disguise the edges of the opaque paint."

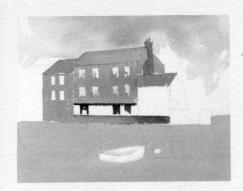

Solution - step 1

Add the windows and boat with opaque white body colour. You might need to apply several layers of opaque white to cover the wash underneath effectively. Leave to dry.

Solution - step 2

Paint over the white areas with watercolour gently, to avoid pulling up the white colour and mixing it with the new colour. You might need to try this a few times to get it right.

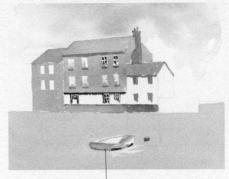

Tonal study applied first before glazing with red

Result Once the initial tonal colours are dry, add the final colours on top. Add shadows and reflections around the boat to disguise the corrected area.

Reserving whites

CREATING LIGHT AREAS

It is not possible to apply a light watercolour tone over a dark one (unless you use opaque body colour – see pp.112–13). Although you can remove paint from the paper, it is never as clean as leaving the paper untouched. The best way to create light areas is to leave "windows" of unpainted paper or a previous light wash. For tricky areas, use a resist, such as masking fluid, which you can remove later. You can then repaint the area if you wish.

PUTTING IT INTO PRACTICE

In this piece, the strong stage lighting on the pianist and piano needs to be sharp and bright - masking fluid is an ideal way of maintaining these lights. Other larger areas of white are simply left unpainted.

Apply masking fluid
Draw the pianist, then, with
your no. 10 soft-hair brush, apply
masking fluid to areas such as the
keyboard, hair, piano edges, and
floor. These are the areas that are
illuminated by the stage lights.

ochre winsor violet

- No. 10 soft-hair and rigger brushes
- Masking fluid
- 25 x 35cm (10 x 14in) NOT watercolour paper

Masking fluid

Paynes grey and yellow ochre wash

a dark wash for the background and for the shadow area underneath the piano. Use masking fluid to create a sharp edge along the bottom of the background, but paint the edges of the shadow freehand.

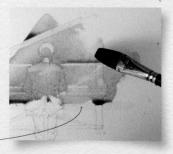

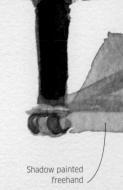

Using masking fluid

Only apply masking fluid to dry paper or it will be very difficult to remove later. Wash brushes immediately after applying masking fluid, or they will be ruined. Avoid using your finest sable brush, even if you are careful about washing it promptly afterwards. Over time, the soft hairs will become damaged.

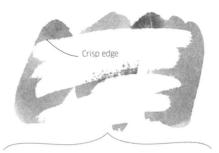

Masking fluid

By applying masking fluid first, you can lay a wash freely over the top. When the wash dries, rub away the fluid to reveal white areas with crisp, clean edges.

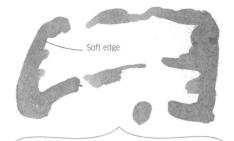

Leaving whites

If the edges left by masking fluid are too sharp, paint around white areas of paper for a looser feel. Keep the wet edge of the wash moving or it may dry with a visible line.

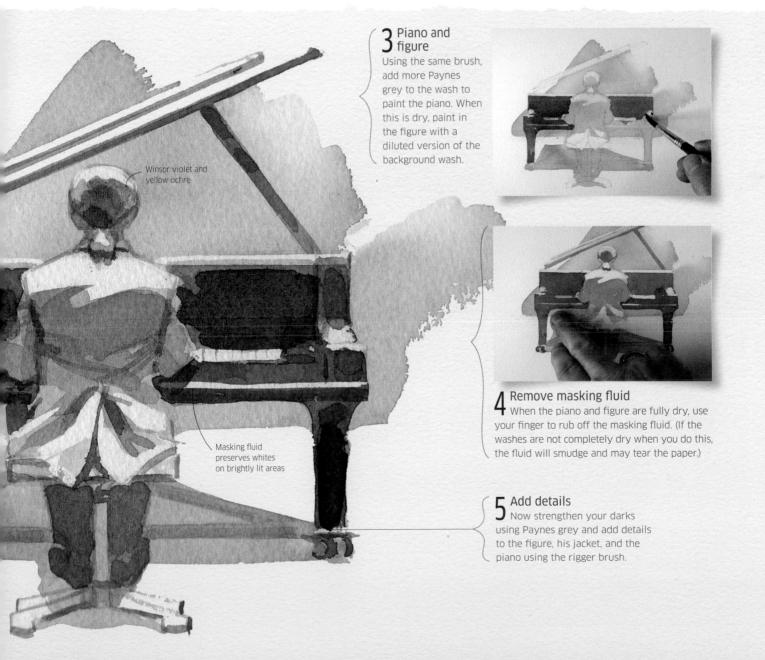

Line and wash

USING PEN AND PAINTBRUSH TOGETHER

Line drawing adds structure and definition to watercolour washes. Make the lines as detailed or as minimal as you wish. Altering the balance between line and wash creates. different effects. You can also use this method as a way of making sketches and studies for later pictures.

Balancing line and wash

You can use either line or wash to create structure. definition, tone, and form. For example, in a painting with tonal washes, you could add single lines to sharpen the edges or dense crosshatching in place of dark tones. For line work, use a pencil, fibre-tip pen, or waterproof ink and a dip pen or brush.

fibre-tip pen

Crosshatching with Dense crosshatching with fibre-tip pen

Line marks

Pencils and fibre-tip pens create even, precise lines. Dip pens and brushes create irregular, characterful lines if you vary the pressure. You can hatch or crosshatch to add tone or texture.

Heavy line, light wash

Here, the tonal range comes from crosshatching lines. The wash is flat and minimal. Heavy line looks prominent and is good for focal points and foreground details.

Light line, heavy wash

Here, the paint creates the tonal range, with lines playing a supporting role. Light line can help background areas recede in aerial perspective.

PUTTING IT INTO PRACTICE

An intricate line drawing makes the mill the focal point in this painting. It is easiest to sketch in pencil first, so you can correct errors, then re-draw in ink

You will need

- No. 4 soft-hair round and no. 6 soft-hair round brushes
- Steel dip pen and waterproof Indian ink
- 25 x 35cm (10 x 14in) rough watercolour paper

Watermill

Sketching

■ Be free with your pen or pencil; you can easily ink over any mistakes. Hatch lines on the building to create shadows. Use fewer marks for the reflections and background to help them recede.

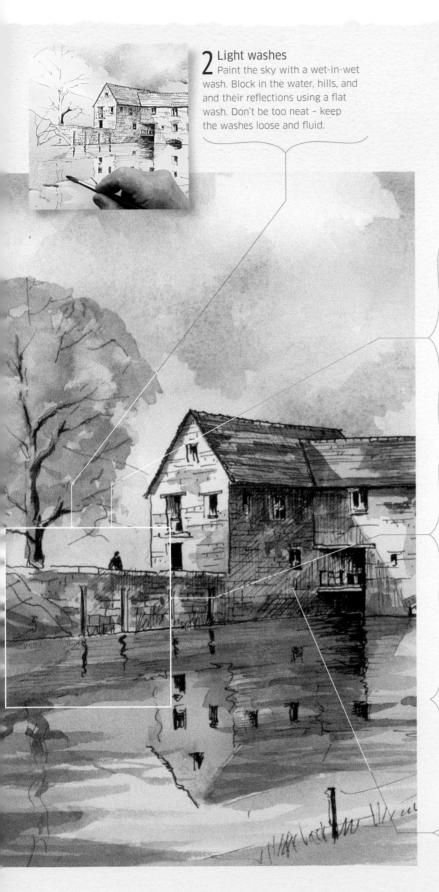

"Line and wash have different qualities that work together when combined in a painting."

3 Building colour
Apply a burnt sienna wash to the building, leaving some white paper for the lightest tones. This allows the line work to form the texture on the white walls. Dilute the sienna wash and use it for the building's reflection.

4 Adding dark tones Paint dark tones over the hatch marks to create extra texture and shadows on the building and reflections.

5 Heavy washes Give the tree's light and simple lines more shape and tone with stronger washes on the trunk and leaves.

6 Final shadows
Apply a light wash
over the hatched shadows
to create a blended effect
of line and wash.

Experimental techniques

CREATING PATTERN AND TEXTURE

There may be times when you want to add textures and patterns to a flat wash. You can do this in several ways, using equipment as diverse as a toothbrush, candle wax, masking fluid, plastic wrap, and rock salt.

Highlights and textures

Apply masking fluid or rub candle wax over areas that you want to keep paint-free, and make interesting patterns with clingfilm or bubble wrap. By sharpening a candle to a point, you can place marks accurately and precisely, whereas the impressions left by salt or clingfilm will be more random.

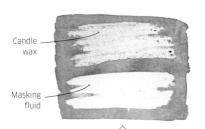

Masking fluid and wax Apply masking fluid or candle wax to areas that you want to keep white. You can paint over masking fluid, but not wax.

Rock salt

Apply a wash and sprinkle rock salt over. Once the wash is dry, brush off the salt. This should leave fairly pronounced marks.

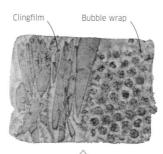

Clingfilm and bubble wrap Lay these onto wet paint and

Lay these onto wet paint and remove when the paint is dry. Clingfilm creates random marks; bubble wrap regular ones.

Toothbrush splatter

Load an old toothbrush with paint and flick it at the paper to create a random series of splatter marks.

PUTTTING IT INTO PRACTICE

An old wall and doorway make a great subject, and these experimental techniques introduce lots of texture and character.

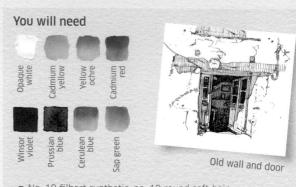

- No. 10 filbert synthetic, no. 10 round soft-hair, and no. 6 round soft-hair brushes
- Rock salt, clingfilm, bubble wrap, and a toothbrush
- 25 x 35cm (10 x 14in) NOT watercolour paper

1 Making marks

Apply masking fluid to the door and window, then lay a wash of yellow ochre and cadmium red. Sprinkle salt over and apply bubble wrap. When the paint is dry, remove the wrap and wipe off the salt.

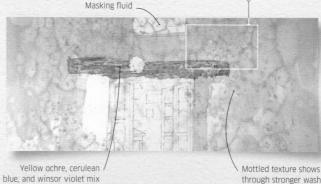

7 Soften textures

Apply a second wash that is darker but that still allows texture to show through. Paint the door lintel with a no. 10 round brush, then apply clingfilm. Remove the film once the paint is dry.

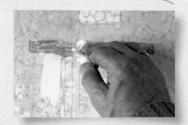

Flowers of cadmium red and opaque white

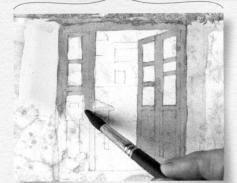

3 Smooth area of colour
With a no. 10 round brush, block in
the doors and window frame using a mix
of sap green and cerulean blue.

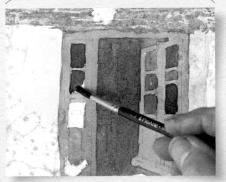

4 Dark tones
With a no. 6 round brush, apply a mix of
Prussian blue and cadmium red to the interior.
Add a second wash, letting areas of the first
wash show through to suggest furniture.

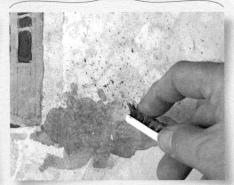

Shadow wash of cerulean blue and winsor violet

5 Final details

Add the shadows and greenery. Enhance textural marks on the walls by strengthening them with a no. 6 brush, and use a toothbrush to add some splatter marks up the wall.

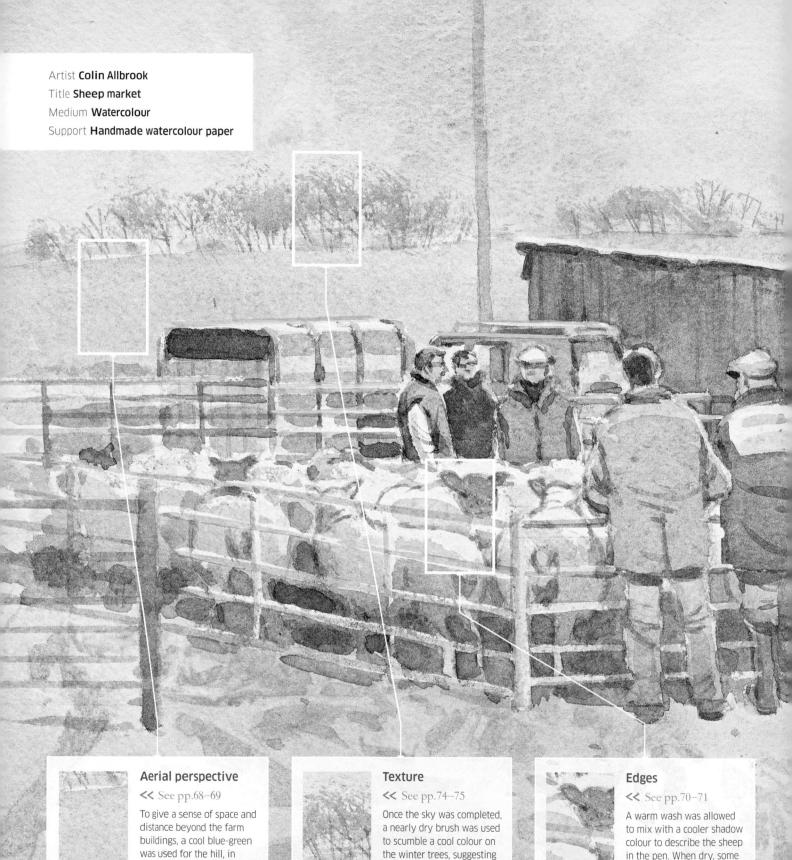

small twigs and branches

against the skyline.

contrast to the stronger

foreground colours.

in the pen. When dry, some

areas were sharpened to

define the shapes.

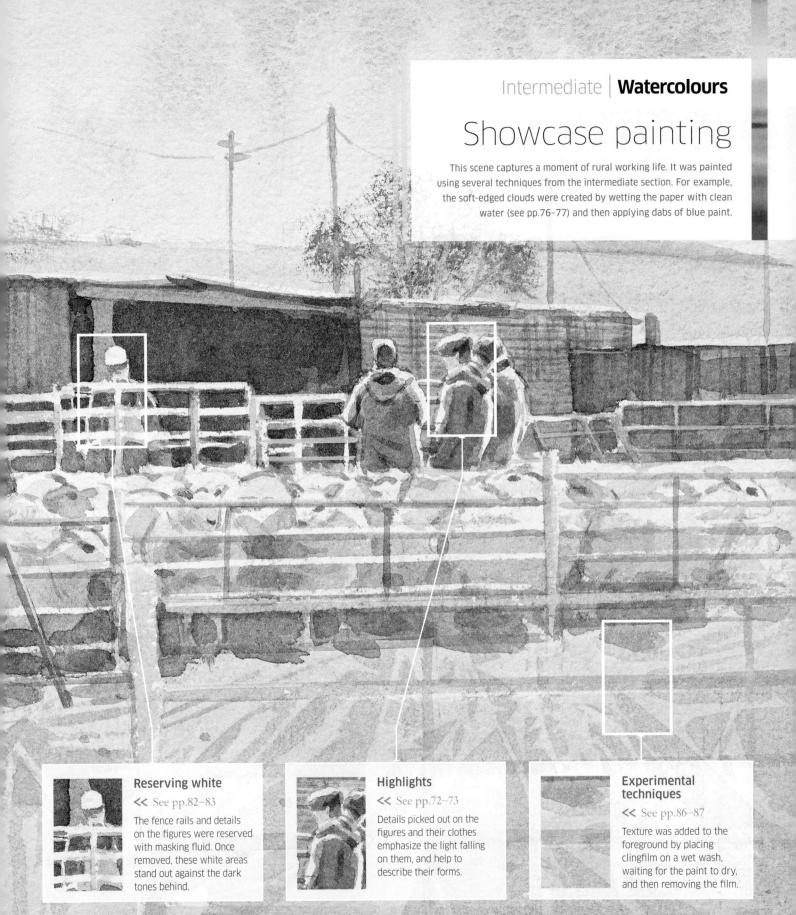

Planning a painting

GATHERING, SKETCHING, AND DEVELOPING

Regardless of the subject matter, try to plan each painting in a similar way. By working through the same stages of development before committing to a final painting, you can be satisfied that your picture is the best it can be.

PUTTING IT INTO PRACTICE

In this series of pictures of a seaside town, the artist made several sketches and took photographs on location before developing the painting and creating the final piece back in the studio.

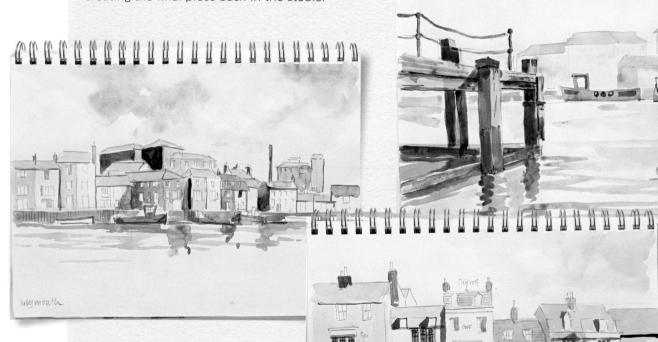

Wagnouth

1 Location sketches

These views were all drawn and colour washed on location to provide reference material for the final painting. Spend time sketching your subject from different vantage points. As well as providing useful reference material, these visual "notes" help fix the subject in your memory.

2 Reference photographs
While working from second-hand photographs alone is not always advisable, it is useful to supplement your drawings with photographs to pick up details that you have not had time to sketch on location.

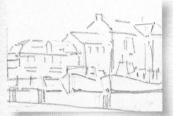

1 - Buildings as focal point

2 - Crane as focal point

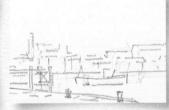

3 - Single boat as focal point

Final composition

The final composition was chosen for its pleasing progression from jetty to boat to houses.

Composition

Back in the studio, analyse your sketches and photographs, creating a shortlist for the final layout. Re as flexible as you can and, at this slage, try not to become wedded to one composition. Feel free to move or remove elements of the scene if it

improves the arrangement. Prepare thumbnail sketches of different compositions, exploring the various views you have recorded. Look for the scene that best captures the essence of the place and will hold the viewer's attention.

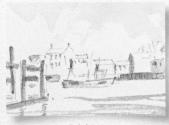

1 - Bright tone

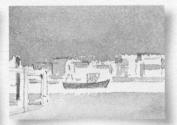

2 - Dark tone

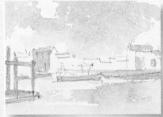

3 - Bright colours

4 After choosing your composition, develop tonal and colour studies using various washes, to explore the mood you wish to convey. Be open minded and

prepared to paint more than one version. Once you have made a decision, transfer the composition to your final paper surface at an appropriate size.

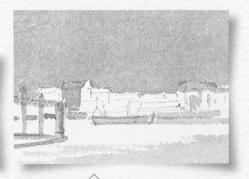

Chosen mood

The artist chose the final tone and colour scheme because they suggest a dark, atmospheric night scene.

Tonal reference This study, chosen for its mood of nocturnal calm, acts as a guide when setting out the main tonal areas in the final painting.

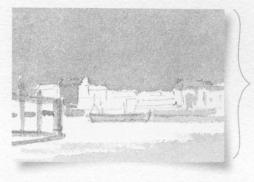

Sky sets the mood with a double granulated wash

Reinterpretation
The final work uses artistic licence to change elements of the scenes captured on location. Re-positioning the jetty and changing its angle were key to the success of the composition.

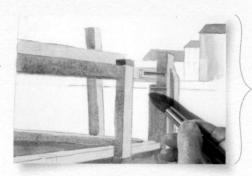

7 Recalling detail
The careful study of the jetty provides a vital reference when it comes to applying detail in the foreground.
Additional photographs taken on location will also prove useful for fine-tuning.

Prinal painting
During the research, planning, and completion of the work, various elements have been adapted or omitted. The final piece does not aim to faithfully record reality, but instead to best capture the spirit of the place.

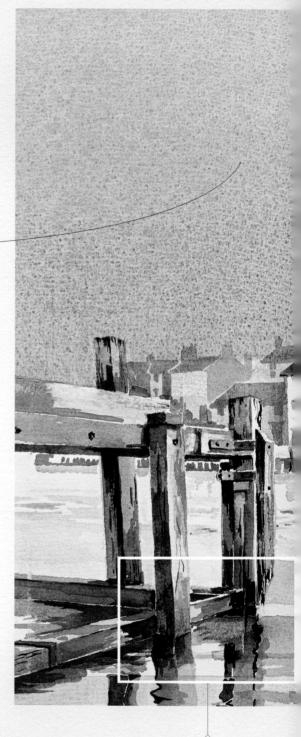

"Look for the scene that best captures the essence of the place and will hold the viewer's attention."

Leading the eye

The detail of the jetty draws the eye. Its dynamic angle points into the centre of the painting, leading the eye towards the main focal point - the solitary red boat.

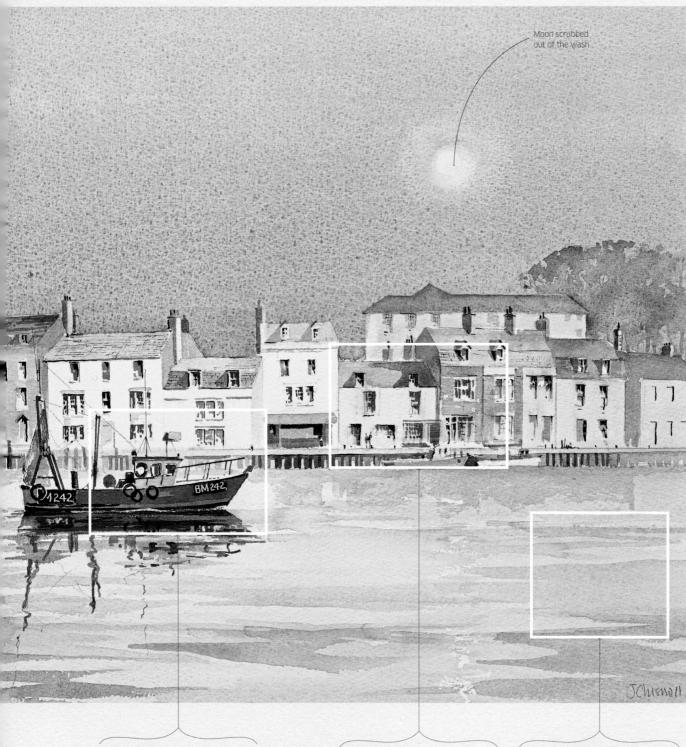

Focal point

The boat is the focus of the work. Its bright red colour and crisp outline immediately catch the eye.

Balance

The colourful red of the houses and the boat balances the overall darker, muted tone of the sky and water.

Atmosphere

Reflections in the still water convey a sense of peacefulness and calm.

Mood

EVOKING ATMOSPHERE AND EMOTION

Creating a mood in your painting is partly to do with depicting environmental conditions. such as sunlight or mist, and partly about creating associations and leaving some things undefined for the viewer to interpret. If everything in a painting is perfectly defined there is rarely a feeling of mood.

Colour, tone, and definition

What we perceive as mood in a painting is often due to the associations we make with colours, textures, light, and shade. All painting techniques contribute to creating mood, but the colours you use, the range of tones you include, and the areas you choose to make detailed or leave undefined are key. These factors create mood even in abstract subjects.

Ouiet mood

The shapes in this illustration are abstract, but the muted, grey colour, narrow tonal range, and softly diffused outlines convey a gentle, quiet mood.

Energetic mood

We associate bright colours with liveliness. In this example, rich colour combines with hard edges and a wide tonal range to suggest sunlight and heat, creating an energetic mood.

EVOKING A QUIET. SUBDUED MOOD

Simplicity is the key to depicting soft, misty subjects. Mist makes distant objects look soft and merged together, and wet-in-wet washes are best for this effect. Choose a heavy-weight paper that won't cockle (or wrinkle) when you apply lots of water.

You will need

- No. 16 soft-hair mop. no. 10 round soft-hair, and no. 6 soft-hair rigger brushes
- 25 x 35cm (10 x 14in) NOT watercolour paper

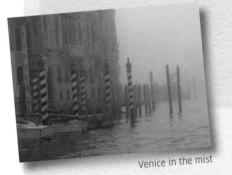

Cold, grey hue mixed with French ultramarine, burnt sienna, and phthalo green

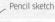

Soft background washes

Soak the paper with a large mop brush, then lay grey washes on the buildings. The wetter your paper, the more the paint will disperse. If your wash totally disappears, wait a minute and try again but don't leave it so long that the paper becomes too dry - the critical time is when the shine just goes off the paper.

2 Suggesting detail
As the paper dries a little more, add strokes to suggest some of the architectural details, but only in the foreground. Leave the background undefined.

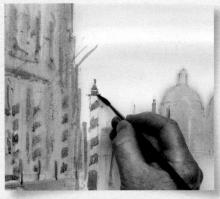

Hints of colour

As the wash continues to dry, add a touch of red to the grey mix and apply it to the red-and-white striped poles, to hint at the colour in the nearest foreground.

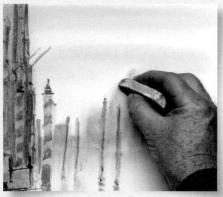

4 Finishing touches
When the paper is almost dry, add more marks to define the foreground. Once the paper is totally dry, erase your pencil lines, which will help the background to recede.

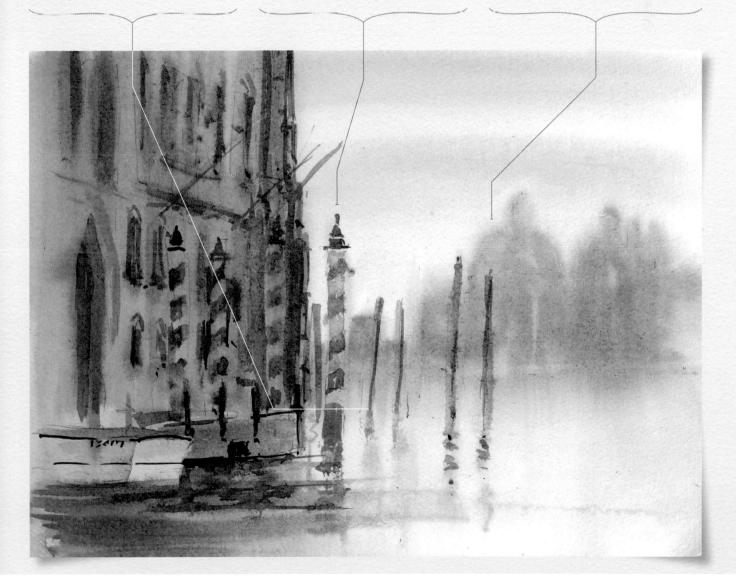

In order to paint a bright, sunny day successfully, you need to ensure that the shadows are dark in relation to the light - the darker the shadows, the sunnier the day will seem. Rich, warm colours also enhance the feeling of a hot day.

You will need

■ 25 x 35cm (10 x 14in) NOT watercolour paper

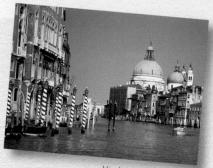

Venice in the sunshine

Bright washes

Paint the sky and water with blue washes. While the wash is still wet, lift out areas of paint with a clean, dampened brush, to create reflections in the water.

> Light shadow colour is burnt sienna with French ultramarine

> > Dark shadow colour is French ultramarine with pyrrol red

7 Blocking in the buildings Paint the buildings with a weak wash

of burnt sienna, adding French ultramarine to your mix for the distant buildings. Mix a stronger tone to paint in the windows and add texture on the walls.

3 Shadows Add shadows to the buildings using a mix of French ultramarine and red, to create the feeling of sunshine.

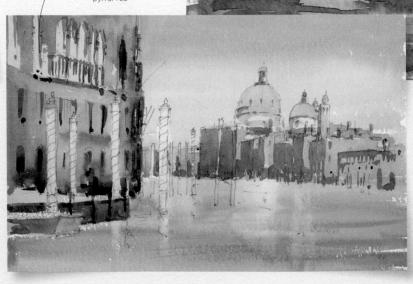

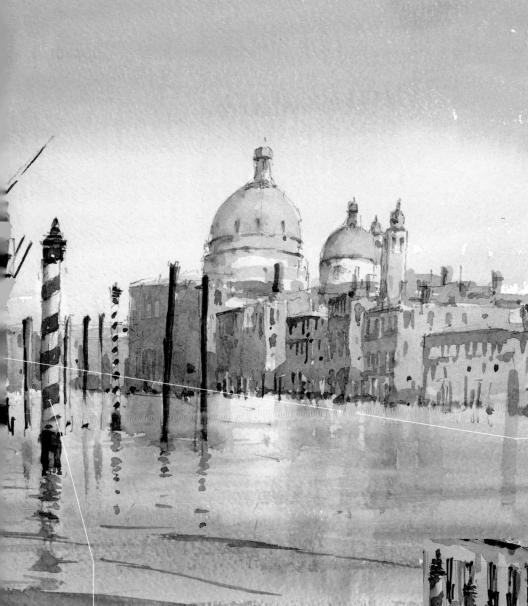

"To create a unified look and extra contrast, try using a dark transparent, glaze over the shadows at the end."

5 Final touches
Create more focus
in the foreground by
adding strong darks
(a mix of French
ultramarine and
sienna), to increase
the contrast between
tones. Finally, create
reflections in the
water to enhance the
sunny atmosphere.

Rich colour
Paint the colourful
poles with neat French
ultramarine and red.
Add more marks to
the distant buildings to
suggest their structure,
but try not to overdo

the details.

Laying a double graduated wash

BLENDING TWO GRADUATED COLOURS

You can create beautiful, complex backgrounds and skies with washes that transition from one colour to another. This technique involves laving two graduated washes (see pp.64-65) on top of each other in opposite directions so that they meet in the middle and blend. It takes some practice, so persevere if you aren't happy with your first attempts.

Laving the wash

Tilt your support to lav the wash - gravity will help the paint to spread downwards. smoothing out marks while the wash is wet. For this reason, lay the wash from the top of the board, turning your paper round if necessary. Apply the lighter colour first.

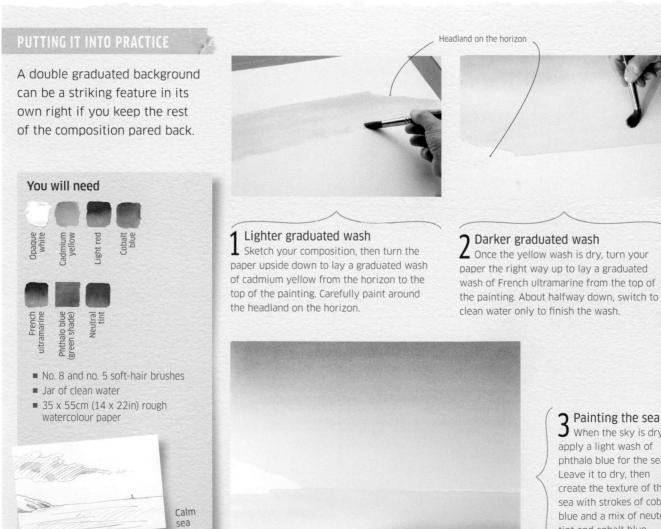

3 Painting the sea When the sky is dry, apply a light wash of phthalo blue for the sea. Leave it to dry, then create the texture of the sea with strokes of cobalt blue and a mix of neutral tint and cobalt blue for the shadows.

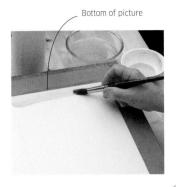

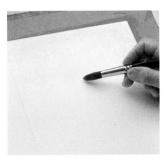

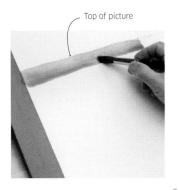

First wash - yellow

Turn the paper round to lay a wash from the bottom of the picture. Wet the paper, charge a large brush with paint, and lay the wash in horizontal strokes. After every stroke, dip the brush in clean water then in paint to gradually dilute the wash, which should fade to nothing at the bottom.

Second wash - blue

Allow the first wash to dry, then turn the paper round so you are working from the top of the picture. Begin laying the second wash, gradually diluting it as before. About halfway down, use clean water only, to keep the colour of the first wash intact.

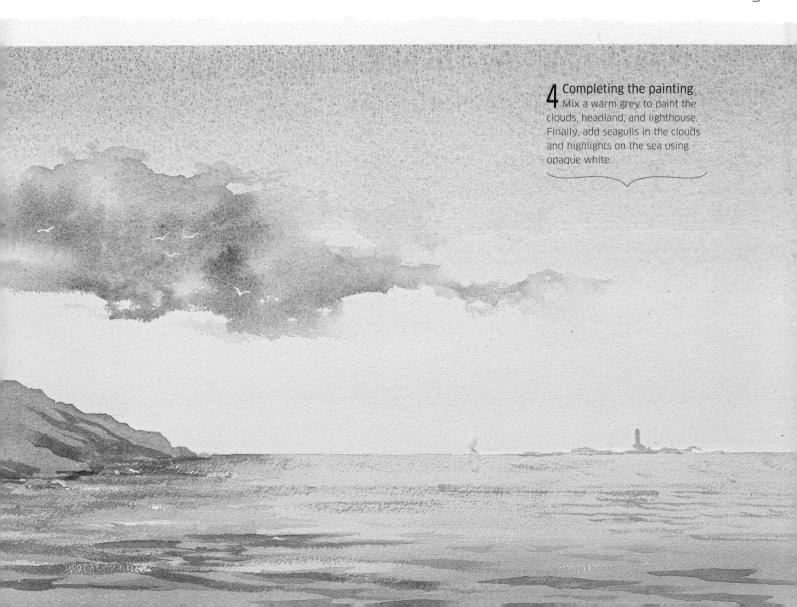

Laying a granulated wash

CREATING GRAINY EFFECTS

Some colours naturally granulate, creating a grainy effect when dry. This happens when pigments separate from the binder and wash, and settle in the hollows of the paper. Some pigments granulate more than others. For example, French ultramarine granulates well, while phthalo blue, which has very fine particles of colour, does not granulate at all.

Encouraging granulation

Pigments that granulate well include cobalt blue, terre verte, cerulean blue, cadmium red, light red, and French ultramarine. You can encourage these pigments to granulate more effectively by tipping the board back and forth, and from side to side, while the wash is still wet. This will shake the pigment from the mix, and help distribute the grains of pigment evenly across the surface. The effect will be more pronounced on rough paper.

Terre verte

Cerulean blue

Cadmium red Light red

French ultramarine

Mixing colours

Mixing certain pigments together – such as French ultramarine and light red – also encourages granulation and can enhance the effect.

Light red

ultramarine

Mix

Mix of light red and French ultramarine

PUTTING IT INTO PRACTIC

In this landscape, naturally granulating pigments were used to enhance the sky and dark clouds behind the poppy seed heads.

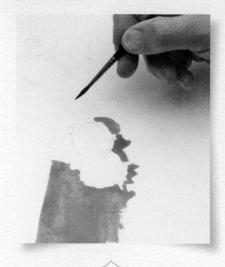

1 Turn board upside down
Sketch the scene, then place the board upside down and at a slight angle so the wash runs away from the poppies. Work a wash of cerulean blue around the poppy outlines using a no. 2 round brush.

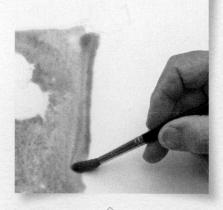

2 Continue wash
Switch to a no. 5 round brush for less intricate areas of the wash. Use continuous brushstrokes across the paper, working your way from top to bottom. Keep the wash fairly wet at all times.

You will need

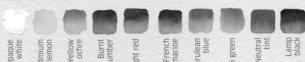

- No. 2, no. 5, and no. 8 round soft-hair brushes
- 25 x 30cm (10 x 12in) hot-pressed watercolour

3 Tip the board Switch back to a no. 2 round brush to apply the wash around the edges of the taller poppies. Tip the board from side to side and backwards and forwards to evenly distribute the colour, and then shake the board to encourage granulation.

4 Final painting
When the first wash is completely dry, paint the field using burnt umber, working carefully around the poppies again. Then, paint the poppy heads, stems, and leaves using mixes of sap green and cadmium lemon. Once these washes are dry, use opaque white for the highlights and lamp black for the shadows. Add the clouds, using French

ultramarine, light red, and a hint of yellow ochre.

Final painting

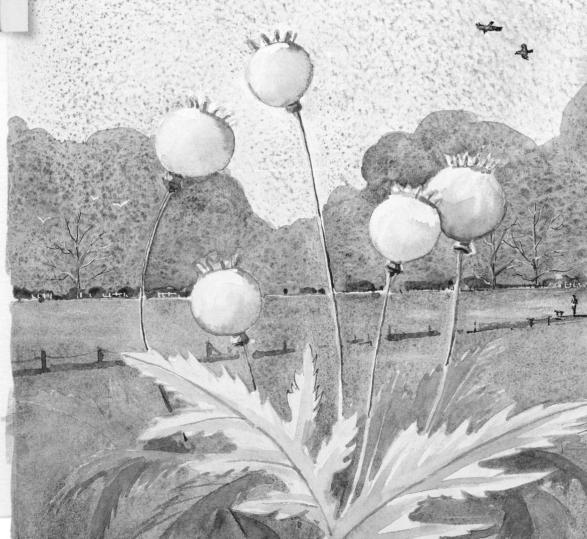

Monochrome

UNDERSTANDING TONE

For a painting to succeed, it should usually exhibit a full range of tones, from extremely light to extremely dark. Painting in a single colour will help you to look carefully at tone without being distracted by the colours you see before you.

Using tone to distinguish objects

To distinguish one object from another and prevent them appearing to merge together, you must vary their tones. A common mistake is to differentiate objects by colour alone, which can make paintings bland. Convert a photograph of your painting into black and white. If the painting is reduced to a variety of dull greys, you need to think more about tone. Painting in monochrome will help you to do this.

Colours created in similar strengths

Similar shades of grey

Colour versus tone

The first swatch appears to be full of contrast, but this is a contrast of colours only. After converting the first swatch to greyscale, it's apparent that there are no distinguishing tones present.

PUTTING IT INTO PRACTICE

Choose a dark colour for your monochrome painting. Neutral tint was used for this painting of a flower stall, but sepia, paynes grey, and indigo would be good alternatives.

You will need

- No. 14 and no. 6 soft-hair mops;
 no. 6 soft-hair round brush
- 25 x 35cm (10 x 14in) NOT watercolour paper

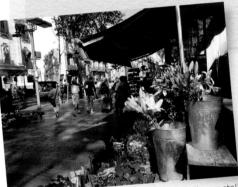

Flower sta

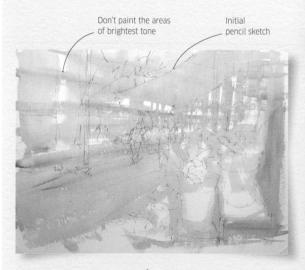

1 Background wash

Although it would be easier to use a black and white photo as reference, the value of this exercise lies in translating colours to tones. Using a no. 14 soft-hair mop, cover most of the paper with a pale wash, leaving only the brightest highlights unpainted.

2 Second wash
Add a darker, second wash with a no. 6 soft-hair mop. A smaller
brush helps you to start adding more detailed tonal differences
between the different areas of the painting.

Build up tone
Using a no. 6 soft-hair round brush, gradually build up tone to create the different shapes. Forget about colour and avoid being too literal in your interpretation: merely hint at elements that might seem quite definite in the photograph.

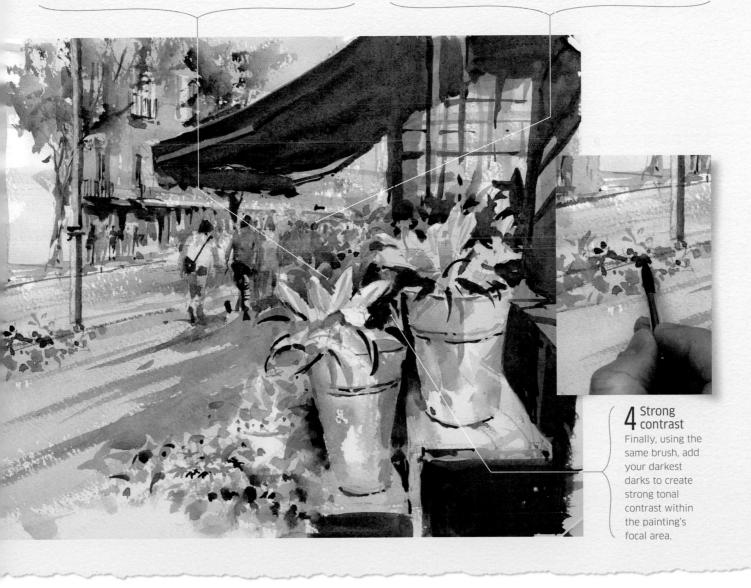

Glazing

ADDING TINTS TO AN UNDERPAINTING

A glaze is a thin wash applied on top of an area of dry paint. Glazing over an underpainting can change the mood of a painting, help connect separate areas, and create depth. Being transparent. watercolours are the ideal medium for achieving glazing effects.

Colour and warmth

You can use glazes to subtly adjust colours, alter the warmth and coolness of an area, or add colour to a monochrome underpainting. You can overpaint subjects and darken the true colour in shadow areas. Glazes can also create or enhance aerial perspective. For example, you can use cool glazes to make background areas recede, and warm glazes to make the foreground advance. A glaze can also gently soften and unite areas that may look disconnected.

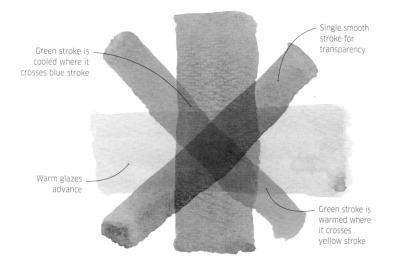

Transparent glazes

Where the different glazes of transparent colour cross, optical mixing creates the illusion of purple from the red and blue, green from the blue and yellow, and orange from the yellow and red.

PUTTING IT INTO PRACTICE

In this depiction of a town square, warm and cool glazes were applied where appropriate to add shadows and enhance the depth of an otherwise flat-looking scene.

You will need

- No. 10 soft-hair round brush
- 25 x 35cm (10 x 14in) NOT watercolour paper

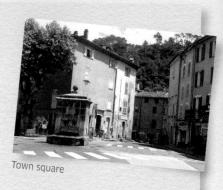

"Glazes subtly change colour, and alter warmth and coolness."

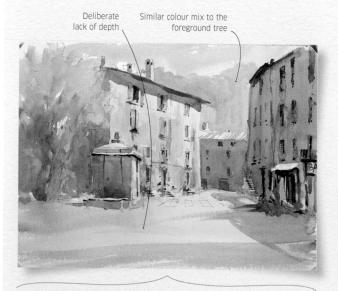

Apply the underpainting f L In this initial underpainting, similar colour mixes were deliberately applied for both the background and foreground, inevitably leading to a lack of depth. A no. 10 soft-hair round brush was used throughout.

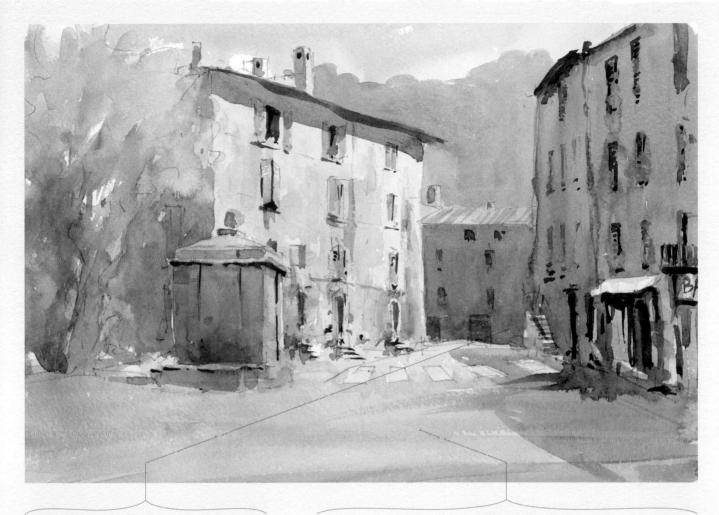

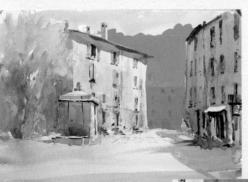

Glaze the foreground with raw sienna to warm and advance this area. Again, use a wash just strong enough to create a subtle effect that alters the warmth of the underlying colours without changing them entirely.

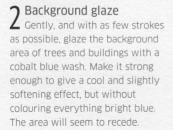

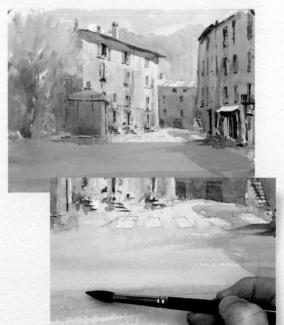

Building layers

OVERLAPPING WASHES

The transparent quality of watercolours makes them ideal for layering. Successive washes of colour will give your painting a sense of luminosity and depth. As long as the previous wash is totally dry, you can lay a new wash without disturbing the pigment underneath and creating unwanted marks.

Working from light to dark

Build up layers gradually, working from light tones to dark tones. That way, you can easily darken a tone by adding an extra wash. Layering over dry paint will create hard lines, which you can use to your advantage by painting negative shapes to let lighter tones show through. Be aware that new layers will modify the colour or tone of the previous layer, in a similar way to glazing (see pp.104–05).

Transparent layers

A blue wash has been applied to half of this picture over a dry layer of paint. The details of the bottom layer are still clear underneath the blue wash, but the tones are deeper.

PUTTING IT INTO PRACTICE

In this stable scene, layered washes create a sense of depth with a clever interplay of light and dark. Use a large mop brush to apply the initial layers, to give the painting a loose, organic feel.

Lightest layers
Create a warm tone
with a light wash of
ochre mixed with violet.
Leave white paper
where the windows
and door will be. Layer
a deeper tone on top,
using ochre mixed with
violet and Prussian blue.

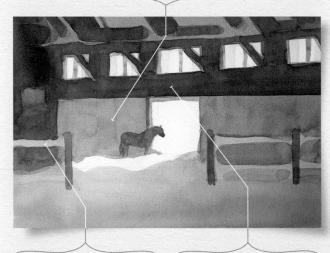

2 Negative shapes
Paint around the fence rails
in the foreground as you apply
a mid tone to the walls. This
creates light-coloured negative
shapes that emerge from the
darker background.

3 Darkest layers
Apply the darkest tones to
the shadows around the roof
and window frames, but leave
some of the previous layer
showing to suggest sunlight
striking the beams.

You will need

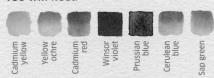

- Large soft-hair mop, no. 10 filbert synthetic, no. 10 round soft-hair, and no. 10 round synthetic brushes
- 25 x 35cm (10 x 14in)
 NOT watercolour paper

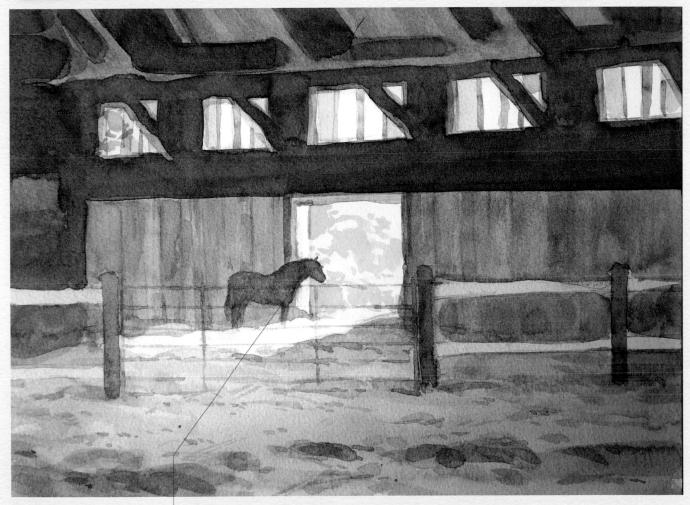

Horse silhouette Pick out the figure of the horse with a mix of red, ochre, and violet. The warm colour will bring the horse forward from the background, but make sure its tone is darker than that of the wall behind it.

5 Finishing touches Apply a pale green wash for the foliage and, once dry, model it further with darker tones. Review your painting and decide whether to add details - such as the straw and floor - or perhaps adjust the tonal contrast to help everything come together.

Adding details

CREATING FEATURES AND FOCAL POINTS

Think about the overall balance of your painting when you decide where to add details – they should enhance the scene rather than overwhelm it. Details help objects to stand out, so are best used on focal points or on foreground elements in aerial perspective (see pp.68–69). Build up details slowly as you add layers.

Ways to add detail

Details can encompass a range of effects, from textures, to fine lines, to highlights. Using paint and various brushstrokes to add details works very well, but you can also introduce other media to great effect.

PUTTING IT INTO PRACTICE

Delicately drawn details make the artichokes the focal point in this painting, while the oranges in the background are painted more simply.

You will need

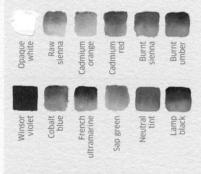

- No. 5 and no. 2 round soft-hair brushes
- Dip pen with steel nib and waterproof Indian ink
- 30 x 35cm (12 x 14in) hot-pressed watercolour paper

Basket of artichokes

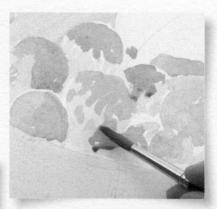

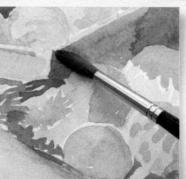

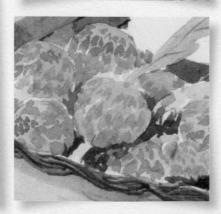

1 Initial washes
Apply light washes
with a no. 5 round
soft-hair brush to
establish the basic
shapes and colours.
Allow to dry, then
add shadows to give
the objects form.

2 First details
Using the side of your brush, apply darker tones on the box of oranges and the table. Switch to the tip of your brush to paint the wood grain.

Continue using the tip of your brush to add the petals on the artichokes and the weave on the basket. Add further details to develop the table and box.

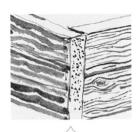

Brush tip and side

Make thick marks with the side of your brush or thin marks with the tip for fine details.

Dry brush

Squeeze excess moisture from your brush before dragging it over the paper to create texture.

Pen and ink

Use a dip pen and ink or a fibre-tip pen to add dark, fine lines for crisp detail.

White gouache

Gouache is opaque, which allows you to add highlights and details over dry paint.

White pastel

You can add textured, expressive details on top of dry paint with white pastel.

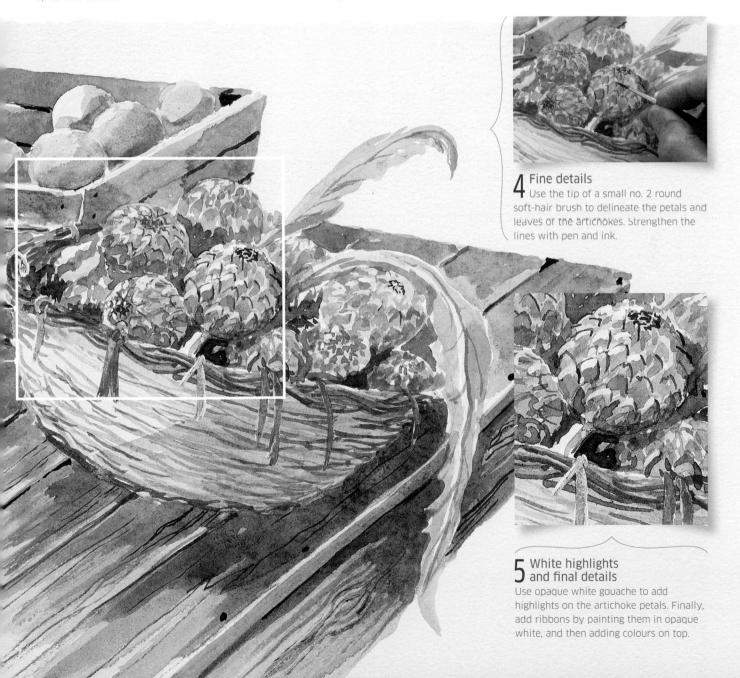

Reflections

PAINTING MIRROR IMAGES ON WATER

Depending on the direction of the light and clarity of the water, the colours of a reflection can vary from slightly less intense than the object being reflected to completely muted. Disturbances on the surface of the water will also affect a reflection's quality.

Surfaces and reflections

You can create the effect of a rippled surface by painting bands of softened colour. With rougher water, colours will become more subdued, and the horizontal bands will become increasingly fragmented.

Still surface

When the water's surface is completely smooth, a reflection will appear as a slightly muted, mirror image of the shore.

Ripples act like curved mirrors, distorting reflections and making them longer, while softening details.

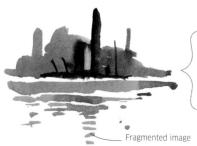

Broken surface

As the water's surface becomes more uneven, reflections will break up and can even disappear completely.

PUTTING IT INTO PRACTICE

In this river scene, bands of muted colours and subdued tones were used to recreate the softer reflections on the river's surface and to suggest movement.

You will need

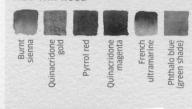

- No. 14 soft-hair mop. no. 10 soft-hair round, no. 6 soft-hair round, no. 6 soft-hair rigger. and small swordliner brushes
- 25 x 35cm (10 x 13in) NOT watercolour paper

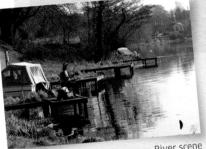

Varied mix of French ultramarine French ultramarine Phthalo blue. quinacridone magenta,

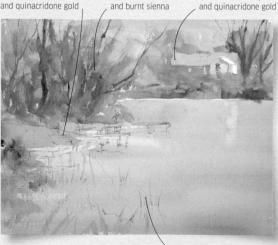

Varied mix of phthalo blue and quinacridone magenta

Underlying wash

f L Lay a merging wash across the whole paper with a no. 14 soft-hair mop and using various mixes. Paint in a suggestion of the house and vegetation. Leave simple, light shapes to hint at the structure of the house.

Foreground elements With your no. 10 round, no. 6 round, and swordline brushes, indicate the trees, vegetation, fisherman, and

fishing stands with mixes of the colours below.

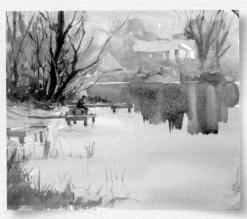

3 Reflections
Use the no. 10 soft-hair round brush to suggest reflections with horizontal bands of colour and tone. Make these deliberately subdued compared to the reflected objects, with lights less light, darks less dark, and colours more muted.

"Watercolour is an ideal medium to show the subtlety and beauty of reflections in water."

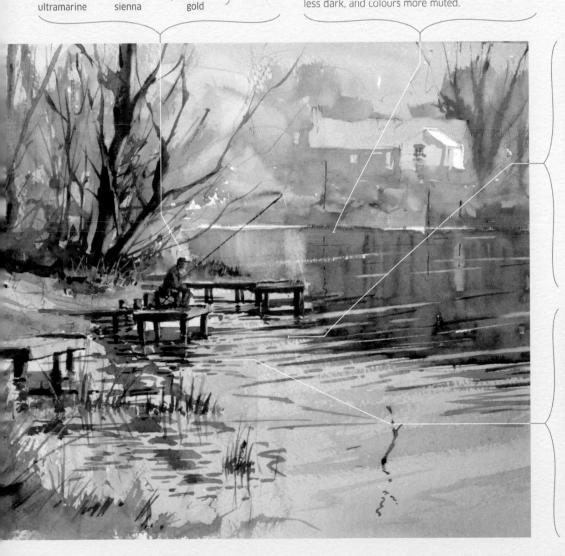

Ripples While the reflections are wet, use a dry no. 6 rigger to create horizontal ripples, breaking up the edges of the vertical bands. Apply extra ripple reflections under the trees and fishing stands.

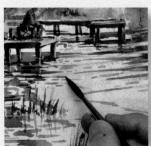

Darks Using a no. 6 round brush and no. 6 rigger, add detailed darks to the trees, fisherman, and ripples under the stands to draw the viewer's eye.

Opaque whites

USING SOLID WHITE COLOUR

Opaque whites are useful in watercolour for adding areas of solid colour, or correcting and altering your artwork. White gouache is perfect for this purpose. While Chinese white can also be used, it is thinner and does not cover as well. When mixed with watercolour, the gouache turns the paint into an opaque body colour which, when diluted, will become a semi-opaque, chalky glaze.

Lights and opaque whites

For the cleanest end result, apply opaque white to areas of paper that you have left unpainted (see pp.82-83). A tinted watercolour paper will show off the technique at its best. Use gouache to create effects such as shimmering reflections on water, or to make adjustments.

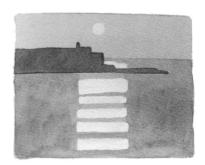

Add shimmer

Here, opaque white paint has been used to enhance the effect of evening sunlight shimmering on water. A touch of yellow ochre in the white will make it a warmer colour, whereas a little blue will cool it.

Alterations

These fence posts were painted in opaque white on top of a background wash. The shaded edges of the posts were added using a layer of opaque body colour.

PUTTING IT INTO PRACTICE

This French café scene is flooded with morning light, conveyed by the brightness of the leaves, table tops, and awning. This piece was painted on cream paper to emphasize the highlights added in opaque white and body colour.

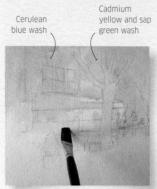

1 Establish forms
Using your large flat brush, lay blues and greens wet-inwet to loosely establish the forms of the buildings and trees, leaving light areas clean.

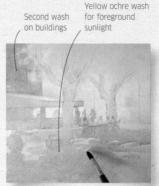

2 Second wash
With your no. 10 round
brush, lay a second, cooler
wash over the buildings. Paint
carefully, allowing the leaves
of the trees to stand out.

3 Add depth
When modelling the
leaves, use a darker wash of
cadmium yellow, sap green,
yellow ochre, and winsor
violet. This will give them
depth and shadow. Use your
no. 10 soft-hair brush.

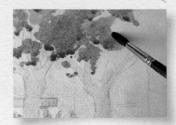

You will need

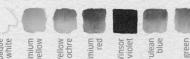

- Large flat soft-hair, no. 10 round soft-hair, and no. 6 round soft-hair brushes
- 25 x 35cm (10 x 14in) cream, NOT watercolour paper

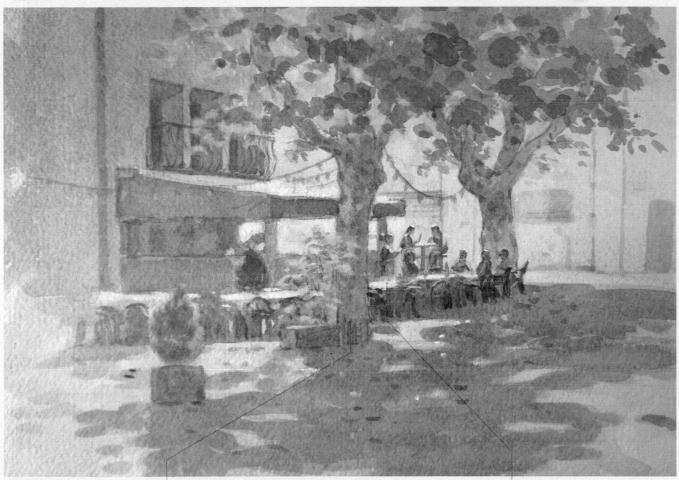

Add colour Using the same brush, paint the sap green awning and use yellow ochre and cerulean blue for the tree trunks. Freely indicate the chairs with a mix of winsor violet and cadmium red, then place the figures and show the window detail.

5 Add opaques With a no. 6 soft-hair brush, strengthen the shadow in the foreground and under the tables, as well as the tree trunks. Also apply white to the table tops. Using a no. 10 round brush, add body colour to the figures and foliage, strengthening detail. Finally, adjust any tone or colour that requires attention.

Skin tones

PAINTING FLESH COLOURS

Painting faces and figures from life will give you a great understanding of form, tone, and colour, which you can apply to everything you paint. When depicting facial features, it's best to tone down the whites of the eyes and the whiteness of teeth, which can otherwise seem too stark. Also, show mouths either closed or with lips only slightly apart, as wide open, laughing mouths can sometimes look grotesque.

Basic palette

Skin tones vary widely depending on age, ethnic background, and even lifestyle. For example, someone who spends a lot of time outdoors is likely to have rugged, weathered features. Rather than using a standard colour, such as "flesh tone", use a basic palette of colours (see below) to recreate the many varied tones seen in life.

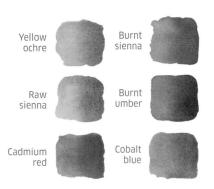

Dark skin tones

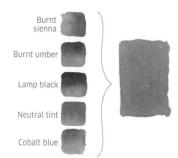

Dark skin palette

Use burnt umber and lamp black for very dark skin, or burnt sienna and burnt umber for medium-dark tones. Shadows and highlights often need hints of blue.

Spectacles painted with opaque white and lamp black using a dip pen

Painting dark skin

The overall hue of the saxophone player was established with a wash of burnt sienna and burnt umber. Once dry, burnt umber and lamp black were added to show the shadows created by the muscles and veins of the arms. Highlights of opaque white were used to indicate the nose and cheek.

Ring helps describe round form of finger

Detail of hand

Once the basic wash was dry, shadows were added to create form. Paler tones were used for the finger nails and to suggest movement of the fingers.

Olive skin tones

Olive skin palette

Establish overall hue and tone, adding darker tones of the basic mix for shadows. Use only subtle variations of colour and tone for olive skin.

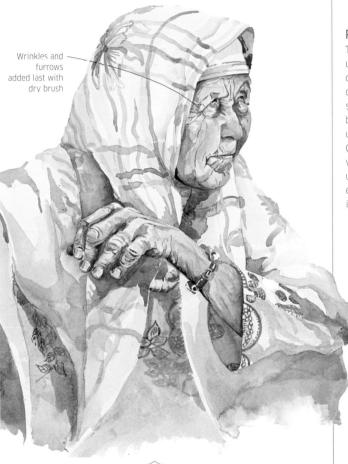

Painting olive skin

A basic wash of raw sienna and a touch of burnt sienna was used for the face and arm. Once dry, a darker mix was used to enhance form. The structure of the face was then added, using a dry brush to delineate the eyes, nose, mouth, and chin.

Detail of hand

Detail on the hand was added using dark tones of the basic wash. The wrinkles, knuckles, and nails were painted with a dry brush to add texture.

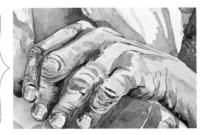

Light skin tones

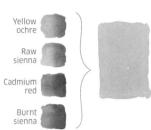

Pale skin palette

Use the basic palette for pale skin, using darker tones of the mix for shadow areas.

Hair is lamp black and opaque white

Hint of grey in whites of eyes,

The head and neck were built up using basic washes of yellow ochre, burnt sienna, and a touch of cadmium red. The wash was strengthed for the shadows, with burnt umber and neutral tint—used for the darkest areas. Cadmium red and opaque white were used for the lips, and burnt umber and lamp black for the eyes, with the highlights added in opaque white.

Cellist's hand

An initial pale wash of yellow ochre and cadmium red was applied first, with a darker wash used to create torm but still keeping the fresh, pink colours.

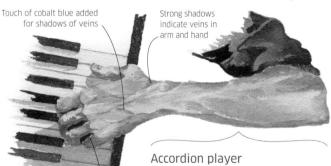

Burnt umber and cobalt blue for dark shadows A preliminary wash of yellow ochre, burnt sienna, and a little cadmium red was applied for the whole arm, to show tanned skin.

Darker shadows

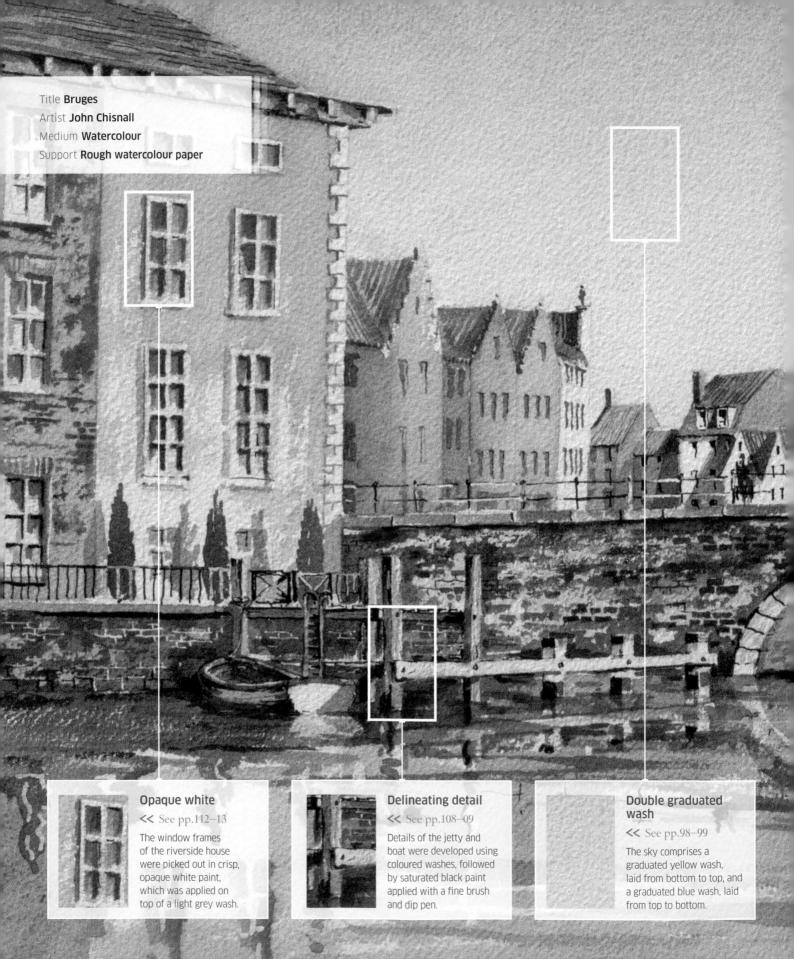

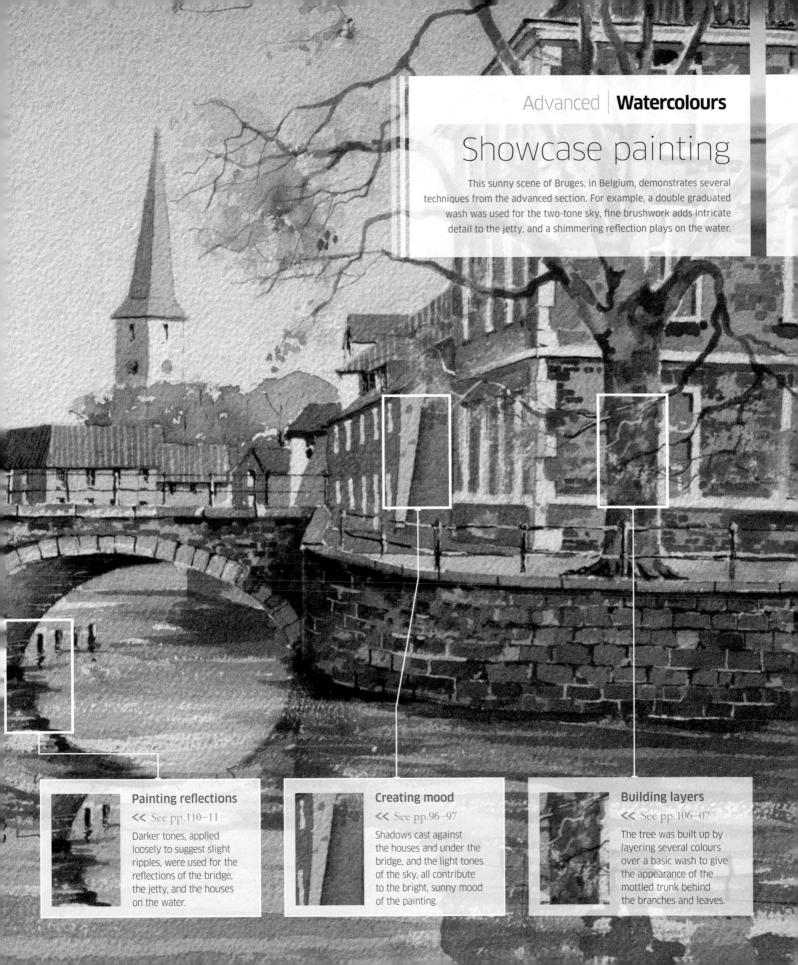

ACRYlics

Painting with acrylics

A quick-drying, water-based medium that becomes water resistant when dry, acrylic paints are quick and easy to use. They are renowned for their brilliant colour, convenience, and versatility. Acrylic paints can be diluted with water to create watercolour effects or used neat to reproduce the thick, impasto layers used in oil painting.

On the following pages, you can find out about the paints and materials you will need to get started. Then, practise and develop your skills with more than 25 acrylic techniques, grouped into three sections of increasing sophistication – beginner, intermediate, and advanced. A showcase painting at the end of each section brings all the techniques together.

Beginner techniques

■ See pp.128-51

In the first section you can find out about colour mixing and using a limited palette. You'll also learn about aerial perspective and how to paint with both diluted washes and thick applications of acrylic paint.

Beginner showcase painting (see pp.150-51)

2 Intermediate techniques

■ See pp.152-79

In the second section, discover how modelling paste can add texture, see the effects produced from using a coloured ground, and learn how to blend, glaze, and use warm and cool colours.

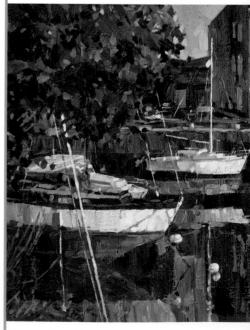

Intermediate showcase painting (see pp.178-79)

Acrylic paints have a relatively short history – certainly in comparison to watercolours or oils (see pp.32–33 and pp.208–09). Developed as interior wall paints in the early 1950s, the first artist-grade paints were introduced in the mid '50s. By the middle of the following decade, manufacturers had vastly improved the quality of their paints by using richer pigments. The popularity of acrylics soon grew among artists, thanks to their quick drying time, lack of toxic ingredients, and their versatility.

Quick and easy

One of the major benefits of the quick drying time of acrylics is that you can easily complete a painting – which might consist of several layers – in one sitting. However, as thin applications will be touch dry in 20–30 minutes, it can be difficult to create subtle blends or soft graduations of colour.

Brilliant colour

Acrylic paints have a great brilliance of colour straight from the tube, although they do have a tendency to dry slightly

darker. It is best not to overwork them, either – whether in the palette or on the canvas – as they can become slightly dull with a matt finish.

There is a vast range of pigments to choose from, including metallic and iridescent colours, and acrylics will adhere to most unvarnished surfaces.

As you can use acrylics to produce precise, detailed paintings or large, abstract pieces, they are undoubtedly an exciting and versatile medium – whether you are a professional artist or are picking up a brush for the first time.

3

Advanced techniques

■ See pp.180-205

In the final section, further develop your skills by creating dramatle fucal points, using optical colour mixing, and painting people, skin tones, animal fur, movement, skies, and rainy weather.

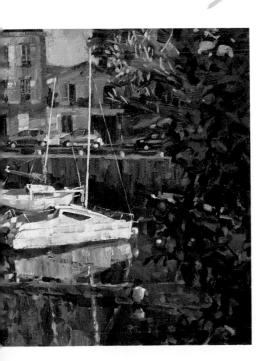

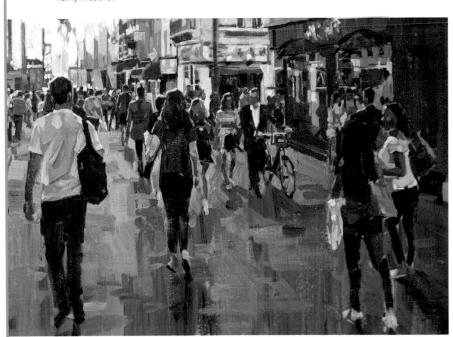

Advanced showcase painting (see pp.204-05)

Acrylic paints

THE PROPERTIES OF ACRYLICS

Carbon black with titanium white

Acrylics are easier to manipulate than oils, as they are water soluble and have a faster drying time. They are available in a huge range of colours and consistencies. Whatever your preference, choosing a good quality acrylic paint of pure pigment is best to ensure lasting colour on your paintings.

Acrylics are available in many forms – as spray-paint, ink, markers, and tubes and tubs of paint. The consistency of acrylic paint also varies widely. Soft body paint has a smooth creamy quality, while heavy body and super heavy body paints are exceptionally thick and buttery. Acrylics can also be obtained in liquid form.

The style you work in will determine the type of paint you choose. A thicker paint is ideal for very expressive and textural work, where you would like brushmarks to remain visible in the paint. A smoother consistency is preferable for detailed work or where you are aiming for a flat finish, particularly on large surfaces.

Paint quality ranges from basic- to student- to artist-quality. Prices reflect the level of pure pigment balanced with binder: the purer the pigment, the costlier the paint. A purer pigment will have less colour shift - the difference in colour between wet and dry paint. It will also have greater permanence or "lightfastness", meaning it is more resistant to fading when exposed to sunlight. Acrylic paintings are generally more durable than oil artworks.

There is a huge range of acrylic colours available from different manufacturers, and different brands of acrylic paints can be mixed together if the binder is the same. As well as the long-standing traditional colours, new additions are occasionally introduced.

Black and white

There are a few variations to choose from when selecting black or white acrylic paint. Differences can range from very subtle distinctions, such as being slightly more transparent or opaque, to very stark contrasts.

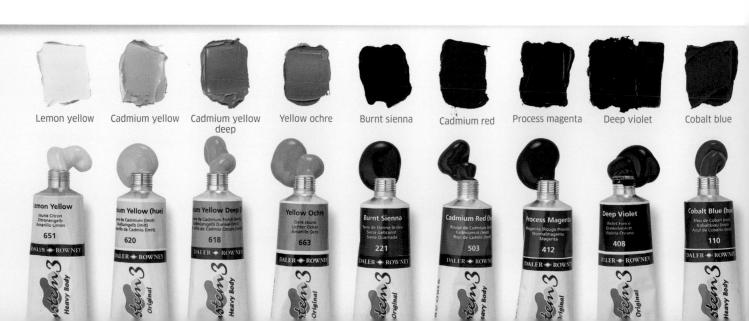

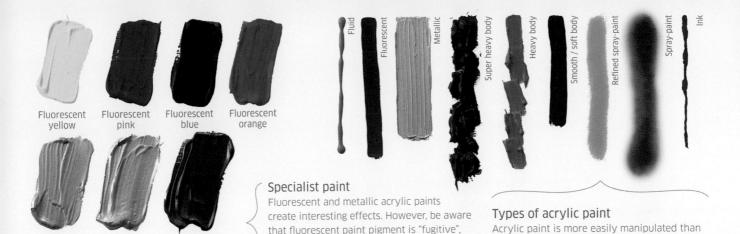

meaning that it fades away in direct sunlight

and can disappear completely over time.

Among the different blacks on offer are bone, mars, ivory, and carbon. Carbon is the darkest black available. When choosing white, the options are zinc, mixing, and titanium, titanium being the most opaque. Your choice will depend on your subject matter and style: a portrait might call for a softer colour mix, while a painting of strong colours may require a more dominant version.

Care of paint

Pale gold

Keep acrylic paint away from heat sources and from direct sunlight, as the paint may dry inside the container. Paint that has been frozen will also be adversely affected. Keep paint containers well sealed and free of contaminants. Acrylics should last several years, but have a much shorter shelf life than oils, which can last decades. Once opened, the intensity of the colour may diminish with time. Look out for mould or a sour smell, which may indicate that your acrylics have passed their expiry date.

To prevent colours you have already mixed from drying out overnight, use a palette with deep wells and an airtight lid. Keep it covered and in a cool place when not in use. If a film forms on the paint's surface, simply pierce it with a palette knife to keep

oil paint and can be applied using a number

of methods, from aerosol cans to pens.

White and black paint

the paint workable.

Tilanium white is the most opaque of the whites, which means you need less paint to give good coverage. Carbon black has a natural sheen and is the darkest black.

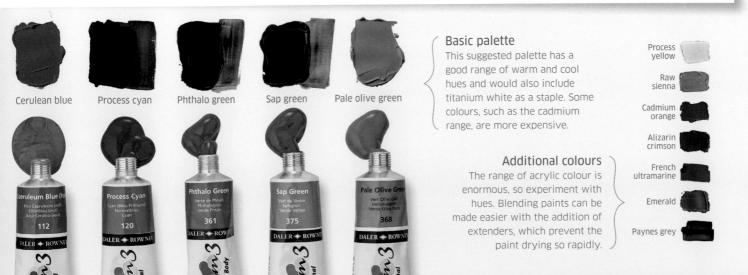

Brushes and palette knives

HOW TO CHOOSE YOUR BRUSHES

The choice of brushes for acrylics is huge. Brushes come in many shapes and sizes, and your selection depends partly on whether you are diluting the paint or using it thick and neat. The bristles can be either made from animal hair, which is costlier, or synthetic fibre, which works very well for this medium, especially when using thick paint.

Stiff, bristle brushes can manipulate thick paint, while soft-hair brushes can carry lots of fluid, diluted paint. Synthetic brushes come in both bristle and soft-hair types, and are robust enough for acrylic paint. Hog hair brushes (popular in oil painting) are stiff and suitable for acrylics, but soft, sable hair brushes may be too delicate.

Types of brush

The main types of brush to look for are flat, round, and filbert brushes. Flat brushes have a square edge, which is good for broad, loose strokes and bold

lines. Round brushes hold lots of paint and have a pointed tip, which makes them ideal for painting details and using with diluted paint. Filbert brushes have a flat shape but a round edge, which makes them versatile. Other types of brush include liners, for fine line work, and fans, for blending. As a beginner, start with two large brushes, two medium, and two small, in a mixture of flat and round shapes. If you prefer to create finely detailed paintings, choose more round brushes, but if you prefer to paint loosely and expressively, large flat brushes may suit you better.

Practise holding your brush in different ways to create different effects – for example, painting fluffy clouds will need gentle skimming brushstrokes but depicting rocks requires firmer strokes. (See opposite.)

Caring for your brushes

Since acrylic paint is a water-based medium, you can clean your brushes with soap and water. Special cleaning solutions are also available to buy if you wish. If you have a brush made from animal hair, you should rinse it occasionally with shampoo and water.

Brushes

Brushes come in different shapes and sizes. They can be round, flat, filbert, or rigger and are numbered: the higher the number, the larger the brush. Using a variety of brushes, you can create everything from fine lines to broad washes.

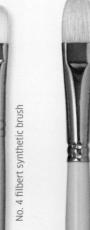

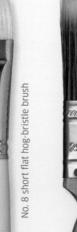

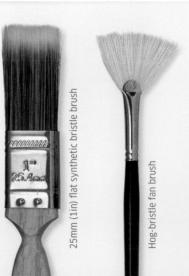

Holding a brush

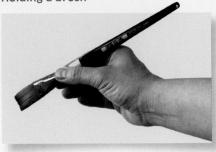

Pencil hold

To paint fine details, hold the brush as if you were holding a pen, with your fingers close to the brush head. This gives you greater control.

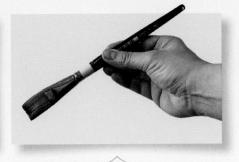

Flexible hold

For flowing marks, hold the brush further up the handle, which allows you to move your wrist and arm freely over the painting.

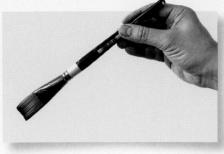

Maximum-range hold

Spray

Hold the brush towards the end of the handle to create very bold, free strokes. This hold helps you to cover large areas quickly.

Never allow acrylic paint to dry on your brushes as this can ruin them permanently.

Palette knives and other tools

There are numerous other ways to apply acrylics for exciting effects. Palette knives come in a range of shapes and sizes, and create very sculptural, textured marks. You can also use palette knives to mix paints quickly and cleanly. To create textural effects, try using sponges, spray bottles, toothbrushes, splatter brushes, or foam rollers.

Sponge

Sponges can create hold effects Use them to give the impression of trees, or try mixing colours on a sponge for interesting, uneven passages of paint.

too little will clog the bottle.

Try mixing acrylic paint and water in

a small spray bottle. You will need to experiment with the amount of water - too much will weaken the colour but

Roller

Acrylic paints work well willi paint rollers. These come in different sizes and textures and you can use them to cover large areas or to create lines and other marks.

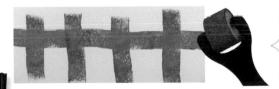

Brushes for special effects

You can make interesting splatter marks using a toothbrush or splatter brush. Paddle brushes are great for spreading thick colour and making broad marks over large areas.

Foothbrush

Palette knives

You can apply paint using the flat, edge, or tip of a palette knife to create a variety of effects. As with brushes, palette knives come in a variety of sizes and shapes. To hold a palette knife, grip it with a closed fist as you would a trowel.

Supports and other materials

CHOOSING A SURFACE FOR ACRYLICS

Acrylics can be used on most surfaces, or supports, that have not been varnished. These surfaces may include wood, stone, ceramics, fabric, paper, canvas, and board. Certain supports will require priming with acrylic primer or gesso to help the acrylic paint to adhere.

It is important to think carefully about your choice of support, as the type of surface you paint on will affect the way the paint is absorbed and how the finished painting will look.

Watercolour paper

Paper surfaces may require a base layer of white acrylic paint so that subsequent applications of paint will glide over the surface rather than

sink into the paper. This is not necessary if you are using a diluted watercolour technique with acrylics.

This is one of the best supports to work on as it is sturdy and lightweight. It generally comes ready primed and there is less need for a frame (and the associated costs) as you can simply

Keeping your canvas tense

Stretched canvas

Stretched canvas usually comes with a pack of wooden wedges. If the canvas starts to sag, place them in the grooves in the corners of the wooden stretcher.

run a cord behind the canvas to hang it. Canvas comes in many forms, including rolls - either primed or unprimed - canvas boards, and pads. These vary in cost from cheaper cotton grain of the canvas, from highly textured to extra fine. It is important

canvases to more expensive linen ones. There are also subtle differences in the that the canvas you buy is tense, as

Canvas, board, and paper Experiment with different

supports - you can even leave some areas unpainted so that the background colour of the support adds to the painting.

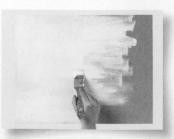

Stretched

Priming supports

Use horizontal and vertical brushstrokes to apply primer to ensure even coverage. Leave to dry for 30 minutes to an hour before painting over the top.

Canvas grain

Grain

Canvas comes in different grains, or textures. Using different grains will produce different effects in your finished paintings.

Palettes

Palettes with deep wells conserve acrylic paint for longer. Large, plastic mixing trays allow you to experiment with colours before using them on the canvas. Use warm water to rinse off excess paint afterwards.

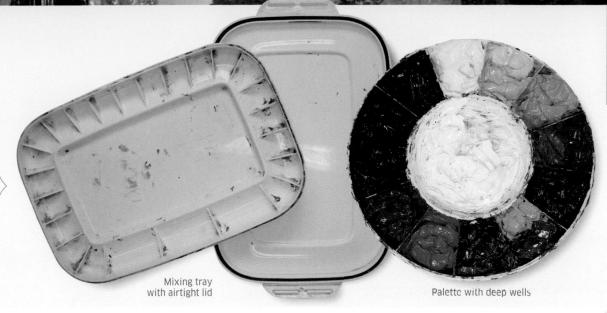

this will provide a good surface to paint on. Artist-quality canvases are usually more tense, and cheaper versions less so. Be careful not to place canvas in direct sunlight or next to a heat source as this can warp the wooden stretchers.

Choosing an easel

Free-standing and table easels are ideal to work on as they allow you to paint standing upright, reducing the stress on your back. You are more likely to create expressive brushmarks if you're standing up. Using a free-

standing easel means you can take a few steps back from time to time to consider the overall painting.

Using palettes

Acrylic paints dry fast. The advantage of this is that it means you can rework areas of your painting almost immediately. But beware – the paints on your palette will also dry out exceptionally quickly. It is advisable to use a palette with an airtight lid, as this will help prevent the paints drying out. Alternatively, you can use a stay-wet palette. This has a damp layer under

the mixing surface to keep the paints moist. You can either buy a stay-wet palette or make your own (see below).

Additional materials

Because acrylic paints are water based, you do not need any special cleaning products. Just make sure you have a couple of large jars of water to hand while you are painting, to clean unwanted paint off brushes or to dilute thick paint. Paper towels or old rags are useful for wlplng excess paint off brushes or skimming paint off the canvas if you make a mistake.

Making a stay-wet palette

Step 1
Cut a capillary mat (available from a florist or nursery) to fit the bottom of a shallow plastic tray.

Step 2
Tuck the mat into the tray. Pour on water and press the mat down until the water is fully absorbed.

Step 3
Cover the mat with three layers of paper towel, followed by a layer of baking parchment or waxed paper.

Step 4
Now you can mix paints on the parchment. When you take a break, cover the palette with plastic wrap.

Colour mixing

USING COLOUR THEORY TO MIX ACRYLIC PAINTS

Many of the colours you may need for a painting won't be possible (or practical) to buy in a tube – a landscape, for example, contains many subtle variations of green. Understanding colour theory helps you to mix your own colours and create the range of hues and tones you need to give your work added dimension.

Mixing primary colours

Practise mixing colours by creating colour wheels using a limited palette of three primaries. There are different versions of each colour, so your choice of primaries will determine the resulting hue of your secondaries and tertiaries.

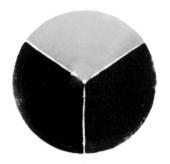

Primary colour wheel
Begin with the primary colours
yellow, red, and blue. You can
create all the other colours from
these three.

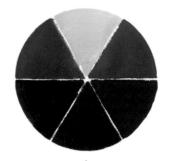

Adding secondary colours
Mix two primaries to create
each secondary colour: yellow
and red for orange; red and blue
for violet; and blue and yellow
to mix green.

Adding tertiary colours Mix a secondary colour with one of its primaries to make tertiary colours. This creates colours that are closer to one primary, such as yellow-green or blue-green.

Optical colour mixing

Optical colour mixing involves placing dabs of colour next to each other to create the illusion of a mixed colour, instead of physically mixing them. Acrylic paint can sometimes look dull when it is overmixed, so optical colour mixing is an alternative method that keeps the individual colours vibrant.

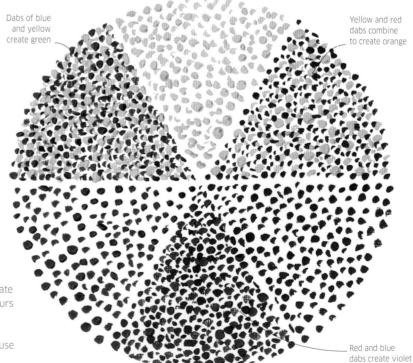

Impression of orange is more intense

Viewed from a distance

Optical mixing and scale

Dabs of pure primary colours create the impression of secondary colours in this wheel. The effect is more pronounced the further away the viewer is from the painting, because the dabs look more dense.

MIXING METHODS

For beginners, it is easier to mix the colour you want on a palette first before applying it to your support. This method is best if you want to create a flat, even colour because pre-mixing will help to achieve this. If you are using neat paint, you can create an interesting, variegated finish by mixing colours directly on the support using either a palette knife or a brush. In these examples, red and yellow are used to create orange.

Mixing on a palette

Use either a palette knife or a brush to mix the paint before applying it to your support. This method

This method usually creates a flat, even colour.

Flat orange colour

Mixing with a palette knife

Pick up two colours and apply them with a thick "impasto" application using a palette knife. Stir them together loosely for a

Impasto application

Yellow

marbled effect.

Mixing with a brush

Pick up two colours on your brush at the same time. Move the brush in different directions to loosely mix the colours.

Loosely mixed colour

Tints, tones, and shades

Adding white, grey, or black allows you to create tonal ranges. These examples show how to create tints, tones, and shades in primary and secondary colours.

Tones - adding grey

Tones are colours that have been adjusted by adding grey. Different greys create a wide variety of tones, from light to dark.

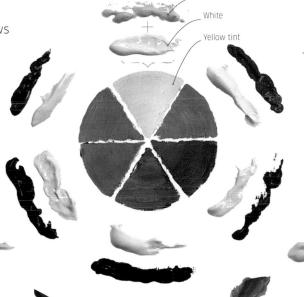

Tints - adding white

Tints are colours that have been lightened with white. Adding while creates pastel shades and highlights, but too much can make your colours look chalky.

Shades - adding black

Shades are colours that have been darkened with black. They are useful for shadow areas. Black is very strong, so use it sparingly,

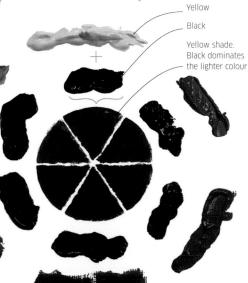

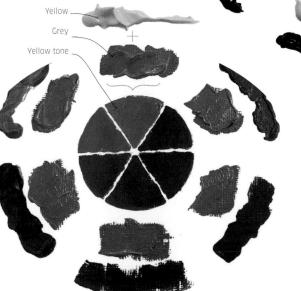

Mixing complementary colours

Complementary colours sit opposite each other on the colour wheel. Every primary has a complementary secondary colour, and vice versa. Mixing a colour with its opposite dulls it, creating a range of useful neutral hues.

Wheel of primary and secondary colours

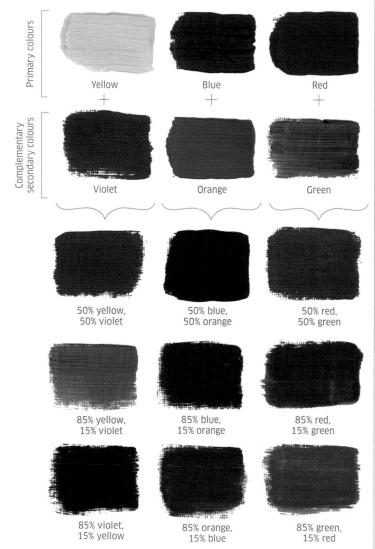

Yellow + violet

Yellow is a light colour, so violet dominates it in a 50:50 mix. A dab of violet with yellow creates golden brown.

Blue + orange

An equal mix of blue and orange creates a rich, dark colour that can be used instead of black.

Red + green

Mixing red and green equally creates a warm grey. Altering the ratio creates dark greens and purples.

Vibrant colour

A limited palette of primary colours and white was used in this painting. The primary colours were combined to create the bright secondary colours that convey the sunny atmosphere in the upper half of the painting.

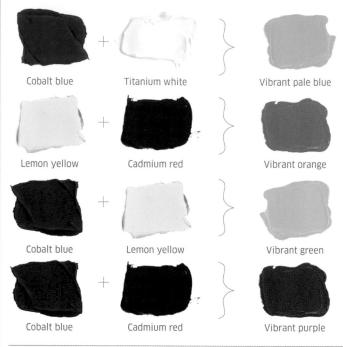

Muted colour

To paint the shadows and reflections in the lower half of the painting, the original colour mixes were muted by adding complementary colours. Darkening with complementaries, or opposites of warm and cool, can be more subtle than mixing with black.

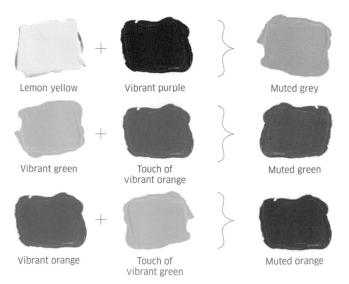

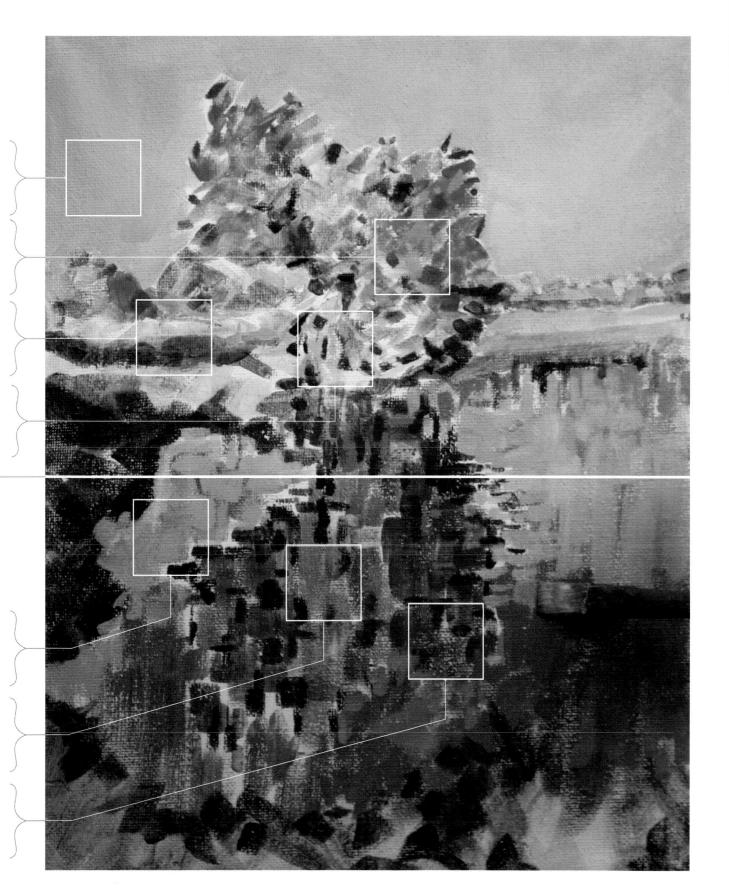

Using a limited palette

PAINTING WITH PRIMARY COLOURS

The best way to get to grips with colour mixing is to limit yourself to the three primary colours. From this simple starting point you can create a wide range of secondary and tertiary colours. With the addition of white, you can introduce pastel tints, too. Choose a simple subject, which features bold colours and has two or three elements of varying shape and scale.

Choosing primary colours

You can buy many different versions of each colour. When used in a mix, light and dark versions of the same primary can produce very different results. Lighter. more passive hues tend to be easier to balance than darker, more dominant ones. However, passive primaries can lead to earthy, somewhat dull mixes.

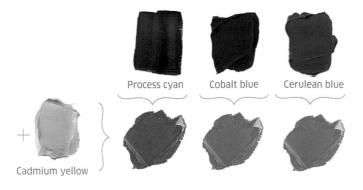

Mixing green with different blues

Process cyan (dark) creates vibrant secondaries; cobalt blue (mid) creates earthy secondaries; and cerulean blue (light) creates soft secondaries.

PUTTING IT INTO PRACTICE

This simple still life is a great showcase for the primary colours. The palette includes a mid red and yellow, and a dominant blue (cyan) to create a strong green for the lime. Each colour mix is echoed throughout the painting to create a sense of balance.

You will need

- 38mm (1½in) and 25mm (1in) flat synthetic bristle brushes
 - 37 x 49cm (14 x 19in) NOT watercolour paper (apply a base coat of white acrylic first)

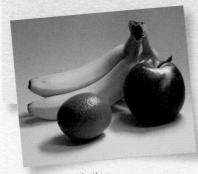

Still life with fruit

Large multi-directional strokes add interest

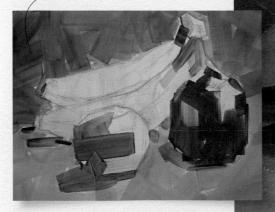

Primary colours

First, draw a pencil outline of the fruit to establish composition. Then, using the largest flat brush, apply blocks of pure yellow, red, and blue. Dilute the blue to create lighter areas in the foreground.

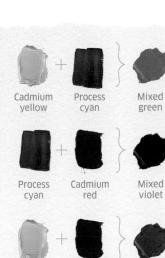

Cadmium

red

Mixed

orange

Cadmium

yellow

2 Secondary colours
Once the first layer is dry, add the secondary colours.
Mix a strong green for the lime and parts of the banana and apple. Mix a deep violet for the dark flecks on the fruit. Mix orange to dab the apple and for areas of the bananas that reflect the apple.

Mixed greenMixed violetMixed orange

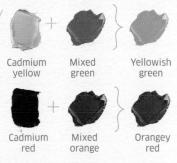

3 Tertiary green and orange

Mix a yellowish green to add subtlety to the bananas and lime. Mix an orangey red to add subtlety to the apple.

4 Tertiary violets
Add white to violet to
create a pastel tint for the
background, then divide
the mix into three. Add blue
for a cool, receding effect
at the top and for the darker
areas of shadow; add red for
the middle section and lighter
areas of shadow; and add
yellow and more white to
give the foreground warmth.
Finally, use a 25mm (1in) flat
brush to add highlights and
fine details.

Drawing with a brush

CREATING INITIAL OUTLINES WITH PAINT

Developing good drawing skills is an important part of learning to paint. However, devoting too much time and energy to creating the perfect preliminary sketch can hamper vour creativity when it comes to the painting itself. Instead, try using paint and a brush to map out the initial shapes. This will keep the process fluid and encourage you to capture only the key elements of your subject during the early stages.

Establishing basic shapes

Whether you're planning a simple still life or a detailed portrait, an initial drawing will help you create basic shapes and establish composition. Detail is not necessary at this stage - using a brush will help keep your sketch simple and impressionistic.

Lines and ellipses

Start off with a few simple, easily recognizable shapes and objects, such as a group of similar-shaped glasses. Practise drawing the lines and ellipses.

Group of objects

Focus on shapes and outlines, using a large group of glasses of different shapes and sizes. Resist the urge to block in any areas of colour.

No. 8 round synthetic brush

Brushes for sketching

Round and flat brushes are the most versatile for drawing, allowing you to vary the thickness of the line and add shape and tone. You will need just two brushes for the exercises here: a no. 8 round for the simple sketches opposite, and a 13mm (1/2 in) flat for blocking in the colour on the exercise on pp.136-37.

Single object

Once you have established the overall shape of an object with simple line work, you can switch your attention to the colours and details.

Portrait

The drawing stage of a portrait helps you place the features correctly and establish the form of the face before you block in shapes with dark and light tones.

LINES AND ELLIPSES

This simple still life of a small group of similar-shaped glasses is a good subject for practising lines and ellipses. Experiment drawing with two or three brushes.

You will need

- 13mm (½in) flat synthetic brush
- 40 x 50cm (16 x 20in) medium-grain canvas

Small group of glasses

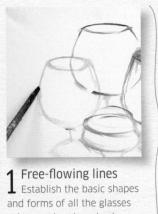

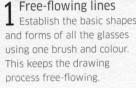

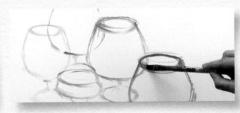

2 Add definition
Introduce darker tones to differentiate the shapes. Experiment with different marks and brushstrokes.

GROUP OF OBJECTS

In this large group of glasses, there are several different shapes and sizes to contend with. As well as accurately describing their shapes, focus on their relative positions, too.

You will need

- No. 8 round synthetic brush
- 40 x 50cm (16 x 20in) medium-grain canvas

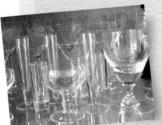

Large group of glasses

Shapes and positions L Draw the various shapes and carefully position each glass. Use the negative spaces between the glasses for guidance.

7 Bolder lines

Develop two or three glasses in the foreground with stronger colour and bolder line work. This will create a sense of depth.

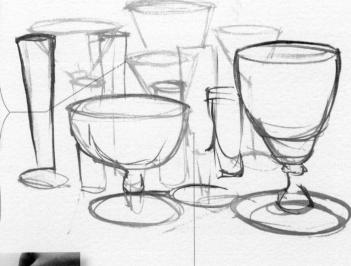

SINGLE OBJECT

A single-object still life, such as this ornate, coloured glass, is a great follow-on exercise. By focusing on one subject without the distraction of surrounding objects, you can work up an initial brush drawing into a more finished painting.

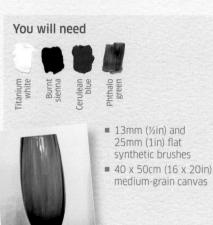

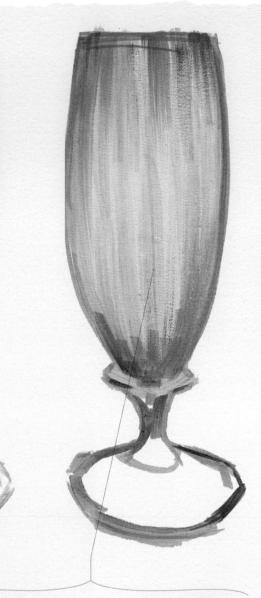

Ornate glass

1 Initial outline
Establish the basic shape of
the glass, sketching its contours
with a 13mm (½in) flat brush.
Use cerulean blue to match
the hue of the subject.

2 Consistent line work
Keep the thickness of the
outlines consistent throughout,
and use the same mix and
concentration of colour. This
helps create cohesion.

3 Block in colour
Using the same brush and starting from the top, fill in the centre of the glass with colour.
Make sure all the brushstrokes are in the same direction.

Add darker, heavier tones of cerulean blue near the edges of the outline and lighter tones towards the centre. This creates depth and form.

"Establish the shape and form of the subject using one colour and one brush. This will help you draw quickly and freely, without having to stop and start as you change brushes and mix new colours."

5 Light tints
Use a mix of cerulean blue and phthalo green for the darkest tones. Add white to create a range of light tints, which suggest reflections in the glass.

Finishing touches 6 Finishing toucnes
Apply dabs of colour to the base of the glass for a sparkly effect. Include subtle hints of burnt sienna to pick out the reflections of the surroundings

Tints, tones, and shades

EXPLORING TONAL RANGE

Every colour has a tonal range of tints, tones, and shades
– a scale of brightness from light to dark. You can use
tonal colour for everything, from your strongest highlights
to your deepest shadows. By doing this you can emulate
the way in which light behaves on an object or scene and
create a three-dimensional effect.

Tints

Adding white to colours creates tints. White softens the brightness of colours and creates a range of pastel hues, depending on how much of it you use.

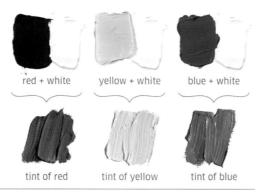

Tones

Adding grey, or a mix of black and white, to colours creates tones. You can achieve many complex variations by adjusting the quantities of black and white in the mix.

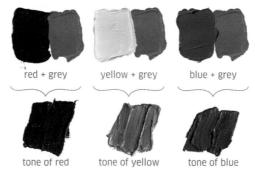

Shades

Adding black to colours creates shades. Use black sparingly - it can be very dominant and too much will make the colour of the shade barely visible.

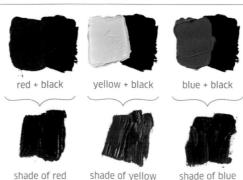

PUTTING IT INTO PRACTICE

Each colour in this painting is mixed with white, grey, or black to create tonal effects of light and shade.

A strongly lit photograph, such as the one of garlic bulbs below, provides lots of contrast with which to experiment. Whatever subject you choose, you can test your success by photographing your finished colour painting in black and white. Doing this will make it easier to see if your use of tonal range is correct.

Shades

Apply deep shades of blue to the background and shadows - the striking contrast of darks against the light garlic helps define the shapes. Where the shadows meet the foreground, introduce softer tones with blue-and-grey mixes.

Tints

Add plenty of pale yellow tints to evoke a sense of light striking the garlic. Use tints of red and blue among the yellow to add interest. The tonal difference between tints and shades provides satisfying contrasts, and creates dramatic lighting effects.

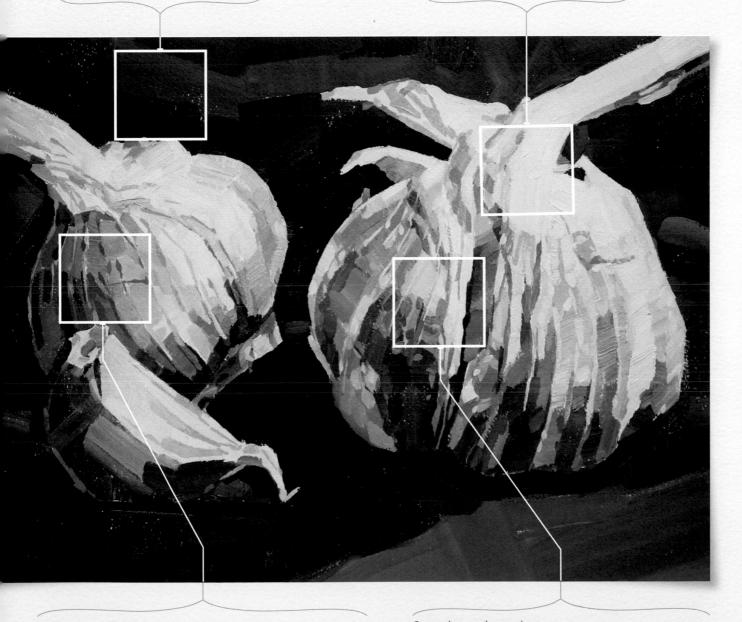

Tones

Suggest the curving sides of the garlic with subtly graded tones of blue, yellow, and red. Use darker tones near the shadows and lighter tones to blend into the tints at the top. Experiment first on a palette, adjusting the ratio of black to white in your grey mixes to make multiple tones.

Secondary colour mixes

Link the primary colours in your painting by mixing tints, tones, or shades of secondary colours. Extend the range of red tints by adding blue to red to make pastel purples; or add a hint of yellow to your blue-grey mixes for a greenish tone.

Acrylic washes

USING DILUTED PAINT

When you dilute acrylics with water, they gain a transparency similar to that of watercolours. The colours don't fade when they dry, you can apply multiple washes with no interference from dry base layers, and you can paint over any mistakes using thicker paint. Acrylic washes don't spread or blend as easily as watercolour, however, so they can look streaky.

Wet-in-wet and wet-on-dry

Applying diluted paint to a wet surface is called "wet-in-wet" and it will give you a soft, diffused wash of colour. Applying diluted paint to a dry surface is called "wet-on-dry" and creates a clean, translucent colour.

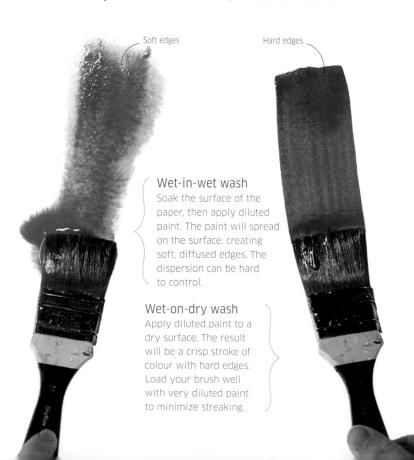

PUTTING IT INTO PRACTIC

This painting combines both wet-in-wet and wet-on-dry washes to create luminous layers of colour. The details are finished with undiluted paint, to create interesting contrasts.

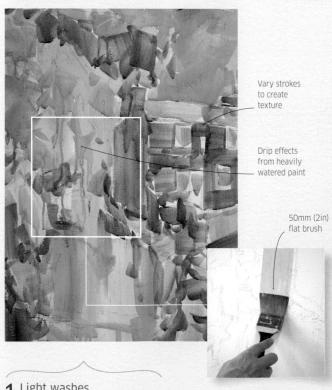

Light washes

Luse very diluted washes initially. Lay wet-on-dry washes for the trees. Wet the paper in the stream area and apply green wet-in-wet washes for a watery effect. Apply greys mixed from cerulean, violet, and sienna as wet-on-dry washes for the stone house and cliff.

2 Dark washes When the initial washes are dry, use a 38mm (11/2 in) flat brush to add darker tones for the shadows. Use less water in the paint to give you greater definition and more control over the washes.

3 Adjusting the contrast Add a third layer of mid tones to bridge the gap between the lights and darks, and to create texture and detail. This won't disrupt the layers of colours underneath.

Highlights 4 Highlights
Use a moist 25mm (1in) brush and almost-neat paint to give definition to the last details. Mix pale green tints to add as highlights to the trees and stream.

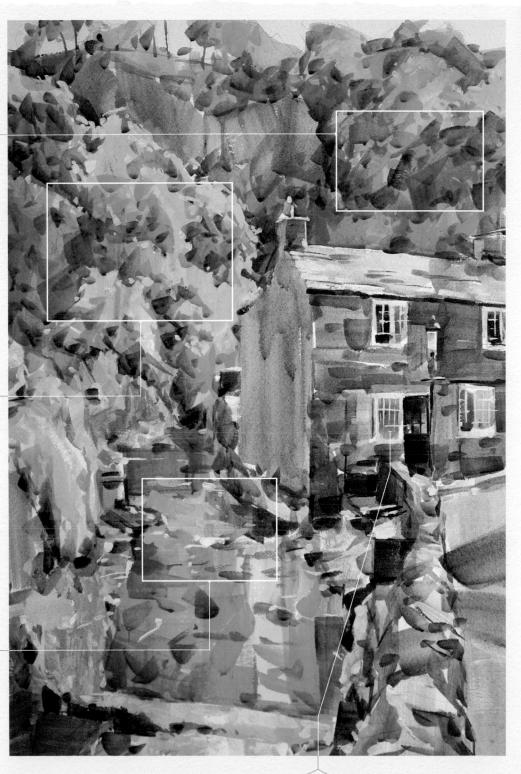

5 Finishing touches
Pick out the window frames in white with hints of lemon and cerulean blue. Don't overdo the finishing touches though - allow the glowing, translucent quality of the washes to take centre stage.

Neat acrylics

USING PAINT STRAIGHT FROM THE TUBE

Undiluted acrylic paint is punchy and vibrant. You can create textured, sculptural impasto effects using artist-quality, heavy body acrylics, as these thick paints hold brushmarks well. They also have a lustre and sheen that is comparable to oil paint. Neat paints are expensive to use in large quantities, however, so use them on a small scale to begin with.

Layering neat acrylics

You can apply thick layers of acrylic in quick succession because they dry so rapidly. Too many heavy layers, though, will reduce the "tooth" of the surface and prevent upper layers from sticking; they may also look dull and overworked.

Acrylic opacity

Neat acrylics are vibrant and opaque because no pigment is lost through dilution. You can layer light colours on top of dark ones with no show-through.

The saturated colour of neat acrylics gives this painting of a rose drama. Large flat brushes were used to create expressive impasto marks, keeping the botantical subject from looking too scientific.

You will need

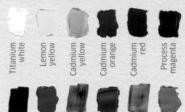

■ 50 x 70cm (20 x 28in) stretched, medium-

50mm (2in), 38mm (1½in), and 25mm

(1in) flat synthetic bristle brushes

grain canvas

Criss-crossing brushstrokes

Blocking in the rose

■ Draw a simple sketch on your canvas. Using a 50mm (2in) flat brush, block in the rose with a mix of red, magenta, violet, and orange to give it a dynamic colour. Block in the rose with crisscrossing strokes to create texture. Introduce a soft red tint at the edges of the petals.

The background Try to establish the right combination of colours at this stage to avoid having to build up too many thick background layers later. Experiment with different mixes: mix loosely to keep the colours vital; add violet to mix dark greens; let colours from other mixes bleed into the pastel colour for the lily. Using a clean 50mm (2in) flat brush, fill in the leaves, lily, and areas of background light using criss-crossing brushstrokes.

Rose shades
Mix red with violet to create darker shades of red and use these to define individual petals.

Dark red mix

Bright red mix

Pink lily mix

Light green mix Blue background light mix

Dark green mix

4 Once the dark reds have dried, add light tints to the outer parts of the petals. The multiple layers of paint create a three-dimensional quality.

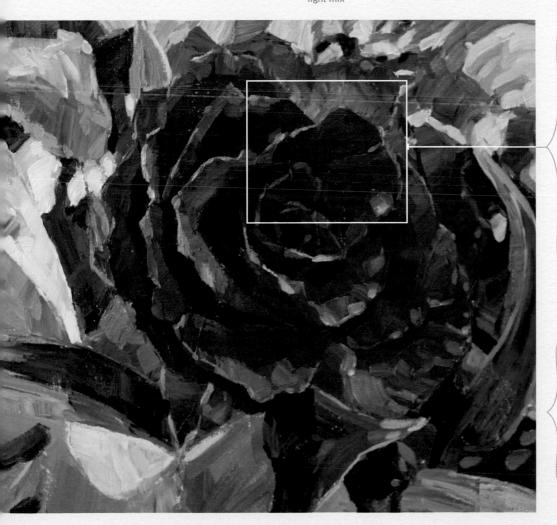

5 Finishing touches
Develop the background, but don't overwork it as it may lose its vibrancy and compete with the rose. Use a 25mm (1in) flat brush to add strong darks and white-lemon highlights. Try to keep the vigour of the impasto marks as you continue to refine the rose.

Painting shapes

SIMPLIFYING COMPOSITION

If some subjects seem too daunting, try breaking them down into basic shapes. For example, the clothes and face of a walking man are less important than the fact that he is walking – a stick figure would work to convey this action initially. Once you start relating basic shapes to more complex ones, you'll find it easier to block in a preliminary composition.

Identifying basic shapes

Look for the basic geometric shapes in any object or scene and use these to compose your painting. You might draw a mountain range as several triangles sitting side by side, for example, or convey an archway as a rectangle with a circle on top. You can practise this technique with almost any subject.

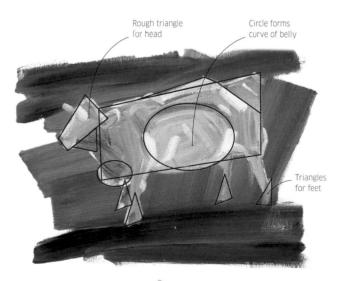

Dissecting into shapes

You can find geometric shapes even in organic subjects. This quick study of a cow was composed from a variety of simple circles, triangles, and rectangles.

PUTTING IT INTO PRACTICE

This painting shows how starting with some basic shapes to represent elements of a picture establishes the structure of a complex street scene.

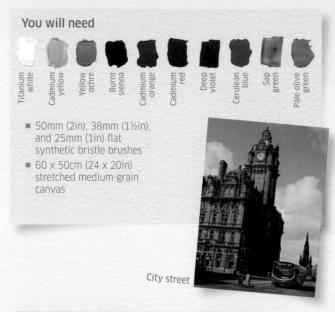

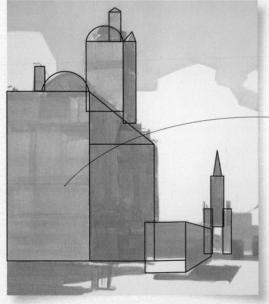

Floors of the building are lightly marked out

1 Preliminary shapes

■ Draw the scene using basic shapes (highlighted above). For tricky shapes, such as the dark side of the building, try using a rectangle with a right-angled triangle on top. Paint in the shapes with slightly diluted acrylics, using tonal colours for light and shade.

2 Dark tones
Use simple dark shapes and lines to suggest the windows. Mix a grey from cerulean blue, sienna, and white for the clouds and road. Don't worry if your strokes look blocky - you can soften them later.

3 Light tones Add blue tints to the windows and the circular clock face. Apply grey tints to create a softer effect for the clouds - they will bridge the gap between the white canvas and dark greys.

Developing details 4 Developing uerans
The bus makes a good focal point. Add dark tones to suggest shadows in the glass, then apply shots of colour. Finally, add tints to pick out the lights and reflections in the bus windows.

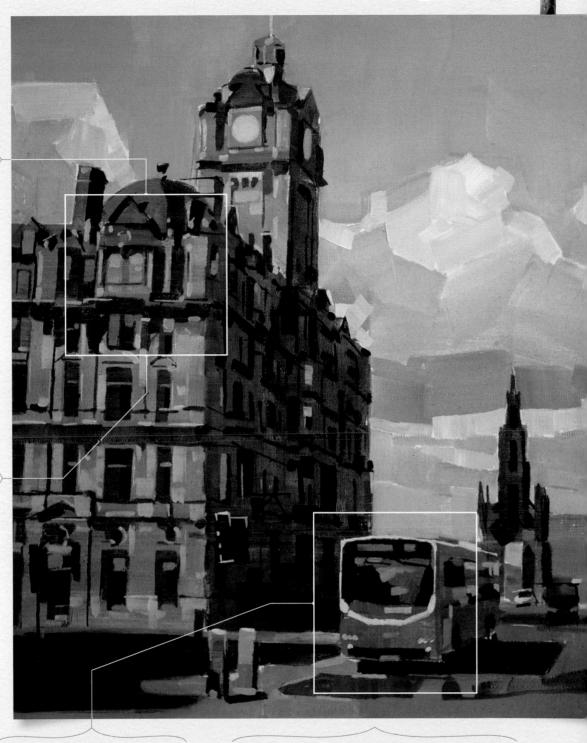

5 Finishing touches
Strengthen the shadows and apply ochre tints to the building; this increases the contrasts and separates elements from each other. Add an expressive splash of red in the road, to provide a counterpoint to the rigid geometric forms in the rest of the painting.

White subjects

PAINTING WHITE USING COLOUR

White objects can be challenging to paint - too much white can appear lifeless, chalky, or washed out. White shows up best when it is juxtaposed or mixed with colours. To paint a white subject, such as a cup or a snow scene, you'll need to look carefully at how it relates to the colours around it - you may see only white at first, but you'll quickly find that you can identify more colour within the white than you imagined.

Identifying colours in white

White objects reflect the colours around them. These reflected colours can be subtle or intense, and you can depict them using white tints (see pp.138-39). A strong background colour presents a counterpoint to the white object and provides a good tonal range for you to create form, a three-dimensional effect.

Photograph of a cup and saucer Coloured paper gives the white shapes definition. The blue colour reflects strongly where the saucer sits on the paper, but casts a fainter hue at the

Painting the cup and saucer

rim of the cup.

Background and foreground colour helps the pale tints stand out. Stronger tones were applied first, with white tints introduced gradually, and highlights added at the end.

PUTTING IT INTO PRACTICE

In this painting, the swan's surroundings provide the colours reflected in its feathers, and help to define its shape. Bright sunlight makes the contrast between the light and dark colours very pronounced.

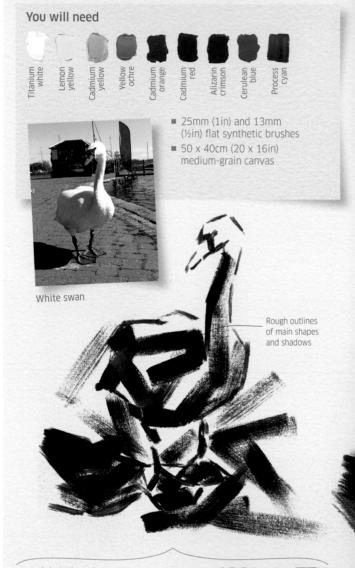

1 Initial sketch

■ Sketch the main shapes in and around the white swan with broad brushstrokes. Use the same colour as your background to unify the painting. A strong colour will help future white mixes stand out.

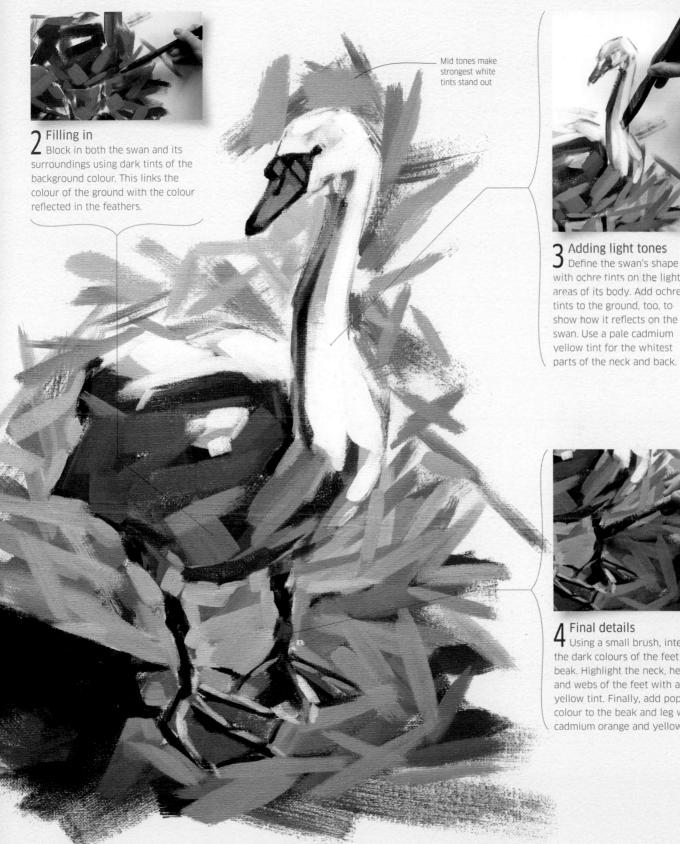

Final details

4 Using a small brush, intensify the dark colours of the feet and beak. Highlight the neck, head, and webs of the feet with a light yellow tint. Finally, add pops of colour to the beak and leg with cadmium orange and yellow.

Aerial perspective

DEPICTING DISTANCE

Aerial, or atmospheric, perspective describes the way in which atmospheric conditions affect the appearance of distant objects. This effect can be recreated in art by applying the most vibrant colours and tones in the foreground, then tinting them with softer, often bluer, hues as they recede.

Colour and distance

By gradually lightening the shade of a colour, you can create a sense of depth. The darker, purer shades look strong and close; as you gradually add white, these lighter tints appear to be further away.

Orange gradation

A shade of pure cadmium orange on both the left and right fades towards the centre as white is gradually added, creating a corridor of receding colour.

Green gradation

Here, using phthalo green, the perspective recedes from right to left and fewer tonal gradation lines have been used.

Blue gradation

The first band is a pure cobalt blue, with incrementally paler tones leading the eye to the horizon, creating the appearance of sea giving way to sky.

PUTTING IT INTO PRACTICE

This piece uses colour gradation as an exercise; the background gradations have deliberately been left exposed. The blue bands of colour suggest the sea fading into the distance where it meets a yellow sky.

PUTTING IT INTO PRACTICE

In this landscape overlooking the sea, the foreground is still quite far away, so shapes, colours, and tonal variations are emphasized without overstating small details. This allows you to be creative without trying to replicate the photograph. The blue in the distance indicates land but its haziness suggests distance.

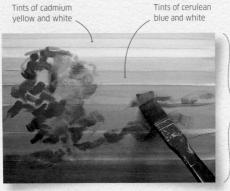

1 Establish formsPaint the background bands with your
25mm (1in) brush, then sketch in the foreground trees and land using phthalo green.

2 Lighten areas
Still using the 25mm (1in) brush, apply lighter tints of cerulean blue and lemon yellow to the green areas.

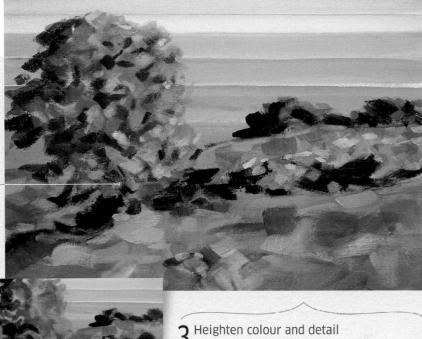

Heighten colour and detail Closer elements will have stronger colours and greater clarity, so intensify colour and definition in the foreground. Use your 13mm (½in) brush for the detail on the tree.

Sketch forms
Use your 75mm (3in)
brush to loosely establish
different elements. Use
pure process cyan for the
sky and phthalo green
with cadmium yellow to
create tonal differences
in the greens. Create
some horizontal lines
using phthalo green
and use burnt sienna
to divide parts of

the landscape.

2 Intensify colours
Continue with the same
brush, adding cadmium yellow
and cadmium orange over the
green to indicate trees. Use
deep violet with burnt sienna
between the green masses.

3 Solidify the scene
Use the 25mm (1in) brush to form strong shapes by varying colour and tone. Lighten the ground between the green areas with a mix of white, violet, and sienna. Also vary the green tones.

4 Finishing touches
With your 75mm (3in) brush, add more
process cyan and plenty of white for the sky.
Then gently skim the distant, blue landmass
with downward directional marks to give it
a hazy edge. Use the 13mm (½in) brush to
lighten areas on the trees.

Title Vibrant still life
Artist Hashim Akib
Medium Acrylics
Support Stretched canvas

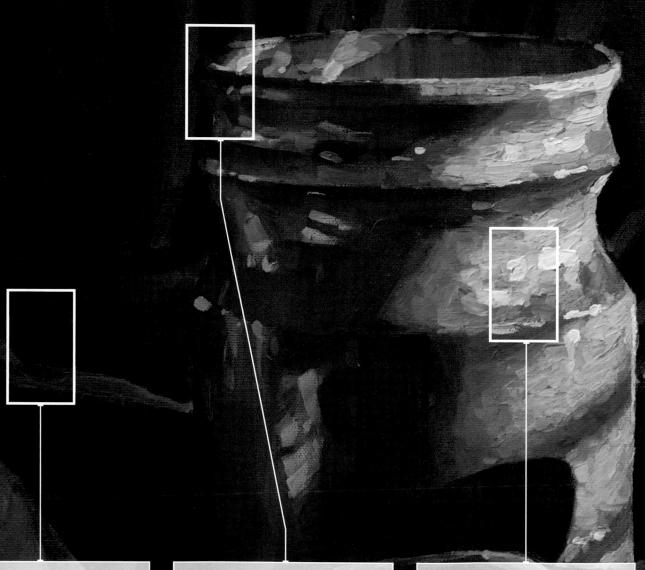

Acrylic washes

<< See pp.140-41

Three to four layers of washes form the foundations of the painting. These washes provide the rich depth seen in the shaded areas.

Painting shapes

<< See pp.144-45

The squares, rectangles, and ellipses that formed the preliminary shapes in the composition have been tranformed by adding layers of detail.

Neat acrylics

See pp.142-43

The lightest areas were built up with thick, neat paint. This creates a subtle texture and gives the objects a three-dimensional feel.

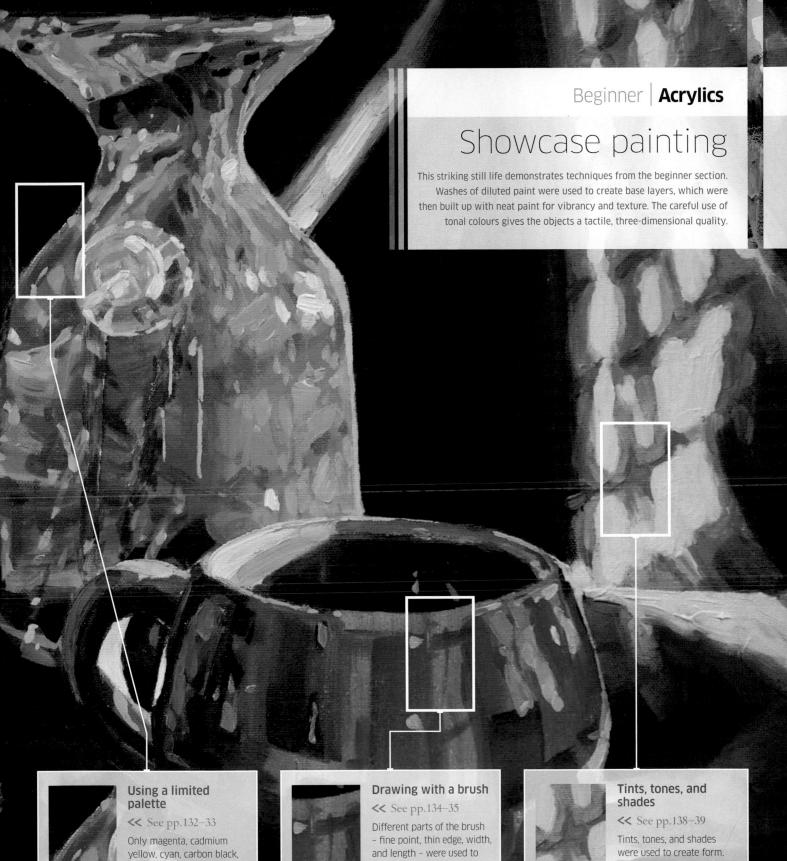

and titanium white were used to create all the mixes in the painting.

create a variety of reflections on the green cup.

The lightest tints were used on the brightly lit areas of the background material.

Adding texture

USING MEDIUMS FOR TEXTURAL EFFECTS

You can use mediums such as texture gels and pastes to create a range of impasto and textural effects. Heavy structure gel will allow you to create the most dramatic effects. White in colour and with a buttery consistency, it dries to a hard, clear, satin finish. Lay the gel directly on the canvas to create a more tactile surface, or mix it with acrylics for a thicker, smoother paint for sculpting layers of colour.

Textural effects

Apply heavy structure gel with a palette knife, sponge, or brush. You can also introduce additional elements while it is wet, such as sand, twigs, or paper for collage. There are several other mediums you can use in conjunction with acrylic paint to create a range of dramatic textural effects.

Sand texture gel A gel containing small particles of

natural sand. It retains its texture when mixed with paint and produces a fine, sandy effect.

Glass beads texture gel

A colourless, medium-body gel containing fine, spherical beads of glass, which create a bubbly effect.

A granular gel containing fine particles of black flint. Grey when wet, it dries to a speckled black when mixed with colour.

String gel

Mix string gel with acrylic paint to produce a string-like web of colour with increased transparency and flow.

Pouring mediums

Add liquid pouring mediums to acrylic paint to produce a range of effects, such as long, thin drips of paint, intricate marbling patterns, and slick, glassy pools of colour. It's great for multicoloured compositions working wet-in-wet.

Modelling paste

This paste is similar to heavy structure gel but not as smooth. When dry, it can be sculpted or sanded into dramatic shapes.

PUTTING IT INTO PRACTICE

This striking still life was created using a base layer of heavy structure gel. Natural sand was then added to introduce more texture and capture the essence of the seashell.

You will need

- 38mm (1½in) flat bristle brush
- Palette knife
- Heavy structure gel; natural sand
- 40 x 50cm (16 x 20in) stretched canvas

Seashell

1 Base layer of gel
On a cyan and white ground, sketch the outline of the shell. Apply heavy structure gel with a palette knife, varying the thickness to emphasize the contours of the shell.

7 Add sand

When the first layer is dry, apply more gel, this time mixed with a little natural sand. Before the gel dries, chisel a series of lines into the shell with the palette knife.

3 Apply paint
Once the gel has dried to a clear finish, you can apply the paint. Using a 38mm (1½in) flat bristle brush, apply layers of acrylic mixed with heavy structure gel, which gives the paint body. The thick, smooth consistency of the paint on top of the heavy structure gel and sand, will give the painting a distinctive, three-dimensional quality. Finally, create more detail and depth by adding highlights and darks.

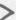

PUTTING IT INTO PRACTICE

The distressed wall on this canal-side building in Venice, Italy, is a perfect subject for exploring a range of textural effects.

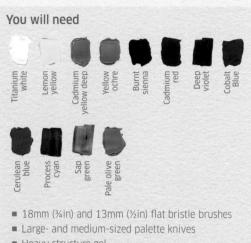

- Heavy structure gel
- 50 x 60cm (20 x 24in) medium-grain stretched canvas

Heavy structure gel and sand

On a violet and white ground, sketch the scene. Mix a little sand into the gel and apply the mixture with a palette knife. Focus on the most distressed areas of wall, avoiding the windows, door, sky, and water.

? Paint and gel mix Wait for the initial layers to dry, then skim the wall area with a mix of gel and heavy body acrylic paint. Use different-sized palette knives and both long and short strokes to vary the marks. Use delicate touches around the windows, but don't worry about being too precise.

"Heavy structure gel thickens and smoothes acrylic paint, allowing you to sculpt thick layers with a palette knife, sponge, or brush."

3 Darker shadows
Add dark shadows to the
windows, doorway, and on top of
the roof using a large palette knife.
Apply rich greens to the windows
with a smaller palette knife. Add
the sky with a cyan and white mix,
but no gel. Paint the canal with
greens and blues, again with no
gel in the mix.

Rich green mix

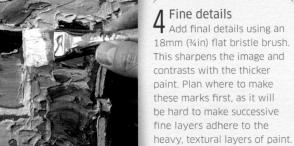

Using ground colours

ADDING A BASE LAYER TO THE CANVAS

Applying a base colour to your canvas can help to tie elements together and unify your scene. You can also make the most of exposed areas of base colour by using them as a substitute for the dark or light tones in your painting. Laying down a base colour can also make a large, white canvas feel less daunting. Your acrylic ground can range from a light, watered-down stain to a thicker, solid application of colour.

PUTTING IT INTO PRACTICE

In this sequence, the vibrant green ground remains visible in the finished painting. A range of purples was used to create harmony, light areas were enhanced to bring the cat forward, and warmer tones were used for the cat's markings to form a contrast with the background.

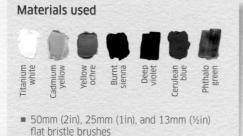

- 40 x 50cm (15 x 20in) stretched canvas
- Pet cat

1 Getting started
With a 50mm (2in) brush, apply a ground colour of phthalo green, cadmium yellow, and titanium white. Use deep violet and white to establish the side of the cat in shadow, and yellow ochre and whites to fill the cat's lighter areas. Indicate the cat's markings with phthalo green and burnt sienna. Apply some of these mixes in the areas around the cat to anchor it in the scene.

"Art should be experimental, so try different ground colours."

Neutrality, mood, or contrast

Traditional ground colours include raw or burnt sienna. yellow ochre, burnt umber, and neutral greys. These are good mid tones, which make it easier to work light and dark areas into the painting. Your choice of ground, whether bright or muted, can help determine the overall atmosphere. You might prefer a warm ground if you are using cool hues to create impact for your main subject, or the reverse. Try out different grounds with your subject to review the effects.

Contrasting ground

The complementary colours blue and orange create vibrancy and impact when juxtaposed in this study of a flower.

Harmonious ground

Using orange for the ground and subject here creates harmony. The darks and lights have been emphasized so they stand out.

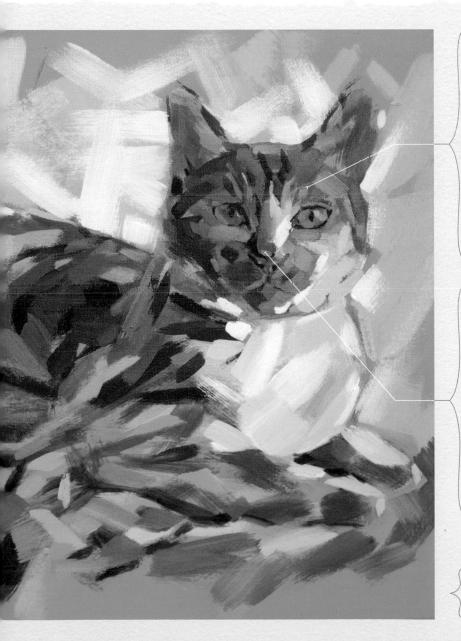

Build up areas

Using the same colour mixes but with a 25mm (1in) brush, build up areas of the cat. On the left-hand side of its body, apply deep violet with extra white added. In other strokes, include a touch of burnt sienna, to create tonal variations.

Finishing touches
With a 13mm (½in) brush, work on the facial features, creating a more finished look to contrast with looser areas in the body. Add extra highlights in the background to bring the subject forward.

The overall effect

With large areas left exposed, the ground colour plays an important role in the finished painting, creating a unique interpretation of the subject.

Blending

PAINTING TRANSITIONS OF COLOUR

Acrylic paints dry so quickly that they can be difficult to blend evenly. To overcome this problem, you can use mediums to improve the paint flow (mimicking watercolour), or inhibit the paint's drying time, keeping the pigment "open" or "active", so that you can work into it for longer (like oil paints). You can also use certain brushstrokes to create the graduated appearance of blending.

Mediums and enhancers

"Open" or "interactive" acrylic paints are available, but they are suitable for thin layers only. If you want to blend thicker paint, use a fluid retarder to prolong drying time. Diluting with water improves paint flow, but too much affects vibrancy and the paint's ability to adhere. This is where mediums can help.

Heavy body paint

This formulation is great for textural effects but needs diluting with water or mediums to create smooth blends.

Soft body paint

This type of acrylic paint has a smoother consistency and is easier to spread than the heavy body version.

Soft body paint with gloss medium added

A gloss medium increases transparency but retains colour strength. It is not as runny as flow improver.

Soft body paint with flow improver added

Flow improver creates a very fluid, transparent mix. Add it neat to paint, for vibrancy, or with water.

Blending techniques

Blending involves mixing colours into each other, but if acrylic paint is mixed too much, it can look dull and lifeless when it dries. To avoid this, you can add a medium, or use short brushstrokes to build up a blended effect gradually. There are various ways to do this.

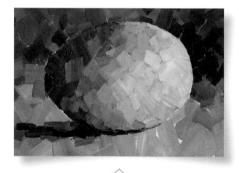

Crosshatching

These diagonal marks weave a semi-smooth impression of the image. Smaller marks and more layers simulate a smoother blend.

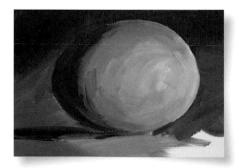

Retarder

This liquid or gel extends the paint's drying time, allowing you to blend colours together. Use no more than 1:1 retarder to paint.

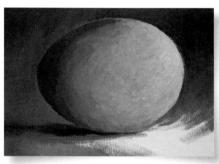

Feathering

These light strokes fade at the edges. You need to make lots of marks rapidly for a seamless effect, so it's better for small areas.

Dabbing

Similar to crosshatching, these impressionistic dabs of colour build up to create the illusion of a blended image. (See also pp.182-85.)

PUTTING IT INTO PRACTICE

This colourful duck presents a good challenge for the acrylic painter. Added mediums and crosshatching brushstrokes were used to blend the graduated colours of the feathers.

You will need

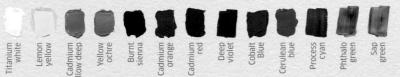

- 38mm (1½in), 19mm (¾in), and 13mm (½in) flat synthetic brushes
- Flow improver and fluid retarder
- 50 x 70cm (20 x 28in) stretched. medium-grain canvas

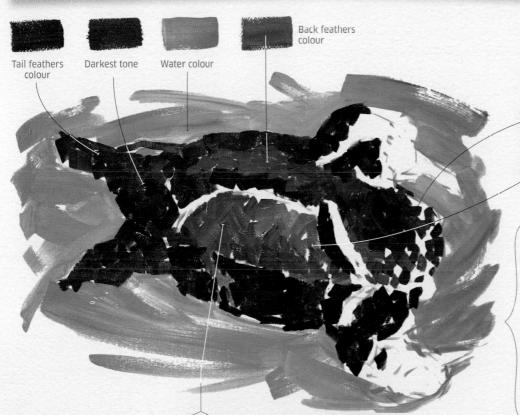

Base colours Mix a light blue with flow improver, then apply it to the water area with a 38mm (11/2) flat brush. Use long, loose brushstrokes to suggest the fluidity of water. Allow to dry. Mix the main colours for the duck with fluid retarder to prolong the paint's drying time. This will allow the layers you apply later to merge and blend.

Crosshatching

Fill in the main colours of the duck with a 38mm (1½in) flat brush, using short, crosshatching brushstrokes. Keep the marks similar in size to create an even finish. If you use dark colour mixes that are similar in tone, they will create subtle transitions of colour.

"Use a retarder to to keep the paint active, giving you more time to blend."

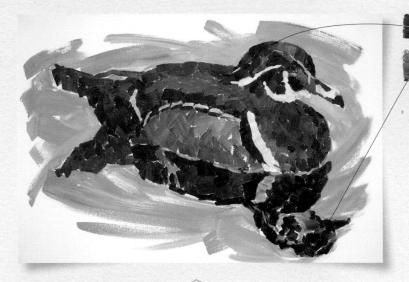

3 Developing the form Switch to a smaller 19mm (¾in) flat

J Switch to a smaller 19mm (3/4in) flat brush for the next layer, in which you will refine the form of the duck. Follow the contours of the head and body, such as the rounded chest and sleek line of feathers on the back, as you make more crosshatching marks.

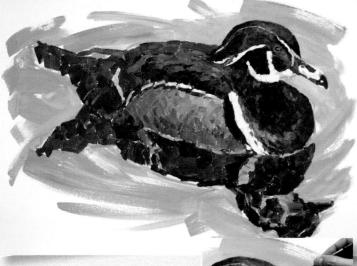

Refining the blends
The next layer "polishes" the colour blends. Use a 13mm (½in) flat brush to paint even smaller crosshatching marks. Develop the colours on the eyes and beak, too. You will need less fluid retarder in the latter stages.

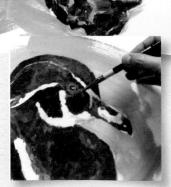

"Crosshatching marks look smoother and fuller as you apply more condensed layers."

Head colour

Reflection of head colour

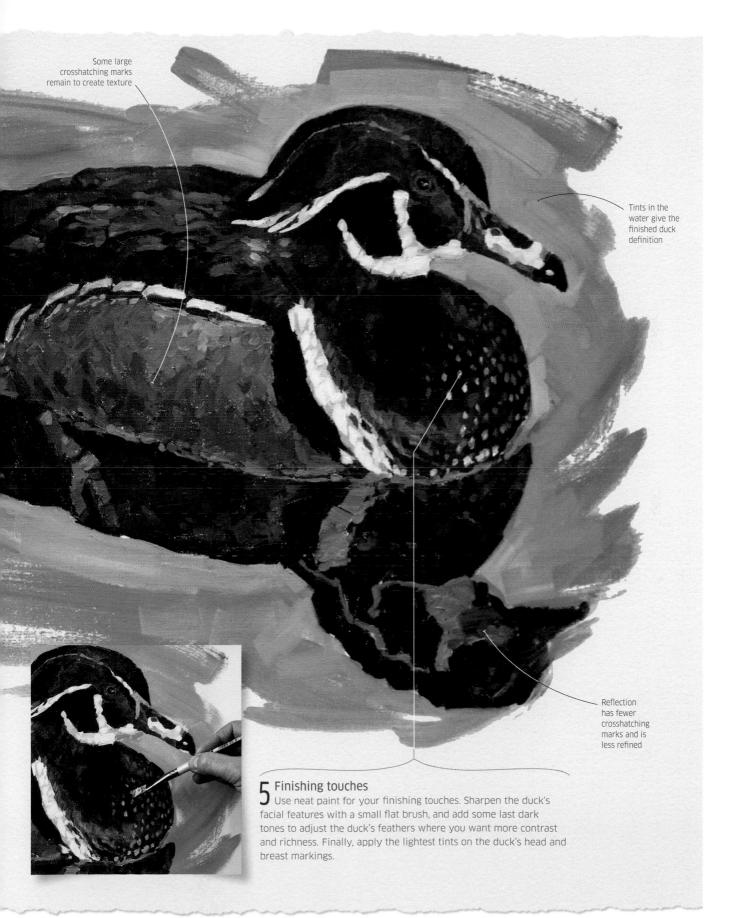

Glazing

BLENDING THIN WASHES OF COLOUR

Glazes are thin, transparent washes that modify colours when you layer them. This allows you to create transparent mixes of colour, which give your painting luminosity and depth. It is important to let each glaze dry completely before you add a new one.

Layering glazes

Mix glazes with a diluting medium, rather than water alone, to avoid reducing the binder in your paint too much. In general, dark colours dominate light colours when you layer them, but colour theory (see pp.14-15 and pp.128-31) helps you to gauge the outcomes. Too many glazes will create muddy shades.

Harmonious glazes

Colours that sit side by side in the colour wheel enhance each other. Harmonious colours are reliable and create pleasing mixes, but too many layers can look flat.

Cool glazes

Blue, green, and violet glazes create a calming effect. Here, a cerulean blue glaze makes cadmium red look purple. Cool hues can dominate – the red looks darker where the blue is deeper.

Warm glazes

Yellow, orange, and red glazes create warmth. Here, a yellow glaze makes cerulean blue look bright green; an orange glaze (complementary to blue). creates an earthier green.

Milky glazes

White gives your glazes opacity. This creates diverse results depending on how much you add, but too much white can look chalky.

PUTTING IT INTO PRACTICE

Warm glazes create the translucent glow of the sunset in this painting. The washes were diluted with flow improver, and the glazes with flow improver and water.

Sketch your scene (shown in magenta), then apply washes in cool colours to the mid tone and shadow areas. The cool colours will look dark under the warm glazes to follow.

2 Adding intensity

Let the initial layers dry. Apply a magenta wash to the sky and foreground - this warm colour will look intense beneath the warm glazes to follow.

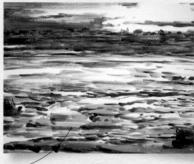

Magenta wash .

3 First glaze
Let the magenta
layer dry. Use a wide
brush to spread a
thin orange glaze
over the entire scene,
with long, even
brushstrokes

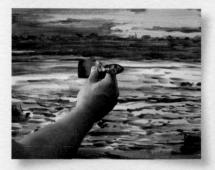

/ Lifting out

H Use a damp tissue to lift out the orange glaze where you want the next glaze to look bright, and from shadow areas, where you want to retain the blue colour.

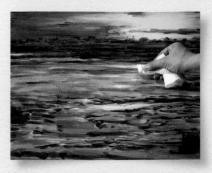

You will need

Estuary at sunset

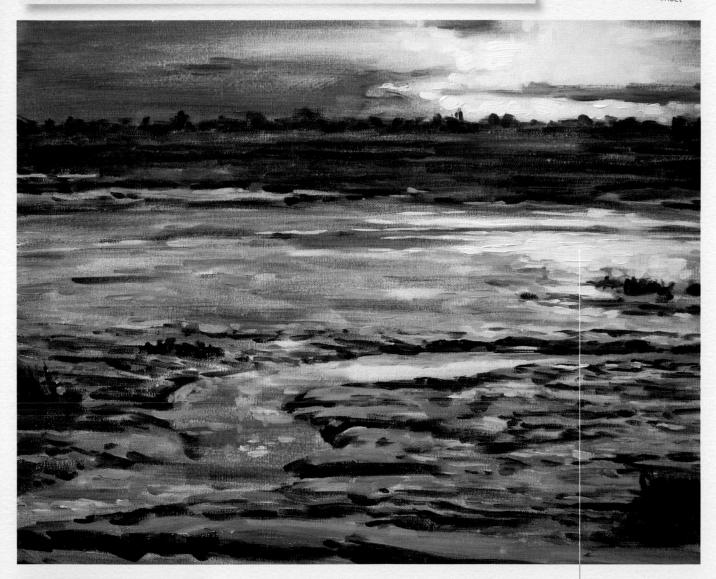

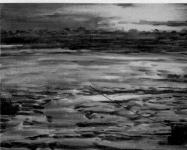

5 Second glaze Let the orange glaze dry. Apply a harmonizing yellow glaze over the whole scene to unify it. This also creates the sunset's glow.

6 Finishing touches
Use a damp tissue to lift out the yellow glaze from the lightest sky areas, and from the blue foreground areas. Finally, apply highlights with thicker paint for definition.

Warm colours

TEMPERATURE AND ATMOSPHERE

We often ascribe hot or cold qualities to colours, for example associating reds, yellows, and oranges with heat, warmth, and fire. You can exploit this sense of association in your work to give your paintings atmosphere. This can be physical – such as a cold, snowy landscape or warm, balmy scene – or emotional. You can also use strong warm or cool tones to create focal points.

Darkest red for

darkest tones

Yellow with some whites for highlights

PUTTING IT INTO PRACTICE

Use a black and white photograph of your subject. Rather than being distracted by actual colour variations, you can focus on creating a sense of atmosphere by using powerful warm tones.

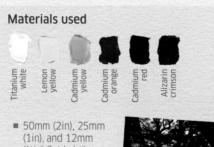

- (1in), and 12mm (½in) flat bristle brushes
- 40 x 50cm (16 x 20in) stretched, mediumgrain canvas

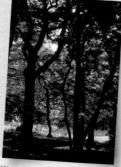

Woodland scene

"Use colour to evoke emotions and create a sense of atmosphere."

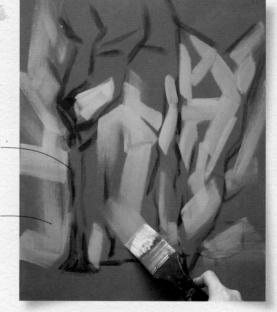

1 Background fill

L With your 50mm (2in) brush, apply a base of cadmium orange, then loosely sketch out the scene using alizarin crimson. Block in lighter tones with mixes of cadmium yellow and orange. Lighter mixes include cadmium orange with lemon yellow.

2 Highlights
Once you have established the forms of the trees, pick out some of the strongest highlights in the scene, using lemon yellow and titanium white with a 25mm (1in) brush.

Mood and harmony

You can use colour to help evoke emotion and create a mood. Limit your palette to warm colours to create a disciplined, harmonious piece, bearing

in mind that warm colours tend to come forwards in a scene. Even when you use them sparingly, warm colours will still dominate.

Warm and cool

Two colour approaches (far right) show how warm colours convey the heat of a candle, and how you can alter the atmosphere by repainting it with cool hues.

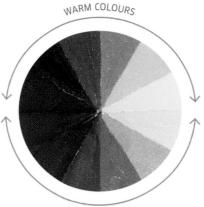

Cool colours

3 Create movement
With your 25mm (1in) brush, use multi-directional brushstrokes, allowing the brush marks to show through to create a sense of dynamism. Dab excess water from your brush after cleaning it to keep the colours strong.

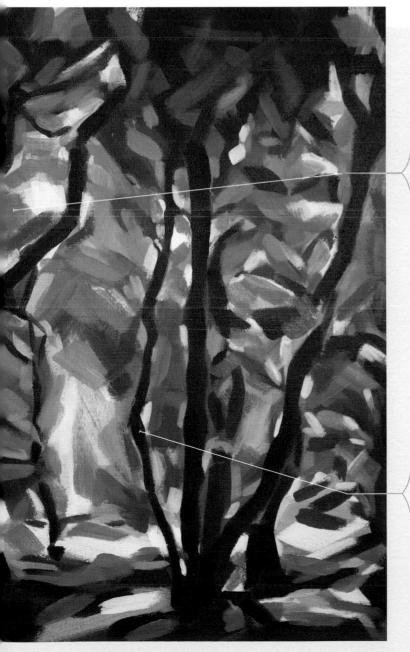

Finishing touches

Create some mid-tone variations in and around the trees using cadmium yellow and red with your 25mm (1in) brush. Make some softer transitions of colour in light areas. Finally, apply alizarin crimson with your 12mm (½in) brush to define the structure of the trees.

Cool colours

TONE, TEMPERATURE, AND MOOD

On the colour spectrum, cool colours tend to be made up of blues, purples, and greens. Just as we associate reds with heat (see pp.164-65), we link blues with the cooler elements, such as water, ice, and sky. Like warm colours, cool hues in a painting can be used to influence the viewer, evoking a sense of coolness and peace.

Cerulean blue provides a good mid-tone base

PUTTING IT INTO PRACTICE

Paint from a black and white photograph to remove all references to colour. This will allow you to be more adventurous when it comes to depicting the scene in cool colours, to create a calm, tranquil atmosphere.

You will need

- 50mm (2in), 25mm (1in), and 13mm (½in) flat bristle brushes
- 40 x 50cm (16 x 20in) stretched, medium-grain canvas

Boat scene

"You can use cool colours to influence the viewer and evoke a sense of peace."

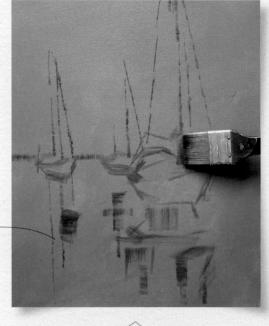

1 Laying the groundwork

With your 50mm (2in) brush, lay a ground colour of cerulean blue before loosely sketching the scene with a pure mix of process cyan. Fill in lighter areas, adding plenty of white to the process cyan.

2 Establish forms

With the same brush, establish the shapes of the boats and their reflections. Mix cerulean blue, phthalo green, and white, adjusting the mix to help the boats stand out from the background.

Tone and depth

As cool colours recede, you will need to introduce dark hues - which advance - to make cool tones stand out against one another. This will enable you to create a

painting with depth and atmosphere without the distraction of other colours. Cool tones work well for shadow, sky, or water, and to create more tranquil moods.

Cool and warm

In the blue painting (far right), darker blues at the base of the candle advance, while the paler background recedes. Dark reds in the warm version achieve a similar effect

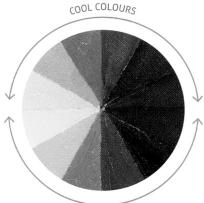

Warm colours

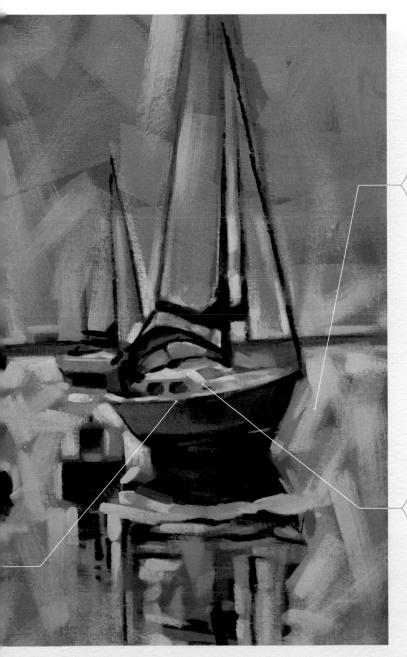

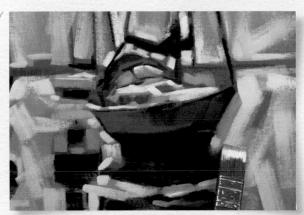

3 Lighten the background Scale down to a 25mm (1in) brush and lighten the background using a hint of process cyan in a predominately white mix.

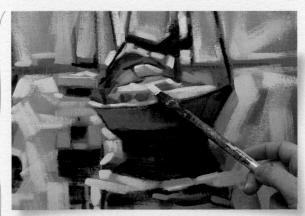

4 Dark and light details
Using a 13mm (½in) brush, apply finishing touches to the dark and light areas of the boats. For the darkest points, use a mix of deep violet and phthalo green, reserving pure white for the lightest areas.

Painting with warm and cool colours

BALANCING COLOUR TEMPERATURE

Some colours, such as red, are considered warm (see pp.164-65), while others, such as blue, are considered cool (see pp.166-67). There are also warm and cool versions of each colour. For example, cadmium yellow is warm because it contains some red, while lemon yellow is cool because it contains some blue. This is called colour temperature. By combining warm and cool colours, you can create paintings with vibrancy and impact.

Warm and cool palette

These swatches include all the colours used in the step-by-step technique (opposite) grouped by temperature. With experience, you can combine several warm and cool versions to find ever more complex mixes.

Warm colours Cadmium Process Cadmium Burnt sienna Cadmium Process Cobalt blue Emerald Pale olive vellow vellow orange magenta green Cool colours Emphasis on warms More warms than cools were used in the painting, opposite, because the main focal points are in the sunlit background area. Deep Cerulean Phthalo Process Lemon violet blue cyan green vellow

Mainly warm colours mixed with subtle additions of cools

Mainly cool colours mixed with subtle additions of warms

Mixing warm and cool colours together

When mixing warm and cool colours, make sure that one hue always dominates. By loading your brush with a large amount of orange, along with small dabs of cool blues or greens, you will always create appealing variations of orange. Using equal quantities of each colour, on the other hand, often results in a flat, muddy mix. Overmixing on a palette beforehand can also lead to muddy colours.

PUTTING IT INTO PRACTICE

This painting of a city square includes areas of bright sunshine and dark shadow. A warm and vibrant atmosphere has been conveyed by emphasizing and combining warm and cool colours.

City square in sun and shade

You will need

 38mm (1½in), 25mm (1in), and 19mm (¾in) flat synthetic bristle brushes
 50 x 70cm (20 x 28in) stratche

■ 50 x 70cm (20 x 28in) stretched, medium-grain canvas

Block in warm colours

Apply a cool ground colour of light phthalo green, which will contrast well with the first blocks of warm colour. Sketch the scene with magenta, then apply blocky strokes of warm yellow and white, using the two largest brushes. Add subtle variations of other warm colours to vary the mixes. For example, use a warm brown mix of magenta, sienna, violet, orange with less yellow, and white to create the mid tones in the arches, around the windows, and for the trees.

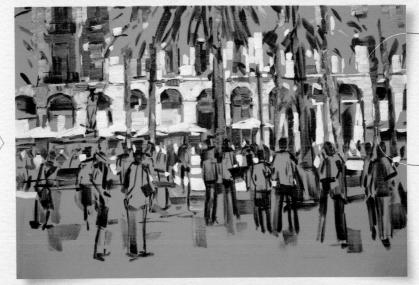

Warm yellow mix

Warm brown mix

Cool blue mix

Cool blue mix with white

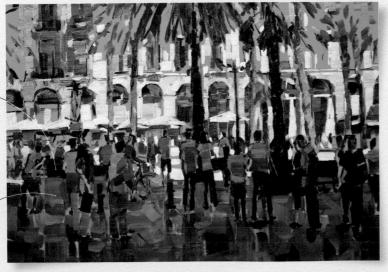

Block in cool colours With clean brushes, apply cool mixes to the foreground and figures. At this stage, simply place warms and cools side by side. Mix cobalt and cerulean, with touches of violet, phthalo green, sienna, and white. Use large blocks of colour in the near foreground and smaller blocks to provide definition on the figures. For the figures and palm trees in deepest shade, use a strong, dark mix of cyan, violet, sienna, cobalt, cerulean, and phthalo green, again with a hint of white.

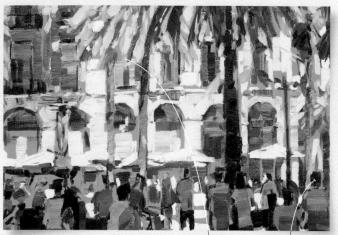

Greens and skin tones
Apply a warm green for the
leaves of the palm trees, using a
mix of pale olive and emerald,
lemon and process yellow, burnt
sienna, and white. Add further
darks in the archways and apply
flesh colours to the figures using a
mix of white, violet, blue, and sienna.

Skin ton

Warm green S

Skin tones

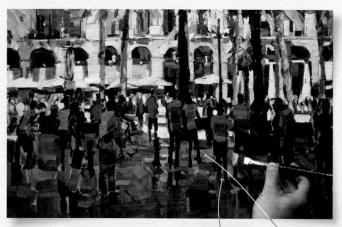

Integrate warms and cools
Blend warms and cools in the
foreground, where sunlight filters
through the trees. To avoid muddy
mixes, make sure either a cool or
a warm colour dominates. So, for
the earthy warm colour of the paving
stones, mix cadmium yellow, sienna,
orange, and white, with just a hint of
violet and cerulean blue.

Cool green mixed with earthy warm

Earthy warm mixed with cool green

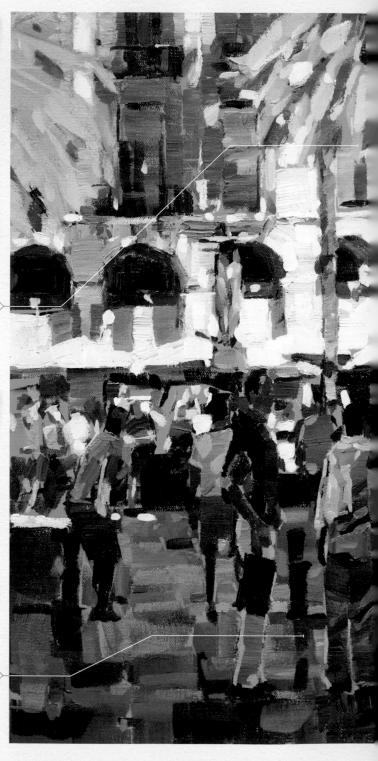

"In this vibrant, brightly coloured scene, the main focal points are in the background, where flecks of warm colours draw the eye."

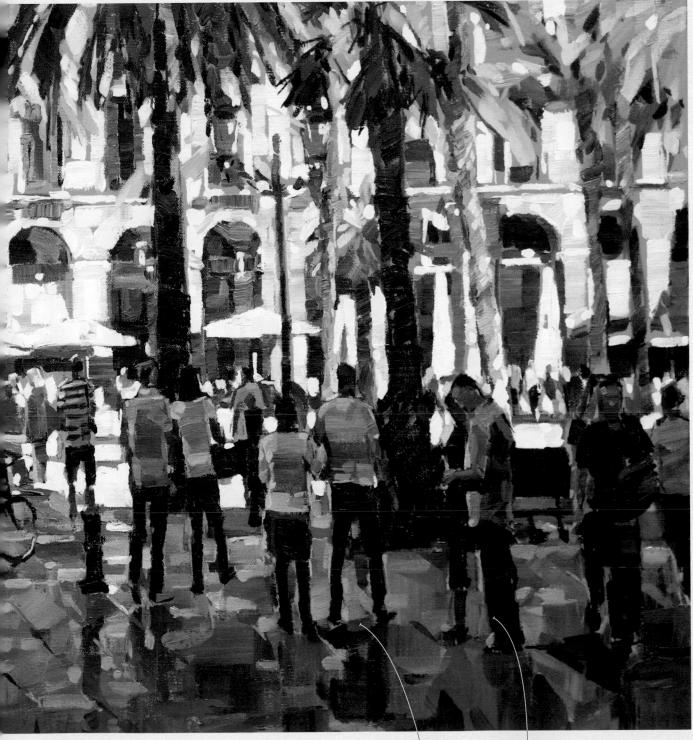

5 Final touches to increase contrast For the final touches, switch to a 19mm (¾in) flat brush. Apply small details to the figures and lamp posts, and add strong highlights to the buildings in the background. Use the darkest darks and lightest lights in these areas, to draw the viewer in.

Blue highlight mix

Darkest blue mix

Negative space

EXPLORING THE SHAPES AROUND A SUBJECT

Negative spaces are the areas that fall between and around the primary subjects, or "positive" spaces, in a painting. The way in which you treat them is an important element of composition. For example, you might choose a particular subject because of its interesting shape, so it follows that all shapes – whether positive or negative – have artistic value. You may even decide to make negative space the main area of interest.

Ways with negative space

Exploring negative space encourages you to look at subjects in a new way as you assess areas you might otherwise neglect. For a more abstract approach, you could use negative space as the main subject. In practical terms, negative spaces help divide a scene into manageable shapes and sections.

In these four studies, although the positive shapes of the birds, tiger, and tree are the main focus of interest, negative space is an important consideration.

Canvas background

This bird was formed from the white of the canvas using applications of blue paint in the background. This emphasizes the abstract shape of the bird and its L-shaped platform.

Painted background

In this example (see also opposite), the painting consists of an initial wash of violet, to add interest, with the subject created by painting the negative spaces in green.

Negative spaces integrated

Here, the tiger's dark stripes were formed from negative spaces, making them feel less contrived and helping to unify the painting.

Negative spaces enhanced

In this example (see also pp.174-75), the positive shape of the tree was painted first, with the negative spaces enhanced later.

"Negative space is an important part of composition. All shapes — whether positive or negative — have artistic value."

PUTTING IT INTO PRACTICE

A flamingo was chosen to demonstrate the use of negative space because of its distinctive shape. The initial stages of painting involved working on the negative space around the bird, rather than on the subject itself. The painted negative space then formed a silhouette of the subject, which was developed for the finished painting.

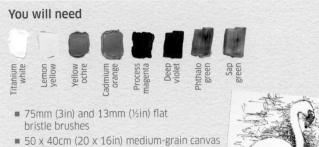

1 Negative spaces

■ Prime the canvas with a mix of deep violet and titanium white using a 75mm (3in) flat bristle brush. Apply a mix of sap green and lemon yellow to the negative spaces around where you want the subject to appear.

Flamingo

2 Tonal range
To stop the negative space simply becoming a flat area of colour, add more lemon to create lighter tones. Use sap green and a little deep violet for dark areas.

3 Add pink
Once you have filled the negative space, a silhouette of the subject will remain. Now fill the positive image, using a mix of violet, process magenta, and white.

4 Final details
Introduce cadmium orange and process magenta to create different tones of pink, adding white for the lightest areas. Using a 13mm (½in) brush, work up details on the bird's head, using orange and violet for the dark areas of the beak.

PUTTING IT INTO PRACTICE

In this painting, the positive image of the tree was created first, and then light tints were added to the negative spaces between and around the branches to create a striking, backlit effect.

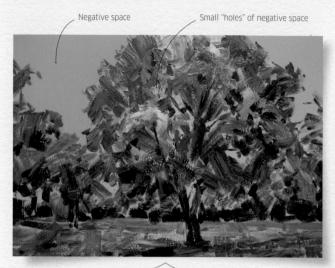

Paint positive subject On a blue base, create an impression of the tree - the positive shape. Apply blues, greens, and yellows with a 50mm (2in) flat brush. Add reds and oranges for contrast.

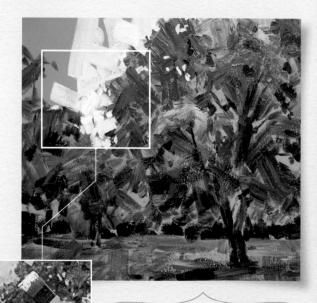

Light tint for negative

2 First negative space marks
Introduce light tints of white with a little lemon and blue to fill the sky and refine the outside edge of the tree.

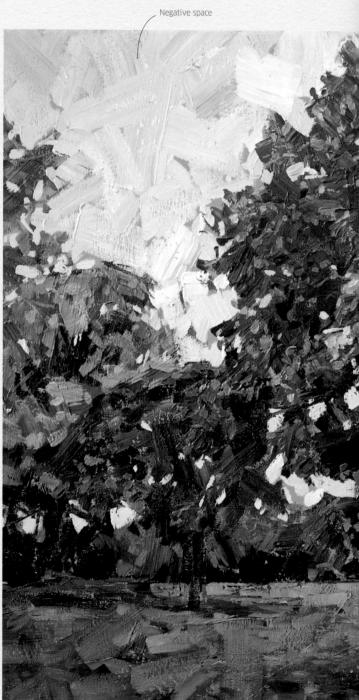

You will need

Autumnal tree

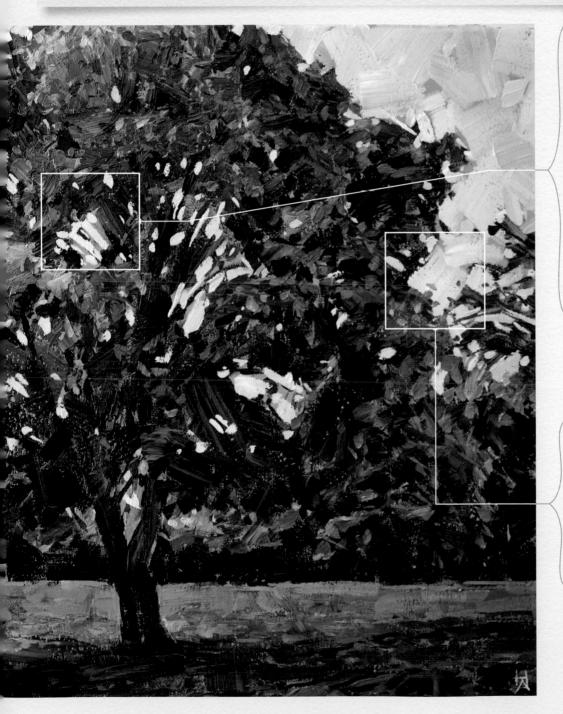

3 Smaller marks
Use the tip of the 50mm (2in) flat brush to create the more refined "sky holes" in the centre of the tree. The branches will take shape from the lines and edges of these negative spaces. Apply the marks loosely to retain the natural feel of the subject.

4 Final painting
Add more light tint to the background to refine the shape of the tree. Once you have filled in the sky, use a 13mm (1/2in) flat brush to go back and develop the positive shapes at the centre of the tree, especially the cluster of multi-coloured leaves. Place more emphasis on the positive shapes in these areas.

Reflections

DEPICTING WATER AND SHINY SURFACES

A constant surface, such as a mirror or still water, creates a solid reflection, whereas a moving or curved surface creates a distorted reflection. The relative position of the reflective surface also has an effect. For example, if the surface is in front of the subject, the image is mirrored, but if the surface is underneath the subject, it will reflect the underside of the subject – an area that might not normally be visible.

PUTTING IT INTO PRACTICE

This painting shows how to treat reflections in moving water, both in the foreground and in the distance. Take advantage of quick-drying acrylics by building the image in layers.

You will need

- No. 6 flat synthetic, no. 1 round synthetic, and synthetic rigger brushes
- 30 x 35cm (12 x 14in) medium-grain canvas board

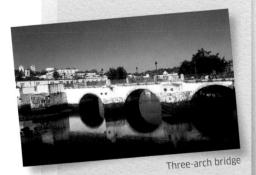

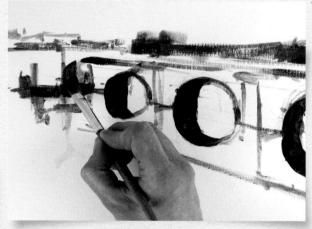

1 Drawing in the subject
Apply the darkest tones first, using a diluted mix of burnt sienna and French ultramarine. Block in the main shapes with a flat brush, including where the reflections appear.

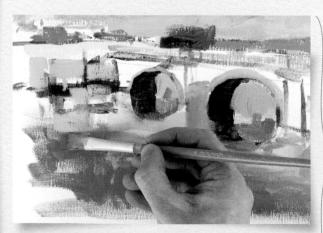

2 Blocking in colour

Apply a pale blue mix for the background water and a stronger blue in the foreground. Block in the reflections with darker, more muted colours than on the bridge itself. Work quickly to blend the colours together.

Mirror images

Painting reflections generally involves creating a mirror image of the subject, but rippled surfaces can distort shapes and spread colour. Usually, reflections have a smaller tonal range. with darker highlights and lighter shadows.

Static reflection

Use crisp lines to show reflections in still water. Note that the tone of the reflection is slightly muted.

Wavering reflection

Reflections in moving water are broken, so use wiggly lines to suggest ripples in the surface.

Leaning object

If an object is at an angle, its reflection should lean in the same direction.

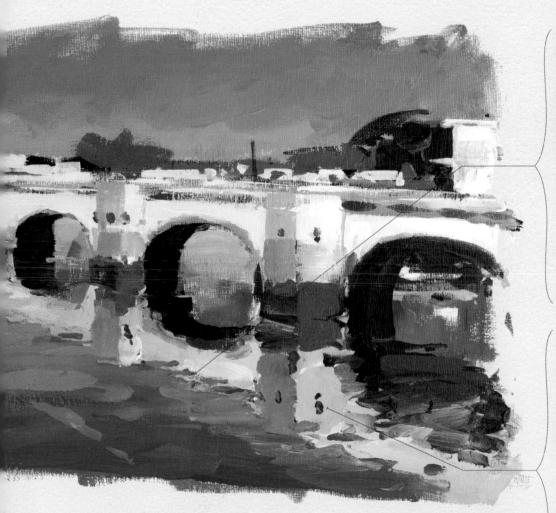

"Create a sense of depth by treating foreground and background reflections in different ways."

3 Adding movement Suggest moving water by breaking up the edge

of the bridge's reflection. Paint larger wiggly lines in the foreground, and finer wiggles the further back the reflection is.

Final details

4 Add more highlights and details with free, loose strokes using small round and rigger brushes. Sharpen the nearest foreground areas with thicker mixes of grey, white, and brown for the base of the bridge.

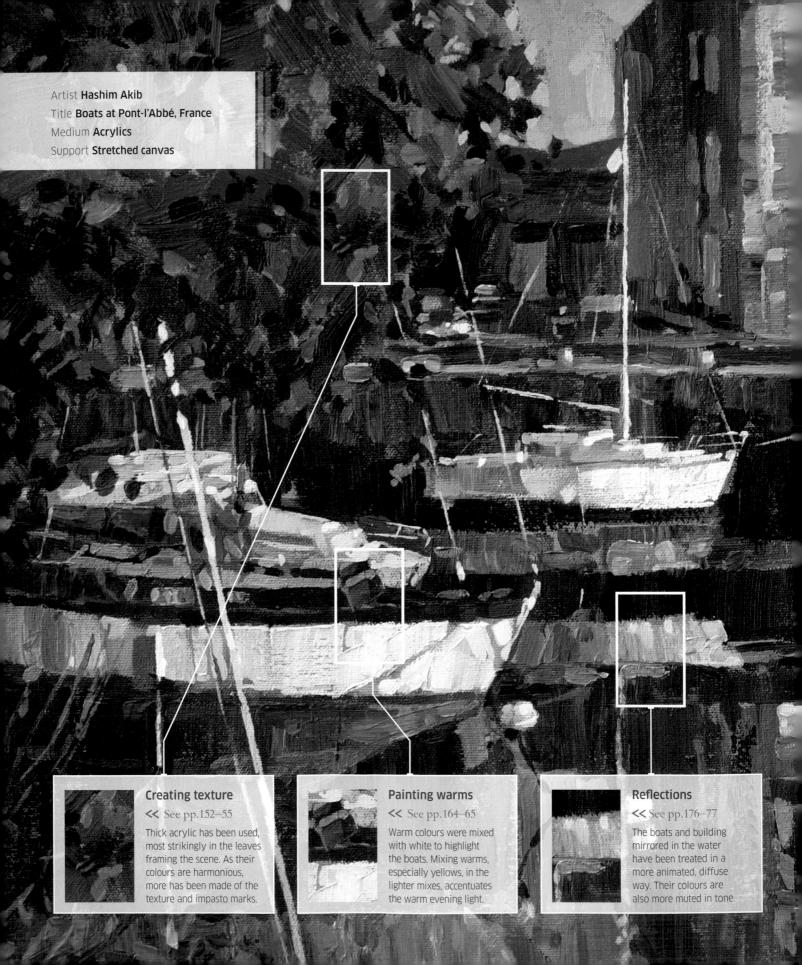

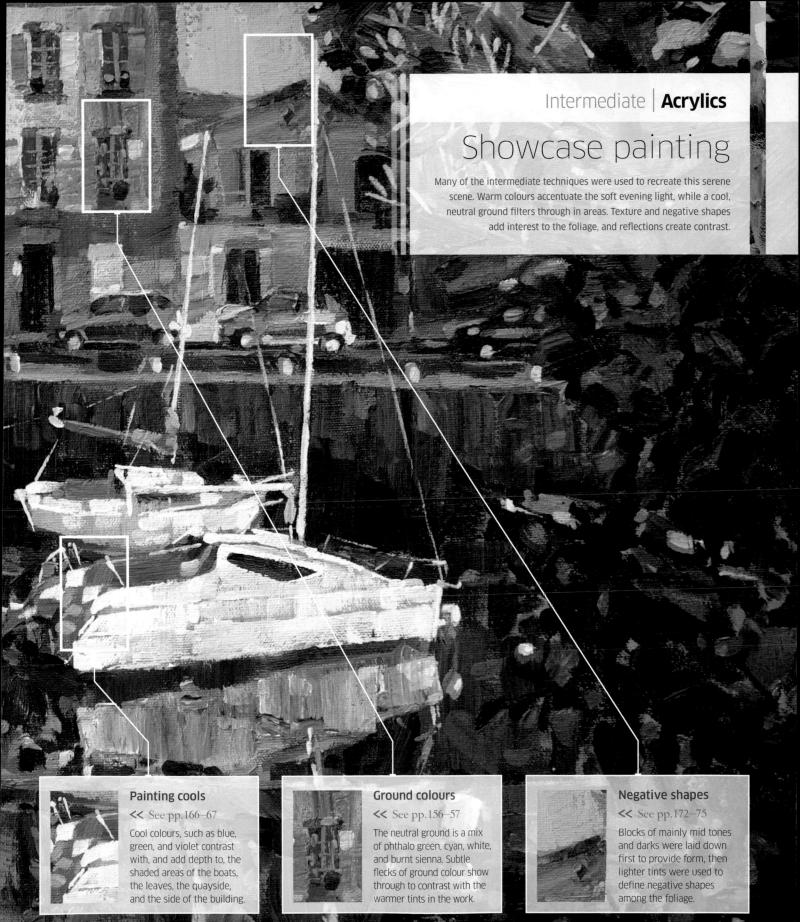

Creating focal points

LEADING THE EYE

Combining loose, broad areas of brushwork with areas of focused detail will help balance the composition and flow of a painting. Use more detailed brushstrokes to anchor the point of interest, and catch the viewer's eye with a streak of colour or area of contrast.

Emphasizing areas of interest

Increasing contrast, using more intense colours and more detail are good ways of emphasizing an area of a painting. By ensuring that the surrounding areas remain secondary to the focal point, you can create a dramatic, punchy image.

Contrast

Increasing the contrast of the figures in the centre makes them stand out from the rest of the crowd. They are the clear point of interest.

Colour

A flash of red, emphasized by the subtle colours of the surrounding figures, identifies this figure as the subject of the painting.

Detail

Developing a figure with finely detailed brushstrokes leads the eye towards it. Again, the central figure is the focal point.

PUTTING IT INTO PRACTICE

This brightly coloured figure makes a dramatic focal point. The use of high contrast, saturation, and detail help to give the monk presence.

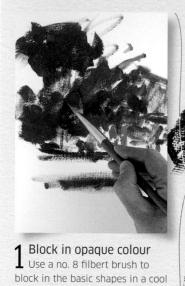

1 Block in opaque colour
Use a no. 8 filbert brush to
block in the basic shapes in a cool
background colour of ultramarine
and cadmium red. You can add
more detail to this backdrop
once it has dried.

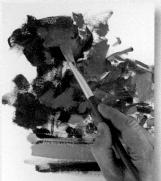

2 Colour and structure

Add more colour and detail to the trees and background buildings using the same brush. Keep the colours muted, with no significant changes in tone, to prevent them conflicting with the main figure.

You will need

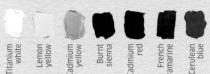

- No. 8 filbert synthetic, no. 6 flat synthetic, and no. 1 round synthetic brushes
- 25 x 30cm (10 x 12in) medium-grain canvas

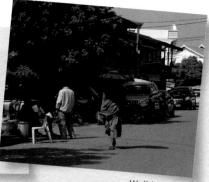

Walking figure

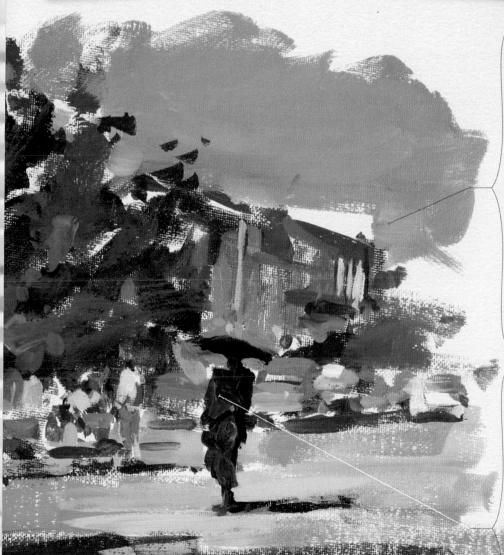

4 Add the focal point

Mix a bright orange from cadmium red and cadmium yellow and use a no. 1 round brush to paint in the figure. Use a darker mix for shadow areas around the figure

to separate it from the background.

"Increase contrast, use more intense colours, and include extra detail to emphasize an area."

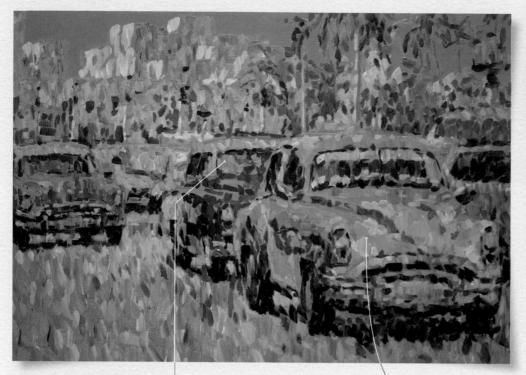

3 Balance and form Develop the forms of the cars, trees, and buildings with tints of the main colours. Tone down some of the colours by mixing them with their complementary colours; apply the resulting neutrals to balance the painting. Place dabs of pure complementary colours to brighten areas such as the shadows inside the cars.

Flecks of the . magenta base colour show through, unifying the whole

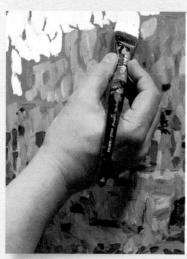

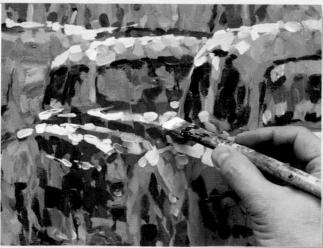

4 Final details
Apply the darkest shadows and lightest tints last with a smaller brush. Use the light sky colour for highlights on the cars to create a unified look.

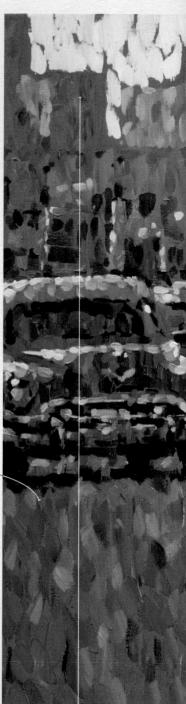

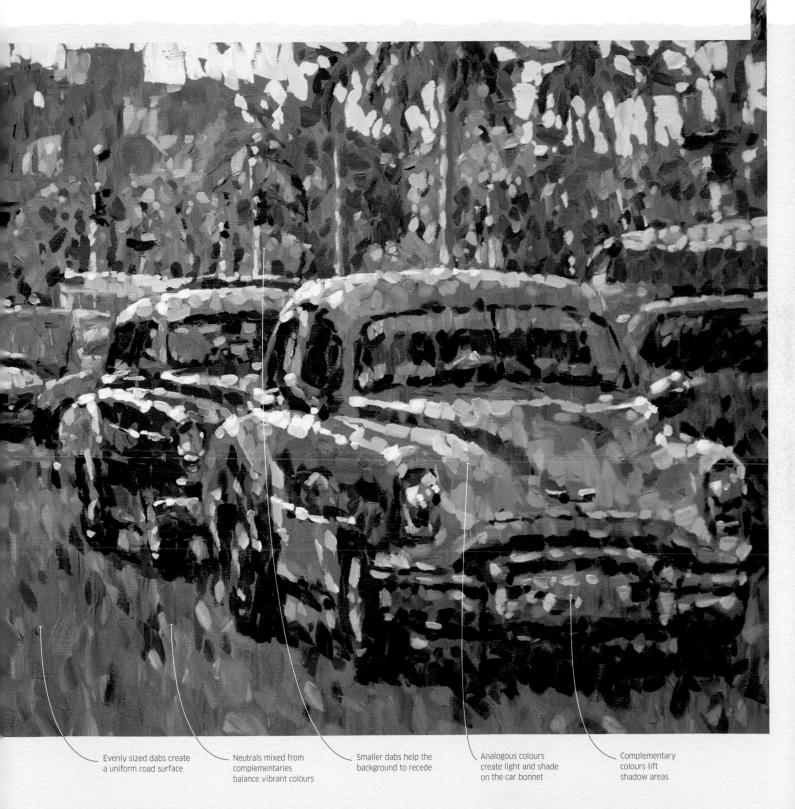

"Optical colour mixing exploits the full potential of colour theory to scintillating effect."

Painting rain

USING STREAKS AND SPLATTER

Misty or rainy scenes can be challenging to paint because you need to create soft, diffused edges and mix earthy tints without them looking dull. Loosely mixed streaks of colour create a wet look that is great for portraying rain, as do splatters of paint. Both techniques require practice to master.

Brushes for special effects

For streaks, load a wide paddle brush with several colours and drag it down the canvas in a single motion. For splatter effects, flick a splatter brush from the wrist to create an erratic spray that makes a range of random marks. A toothbrush creates a more even spray, which is useful for small areas.

PUTTING IT INTO PRACTICE

In this painting, streaks of colour evoke wind and rain with exciting energy. Brightly coloured raincoats, umbrellas, reflections, and darting figures make sure the scene is rainy but not dull.

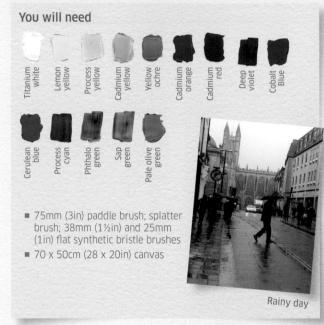

1 Mixing streaks

■ Squeeze more paint than usual onto your palette, to make it easy to pick up multiple colours on a damp 75mm (3in) paddle brush. Dab at the paint, rather than scoop or swirl, to avoid too much mixing. If you have white in the mix, you'll need to blend slightly more – otherwise strong highlights will show in the streaks.

Practise your mixes on a scrap of paper

? Painting streaks

Apply a violet base to counterbalance the warm ochres and blues in the main mixes. Draw a loose composition, then use the paddle brush to apply multiple streaks using single downwards strokes. Apply light colours first, and use the same brush (without cleaning) to allow the colours to bleed together. The running colour evokes the effects of rain.

Building colour

Building colour variation

Road colour 1

Cerulean. cobalt, phthalo green, ochre, sienna, violet, and a small amount of white

Ochre, sienna,

and white, and

small amounts

olive, greens,

of orange.

and blues

days may be grey, but your painting doesn't have to be."

"Inject some

colour. Rainy

Work around any sketched figures

Add blue and green | Mixes don't need to the colour used lightest part of the road

to match each other; for the buildings for apply darker tones to shadowed areas

> Colourful red raincoat

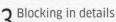

3 Blocking in details
Once the large areas are filled, use a 38mm (1½in) flat brush to block in initial details for the buildings, street signs, and cars. Keep the brushstrokes loose - you can add more detail later.

4 Adding people
Block in shapes for the figures using loosely mixed dark colours to create a sense of depth. The red raincoat introduces a shot of colour. Match the spontaneity of the streaks by painting the people with loose brushstrokes at this stage.

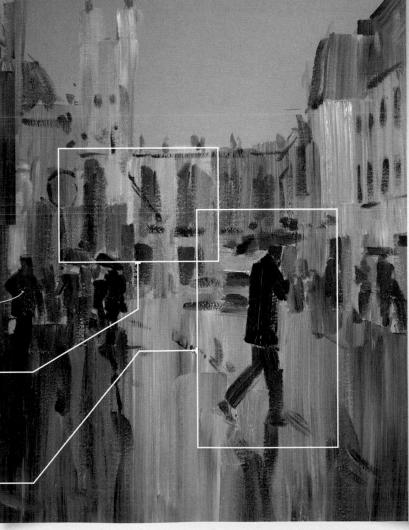

5 Sky and highlights
Using a clean paddle brush, mix a strong, light colour for the sky. Apply streaks with the same dragging action as before. Use the same colour for the vehicles. Add sienna, phthalo green, cerulean, and violet to the sky colour for streaks to highlight the centre of the road. Use a 38mm (1½in) flat brush to apply details to the buildings in a soft ochre tint, and to add shadows to the people.

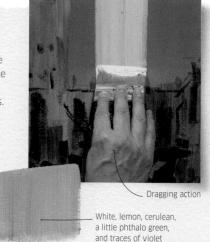

Sky colour

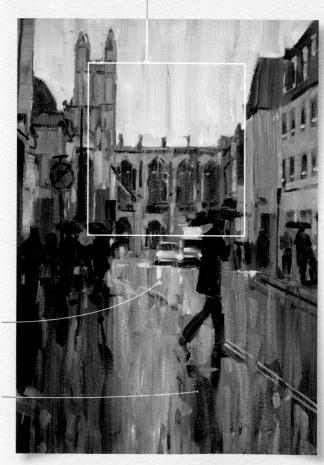

Add highlights to suggest wet reflections

Add shadows for the figures

> "Paint around the buildings carefully but not too neatly to keep a sense of spontaneity."

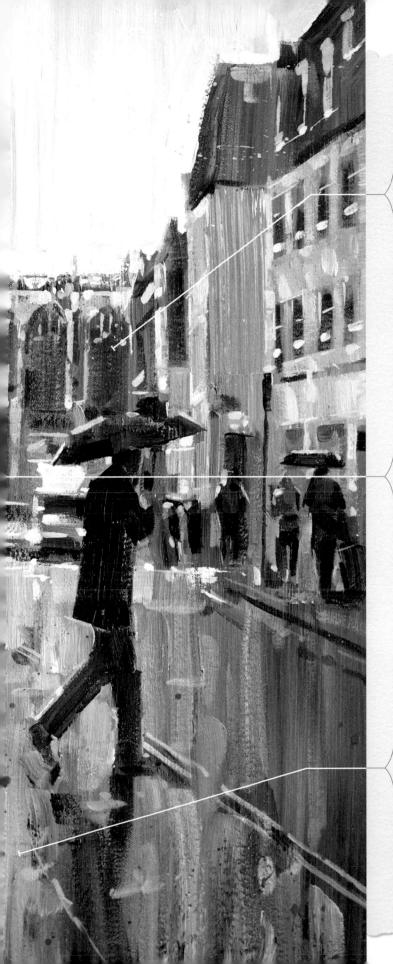

6 Finishing the buildings
Sharpen the details with a 25mm (1in) flat brush. Apply strong, definitive darks and light tints of ochre to pick out details in the buildings, such as on windows and roofs.

7 Finer details

Pick out details in the street scene using the 25mm (1in) flat brush. Add highlights and flecks of rich colour to areas such as the green umbrella and red raincoat.

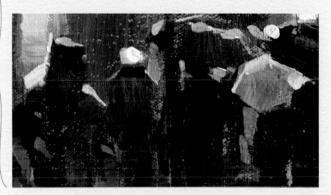

8 Splatter marks
Finally, add splatter marks with diluted paint. Experiment first on paper and be careful not to overdo them on your painting. Use a mixture of runny and thick mixes to get a variety of marks. Load the splatter brush fully with paint for heavier streaks or pick up a small amount for a sprinkling of dots.

Dramatic skies

PAINTING SKY AND CLOUDS

It is important to pitch the tonal range correctly to achieve a dramatic sky. In order to create a sense of depth, start painting at the horizon, moving forward with thicker layers of paint until you reach the nearest clouds. Dramatic skies often have a lot of colour, and darkening hues with blues or browns will help give your painting life and energy.

Creating characterful skies

You can use a range of techniques to create dramatic skies. Use simple strokes for dark, heavy clouds, blends for varied skies, or a dry brush for detail.

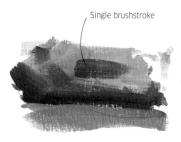

Strong strokes

Use bold, definite brushmarks to depict threatening cloud. A single brushstroke can give the impression of a dominant cloud.

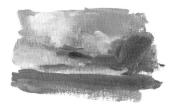

Blending

Balance heavy cloud with gently blended passages. A good mixture of blended and definite marks will add interest and character to skies.

Dry brush

Use a dry-brush technique to add detail. Exploit the texture of the canvas by dragging paint along the surface to suggest light catching the clouds.

PUTTING IT INTO PRACTICE

This landscape, with strong directional clouds. shows how blending, dry brushwork, and dominant brushstrokes can all create the impression of a dramatic, summer sky.

You will need

- No. 8 filbert synthetic and no. 6 flat synthetic brushes
- 20 x 30cm (8 x 12in) medium-grain canvas

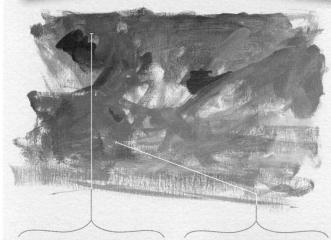

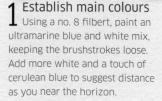

Cloud shadows L Use a darker mix of ultramarine and cadmium red to block in the darker areas. Apply strokes in the direction in which the clouds are drifting, to suggest movement.

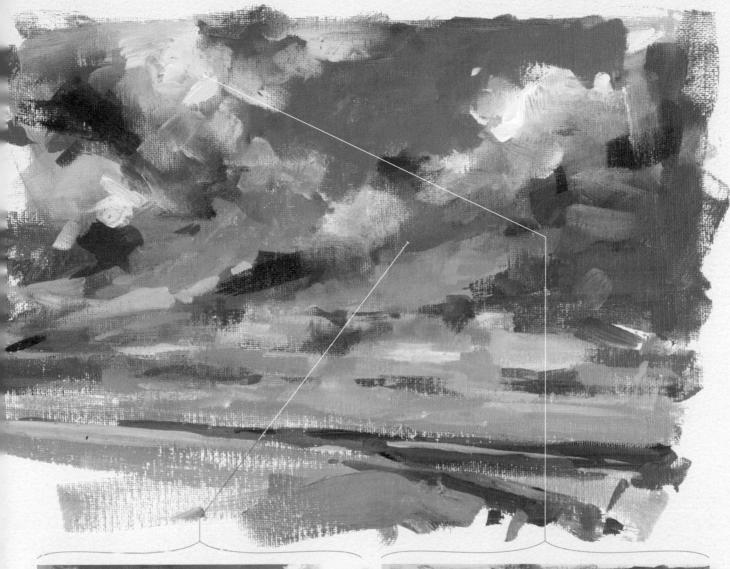

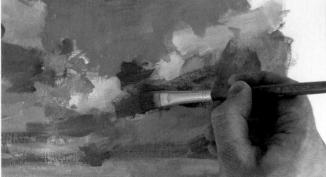

Add depth
Once the first two layers have dried, add another dark mix of blue.
Using a no. 6 flat brush, blend lighter and darker mixes together to create depth. Lighten the colour with white for the tops of the clouds, but avoid making the colour too bright.

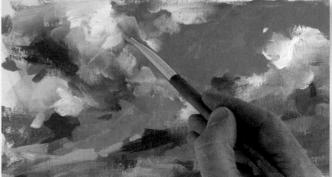

4 Create highlights
With the same brush, use a whiter mix to add highlights to the clouds while the previous layer is still wet. When dry, use the lightest mix to drag highlights over the clouds using a dry-brush technique.

Add more detail to the nearest clouds, using less white in the distance.

Painting people simply

CAPTURING THE ESSENCE OF FIGURES

Including people in your work can bring it to life, but you don't need to paint individual portraits. If you focus on the overall activity and spacial relationships between people rather than their facial features and details, your figures will become successful, integrated elements of your painting.

The principle at work

Proportion and scale are the most important factors when you paint figures, and the most noticeable if they are wrong. There are a few basic rules that can make painting figures easier.

Proportion

Although the proportions of individuals vary, the average adult's height is roughly equal to eight head lengths. Children's body lengths are made up of fewer head lengths the younger they are.

Scale

Heads, hands, and feet can be challenging to depict on middle-distance figures, so it's best to avoid painting them in any detail. Start by making the head smaller than you think; you can adjust it later if necessary.

Space

Include slivers of space around the head, arms, and legs of your figures. This stops them looking too solid, and creates a sense of movement, detail, and structure.

PUTTING IT INTO PRACTICE

In this painting, the footballers' shapes have been simplified to create an impression of movement. Nothing is painted in too much detail to keep the focus on the activity rather than individuals.

Blocking in shapes

L Use a no. 6 flat brush to roughly block in the three players. Focus on getting the proportions and positions of the figures right, using approximate colours at this stage. You can refine the details later.

Adding structure

Refine your drawing by painting shadows onto the figures and adjusting the colour and tone of their clothing. This gives them more solidity and form,

You will need

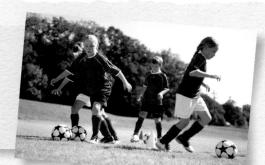

Football practice

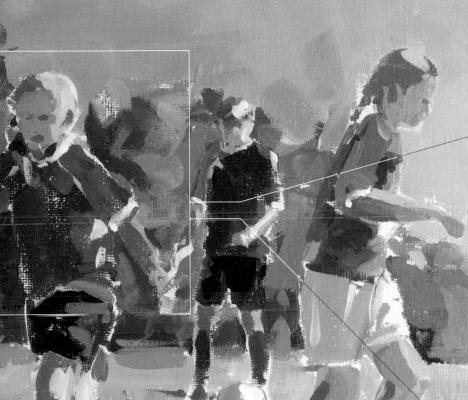

Refine the heads, arms, and legs a little more to bring out each figure's distinguishing features. Use a no. 1 round brush for these details, and paint freely to maintain a sense of movement.

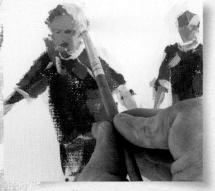

4 Final details

Add small details and highlights to create definition, but don't go into too much detail. To finish, cut in around the figures to fill in the background, and add shadows on the ground to anchor the figures.

Skin tones

PAINTING FLESH COLOURS

Painting different skin tones or showing subtle variations in pigmentation can seem challenging. Amateur painters sometimes just opt for "flesh tint", or use pink for light complexions and brown for darker ones, but these choices fail to capture the luminosity of skin. Instead you need a palette of colours, including red, yellow, green, blue, and violet – with white to soften tones. The proportions of the mixes will vary according to skin tone.

Basic palette for skin tones

This range of colours provides the building blocks to create various skin tones. Begin by mixing all colours together in very small amounts with one or two dominant colours. Add varying amounts of white to create lighter tints and highlights.

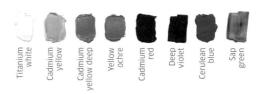

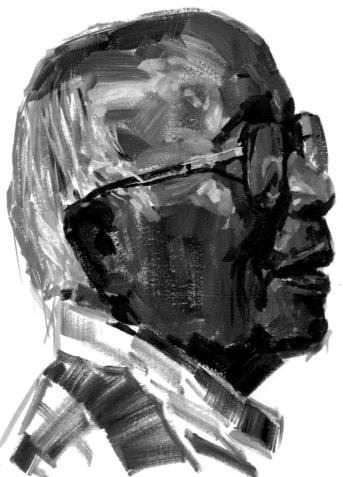

Brown skin tones

Colour sketch
Create an initial colour sketch to
experiment with warm colours
and dark tones. You can expand
on these in the final work.

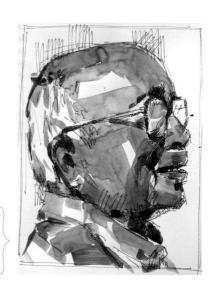

Ochre hues

This face's glowing brown colour is achieved by a greater proportion of cadmium red and cadmium yellow in the basic mix. Add more deep violet for darker tones. For lighter tints add white, with a hint of sap green and cerulean blue to temper the vibrancy of the warm hue.

Cadmium red

Basic mix for brown skin tones

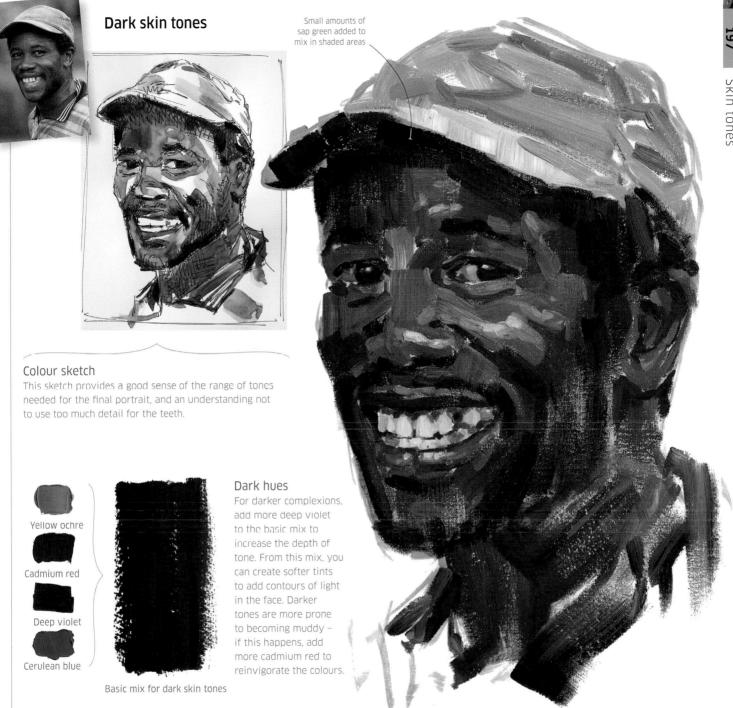

"Painting from life provides valuable information about the subtlety of skin tones, and gives insight into your sitter's character."

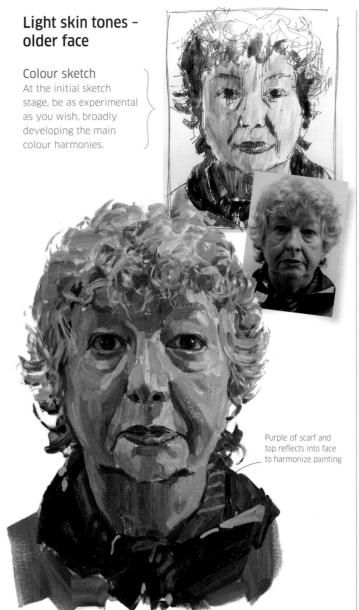

Light hues

In an older complexion, the skin is deeply textured and there are more shadows. Here, subtle changes of light from left to right leave half the face in soft shadow. For the deepest darks, use more deep violet and sap green in the basic mix. For the lightest areas of the face and for the hair, add small amounts of cerulean blue and white.

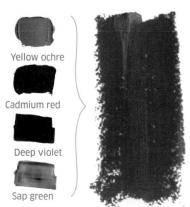

Basic mix for older, light skin tones

Light skin tones younger face

Colour sketch

A guick colour sketch emphasizes the

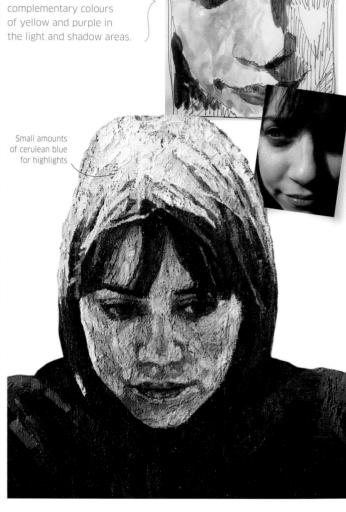

Light, even hues

In a younger complexion, the tones are generally even. with subtle combinations of colour. Use plenty of white with mainly cadmium red. cadmium yellow, and deep violet. (Using too much white can result in flat, chalky colour - if this happens, re-energize the mix with cadmium yellow.) For the lightest tints, use additional sap green and cerulean blue to temper the warm colours and create a natural look.

Cadmium yellow

Cadmium red

Deep violet

Basic mix for younger, light skin tones

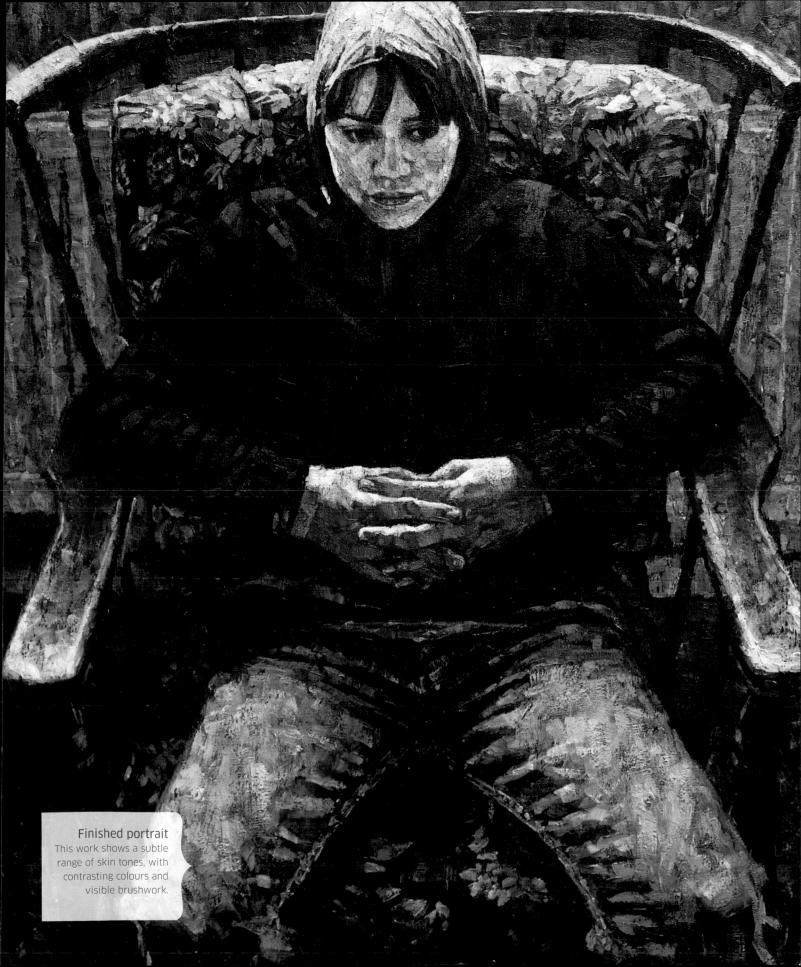

PUTTING IT INTO PRACTICE

This artwork shows how you can first apply energized marks before introducing the main subject (the cyclist). When adding to the figure, be careful not to overwork it and lose the sense of movement already established by the initial dynamic strokes.

You will need

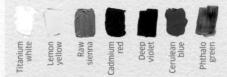

- 50mm (2in), 25mm (1in), and 13mm (½in) flat brushes
- 50 x 40cm (16 x 20in) medium-grain canvas

Cyclist in motion

Background motion
On a ground colour of
deep violet and titanium
white, begin by applying
a few random directional
brushstrokes with a 50mm
(2in) brush. Use a mix of
cerulean blue, deep violet,
and titanium white.

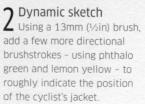

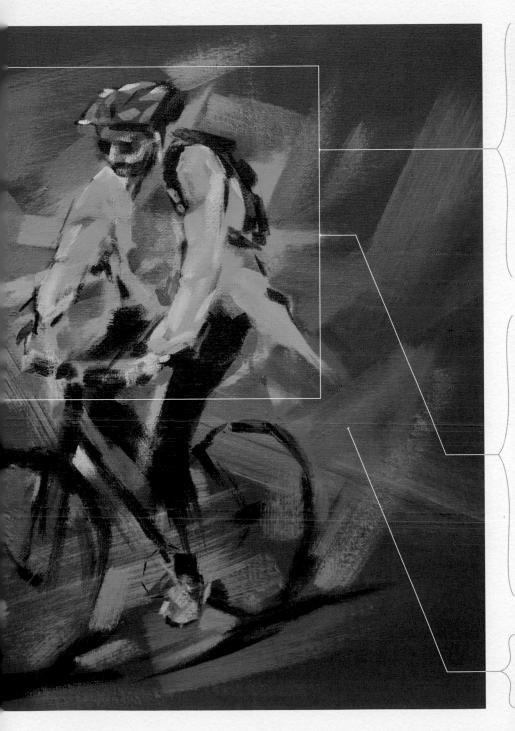

Outline the subject 3 Outline the subject Now begin to plot the figure and bike on top of the marks created in the previous step, using a 25mm (1in) brush with deep violet to indicate dark areas. Then apply a mix of cadmium red and raw sienna for the flesh tones of the figure.

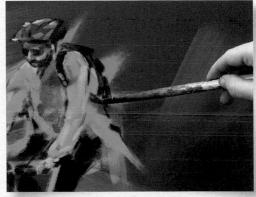

Work up figure Use a 13mm (½in) brush to pull out dark areas of colour. Establish the figure using cadmium orange and process cyan. Avoid overworking the image or sharpening it too much.

5 Finishing touches
Use a 25mm (1in) brush for your final additions to the background, emphasizing the directional brushstrokes.

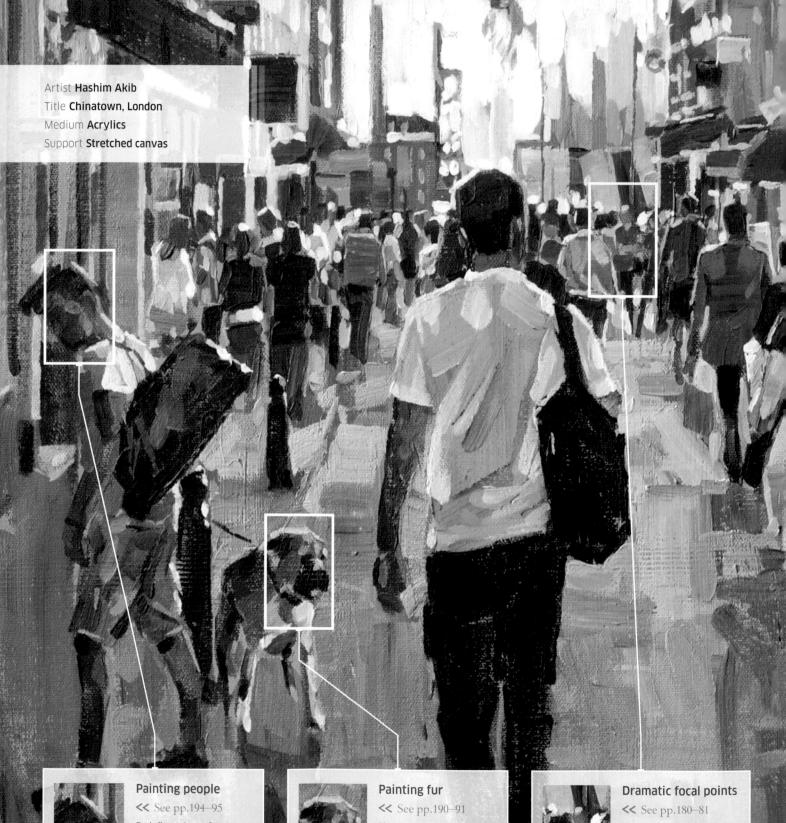

Each figure has a feature that makes them uniquely interesting, such as a pose or their clothing. A few figures have been prioritized with more careful brushwork.

The dog was added to the left corner to create more interest. It also provides a point of scale for the figures and buildings.

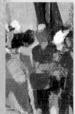

Stepping stones of focal points, using detail, colour, and tone, guide your eye towards the background. The buildings' perspective lines also lead to this area.

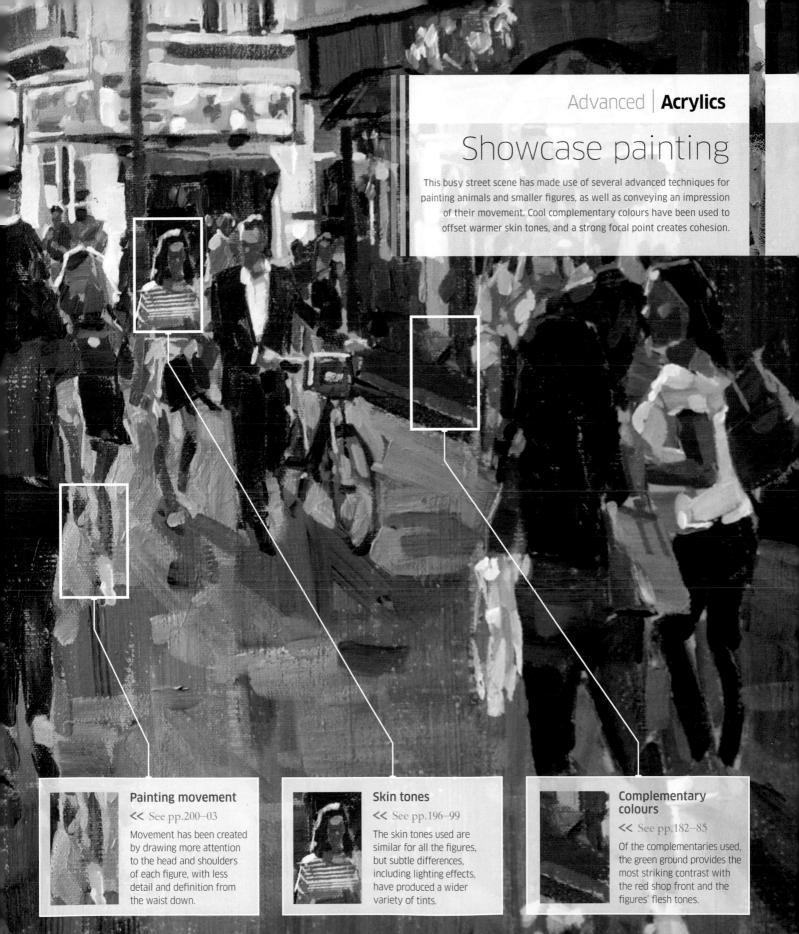

01/5

Painting with oils

Oil paints are popular with artists because they are versatile, expressive, and forgiving. Used with a heavy consistency, they can be applied thickly and then sculpted, cut, or scratched back. Alternatively, they can be thinned with solvents or oils to give greater translucency and create thin glazes of colour.

On the following pages, you can find out about the paints and materials you are likely to need. Then, three sub-sections – beginner, intermediate, and advanced – teach you more than 30 step-by-step oil-painting techniques. Each sub-section culminates in a showcase painting that demonstrates the techniques you have explored.

Beginner techniques

■ See pp.216-41

In the first section, find out about colour mixing, mark making, using "fat over lean", and layering and blocking your colours. Also look at working in decreasing stages, *alla prima* techniques, and how to create form.

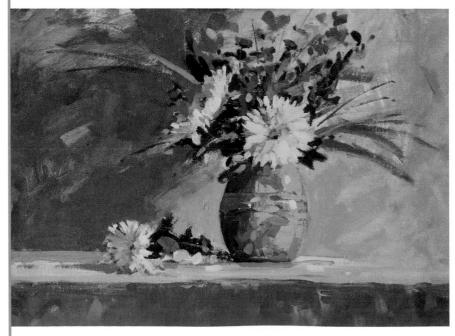

Beginner showcase painting (see pp.240-41)

2 Intermediate techniques

■ See pp.242-65

In this section, find out about aerial perspective, blending, impasto, and how to apply and remove paint from the canvas to create textures and effects, as well as to remove mistakes.

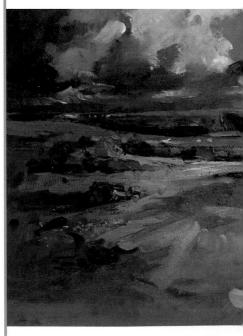

Intermediate showcase painting (see pp.264-65)

Oil paints have a long, illustrious history, with evidence of their use dating back to the 7th century. The medium was favoured by the Old Masters – the great European artists who worked from the 13th to the 17th centuries.

The introduction of paint tubes in 1841 was an important development for oil paint, making it more accessible and portable. This made it possible to paint outdoors and travel further afield to capture light and landscape from life. It paved the way for artistic movements such as Impressionism.

Brushes have also played a key role in oil paint's history. The invention of metal ferrules led to flat-chiselled brushes, as well as traditional bound, round ones, permitting a greater variety of sculptural marks, and encouraging experimentation and different styles.

Versatile and rich

Oil paint remains a popular choice with artists, mostly due to its versatility. Paints can be opaque, transparent, or translucent, as well as thick or thin, and their luminescence and glossy finish

make it possible to create highly realistic paintings. Slow drying times allow for plenty of blending.

Paint can be applied with a brush or palette knife, and there are a great many colours available.

The depth, consistency, and richness of oil paint remain its greatest qualities, and the many techniques available to the oil painter make it the perfect vehicle for artistic expression. Once basic processes are mastered, oils offer a wealth of creative opportunities for both beginners and experienced artists.

3

Advanced techniques

■ See pp.266-93

The final section looks at skin tones, colour harmony, tonal values, and how to use mediums. Also, discover more complex methods of correcting, adjusting, and finishing your painting, and how to find your own style

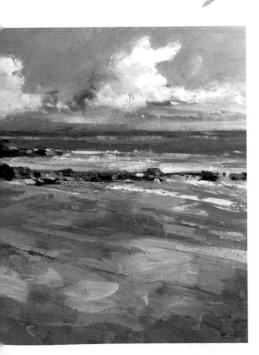

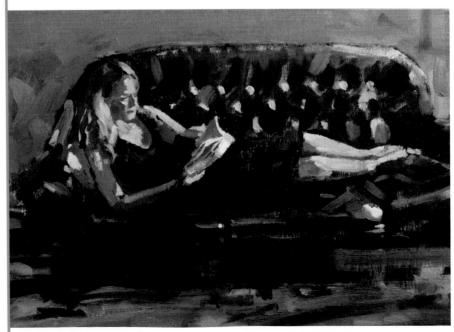

Advanced showcase painting (see pp.292-93)

Oil paints

THE PROPERTIES OF OILS

Oil paint has a unique quality. Its depth and richness of pigment, together with a thick, buttery consistency make it a versatile and popular medium. As well as standard oil paints, alkyd oil paints are also available. These include an alkyd dryer to speed up the drying process and can dry in as little as a day. If you want to avoid using solvents, oil paints that mix with water are also available.

Oil paint, as the name suggests, is oil-based, with the pigment usually suspended in linseed oil. As oil does not evaporate as water does, oil paints take much longer to dry than water-based paints.

The drying time of paints will vary, depending on the make, and certain colours dry faster than others, depending on the oil content and the materials used to create the pigments. Earth colours, such as burnt sienna or burnt umber, are usually made from iron oxide and dry relatively quickly, making them good basic colours for

underpainting. Transparent colours tend to be used for underpainting and to mix glazes. Most colours applied sparingly will be touch dry within a week, although thick underlying layers can take years to dry.

Choosing oils

There are many different manufacturers of oil paint and most produce two ranges. Artist-quality paints offer the best purity, the highest pigment content, and widest range. Student-quality paints are cheaper, as more fillers are used to bulk out the paint and

there is less pigment. A higher pigment content is desirable to achieve purer mixes and more accuracy when colour mixing. It will also influence the permanence of your painting's colour, increasing its longevity and resistance to fading in sunlight. Both artist- and student-quality paints will produce good results, but artist-quality is recommended.

Within each range, colours are separated into series. Each series has a different price band, which varies according to the cost of the pigment used in manufacture. Some colours are

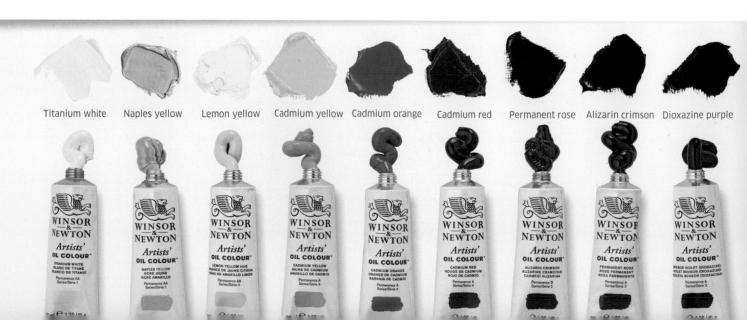

Thick application

Thin application

Opacity

Transparent

pigment

Some pigments are more transparent than others. Transparent colours are good for glazing (see pp.284-85), while opaque ones are better for solid coverage.

Semi-transparent pigment

Paint thickened with medium

Adding mediums

Paint thinned with medium

Mediums can affect drying times, consistency,

and sheen. They can be added to paint on the

palette or dipped into like water. Be aware

that some may add a yellow tint to colours.

Paint thinned with solvent

Consistency of oils

A distinguishing feature of oil paints is their thick consistency. You can apply them directly from the tube to capitalize on this quality, or thin them with mediums.

more expensive than others, although alternatives are sometimes offered for costly pigments, such as cadmium colours. Where substitutions have been made this will be indicated by the word "hue" following the colour's name.

Transparency

Colours are also graded from transparent to opaque: transparent, semi-transparent, semi-opaque, and opaque. A colour's transparency influences the amount of paint required to give good coverage. However, be mindful of the fat over lean principle

(see pp.224-25); for underpaintings, it is better to mix a transparent colour with an opaque colour than apply it too thickly. Transparency in a white paint can be useful when mixing colours. Your choices will vary according to your subject matter and style. Note that even colours with the same name may differ from supplier to supplier, even though the same pigment has been used.

There are many different oils and prepared mediums available. They can be used to thin or thicken consistency,

hasten or slow drying time, add glazes, or otherwise alter the final appearance of the paint.

Solvents for cleaning brushes and thinning paint include turpentine, white spirit, and their low-odour alternatives. There are also more environmentally friendly options based on the zest of citrus fruit, which dilute paint and clean brushes well. Thinners can be reused if carefully decanted into another vessel and left to settle

Use solvents and oil paints only in well-ventilated areas. Wash your hands well after use, or wear vinyl gloves.

Mediums

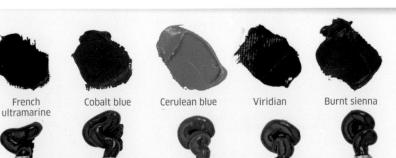

Choosing colours This selection of oils offers a good range of warm and cool hues. Whichever colours you select, make sure that they

are good quality.

Black

There are several blacks to choose from, or you can mix a dark tone with burnt sienna and ultramarine blue to create a warmer (browner) or cooler (bluer) dark.

Brushes and palette knives

HOW TO CHOOSE YOUR BRUSHES

An assortment of brushes is essential for working in oil paint. Some artists have a duplicate brush in each size, one for light paint and one for dark, to keep colours separate and clean during painting. Stiff, bristle brushes are the usual choice for oil painting, and palette knives are excellent for mixing paint and creating texture.

Brushes for oil painting need to be stiff enough to move the thick paint and robust enough to withstand cleaning in solvents. Bristle brushes made with hog hair are the traditional favourite, but synthetic fibres also work well and are less expensive. Soft-hair brushes are useful for working into wet paint, but synthetic fibres are more practical than delicate, natural fibres.

Types of brush

There are various shapes of brush available, each used for making different marks. Flat brushes have

squared tips, which make chiselled marks with the flat side and fine lines with the thin edge. They also have long, springy bristles, which allow you to apply the paint by pressing or sweeping. Short flat brushes, also known as brights, are similar to flats, but the hairs are cut shorter so they are firmer. Filbert brushes have flat ferrules (the metal piece that holds the hairs) and rounded tips, which means they can create broad marks, like a flat brush, but with soft edges, similar to a round brush. Round brushes are bound together in a circle so that the hairs come to a point. They

can carry a lot of paint and produce a variety of marks, from wide strokes with the side to delicate dabs with the tip. Fan brushes don't hold much paint so are useful for dry-brush techniques and gentle blending. Riggers are small brushes with long hairs, and they hold a lot of paint due to their length. They are suited to fine line work, such as tree branches or rigging on boats.

Palette knives

You can also apply oil paint with palette knives to create bold, direct marks and textures. Palette knives come in a

Brushes Each shape of brush comes in a range of sizes; the higher the number, the larger 6 round synthetic brush No. 4 filbert synthetic brus 2 flat hog-bristle brush the brush. Large and medium-sized brushes are used for covering the canvas in the first stages of painting. Smaller, soft-hair brushes are used for painting details.

Holding a brush

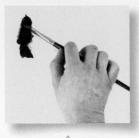

Mid-handle hold Hold a large flat or filbert brush halfway down the handle to create pressure for broad strokes.

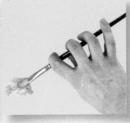

Flat hold
To create expressive marks, place your thumb at the back of the handle for a loose. flat hold.

Shallow angle
Hold the brush close to the
ferrule between forefinger
and thumb to help you
create light, broken lines

Close pencil hold
For maximum control when
you are painting details,
hold the brush close to the
tip, as you would a pencil.

Flexible pencil hold Grip the brush like a pencil further down the handle to give you control and allow you to change pressure.

variety of shapes, widths, and lengths, just as brushes do. Those with flexible handles are best for painting with – select larger sizes for laying broad strokes of paint and smaller, narrower shapes for precision work. Use the flat of the blade to apply lots of colour, the edge of the blade to scrape into paint and create texture, and the tip to apply small dots and dabs. Flat, straight-edged palette knives are useful tools for mixing and moving paint. Their straight sides make them ideal for removing excess wet paint from the canvas. You can also use them to mix paint on the

palette instead of using a brush, which keeps your culours cleaner and prevents your brushes from being contaminated with different colours. Palette knives are easy to clean by wiping with a rag.

Caring for your brushes

Looking after your brushes properly will make them last much longer. After working, wipe the oil paint from your brush

with a rag, then rinse it in solvent or white spirit to remove any remaining paint. Wash the brush with warm (not hot) water and soap (not detergent), then rinse until the water runs clear. When the brush is clean, wipe it off, gently reshape it, and leave it to dry completely with the bristles facing upwards. Do not store the brush until it is completely dry, or it could develop mildew.

Palette knives

Knives with "cranked", or bent, shanks are flexible, and keep your hand away from the canvas as you paint. Grip the handle with your thumb at the front for maximum control. Palette knives that are flatter and straighter are perfect for mixing paint or scraping it from the canvas.

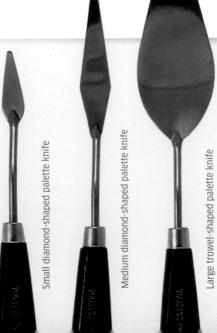

straight, flat palette knife

Supports and other materials

CHOOSING A SURFACE TO PAINT ON

There are many different supports, or surfaces, that you can paint on using oil paints. They range from canvas to paper and many different types of wood. As long as it is primed well, you can paint on almost any surface. Canvas is the classic oil painting support and is available in cotton or linen, but many artists prefer to paint on board.

All supports need to be primed before use, so that the surface is sealed and the support does not absorb the paint. While many supports are available ready primed, if you are using your own you will need to prime it yourself. Traditionally, a gesso mixture made from rabbit-skin glue, chalk, and lead white was used, but ready-mixed acrylic gesso primer is safer and easier to use.

Alternatively, a water-based undercoat or primer with a little added chalk and wood glue can work well.

Priming with a

decorator's brush will leave visible brushstrokes on the surface, creating texture and movement. Use a roller for a more uniform finish, or experiment with imprinting fabrics into the wet gesso to leave texture.

Types of canvas

Canvas is a popular choice and is available in many variations. Linen canvas is the most traditional option, whereas cotton canvas is a more affordable support and has a more regular weave. To create a suitable painting surface, canvas is stretched

over a wooden stretcher and secured in place. It is then tightened using wedges around the corners, which push the stretcher bars apart. Canvas is available in a range of textures from fine to coarse. It should be primed before use.

Wooden boards

MDF, hardboard, and plywood are good sheet materials to use for oil painting. The main advantage of these is that they can be cut to any size and primed with a texture of your own choosing. Boards are also more durable than canvas and easier to store without the

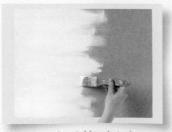

1 - apply horizontal brushstrokes

2 - apply vertical brushstrokes

3 - allow to dry before painting

Papers and boards

Canvas, hardboard, MDF, and plywood are all popular supports for oil paints and all have different advantages.

Priming boards

Start by using horizontal brush or roller strokes to cover the support with primer, then allow to dry before applying a second coat using vertical strokes to ensure even coverage. Once this has dried, your support will be ready for paint.

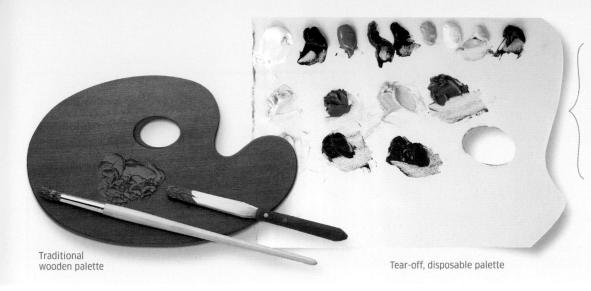

Palettes

Traditional wooden palettes are still a popular choice and come in a variety of sizes. Plastic palettes are a cheaper option and are usually white. Tear-off disposable palettes are useful for working outside.

risk of damage. Boards are useful when painting outside, as you can carry them in a wet panel carrier and they take up less space than canvases. You can also adhere linen or cotton canvas to the surface of the board if you wish.

Using paper

Some artists prefer to work on paper, and oil-sketching paper is a canvastextured paper suitable for oil paints. It is available in pads, is more affordable than canvas, and can be mounted on a board for rigidity. It is worth having some in the studio to test compositions or colour mixes before committing to canvas. Primed heavyweight watercolour paper is also suitable for oil painting.

Easels in the studio

To hold your support you will need an easel of some kind. There are easels designed for every situation, from the dining room table to a large-scale studio. Aluminium easels are lightweight and portable, while wooden easels are strong, long lasting, and traditional. Wooden easels are heavier, which makes them more difficult to move around, so they are better for studio

work. Larger studio models include a crank handle to raise and lower large paintings to make working on different sections easier.

Out and about

Pochade boxes (see also pp.26-27) store equipment and provide a place to rest a board when working outside. French easels also incorporate a storage box.

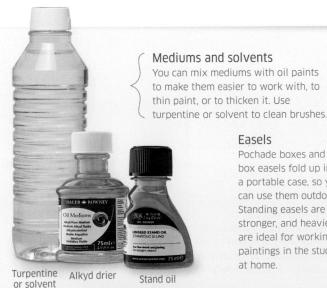

Easels

Pochade boxes and box easels fold up into a portable case, so you can use them outdoors. Standing easels are larger, stronger, and heavier. They are ideal for working on paintings in the studio or at home.

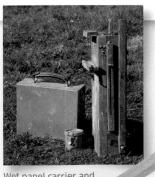

Wet panel carrier and folded box easel

Wooden standing easel

Colour mixing

USING COLOUR THEORY TO MIX YOUR OIL PAINTS

You can buy paints in many different hues, but with a few basic colours you will be able to mix numerous variations yourself and so have greater control over your work. Unlike other media, oil paint doesn't change colour as it dries, so what you mix is exactly what you'll get.

MIXING METHODS

To create new colours, you will need to mix two or more oil paints together by stirring them into each other. You can do this with a brush or palette knife, either on a palette or directly on the canvas.

Mixing on a palette

Pick up a little of each colour on the same brush. The first mixing stroke will produce different strands of colour. Circle the brush a few times to blend the colours.

Mixing on the canvas

Pick up a little of each colour on the same brush. Mix the colours on the support in one stroke. Circle the brush to blend the colours, first partially and then thoroughly.

Mixing with a palette knife

Pick up each colour on a palette knife and spread them on the palette. After just one movement, the mixed colour will be visible. Move the knife back and forth to blend thoroughly.

Colour temperature and bias

Reds, oranges, and yellows are considered "warm", while purples, blues, and greens are considered "cool". Your choice of warm or cool colours will affect the balance and mood of your work.

There are also warm and cool variations of every colour. For example, a blue with a red bias (purplish-blue), is considered a warm blue, while a blue with a yellow bias (greenish-blue) is considered cool. As this bias will affect the result when mixing with other colours, you should include a warm and cool version of each primary colour on your palette for flexibility.

PRIMARY REDS Alizarin crimson Cadmium red (blue bias) (yellow bias) Warm colours French Cadmium ultramarine vellow (red bias) to red (red bias) Cool colours PRIMARY **PRIMARY BLUES** YELLOWS close to blue Close to yellow Cerulean blue / Lemon yellow (vellow bias) (blue bias)

Colour bias wheel

In this version of the colour wheel (see also pp.14–15), the inner circle shows which colours are considered warm and which are cool. The outer circle shows how each colour – in this case the primaries – has a warm and cool version.

Mixing vibrant secondary colours

Mixing two primary colours will create a secondary colour (see pp.14-15). If you mix two primaries that are close to the same secondary colour on the colour wheel, they will create an intense secondary colour. For example, French ultramarine and alizarin crimson make a vivid violet because they are both close to purple.

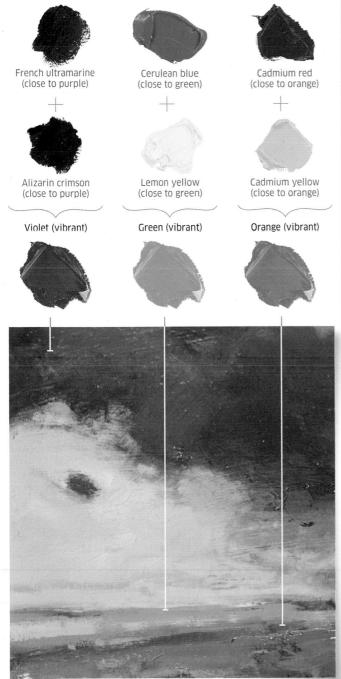

Vibrant landscape

Mixing muted secondary colours

If you mix two primaries that are close to different secondary colours on the colour wheel, they will create a muted secondary colour. For example, cerulean blue and cadmium red make a subdued violet when mixed together because, on the colour wheel, they are close to green and orange respectively.

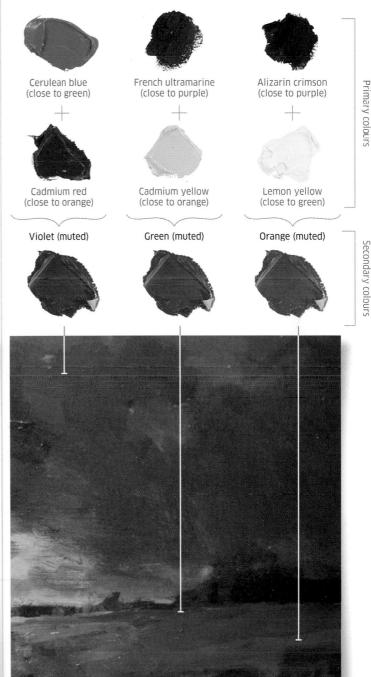

Muted landscape

Mixing all three primary colours to create darks

By mixing all three primary colours together you can create a range of dark, muted colours. Depending on the ratio of each primary in your mix, you can create your own blacks and browns - typically with greater depth and subtlety than bought versions. This can be especially useful for landscape painting.

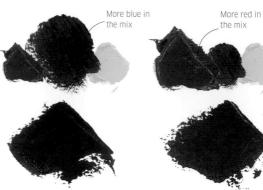

Dark blue mix Adding more blue will create a dark, cool mix that is almost black.

Adding more red will create a warm, dark mix with a purple tone.

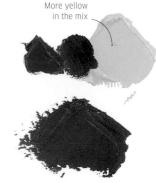

Dark brown mix Adding more vellow to the mix will create a light, brown colour.

Mixing complementary colours to create greys

Complementary colours are colours that sit opposite each other on the colour wheel, for example red and green or yellow and purple (see also pp.14-15). When placed side by side, complementary colours intensify each other but when mixed together the effect is reversed and the result is grey.

You can vary the mix to make warm, cool, or coloured greys, which will introduce subtlety and depth to your paintings. Adding white will extend the range even further. As you can see in the painting, right. greys can look surprisingly interesting using this method.

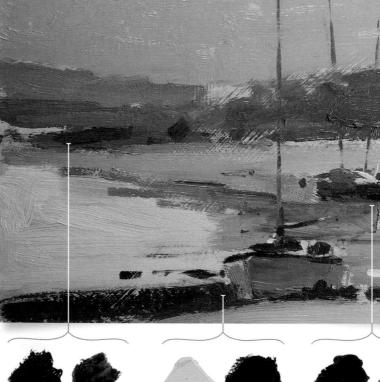

"Mixing your own greys will give your work subtlety and depth."

crimson green

Cool, blueish grey

Dioxazine

purple

Warm, reddish grey

Cobalt Cadmium blue orange

Neutral grey

Mixing "light"

Instinctively, we think of adding white to lighten a colour and it often does the job well. However, adding white to a mix desaturates it and gives it a pastel appearance. When light shines on an object, the colour is often intensified rather than weakened, so painting light requires judicious use of saturated colour and added white.

Pastel colours Adding white to a colour creates a pastel. For example, adding white to red creates a pastel pink.

Cadmium red + white = pastel pink

Using saturated colour

In this landscape, a pure saturated colour was used to depict a vibrant sunset. No white was used in the mixes.

French ultramarine + a little cerulean blue + a hint of alizarin crimson

Warm blue

Cadmium yellow

Warm yellow

Cadmium red + a hint of cadmium yellow

Warm red

Cadmium yellow + a hint of Naples yellow + a hint of cadmium red

Warm urange

Adding white

Here, white was added to each mix. The resulting pastel colours give the painting a softer, cooler look.

+ white

+ white

Warm yellow

white

Warm red

+ white

Pastel blue

Pastel yellow

Pastel pink

Pastel orange

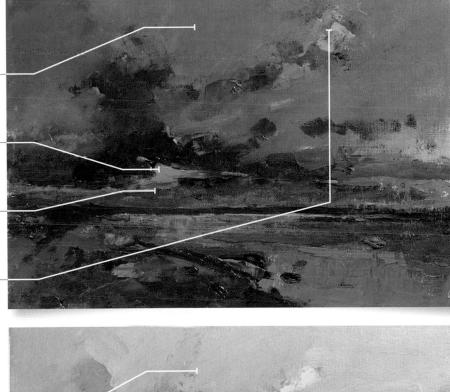

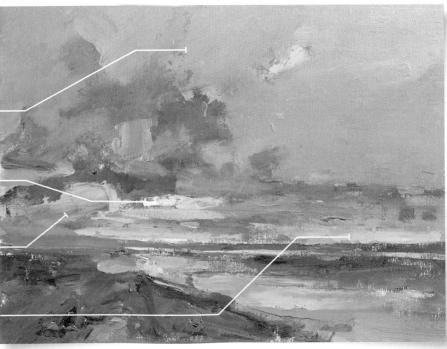

Mark-making

USING BRUSHSTROKES TO CREATE EFFECTS

You can create a variety of effects – from photorealism to abstract expressionism – depending on the brush you choose, the marks it can make, and the way you apply the paint. This will set the mood of your piece, so practising different ways of making marks will enable you to interpret any subject matter in your own style.

Five brushstroke techniques

There are five main brushstroke techniques that will help you to create different textures within a painting. Experiment with all five methods to add depth and interest to your work.

Coarse brush

Use a large bristle brush to cover a big area quickly. The stroke will retain some of the texture of the bristles.

Dry brush

Drag undiluted paint across the canvas to create effects such as shimmering light on water or to suggest areas of detail.

No. 4 flat

synthetic

Random expressive marks

Apply multi-directional marks with varying amounts of pressure to create energy and movement.

Considered line

Use a small bristle brush for areas that you need to approach carefully, such as working up to a line.

Fine brush

Use a small, synthetic brush and diluted paint to make a crisp, detailed mark. For long lines, use a long-haired brush,

PUTTING IT INTO PRACTICE

This sequence shows how to apply the main brushstroke techniques to create a simple yet dynamic study of a family group. Although you are making several different types of mark, it is important to treat the painting as a whole rather than as a series of isolated objects.

Coarse brush

▲ Holding a no. 6 filbert bristle brush flat, paint the darker areas of the figures' coats with bold, coarse strokes. You can cover a large area quickly by applying enough pressure to lay the paint in one go.

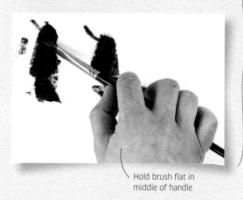

7 Dry brush

Luse the dry-brush technique to suggest the legs and arms. Hold a no. 6 filbert bristle brush at a shallow angle to the canvas and gently drag it down the surface using vertical strokes. The broken lines will suggest movement and provide a base for more considered lines later.

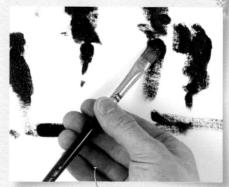

Apply gentle pressure

You will need

- No. 4 flat bristle, no. 6 filbert bristle, and no. 6 round synthetic brushes
- 25 x 30cm (10 x 12in) medium-grain canvas board

Small family group

Considered line

Take your no. 4 flat bristle brush and hold it halfway along the handle, gripping it as you would a pen or pencil. This will give you the control you need to add detail to the faces, but still allow you to easily change the pressure of each mark to give your work a painterly quality.

Use a pencil hold to add detail

5 Fine brush Hold a no. 6 round synthetic brush as if it were a pencil to add final details to the painting. Rest the side of your hand on the canvas for maximum control of the brush. If the area is wet, use your little finger to steady your hand.

Rest your hand . against the canvas

3 Random expressive marks

Use a no. 6 filbert brush to fill in the ground around the figures' legs and feet. Hold the brush flat and loosely for this, as it will enable you to paint freely and create a sense of light and texture on the ground. Vary the colour mix as you go along to add interest.

Palette knives

MARK-MAKING WITH KNIVES

Palette knives are great for adding texture and a change of pace to your work. They are available in many different shapes and sizes, and are surprisingly versatile. The straight, durable edge of the blade will give you consistency and control over shapes and hard edges, while the flat surface is ideal for both sweeping strokes of colour and more detailed work.

Application techniques

There are three main ways of painting with a palette knife: using sweeping, expressive, or fine applications of paint. Combining a range of different brush and palette marks can also produce interesting results.

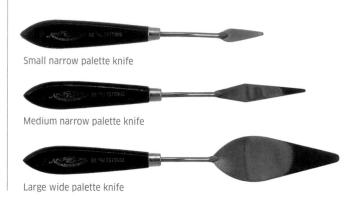

This painting of a pretty white stone cottage was created solely with palette knives. The picture features a range of marks made with the three different forms of application.

You will need

Titanium white Cadmium yellow Alizarin crimson French Ultramarine sienna

- Large wide, medium narrow, and small narrow palette knives with crank handles
- Rag or kitchen towel for cleaning knives
- 25 x 30cm (10 x 12in) medium-grain canvas board

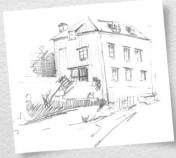

White stone cottage

1 Broad area

L Use the largest knife and a sweeping action to cover broad areas of wall quickly. Vary the pressure to control the thickness of the paint.

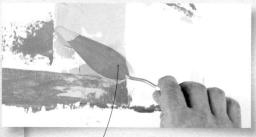

Sweeping action /

_ Edge of palette knife

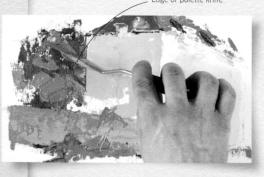

2 Expressive marksGive the trees texture and a sense of movement by applying expressive marks

movement by applying expressive marks with the edge of a medium-sized knife. Experiment with hard shapes and marks.

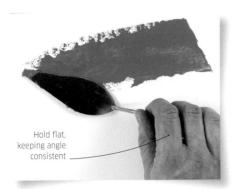

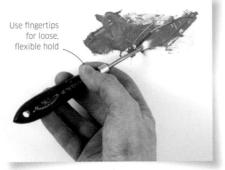

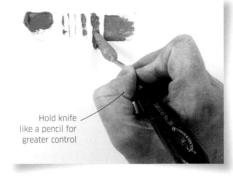

Sweeping application

Block in big areas of colour with a large palette knife, holding it as you would a dinner knife. Spread the paint in long sweeps, maintaining a consistent angle.

Expressive application

Scrape the edge of the blade along the surface to create varied shapes and patterns, or work the flat of the blade into areas of wet colour.

Fine application

Dip the tip of the knife in paint and apply it to the surface by twisting and turning the knife, changing the angle until you achieve the effect you want.

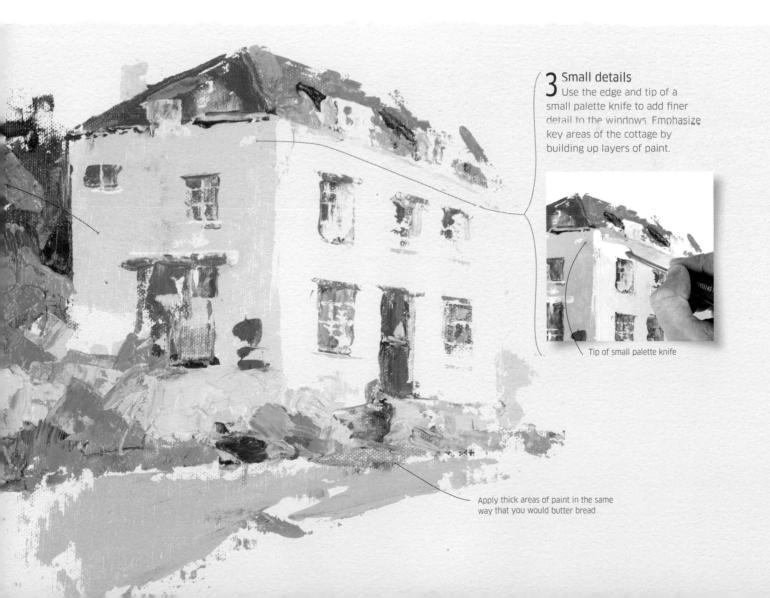

Fat over lean

HOW TO LAYER OIL PAINTS

Neat paint has a high oil-to-pigment ratio and is called "fat", while thinned paint has a low oil-to-pigment ratio and is called "lean". Fat paint takes longer to dry than lean and is more flexible, while lean paint dries more quickly and can be brittle. Applying fat paint over lean, therefore, should prevent your work from cracking or discolouring.

Preparing each layer

Prepare a lean mix for the initial layers of your painting by thinning paint with turpentine. Build up each layer using progressively fatter paint, either by reducing the amount of turpentine used in each mix, or by adding an oil-based medium.

Very lean paint

Add turpentine to make very lean paint, which you can apply as a wash. The mix will dry quickly as the turpentine evaporates.

Lean paint

Add less turpentine for more dense paint. It will be more workable and some brush marks will be visible.

Fat paint

Neat paint from the tube has a high oil content and thick texture. It is easy to sculpt and most brush marks will remain visible.

Very fat paint

Adding a medium with a high oil content makes the mix fatter than neat paint, even though it may look thinner.

PUTTING IT INTO PRACTICE

This simple painting of a house plant on a windowsill was built up in several layers. Following the fat-over-lean principle, the thinnest paint was applied first, with thicker paint added on top.

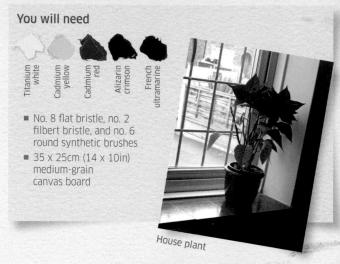

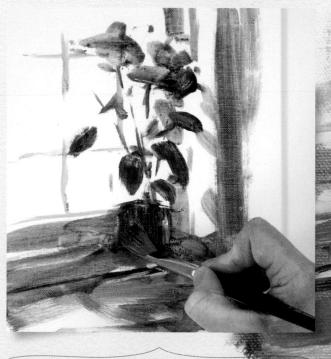

1 Lean paint

L Mix French ultramarine, cadmium yellow, and a hint of burnt sienna. Thin the mix with turpentine to create lean paint. Using a large bristle brush, paint in the basic shape to establish tonal areas. Allow this initial layer to dry fully.

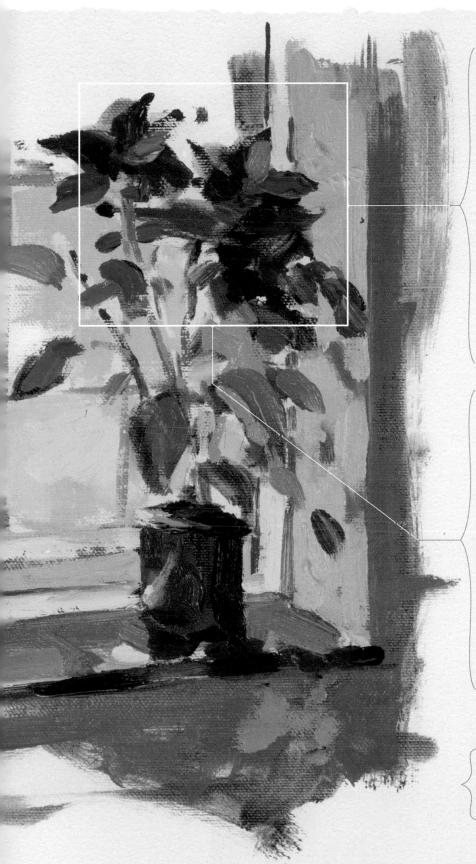

7 Fatter paint Create the form of the petals by using the same mix of colours, but with the addition of titanium white. Use less turpentine than before to make a fatter, more opaque mix. You will now be able to add texture by using thicker strokes.

3 Fat paint Add detail to the petals and leaves that are closest to the viewer using neat paint straight from the tube. Use a no. 2 filbert bristle brush to apply thick strokes.

4 Finishing touches
Switch to a no. 6 round synthetic brush and continue working up the painting, making final adjustments to opacity, tone, and colour. Use the fattest paint for these final strokes.

Layering

ADDING DEPTH AND DETAIL

Painting in layers allows you to add depth and detail to your work, with each new layer being slightly more refined than the last. You can also use the technique to create a multi-layered finish, in which a part of every layer remains visible in the final piece. Another advantage of working this way is that it gives you time to reflect on your painting as each layer dries.

Loose and refined layering

There is no limit to the number of layers you can add, as long as you follow the fat-over-lean principle (see pp.224-26). Apply your layers with loose, free strokes to achieve an energetic, painterly style, or use accurate strokes and defined edges to build depth and create more realistic work.

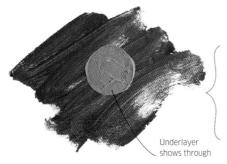

Loose layers

Using loose brushwork for the underlayer and allowing it to show through adds character to your work. The top layer adds depth.

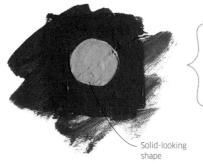

Refined layers

Build a more solid-looking image on the top layer – with crisp outlines and hard edges – by allowing the first layer to dry first.

PUTTING IT INTO PRACTICE

In this painting of a field of cows, the layering technique was used to refine the painting and bring all the elements of the final image together.

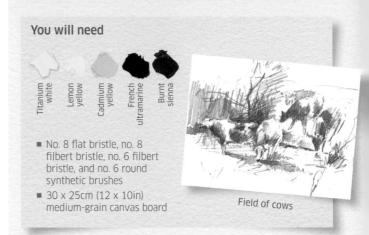

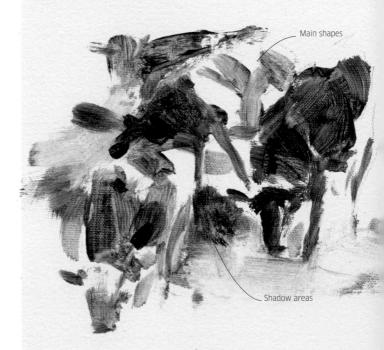

1 Underpainting layer

▲ Apply an underpainting of thinned paint to block in the shapes and provide a base for the subsequent layers. Use a large, flat brush and a mix of ultramarine and sienna thinned with turpentine. Pay particular attention to the shadows, as they may remain visible in the final painting.

2 Add colour Once the first layer is

Once the first layer is dry (being thin, this won't take long), add the second one. The aim of this layer is to add colour and build up the darker areas. Use a mix of cadmium yellow and ultramarine, applied with a medium-sized bristle brush, to introduce detail.

3 Mid tones
For the third layer,
use a more opaque mix
with a hint of white. Using
a medium-sized bristle
brush, work up the mid
tones. As the paint is
thicker, it will create an
image with more density.
Continue to refine the
shapes at each stage,
applying more colour.

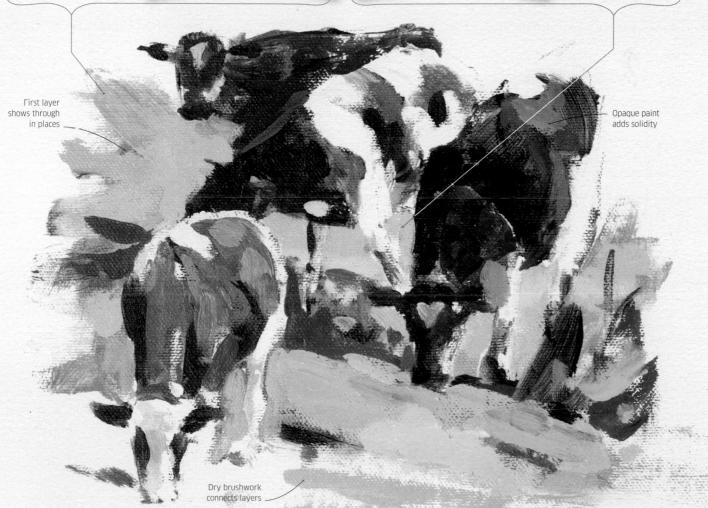

"By working in layers you can make adjustments and refresh areas that have become muddy."

/ Final details

With most of the mid tones established and the picture taking shape, use smaller bristle and synthetic brushes to add thick paint in the foreground, to refine details and correct any colour inconsistencies.

Drawing and underpainting

LAYING A FOUNDATION

The painting process is easier when you work through it in stages. The purpose of drawing and underpainting is to establish the initial structure of your painting and create a starting point from which to work. At this stage, you will draw in basic elements, establish their shape, and block in basic colour and tones.

Lean paint and simple marks

Thin the paint for your underpainting with a solvent so that it won't compromise subsequent layers, following the fat-over-lean rule (see pp.224-25). Fine detail isn't needed for an underpainting, so a larger brush will serve most of your needs.

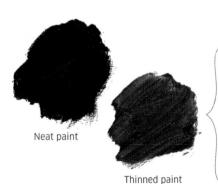

Thinned paint

Flat brush

Use a large or mediumsized brush for drawing, to prevent the urge to include

too much detail. A flat

a variety of marks.

bristle brush is versatile

enough for you to create

Thin the paint to a watercolour-like consistency. You can use turpentine, a low-odour white spirit, or environmentally friendly thinners such as citrus oil paint dilutant. The paint will spread easily and dry quickly.

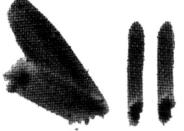

Thick lines made with flat side of brush

Thin lines made with edge of brush

PUTTING IT INTO PRACTICE

This underpainting is the first stage of a still life with apples. Basic shapes and lines, key tonal differences, and blocks of the main colours were painted in to provide a foundation for later stages.

No. 8 flat bristle brush

Drawing in the subject

1 Use a thinned mix of French ultramarine and burnt sienna to roughly sketch in the subject. You don't need to draw everything in detail at this point - you can re-evaluate and re-draw as your painting develops.

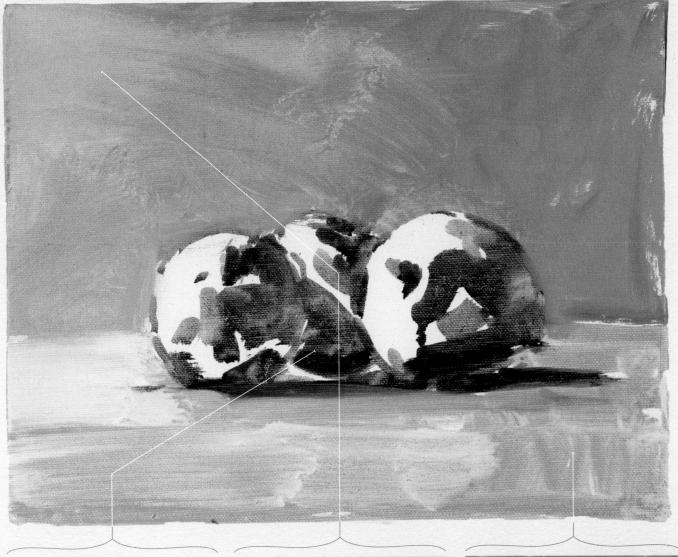

2 Establishing tonal areas
Block in the main shadow areas. Vary your
mix of French ultramarine and burnt sienna to
create warmer or cooler tones as needed.

Background tones

Apply a wash of paint to the background, adjusting the amount of thinner to vary tone. Wipe the paint if you want to lighten areas.

4 Softening shadows
Lighten shadows with a rag, not paint - it is hard to darken oil colours after lightening, so use darker tones for the underpainting.

5 Blocking in colours Apply a thinned in

Apply a thinned mix of cadmium yellow, alizarin crimson, and burnt sienna to block in the main colours of the apples with a no. 2 filbert bristle brush. Vary your mix to create colour changes and suggest the form of the apples. Keep in mind the shadow areas and adjust the tone of your mix accordingly.

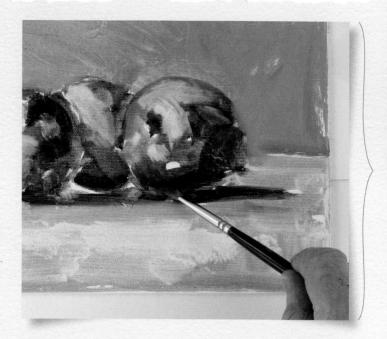

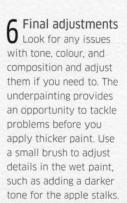

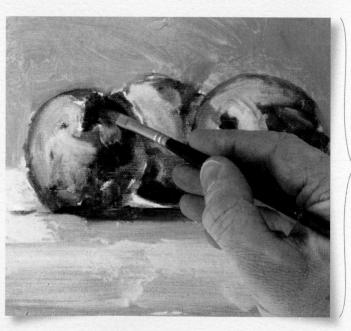

"Think of your painting as an evolution from the drawing stage, refining it so that it takes shape as a whole."

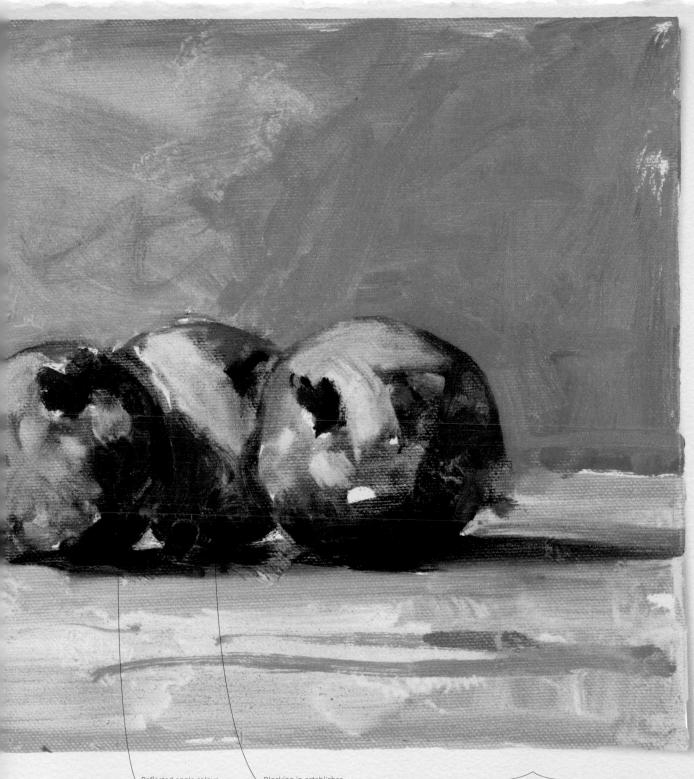

Reflected apple colour in shadows provides reference for later layers

Blocking in establishes basic colour relationships

Reviewing your underpainting
The underpainting will dry quickly due to the thinned paint. Review the finished result before you apply thicker paint; for example, you may want to keep some areas semi-transparent.

Decreasing stages

PAINTING A SMALLER AREA WITH EACH LAYER

Working in decreasing stages involves refining a smaller portion of your painting with each layer. This helps you to create strong focal points while keeping peripheral areas loose - a visual change of pace that keeps your painting interesting.

Choosing where to add detail

Cover the whole canvas in the first layer, then decrease the area you paint in each subsequent layer by about one-third. This lets you assess your painting as you work. For example, in the next layer, you could make a feature of any accidental marks from the first layer. Let each layer dry fully before adding another, and follow the fat-over-lean principle (see pp.224-25).

Layer 2 Tighten the structure with more detail and colour in the second layer

Laver 3 Use smaller brushes to add more detail

Add the finest details, shadows, and highlights to define the focal point

PUTTING IT INTO PRACTICE

This complex interior scene was simplified by working in decreasing stages. Only one corner of the room was painted in detail, but the loosely painted surrounding areas create the impression of a large space.

You will need

- No. 8 flat bristle, no. 2 filbert bristle. and no. 6 round synthetic brushes
- 40 x 50cm (16 x 20in) medium-grain canvas board

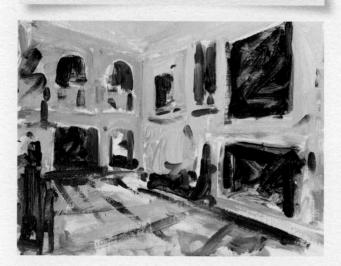

The first layer

▲ Block in the whole canvas for the first layer. Using a no. 8 flat brush, apply darker tones at this stage (this will help the highlights you add later stand out) and keep detail to a minimum.

Layer 1

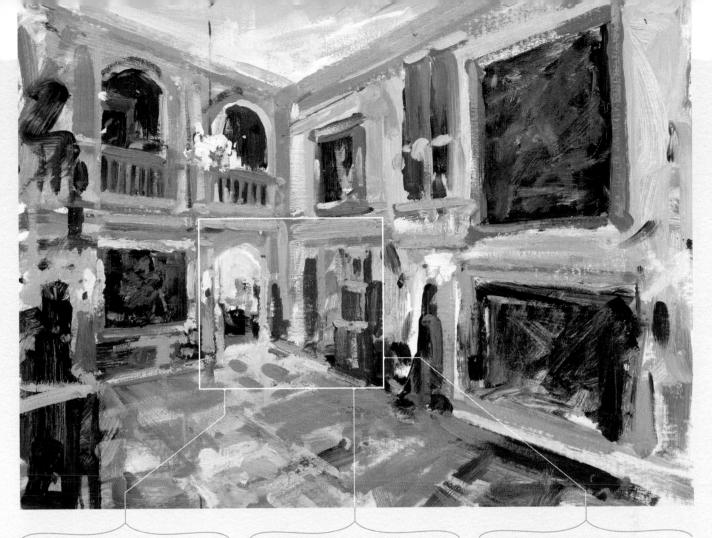

2 Building structure For the second layer, focus on a smaller section of the painting, leaving the rest as it

was painted in the first layer. Add colour, tone, and detail in the focal area to give it form.

3 Focusing in Refine the corner of the hall with a smaller brush. Add brighter colours and a greater contrast of light and dark lones to develop details such as the paintings by the doorway.

4 Final details

Darken shadows and add pale, yellow-andwhite highlights around the doorway and the edge of the painting beside it, to help them stand out as the focal points.

Layer 2

Layer 3

Layer 4

Alla prima

WORKING IN ONE SITTING

Italian for "at first attempt", alla prima is a popular method of working, in which a painting is completed in one go. It is a useful technique when working outdoors, as you need to capture the essence of a subject quickly. The technique often results in a fresh "painterly" quality.

Working methods

There are three main ways of working *alla prima*: applying a single layer of paint and working around the shapes of objects; working wet-in-wet (see pp.258-59); and painting over a wiped area. These all involve working into one wet painting and leaving it to dry when it's finished. This creates a fresh, energetic style, as there is less opportunity to overwork the painting. Careful planning before you start is essential.

Painting around a shape

"Cutting in" and painting up to the edges of objects keeps your colour mixes clean and lines crisp. Plan ahead at the drawing stage to identify which shapes to paint around.

Working wet-in-wet

You can paint layers in wet paint to a certain extent by using a soft brush and applying marks delicately with light pressure.

Painting over a wiped area

Use a cloth or rag to wipe out areas of paint. You can then paint back into the area without the risk of interfering with the underlying colour. (See also pp.256-57.)

PUTTING IT INTO PRACTICE

Working *alla prima* encourages you to look at objects as shapes, work up to edges, and focus on the negative and positive spaces equally. Identify the different planes in the composition during your initial drawing, as shown in the colour-coded sketch below, and plan your working methods accordingly.

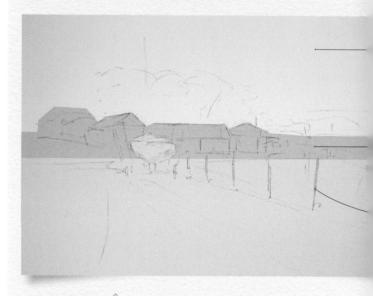

1 Mapping out

■ Draw the main elements of the scene, paying attention to the different planes (background, middle ground, and foreground) and which objects are in front of others. Begin painting at the horizon; you can work around objects in front of the horizon and revisit them later.

Mixing your paints
It's a good idea to
spend a little more time
than usual mixing your
colours in advance - the
less you need to adjust
colour and tone on the
canvas, the fresher your
painting will look.

You will need

No. 8 flat bristle, no. 4 and no. 2 filbert bristle, and no. 5 round synthetic brushes

■ 35 x 45cm (14 x 18in) medium-grain canvas board

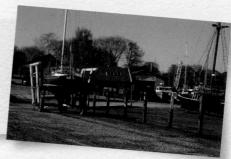

Boatyard

Background: the distant trees provide. a backdrop for the buildings and make the sky recede

Middle ground: the buildings cut into the background trees but are behind the foreground objects

Foreground: the posts and red boat sit in front of the middle ground

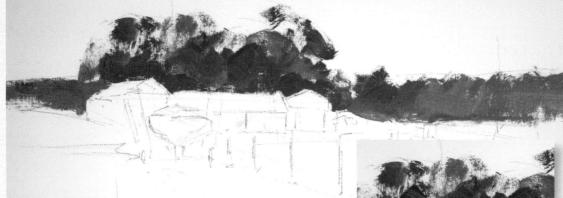

Working on the horizon

3 Start the painting at the horizon by thinly blocking in the trees. Use a flat bristle brush, which will allow you to make considered brushstrokes as you cut in and around the building. Apply a mix of French ultramarine and Naples yellow to create an opaque green.

A flat brush offers control when "cutting in"

Moving forward to the buildings

4 Apply a mix of sienna and Naples yellow to the buildings using a no. 2 filbert bristle brush, cutting in around the objects in the foreground. These negative shapes help create the shape of the boat. It is useful to paint simple shapes when working alla prima, as it is difficult to paint in detail over a wet area of paint.

5 Painting the sky
Paint the sky by cutting
in around the trees and
buildings. Use a mix of
French ultramarine and
titanium white, adding some
cerulean blue nearer the
horizon. Clean the brush
carefully after painting
into the darker trees.

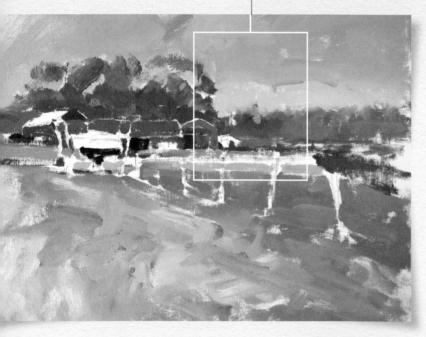

6 Filling the foreground
Paint around the posts using simple brushstrokes to complete the foreground. Mix the colours carefully to try to get them right first time. This will minimize the amount of reworking you need to do later.

7 Adding the boat
The boat is a good focal
point for the composition,
so give it a punch of colour
using a mix of cadmium
red and alizarin crimson.
Add further detail to the
background buildings
using a soft brush.

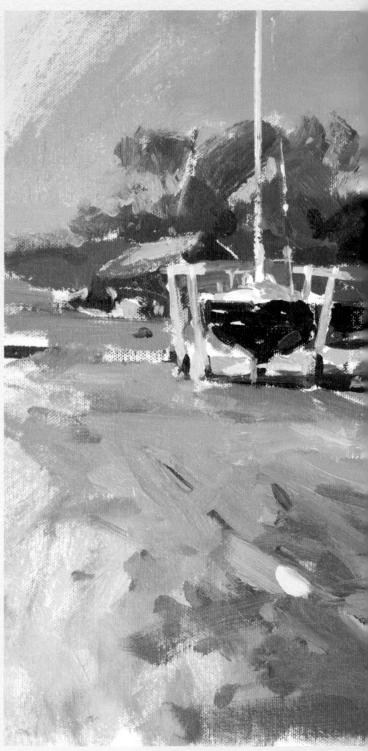

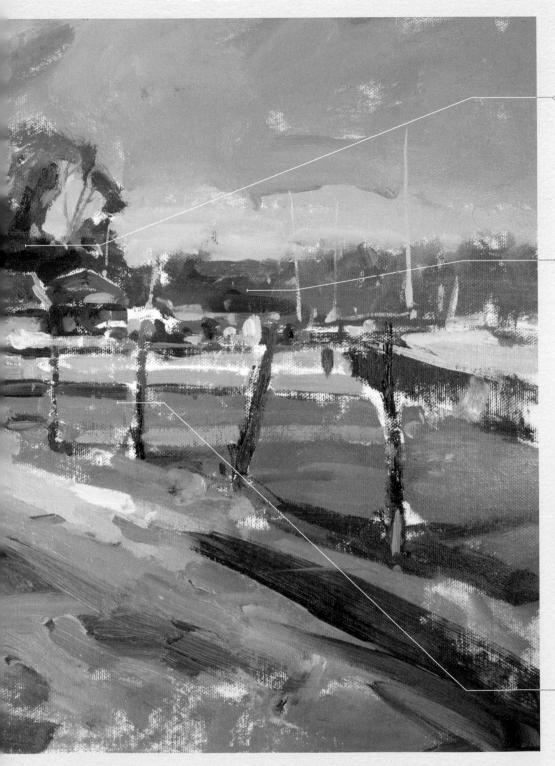

8 Making adjustments

The painting is still wet and everything that has been done so far can be developed further, wiped out, or adjusted. You can make minor alterations to tone and colour, such as darkening the base of the trees, by mixing into the existing brushstrokes.

9 Adding structure
Use medium articles Use medium and small soft-hair brushes to add the finer details, such as the boat masts, background objects, and the posts in the foreground.

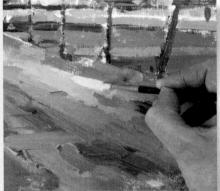

10 Finishing touches With a soft, synthetic brush, add details to bring the painting together. Use light pressure and resist the urge to go over an area too often.

"Leave an unpainted gap between objects to keep the edges clean."

Creating forms

GIVING OBJECTS VOLUME AND SUBSTANCE

Form is the three-dimensional quality of a shape or object. To paint convincingly, you need to create forms with a strong identity. For example, give buildings in the main focal area hard edges and a sense of texture, but use loose, free brushstrokes to paint a moving crowd.

Different techniques

You can create form with tone and texture, painting shadows, and adding a background – as shown in the simple cube painting, below. If you want to create a curved surface, gently blend paint from a light to a dark tone. Your use of colour, negative space, and mark making also play a part in creating form.

Tone and texture

Use three tones of blue to suggest light falling on the cube from the top right. Add texture to the two nearest sides with bold strokes.

Light source from top right

Shadow

Real objects cast a shadow, so paint one in to give the cube weight and presence. This also makes it look as if it is sitting on a surface.

Background

Add a background to give the cube context. Use a different colour and texture for the background to create a sense of contrast.

Background adds context

PUTTING IT INTO PRACTICE

This urban scene includes the solid, hard-edged forms of the buildings as well as the freer, loose-edged forms of the people. It was painted *alla prima* (see pp.234–37), starting with the background.

1 Negative space
Paint in the trees with
an initial dark mix of French
ultramarine and burnt
sienna, with a little cadmium
red and Naples yellow.
Filling in this negative space
starts to create the building's
form, and the dark mix
emphasizes the light
shining on the building.

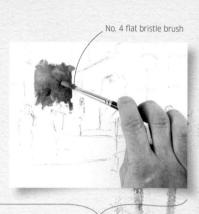

7 Shadows

Add shadows to create a three-dimensional effect. These should all face the same way and vary in length depending on the height of the subject.

High contrast
Placing a dark element
against a light one creates
contrast and separates
the forms. This figure
is well defined against
the bright ground
and the sunlit building
in the background.

You will need

- No. 4 flat bristle, no. 4 filbert bristle, no. 6 filbert bristle, and no. 6 round synthetic brushes
- 30 x 25cm (12 x 10in) medium-grain canvas board

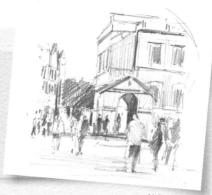

Urban scene

4 Solid shapes
Each solid shape has a shadow and a highlighted side. Use vivid, warm colours for areas of light, and more muted, cool colours to give areas of shadow depth.

Broken lines create the illusion of detail in middle distance

5 Texture
To distinguish between forms of a similar tone, use a range of brushstrokes applied in several different directions. Leaving a sliver of background between these two figures separates them and prevents the forms from looking flat.

6 Movement
Suggest movement and energy with looser strokes and less detail. The dry brushstrokes used here give the marks a light, free touch.

No. 6 round synthetic brush

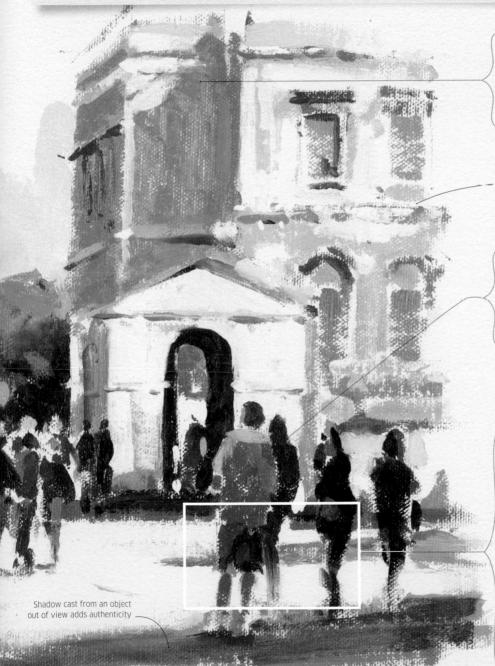

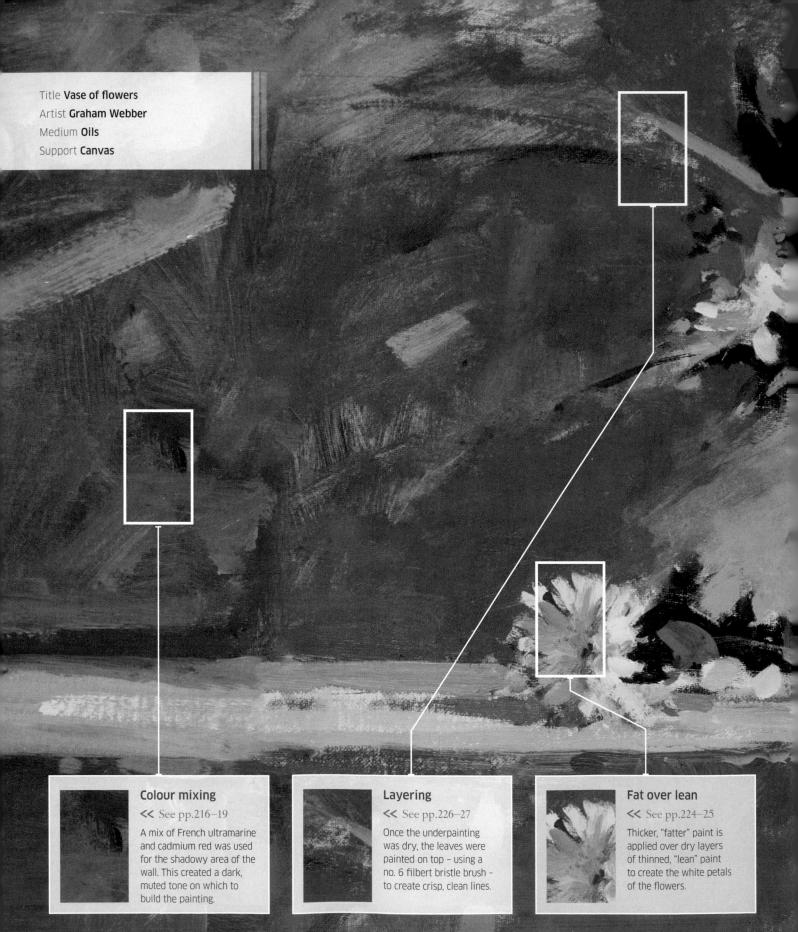

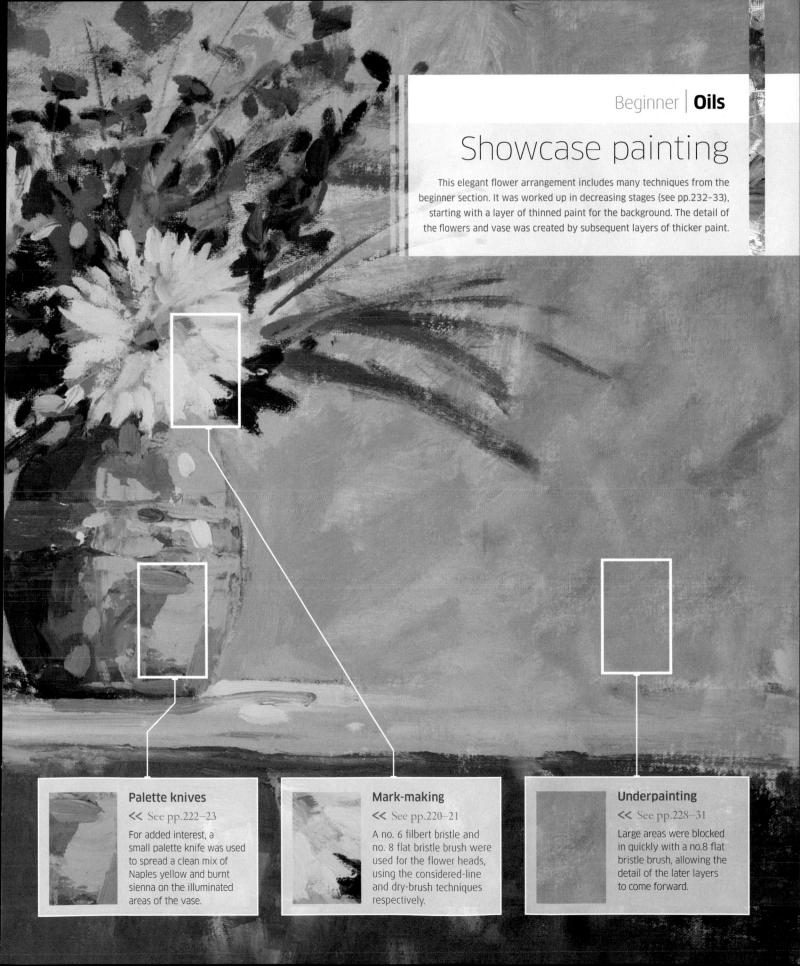

Aerial perspective

CREATING DISTANCE THROUGH COLOUR

The greater the distance between the viewer and an object, the greater the haze of atmosphere between them. This makes colours look gradually cooler and less saturated, the further away an object is. You can emulate this effect to create an impression of depth in your work.

Colour and contrast

Visually, cool colours recede and warm colours come forward. Keeping this in mind, you can vary your colour mixes, introducing warm and cool hues to indicate degrees of depth. Contrast also diminishes and softens with distance, so keep high contrast and detail for the foreground.

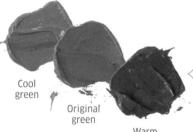

Warm green

Cool and warm

Add white and ultramarine to your mix to create a cooler, lighter green for distant subjects. Add a little cadmium red to make a warmer, deeper colour for the foreground.

Foreground – high contrast Use bold colours and areas of high contrast for objects in the foreground.

Background - light colours
Use white to desaturate and
lighten colours in the background
to achieve a sense of depth.

PUTTING IT INTO PRACTICE

Working from the horizon forward, this study of a mountain scene demonstrates aerial perspective, creating a painting with a sense of space and distance.

You will need

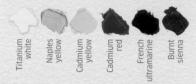

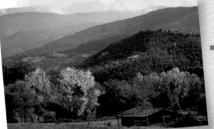

- No. 8 flat bristle, no. 4 flat bristle, and no. 2 filbert bristle brushes
- 25 x 30cm (10 x 12in) medium-grain canvas board

Mountain scene

Less saturated blues help make the distant mountains recede

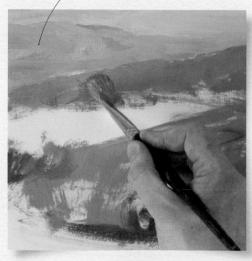

1 Background

L Starting at the horizon, paint the most distant mountains with a mix of French ultramarine, Naples yellow, and a little cadmium red using a no. 8 flat brush. Lighten the mix with titanium white for the sky, so that it is paler than the mountains. Keep all detail to a minimum.

2 Middle distance With a no. 4 flat brush, paint the mountain in the middle distance, adding more cadmium red and using less white in the mix. Use coarse brushwork to suggest more detail.

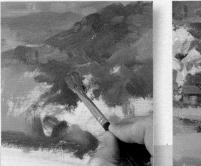

Foreground

Add more warm colours, such as cadmium red and sienna, to bring objects forward. Use a no. 2 filbert to add lighter and darker tones, and create contrasts in the foreground trees.

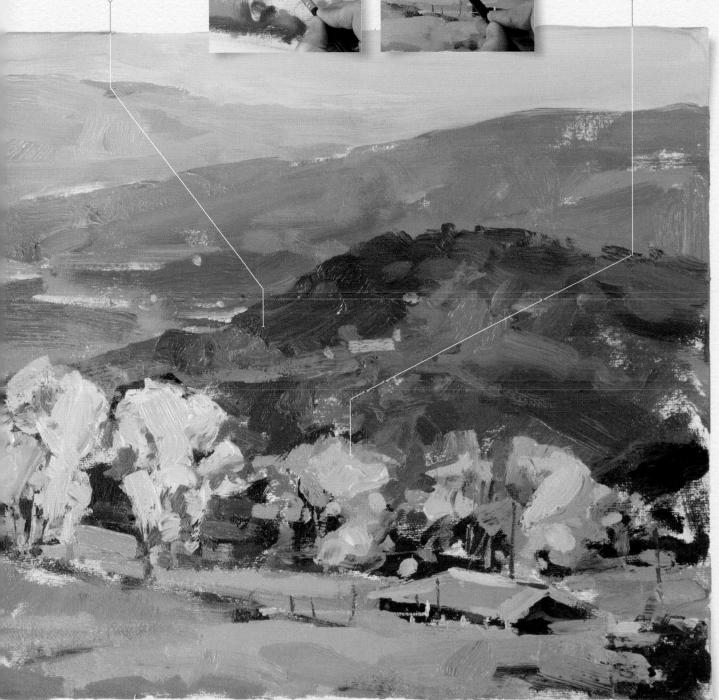

Blending

MIXING COLOURS INTO EACH OTHER

Blending allows you to create subtle changes of colour, which is great for shading and for giving objects realistic form. You can also bring your point of interest into sharp focus by blending other areas of your painting to soften and blur them. A soft brush is the traditional tool for a delicate effect, but you can also use a palette knife, your fingers, or a rag to blend the colours for a more impressionistic effect.

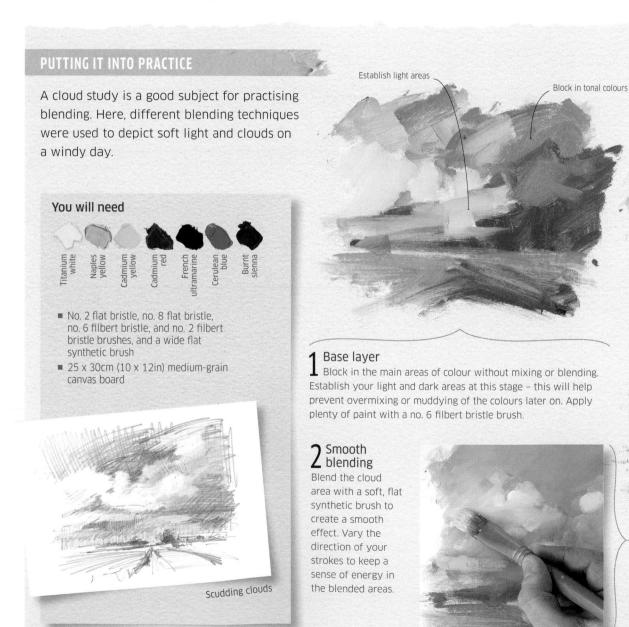

Blending tones

To blend graduated tones, try starting with three basic tones: light, mid, and dark. You can combine these to make intermediate tones, then blend them together to create a smooth transition. Blend from dark to light, because once white is added to wet paint, it is hard to darken it without creating a pastel hue.

From light to dark Mix a light, mid, and dark tone of a colour, and paint

tone of a colour, and paint them next to each other. French ultramarine is shown here.

Intermediate tones

Combine the light and mid tones to mix an intermediate tone, which you can place in between. Do the same for the mid and dark mixes.

Smoothing the transition

Gently soften the areas in between the tones with a soft brush, your finger, or a rag to create a graduated blend.

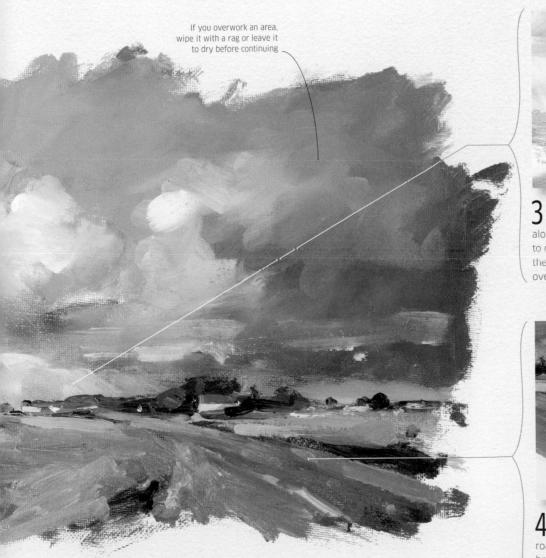

Blending with fingers
Create the effect of distant rain along the cloud line. Use your finger to drag the wet paint down to meet the horizon, being careful not to over-blend it.

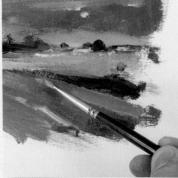

Coarse blending
Scrub together the colours in the road area with a no. 2 flat bristle brush. This coarser blending technique brings details forward and works well in the foreground.

Impasto

ACHIEVING SCULPTURAL EFFECTS

Oil paint has a rich, buttery quality and the impasto technique – in which you apply thick, undiluted paint to the canvas – makes the most of this trait. While bearing in mind the "fat over lean" rule (see pp.224–25), you can use impasto to sculpt the surface of your painting and produce highly textured areas. You can also make a feature of the shadows and highlights created by the thick paint.

Impasto effects

You can use impasto to create focal points or to emphasize elements in the foreground, achieving contrast by painting thinner layers in the background. Alternatively, you can complete entire works in one thick layer, creating large relief paintings with peaks of paint. Whether applying paint with a palette knife or bristle brush, the aim is to let your method of working show, remembering to apply the thickest paint last. Add paint in one layer to avoid losing its purity and quality.

Brush impasto

Create a thick impasto effect by loading paint onto the brush and rolling it onto the canvas. The paint will retain the brush marks, adding relief to the surface. Bristle brushes are ideal for this as they are rigid enough to sculpt the paint.

Palette knife impasto

A palette knife is a good tool for adding thick, clean mixes to your work. You can also lift peaks of paint like icing on a cake and create great effects by cutting and sculpting the paint on the canvas.

PUTTING IT INTO PRACTICE

An old artist's table, splattered with dried paint and set with jars of turpentine, makes an ideal subject for the impasto technique. Remember to let layers of paint dry fully and to follow the "fat over lean" rule.

1 Adding texture
Using a no. 6 filbert,
roll a loaded brush across
the canvas, leaving thick
brushstrokes and a buttery
texture. You can modify
the colour at a later stage,
but the texture will remain,
giving the painting a tactile,
sculpted finish.

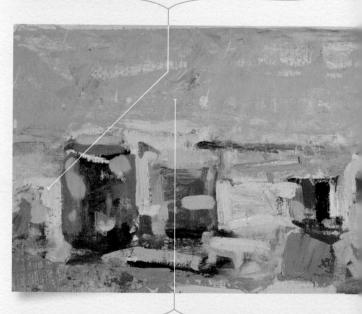

2 Creating a smooth background

Using a long, narrow palette knife, plaster the canvas with a well-mixed layer of grey-blue paint. Keep the paint thick but with a smooth texture, to create a solid background that won't compete with elements in the foreground.

You will need

No. 4 flat bristle, no. 8 flat bristle, no. 2 filbert bristle, and no. 6 filbert bristle brushes

- Long, narrow palette knife
- 30 x 50cm (12 x 20in) medium-grain canvas board

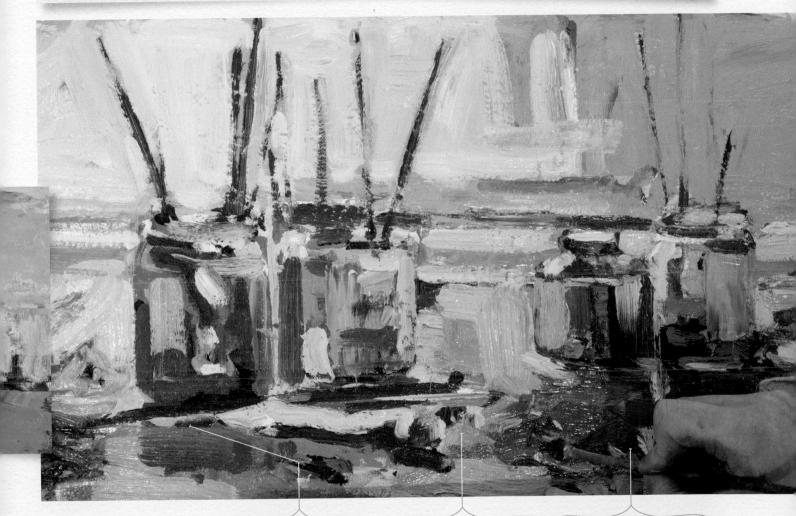

3 Stippling for softer edges To add a different texture, use a no. 8 flat brush for some stippling, adding small dots of burnt sienna mixed with French ultramarine into the shadow areas. The effect will provide a varied colour base for subsequent layers, as well as a softer edge for the shadows.

Soften shadows

Vary the base colours

Add texture

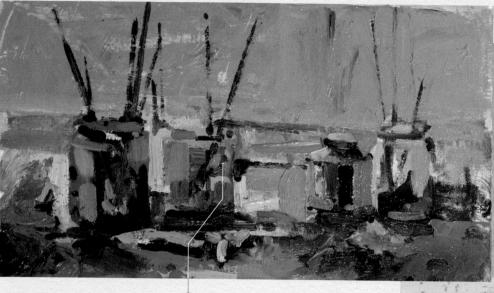

filbert brush to add colour to the tubes of paint in the foreground. The thicker your applications of paint, the closer objects will seem to the viewer. Apply the same colours used here in other areas of the painting to help unify the separate elements and prevent them from looking "cut out".

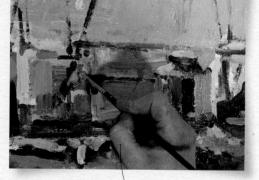

Use thick applications of paint in the foreground

"Impasto is the perfect technique for creating bold artworks that allow your method of working to show through."

Thick, smooth background applied with palette knife

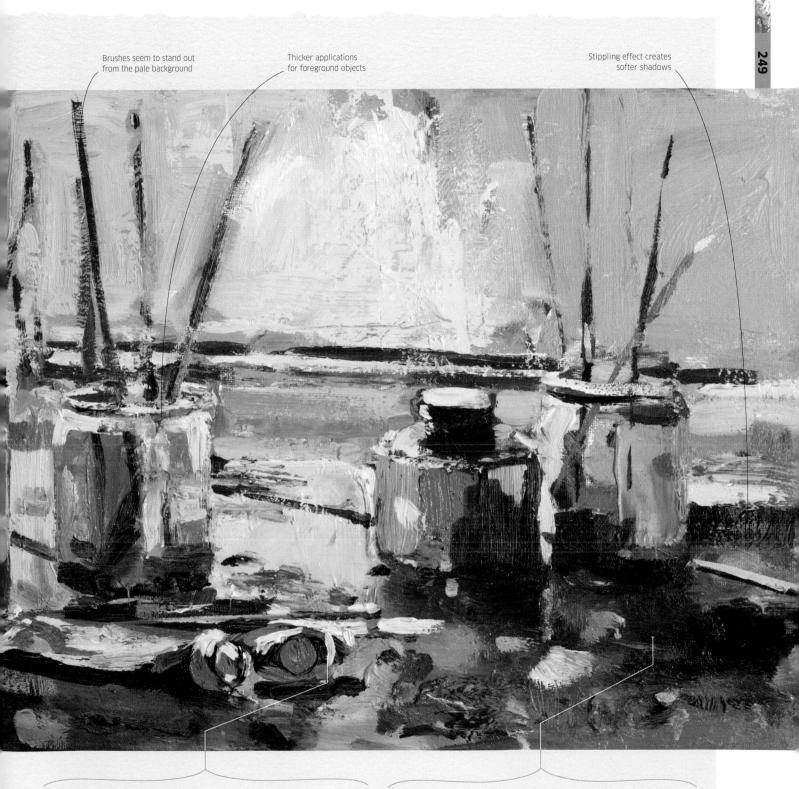

5 Detail and variation Once the previous layers have dried, you can add further details and repaint lines. Use "fatter" paint to prevent any cracking. If you are using the same unwashed brush from the previous step, you can roll paint from the top of the bristles to vary the colour.

6 Adding shadows
Using the dry-brush technique (see pp.220–21) and a large brush, drag light and dark paint over the thick underlayer to emphasize its texture. Finally, add shadows to peaks of paint to enhance their three-dimensional quality.

Sgraffito

SCRATCHING THE SURFACE

Sgraffito means "to scratch" in Italian and you can use this technique to great effect in all kinds of painting. By scratching off areas of a layer of wet paint, you can reveal underlying paint below. Tools for removing paint can range from the end of a brush handle for fine lines to a filling knife for scratching off large areas of paint.

Creating movement and texture

Use crosshatching or scribbling to accent an area of fine detail, to sharpen up lines, or to create texture and movement. You can also use sgraffito on layers of dried paint, which will result in stronger lines. Use this method freely on primed board, but be wary of damage if using canvas.

Vary markings

Manipulate the palette knife to create markings of varying width. Also, use the layer beneath to dictate the colour, tone, and energy of the scratches you are making.

Add movement

If you have made an area too dark or opaque, you can scratch the surface to add interest and movement to the painting.

Reveal contrasts

Try painting over a layer with a complementary colour, then scratching into the top layer to reveal the vibrant complementary colour beneath.

PUTTING IT INTO PRACTICE

The sgraffito technique is perfect for portraying this grassy scene, in which scratches and scrapes through layers of paint help to evoke the textures of grass and scrub.

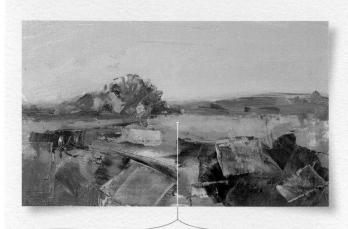

A bold base

You can treat sgraffito as you would mark-making with a brush or palette knife (see pp.220–23). Use a household filling knife to apply paint to areas of broad, bold working, such as the base colour of the foreground grass.

"Use sgraffito to accent an area of fine detail, to sharpen up lines or to create texture and movement."

You will need

- No. 4 filbert bristle, no. 4 synthetic round brush
- Medium-narrow palette knife
- Household filling knife
- 20 x 30cm (8 x12in) mediumgrain canvas board

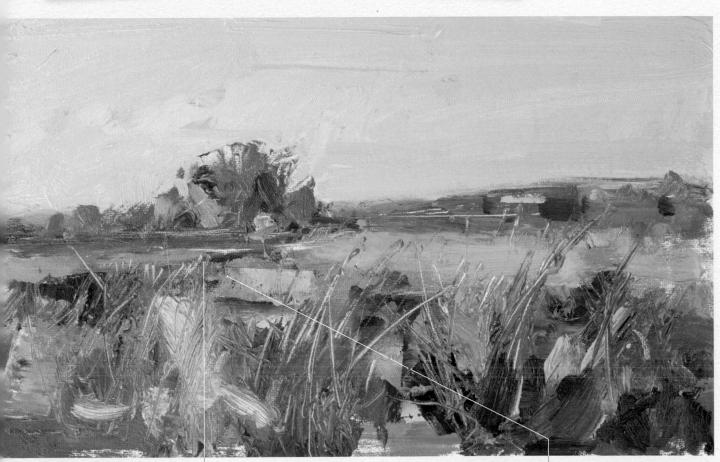

Multiple markings
Apply more paint with a no. 4 filbert bristle brush. Partly cover the initial filling knife markings, then use a medium-sized palette knife to create a variety of scratch marks in all directions. You can rub over areas with a rag or your finger to reduce the severity of a mark.

Final details
Lastly, with the handle of a small paint brush, refine the details and create a sense of depth and scale with finer marks in the background. Paint over dry marks with a dry brush for added texture, or apply glaze to help them blend in while retaining their texture.

Scumbling

ADDING A LAYER OF BROKEN COLOUR

Scumbling is a technique used to create depth and texture by randomly scrubbing thin paint over an existing layer. The original paint shows through and, in the eye of the viewer, mixes with the scumbled layer. The technique can be used to suggest movement, give life to bland areas of solid colour, and create subtle changes in atmosphere.

Applying a layer of scumbling

Before scumbling, always make sure the initial layer of paint is dry. That way, you can push and scrub paint over the top without disturbing the underlayer. The less paint you have on your brush, the easier it is to achieve the broken pattern indicative of scumbling. Remove any excess paint with a rag to achieve the level of cover you want. Use larger bristle brushes to cover bigger areas quickly, and because they are more durable. You can also scumble with a sponge, rag, or using your finger.

Scumbling with an impasto medium

Adding an impasto medium to your mix before starting will stiffen the paint and give a more textured finish. Roll the brush loosely across the canvas to prevent too much paint being applied.

Scumbling with a dry brush

If using paint without an added medium, dry the brush on a rag first. Apply paint to the canvas by working quickly across the area with random scrubbing movements, leaving behind small amounts of paint.

PUTTING IT INTO PRACTICE

In these three paintings, scumbling was used to create a variety of effects. Three different tools were used to change the intensity of colours, introduce texture, and emphasize depth.

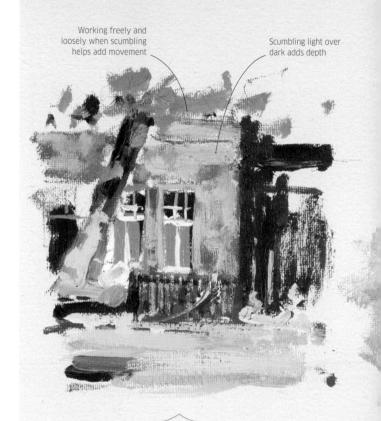

Adding texture

A layer of scumbling was used on the shadows and darker areas of the building to give it a sense of texture. For the highlights on the rough surface of the brick, a dry opaque colour was added. A rag was used to apply and move the paint around broad areas, while a brush was used for the finer details.

Emphasizing colour

Scumbling was used here to emphasize the bright colour of the poppy fields. A little cadmium red was scumbled over darker areas in the background with a rag, to highlight distant poppies and create a sense of depth. In the foreground, thicker red was scumbled with a brush to bring the area forward.

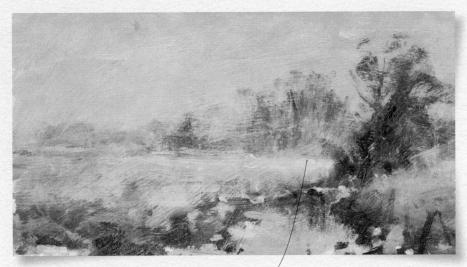

Subduing colours

In this misty river scene, scumbling was used to subdue the colours and create a sense of swirling mist on an autumn day. If a painting has only slight variations in tone and colour, as is the case here, scumbling can introduce energy and provide an atmospheric effect that finishes the piece well.

Scumbling with a bristle brush and multidirectional strokes adds movement and energy Use less paint than normal when scumbling to make the effect easier to control

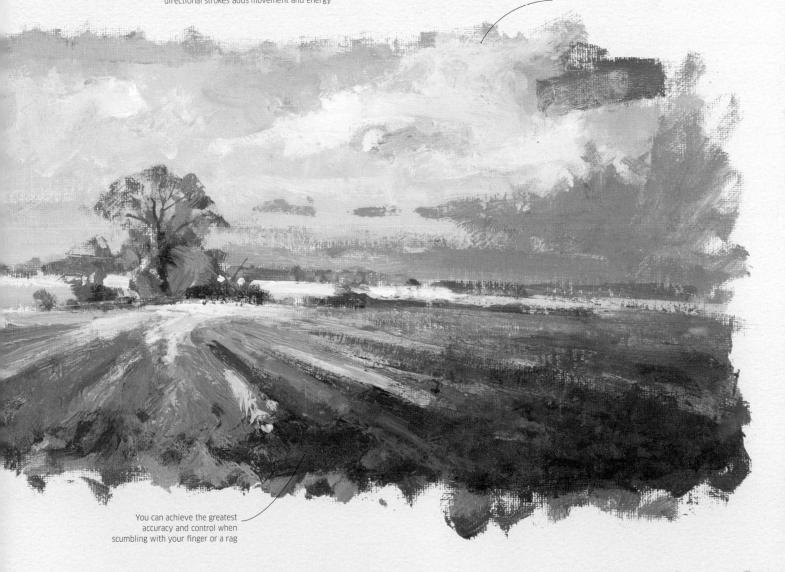

Broken colour

USING MARBLING EFFECTS

Paint applied to the canvas before it is mixed into its final colour is known as "broken". This creates a marbling effect with streaks of colour visible in the final brushstroke. It is particularly effective in areas with several different colours, or where you want to suggest movement. The technique is similar to scumbling (see pp.252–53), although broken colour uses wet paint rather than several layers of dried paint.

Degrees of mixing

Broken colour is a form of optical colour mixing in which your brain produces the illusion of a mixed colour. Once you apply a brushstroke, you can continue to mix on the canvas to modify the degree to which the colour is "broken", as shown in the examples below.

Highly broken

Fench ultramarine and cadmium yellow have been loaded onto opposite sides of a no. 5 round synthetic brush and applied directly to the canvas.

Moderately broken

The same colours have been mixed loosely on the palette first, and then mixed again on the canvas. This creates a finer degree of broken colour.

Slightly broken

Finally, the colours have been mixed more thoroughly on the canvas. A hint of yellow is still visible, but the final mixed colour is more dominant.

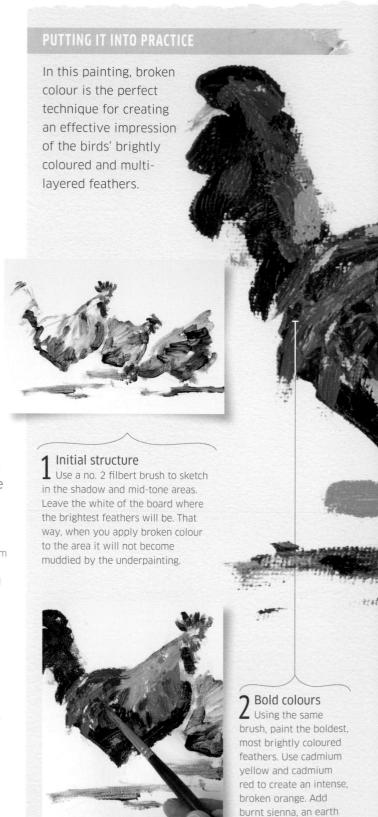

colour, to the mix for

the darker areas.

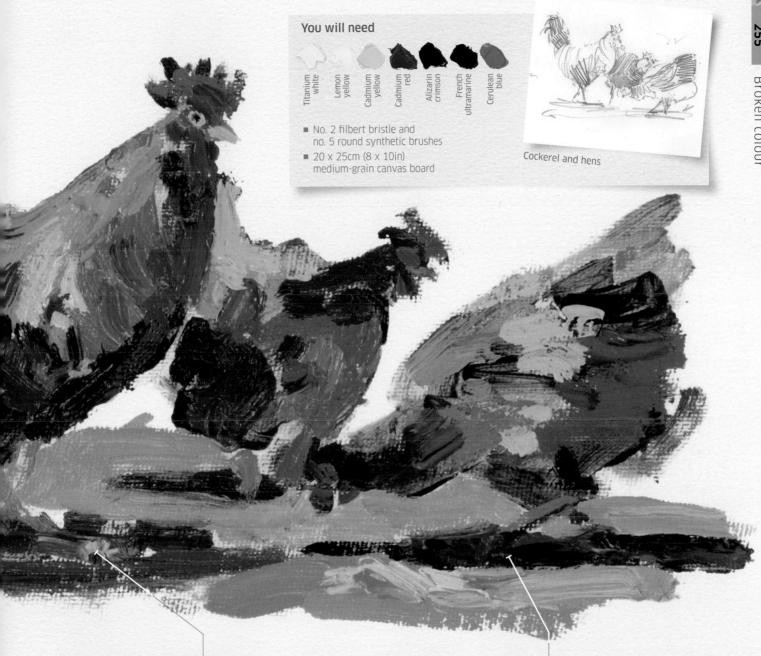

3 Shadow areas
Use the technique more subtly in the shadow areas. This will prevent them from looking too dull and ensure that the full palette of colours is used across the painting, creating harmony and balance.

4 Adding colour
Use a no. 5 round synthetic brush and a mix of blue and purple to intensify the shadows. A mix of French ultramarine and alizarin crimson will create a vibrant, intense purple.

Wiping and scraping back

REWORKING WET PAINT

Wiping and scraping involves spreading and removing wet paint from the canvas. This technique creates a range of textures that are useful for the initial layers of your painting. You can also use it to block in large areas, mix colour on the canvas, and make corrections or additions

Tools for wiping and scraping

You can remove paint with different tools to create a range of textures. If you use a palette knife to scrape off wet paint, you can also spread and mix the excess paint over other parts of the canvas.

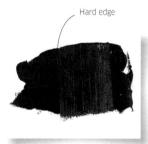

Large palette knife

Scrape with the side edge of a large palette knife or decorator's filling knife to create a smooth, flattened area. Use a single action, applying light pressure and holding the knife at a consistent angle.

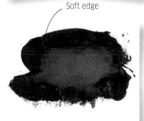

Rag

Wipe with a rag to create a softer effect. Change strokes to create different finishes, from broad sweeps with the flat of your hand to finer details with the tip of your finger.

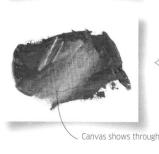

Small palette knife

Scrape vigorously with a small palette knife to reveal the colour or texture of the canvas. The harder you press on the blade, the more paint you will remove.

PUTTING IT INTO PRACTICE

This painting is completed *alla prima* (see pp.234-37), or in one sitting, which means the paint remains wet enough throughout to rework.

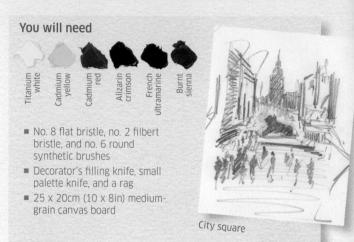

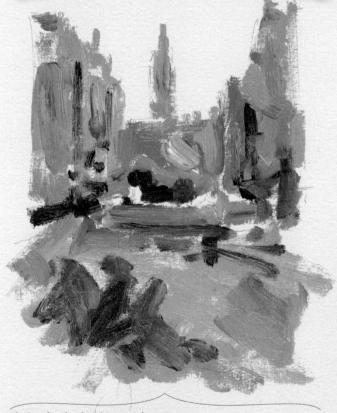

Apply the background

■ Start with fairly thick paint, so that it can be manipulated later. Apply greys mixed from French ultramarine, cadmium red, and white to the buildings, and a dark mix of ultramarine and sienna to the main areas of shadow.

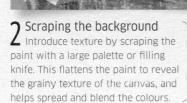

Adding detail back in
After scraping, paint in details
to define the buildings. Cut in (see
p.234) around the buildings to paint
the sky using pale tints. Apply these
to the light areas in the foreground
as well, to balance the painting.

4 Wiping the foreground
Use a rag to wipe the area where you will paint the crowd figures.
This creates a dry area that you can paint over.

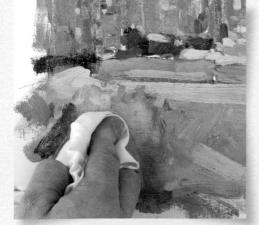

5 Finishing touches
Create focal points by
introducing touches of strong
colour to figures in the crowd.
Finish by scraping areas at the
back of the painting with a small
palette knife. This blurred effect
creates a sense of distance.

Wet-in-wet

APPLYING LAYERS OF WET PAINT

Wet-in-wet is a technique in which fresh paint is applied on top of an area that is still wet. It can be used to create a single-layered painting, when you want to change a colour midway through a painting, or when you want to create soft, subtle changes in colour and tone. Wet-in-wet is especially good for painting water and skies, which often include soft shapes, movement, and blending.

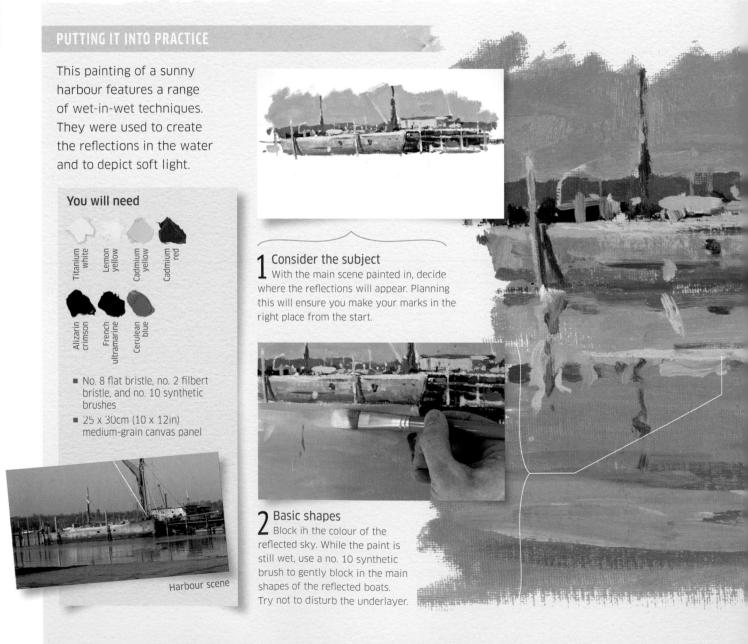

Wet-in-wet effects

One of the challenges of painting wet-in-wet is controlling how much the colours blend. If you use a soft-hair brush and apply only light pressure, you can lay "pure" colour without disturbing the underlying paint. If you use a firm bristle brush, on the other hand, you will stir up the underlying paint and mix the two colours. Both techniques can be used to great effect.

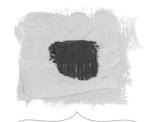

Soft-hair brush

The top layer of blue paint was applied with a soft-hair synthetic brush using light pressure. The colours remain distinct and pure, and the edges are well defined.

Bristle brush

The top layer of green paint was applied with a bristle brush using firm pressure. Some of the yellow paint has been dragged into the top mix. The edges are soft.

Overworked paint

Try not to overwork an area of wet-in-wet. This can disturb the underlayer, cause the layers to fully combine, and lead to unwanted colour mixes.

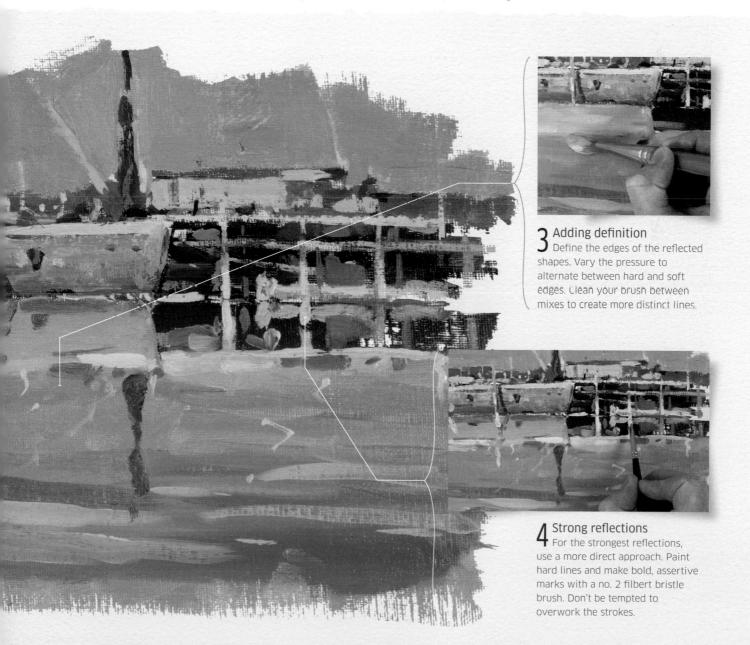

Texture

MAKING ADDITIONS TO MIXES

Adding texture to your work can introduce unusual and striking effects. Try mixing additional material into the paint, such as sand, sawdust, or chalk. Alternatively, press coarse fabric onto the canvas to leave textured imprints. You can then paint on top of the resulting textures to incorporate them into your finished painting.

Materials and effects

Additions can create texture or alter the quality of the paint. Whenever you add a substance to oil paint, the balance of pigment to binder and filler will change, so add sparingly to ensure the longevity of the painting.

Sand

Adding sand not only gives a great textural effect, but also, once dry, provides a good base for dry brushwork.

Coarse fabric

Oil paint's thick consistency is ideal for showing imprints of patterns and textures. Thick paint has more oil and will dry slowly.

Chalk

The addition of chalk will dry the paint, giving it a matt finish. It will also tend to absorb oil from subsequent layers of paint.

Sawdust

Sawdust, when overpainted, can enhance the effect of dry-brushwork and is great for stony foregrounds or beaches.

PUTTING IT INTO PRACTICE

The sand, shells, seaweed, and stones in this beach scene were ideal for exploring texture. Adding sand and sawdust to the paint mix, and applying it thickly with a palette knife, created a three-dimensional effect.

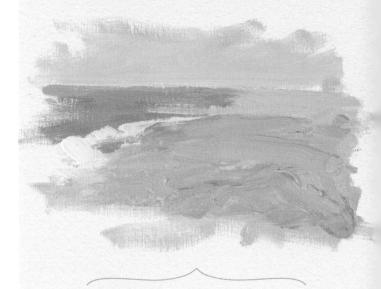

1 Initial scene
Paint the basic scene with thick strokes using a no. 4 flat bristle brush. Use Naples yellow, burnt sienna, and titanium white for the sand, French ultramarine and white for the sea, and

ultramarine, cerulean, and white for the sky.

"Include additional textures in your work, and then paint into and on top of them to create a rich, multilayered painting."

You will need

- No. 4 flat bristle and no. 5 round synthetic brushes
- Coarse sawdust, sand, palette knife
- 20 x 25cm (8 x 10in) medium-grain canvas board

Mix of cadmium yellow and burnt sienna, with a hint of French ultramarine and titanium white

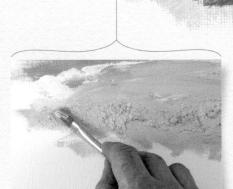

Sawdust mix Build up the foreground, using a no. 4 flat bristle brush, by adding sawdust to a mix of burnt sienna and titanium white with a little cadmium yellow.

Sand mix 3 Sand mix
Create texture in the middle distance beach area by adding sand to the mix. Add the sand on the palette and, once mixed with the paint, apply with a no. 4 brush.

Palette knife 4 Use a palette knife to suggest rocks in the foreground, then paint darker shadows around the raised areas with a no. 5 brush, to exaggerate the three-dimensional effect.

Tonking

REMOVING EXCESS PAINT

A build-up of paint can make your work unmanageable. If this happens, you can either wait for the paint to dry or use a technique called tonking. This involves pressing a sheet of absorbent paper, such as newspaper, onto the surface and then slowly peeling it off to remove some of the paint. The texture left behind can be a feature in itself, providing a contrast and a new surface into which to work.

Lack of definition .

PUTTING IT INTO PRACTICE

Excess paint has been removed from this study of a tree by tonking. This allows an area to be reworked to increase contrast and clarity.

You will need

Titanium white Naples yellow Cadmium yellow Cadmium red French Ultramarine Sienna

- No. 4 flat bristle, no. 8 flat bristle, no. 6 filbert brushes
- Sheet of newspaper
- 40 x 50cm (16 x 20in) medium-grain canvas panel

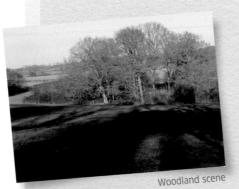

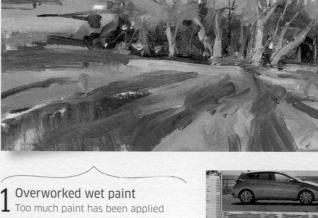

1 Overworked wet paint
Too much paint has been applied
around the base of the trees, leading
to a loss of contrast, depth, and
definition. Colours have mixed
and blended together.

2 Apply newspaper
Place a sheet of newspaper onto
the surface, smoothing or pressing
down over the problem area. Take
care not to manipulate the paint
beneath too much.

Remove paper Carefully peel back the newspaper to reveal the painting underneath. Different types of paper will have different effects. Impermeable paper will remove less paint from the surface of the painting than absorbent paper.

Excess paint adheres to newspaper

4 Final painting
Now you can apply fresh colour without the paints mixing on the canvas. Here, more detail and contrast have been added to the distant treeline, fresh colour has been introduced to the grass, and a pure mix of French ultramarine and white has been painted into the tops of the trees.

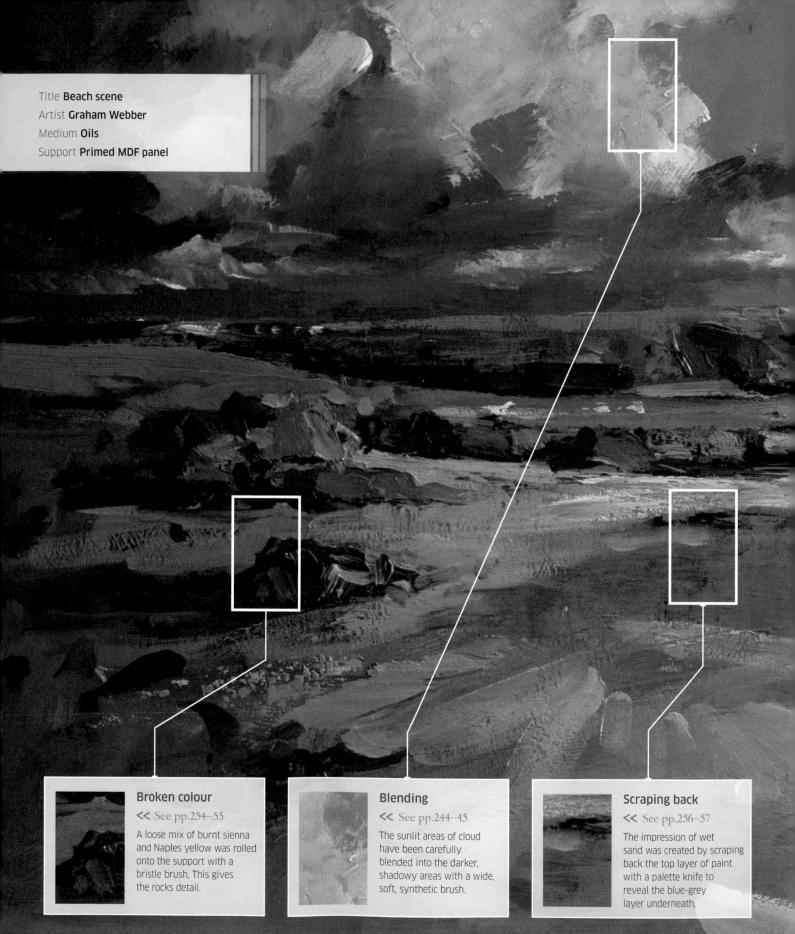

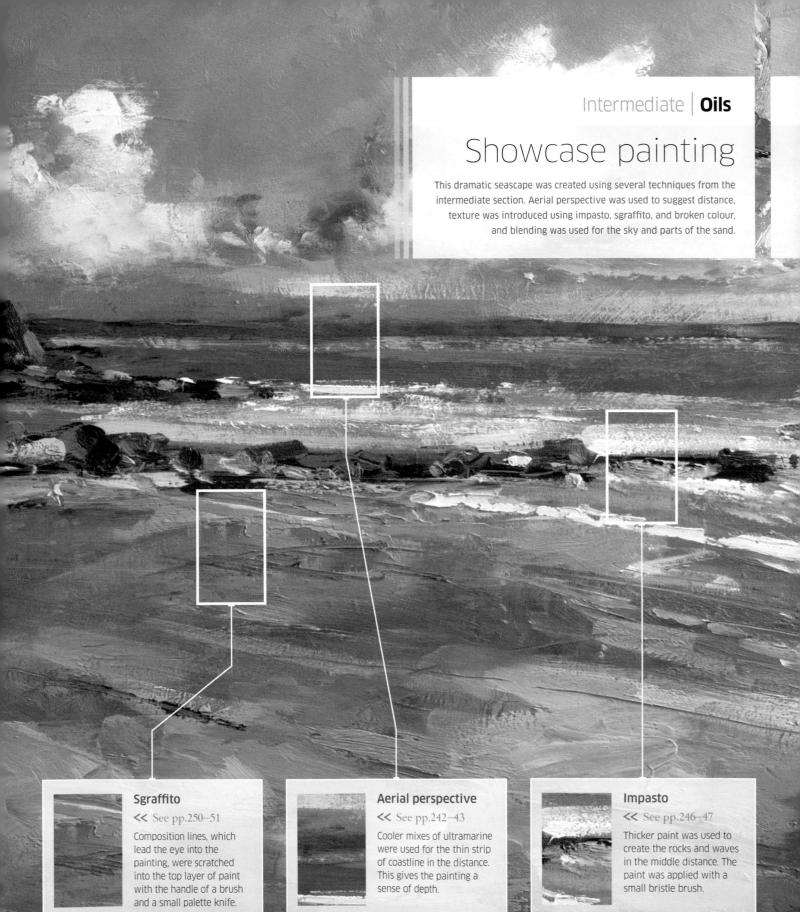

Ground colour

PAINTING BACKDROPS

The ground is a layer of paint applied on top of a primed surface before painting begins. If you paint directly onto canvas primed with white paint, you risk creating a painting in too high a tonal key: using a mid-tone ground will allow you to control the tonal range better. A coloured ground especially when allowed to show through in places - will also help unify a painting.

Grounds and effects

Different coloured grounds will influence the colours you subsequently apply, while textured applications can add interest. Allowing ground colours to show through in areas will help bring elements together.

Blue ground shows through green circle to unify image

White ground

On a white ground, areas of thin paint will seem to "glow" where the white shows through. However, the high contrast can make it difficult to control the painting's overall tone.

The dark ground wash was applied generously to provide an opaque layer, leaving visible brushstrokes and variations in tones. The blue ground influences the green colour of the circle.

Complementary ground

The red ground is complementary to the green and highlights the image, making the circle vibrant and intense. Using a coloured ground in this way can help shift the eye to the point of interest.

PUTTING IT INTO PRACTICE

A mid-toned ochre background was used in this still life. Allowing the ground to show through gives the piece a natural warmth and helps link the elements.

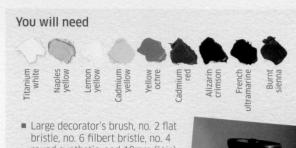

- round synthetic, and 19mm (3/4in) flat synthetic brushes
- 25 x 30cm (10 x 12in) medium-grain canvas board

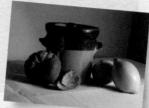

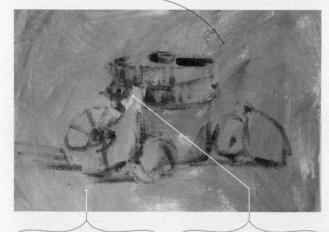

Apply the ground L Use a decorator's brush to apply a ground of yellow ochre, French ultramarine, and titanium white, varying the colour and tone slightly as you work across the canvas.

Sketch shapes Use a no. 2 flat bristle brush to draw the subject with a French ultramarine and burnt sienna mix. An accurate sketch will help you plan where to let the ground show through.

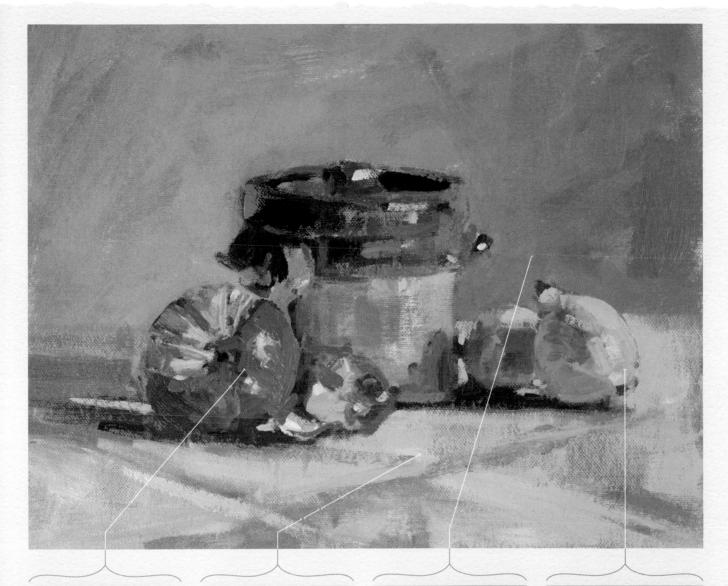

3 Block in main shapes
Add a background of French
ultramarine and Naples yellow.
Make light brushstrokes with a
no. 6 filbert to limit the amount
of paint on the surface and allow
the ground to show through.

4 Develop tones
With a 19mm (¾in) synthetic brush, use a dry-brush technique to apply a mix of titanium white and burnt sienna to the tablecloth. Make sure the ground is showing through to unite colours.

5 Add detail
With the same brush, add
detail to the fruit and pot. Apply
dry-brush marks of yellow ochre
and French ultramarine around
the painting where the ground
has been covered too much.

6 Finishing touches
With a no. 4 round synthetic brush, place final highlights on the pot and add detail across the painting, refining it and darkening areas of shadow.

Skin tones

PAINTING FLESH COLOURS

The colour of our skin constantly changes, becoming paler or more flushed as it adapts to the environment. It is hard to paint skin with a single colour, so it makes sense to use a variety of colours and tones. Oil paint is an ideal medium for painting portraits, as the slow drying speed allows greater time to reassess and adjust colours as the portrait progresses.

Light source

Skin can appear paler, yellower, and cooler the nearer it is to a light source, while areas of shadow will seem to have greater depth and warmth. Therefore, to prevent the shadows dominating, paint them using cooler greens and violets. These cool colours will seem to recede slightly, and will complement the reds, yellows, and oranges in the lit areas of skin, giving the portrait a sense of energy and life.

Subdued palette

Use duller colours than you might think when starting a portrait: it is easier to add richer colours later than it is to knock back areas of bold colour. Assess the highand mid-tone areas, and consider the shadow colours. Try painting your own hand, applying basic tones and colours before adding detail, and then apply what you have learned about skin tones to painting a portrait.

Flesh tones palette

A good basic palette for portrait painting, regardless of the subject's complexion, should include:

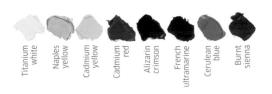

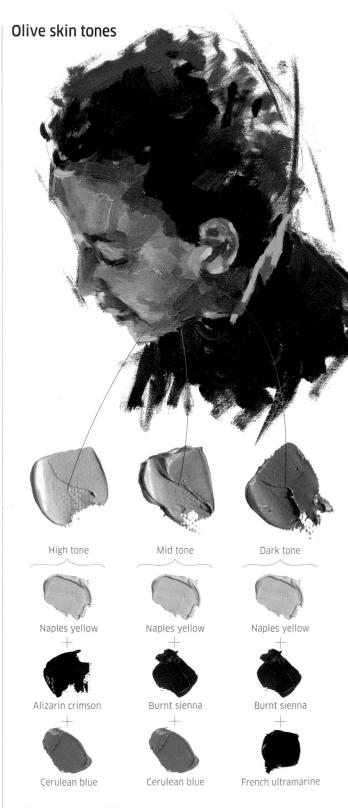

Palette for olive skin

You can create a good range of tones for olive skin using just five colours. Use alizarin crimson instead of burnt sienna for highlights, and French ultramarine instead of cerulean blue for shadow areas.

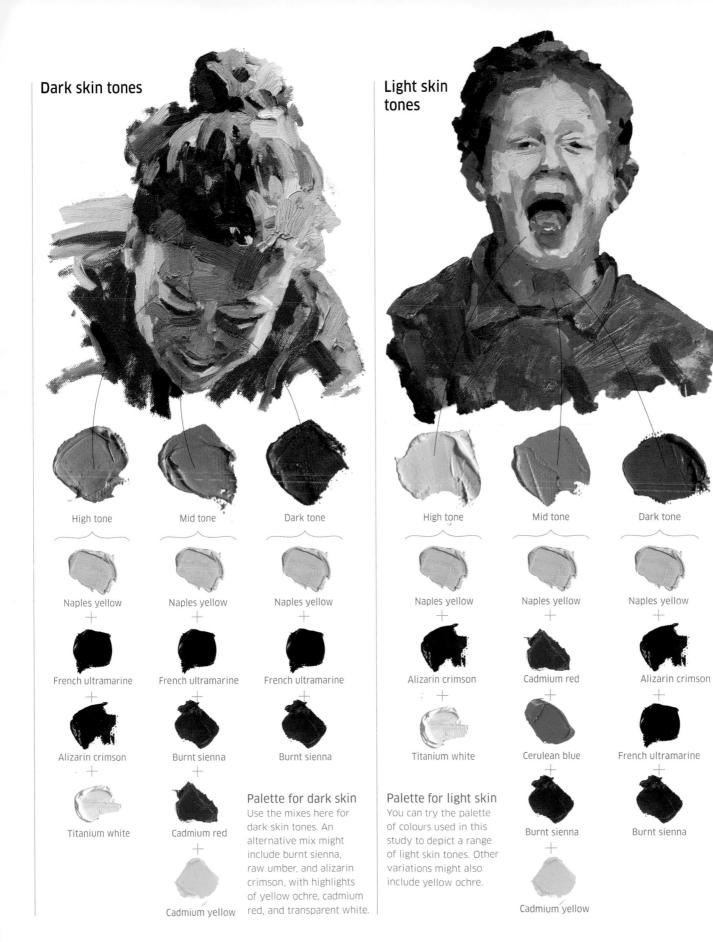

>

PUTTING IT INTO PRACTICE

This self-portrait uses a range of colours and tones to convey the contrast between strongly lit parts of the face and those in shadow. Darker tones are established first, followed by mid and light tones. Blocks of colour describe facial contours.

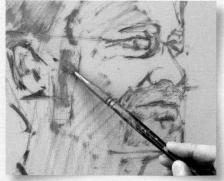

1 Sketch the features
Draw the face with a pencil, ensuring all proportions are correct. Then use a no. 6 filbert to sketch in the basic contours of the face using a thinned mix of burnt sienna and French ultramarine.

You will need

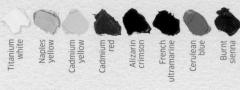

- No. 6 filbert bristle brush
- 30 x 40cm (12 x 16in) medium-grain canvas

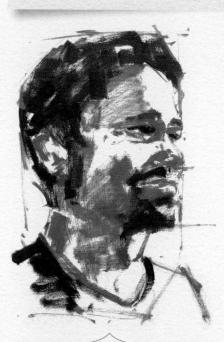

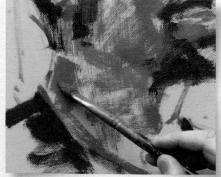

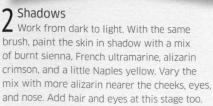

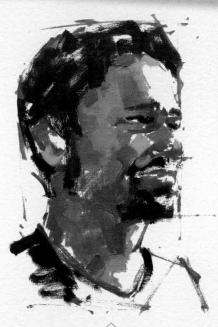

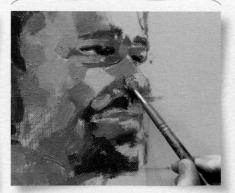

3 Mid tones

Mix burnt sienna and Naples yellow, adding a little cadmium red and cadmium yellow to achieve the correct colour. Reduce the intensity by adding small amounts of cerulean blue and block in the mid tones. Add more blue to shadows and more Naples yellow to highlights.

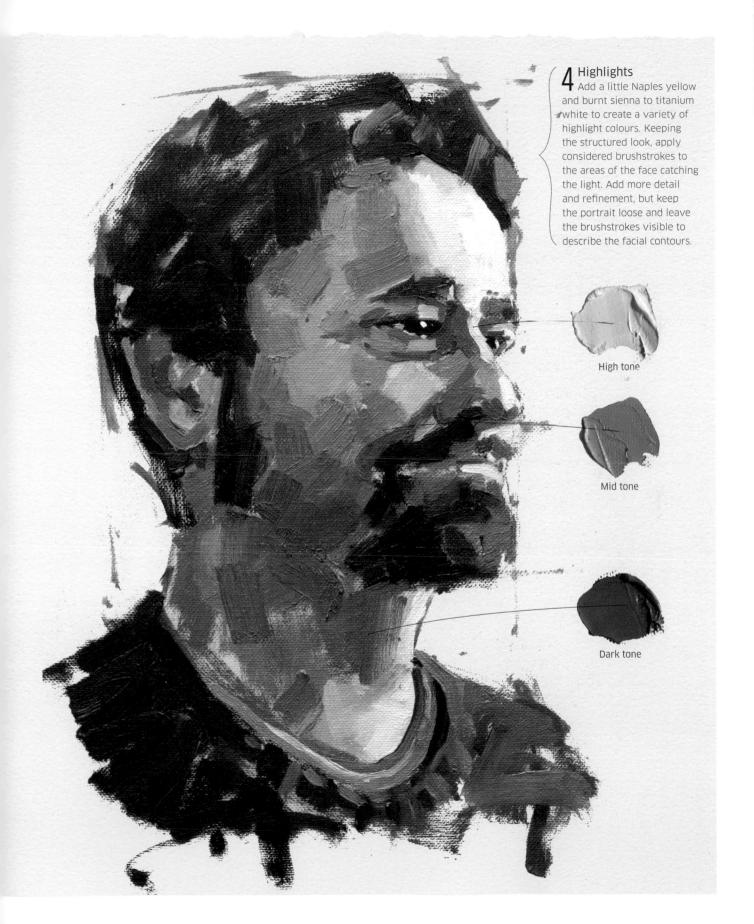

Colour harmony

CREATING BALANCED PAINTINGS

Colour harmony will help you create pleasing, well-balanced paintings. There are several ways to achieve colour harmony, and every method requires a considered, unified palette in which each element supports the next. It is important not only to consider the colour of your subject, but any additional colours that you may wish to introduce as part of your artistic interpretation of a scene.

Four ways to harmonize colour

There are different ways to harmonize colour, most of which involve working with a limited palette. Using complementary colours is an effective way to achieve colour harmony for vibrant subjects, while a narrow range of analogous natural hues is ideal for landscapes.

Colour harmony is as important as drawing in balancing a composition. However, it is important to know when to apply the rules and when to break them – following any one rule too closely can lead to a lack of spontaneity. Look for colour harmony in your subject matter, but incorporate colours of your own choosing, too.

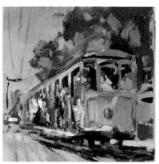

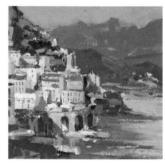

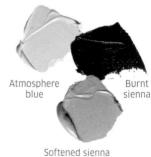

Anchoring the primaries

Vibrant mixes of primary colours can be discordant in a painting. To counter this, introduce an earth colour – in this case yellow ochre. The ochre helps link the bold colours and creates a sense of harmony.

Analogous colours

Use a sequence of up to five colours, which sit next to each other on the colour wheel. For example, a yellow, yelloworange, and yellow-green will give a harmonious range on which to base your painting.

Complementary colours

Colours that sit opposite each other on the colour wheel, such as red and green, have a vibrant colour relationship. They won't clash with each other and you can use them with varying intensity for a range of effects.

Atmosphere colour

Mixing a central atmosphere colour and adding it to subsequent colour mixes will link your colours. Here, a central blue mixed into burnt sienna softens the colour and brings it into harmony.

ANCHORING THE PRIMARIES

Using an earth colour to anchor the bright colours in this scene links the separate elements and creates a well-balanced painting.

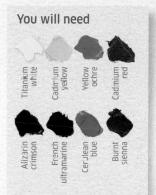

- No. 4 filbert bristle, no. 6 round synthetic, and no. 6 flat synthetic brushes
- 25 x 20cm (10 x 8in) medium-grain canvas board

Coloured ground
Starting on a coloured ground of yellow ochre, sketch in the tram and dark areas with a mix of burnt sienna and French ultramarine using a no. 4 filbert.

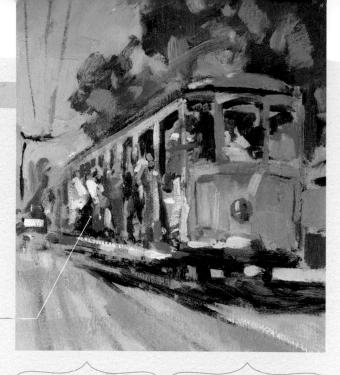

2 Leaving gaps
Paint the trees and tram,
leaving gaps for the ground
to show through, and link the
yellows, greens, and blues.

Adding back
Add a mix of yellow ochre
back into areas of the tram,
tree, and road. This reduces the
intensity of large areas of colour

Lighter tone used for the sky

ANALOGOUS SCHEME

A range of three analogous colours was used to create this desert landscape. Violet, violet-blue, and violet-red all sit next to each other on the colour wheel and were used here in varying tones.

- Small, flat synthetic brush
- 20 x 25cm (8 x 10in) medium-grain canvas board

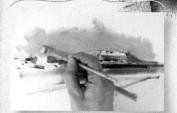

1 Using violet-blue
Apply a light mix of violetblue to block in the sky with
a small, flat synthetic brush.
Carefully work up to the
rock formations.

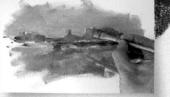

2 Adding violet
Add alizarin crimson to the
mix and paint the rocks with a
warmer mix, slightly darker in
tone than the sky. Add cooler
blue for the shadows.

Warm and dark colour More alizarin crimson makes the mix warmer still, and adding French ultramarine darkens it enough to use in the foreground.

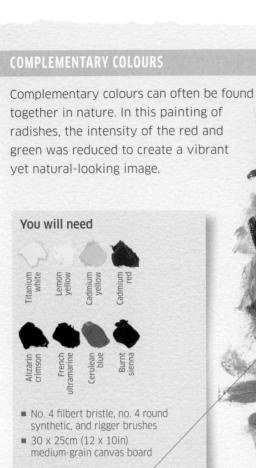

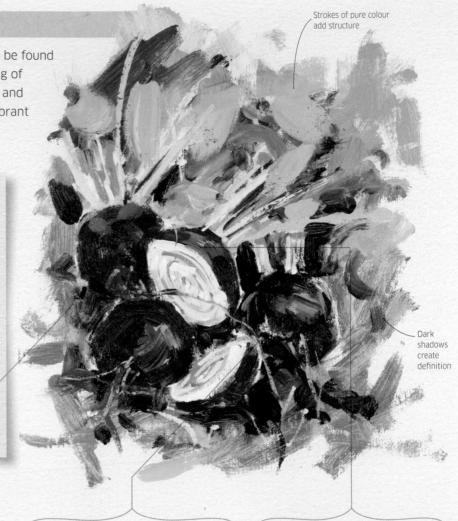

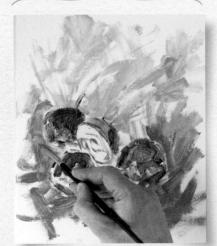

1 Block in main areas
Establish the main areas of colour
first to ensure that colours don't become
muddled later on in the painting.

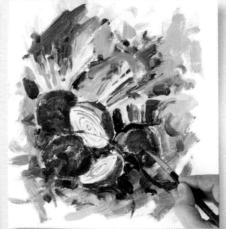

2 Creating definition
Add darker shadows and deeper greens and reds using a no. 4 filbert. This helps create more definition.

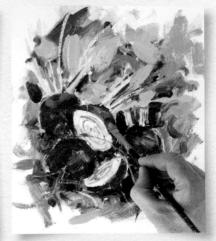

3 Emphasize colour
Apply purer reds and greens last to emphasize the colour relationship and give structure.

ATMOSPHERE COLOUR

The warm haze of this scene is ideal for using atmosphere colour. Blues bring the shadows to life and unite the buildings and mountains, bathed in soft light.

You will need

- No. 6 and no. 4 filbert bristle, and no. 6 round synthetic brushes
- 25 x 30cm (10 x 12in) medium-grain canvas board

1 Atmosphere base colour
Paint the sky using an atmosphere
mix of French ultramarine, titanium
white, and cadmium red.

No. 4 filbert brush

2 Lighter tone
After painting the background, use a lighter tone of the atmosphere colour to add the reflection of the sky in the water.

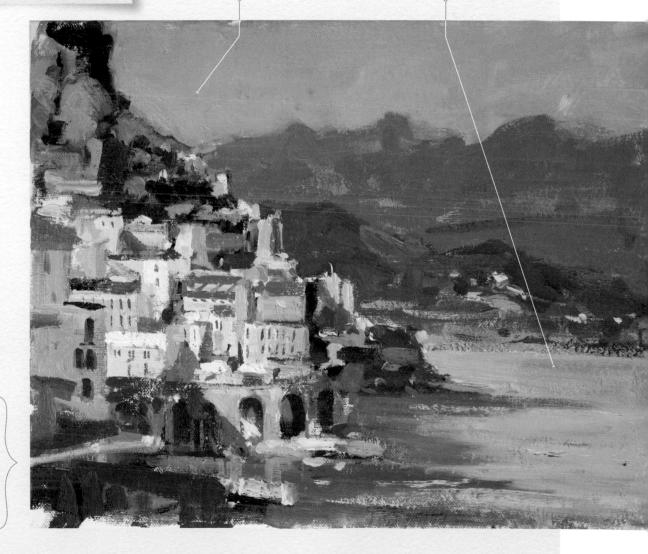

3 Use base mix throughout Continuing to use the atmosphere blue as a base, mix a variety of colours and tones. Use darker tones in the foreground to create a sense of depth.

Tonal values

PAINTING LIGHT AND SHADE

The tonal value, or key, of a painting is how light or dark it looks. In this regard, you can view a painting in the same way as a photograph: an overexposed photo looks washed out, while an underexposed one lacks clarity and detail. It is best to begin a painting in a lower, or darker, key than you would expect, as it is easier to scale from dark to light. A good tonal range helps create a dynamic finished piece.

Comparing tones in colour

Colour can be distracting when trying to identify tones. You may assume yellow is lighter than blue, for example, but each colour has its own tonal range. Squinting slightly can help you compare different colours tonally. In the examples below, a black and white image of each pair of colour mixes makes it easier to assess their tone.

No white added to blue

Less white in yellow

White in both mixes

Tones look similar

Yellow looks darker

Blue looks darker

Similar tones

A mix of cadmium yellow and titanium white (top left) and French ultramarine and titanium white (top right) are similar in tone.

Dark and light

Adding less white to the cadmium yellow mix changes its tone slightly. This time, the blue is lighter in tone than the yellow.

Light and dark

Finally, when placed next to pure French ultramarine. the yellow and white mix is much lighter in tone than the blue.

PUTTING IT INTO PRACTICE

It is important to consider tone as well as colour to create a balanced painting. In this cityscape, low contrast was used to subtly differentiate certain areas, high contrast was used for a bolder statement and, where two objects share the same tonal value, the colour was adjusted to distinguish them.

Use loose shapes at this stage

Block main shapes of shadow areas

Warmer mix in the foreground

Block shadows

L First, assess the tonal values and identify areas of shadow. Then, using a no. 8 flat bristle brush, apply a mix of French ultramarine and burnt sienna to block in the main shapes of the shadow tones. Subtly change the colour from warm to cool as you work.

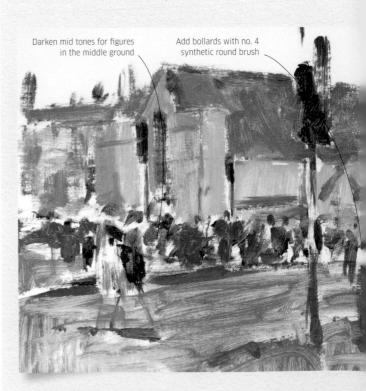

You will need

tonal balance right at this stage.

- No. 8 flat bristle, no. 6 filbert bristle, no. 4 filbert bristle, no. 4 flat bristle, and no. 4 round synthetic brushes; synthetic rigger
- 25 x 30cm (10 x 12in) medium-grain canvas board

for the foreground objects.

Cityscape

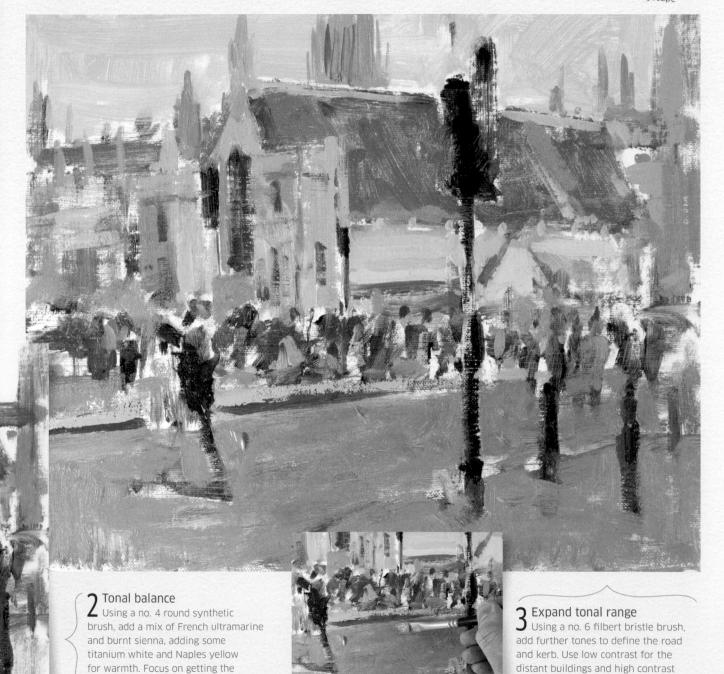

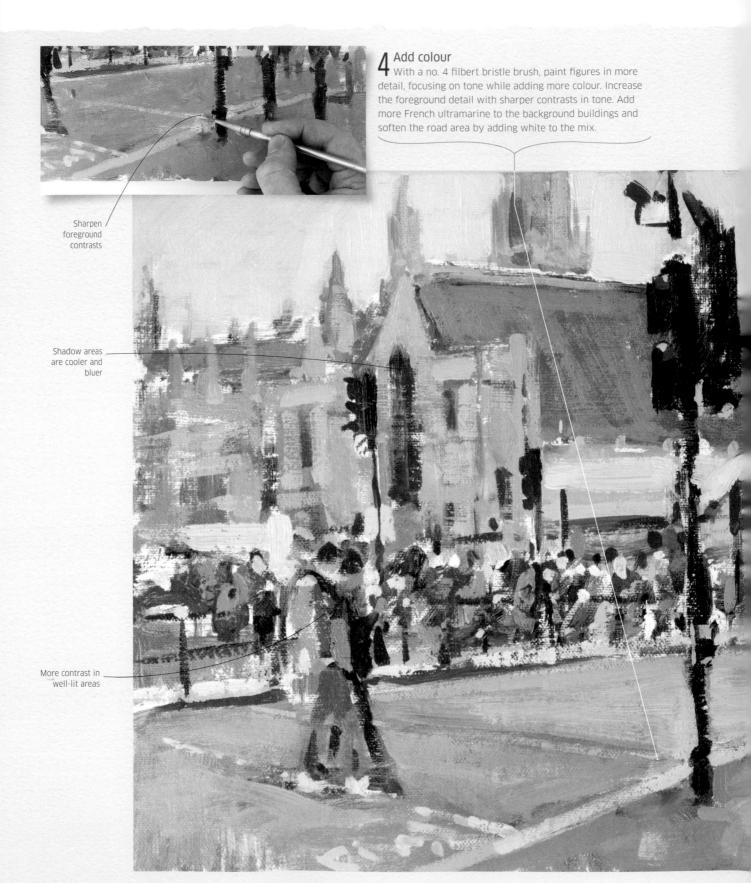

"Generally,
the darkest darks
are found in the
foreground. There is
more contrast in
well-lit areas and
less contrast in
shadow areas."

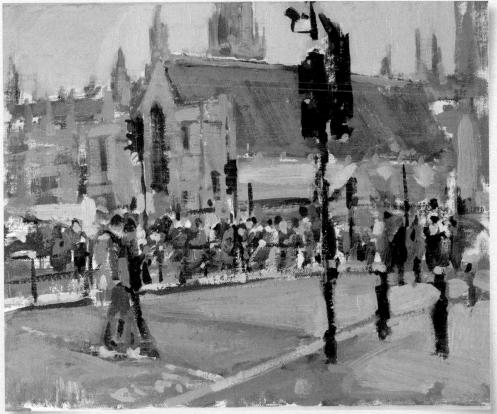

6 Light and balance
Having established a full range of tones at the beginning, the final painting now has a good balance of light and dark areas.

7 Black and white image
A black and white image of the completed
painting confirms that the tonal range has been
covered from the darkest dark to the lightest light.

Using mediums

TAKING CONTROL OF OIL PAINT

A medium is a liquid or gel that changes the consistency of your paint. Mediums can alter the paint's drying time, texture, thickness, or opacity. This changes the way the paint behaves and makes it easier to achieve certain effects, such as impasto (see pp.246–49). Always keep in mind the "fat over lean" rule (see pp.224–25) when using mediums.

Mediums and their uses

Turpentine thins paint and makes it dry faster. You usually mix it with a stand oil, such as linseed. The more oil you add, the glossier and more transparent your paint will become. Alkyd liquids increase the gloss of the paint and, unlike linseed oil, will not yellow over time. Use alkyd impastos to thicken your paint.

Thin mixes

For a smooth finish with less visible brushwork, add an equal mix of turpentine and a stand oil such as linseed.

quantity of oil as the

painting progresses.

Impasto mix

Adding an alkyd impasto medium helps give body to colours without changing the colour consistency. Used sparingly, it can halve drying times.

PUTTING IT INTO PRACTICE

Several different mediums were used in this pet portrait, to give the paint a range of different properties. This made it easier to create the wide variety of textures needed to portray the dog.

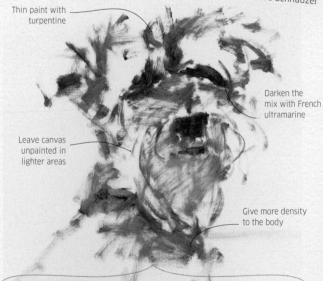

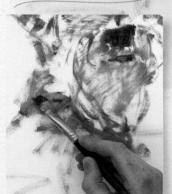

Thinning paint
With a no. 8 flat bristle
brush, use a mix of burnt
sienna and French ultramarine
thinned with turpentine to
roughly suggest the main
areas. Add more ultramarine
for the darker tones. The paint
will dry quickly and, after an
hour or two, you can start
the next stage.

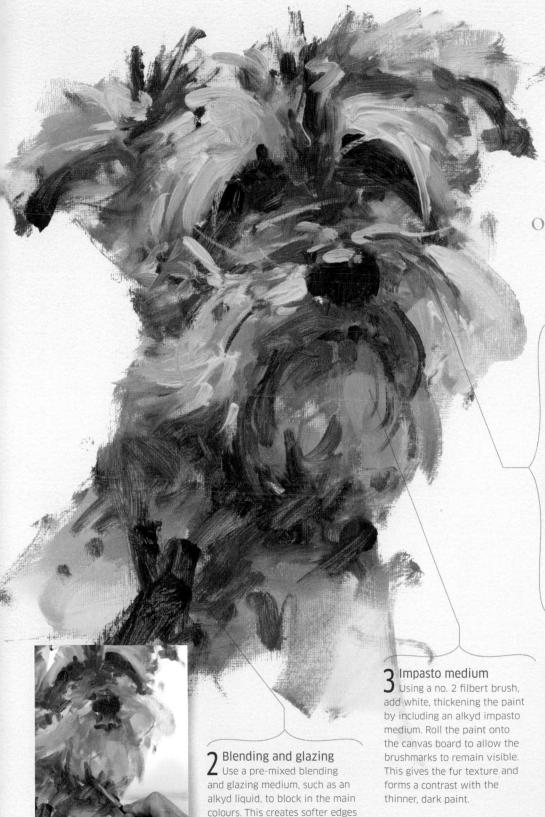

and subtle transitions.

"Mediums alter the drying time, consistency, and opacity of oil paint, giving you greater control."

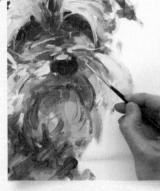

4 Flow medium
Add an equal mix of
turpentine and stand oil to a mix
of titanium white and French
ultramarine. This helps the paint
to flow easily when painting fine
details with your rigger brush.

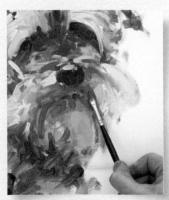

Oiling out

REVIVING AREAS OF DULLNESS

Applying additional oil – such as stand or linseed oil – to "sunken", matt-looking areas of paint can lift the colour and restore lustre. Sunken paint is caused by some of the oil content of the paint being absorbed into the layer beneath. As sunken areas will draw out oil from subsequent layers of paint, and so exacerbate the problem, it is important to restore the area with oil before applying more paint.

PUTTING IT INTO PRACTICE

You can use pure oil to even out the surface of the painting, but it can take up to a week to dry. Mixing the oil with a thinner, such as turpentine, will speed up the drying time. Aim for a ratio of about 4:1 stand oil to turpentine. You only need a thin layer, so it is important to wipe off any excess oil. The aim is to replace only the oil that has sunk, and it is better to apply it sparingly several times.

You will need

- Stand oil
- Turpentine
- Medium-sized flat, wide synthetic brush
- Lint-free cloth

"Restore 'sunken' areas of paint with oil before applying more paint."

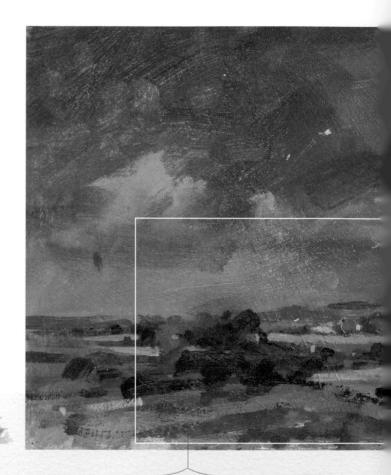

Apply oil
Once the painting
is touch-dry, hold it
up to the light and
look for any matt
areas. Once you have
identified any sunken
paint, make sure the
painting is clean
and then apply the
oiling-out mix with a
flat, synthetic brush.

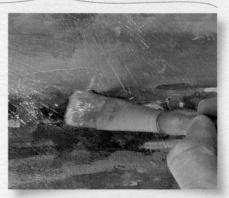

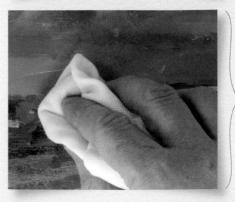

Before

Areas of sunken paint can affect the finish of the painting. A section around the trees in this landscape has a matt finish and is inconsistent with the rest of the work. Make sure the painting is free of dust before oiling out.

Glossy finish

"Areas of oil paint can 'sink' over time, which reduces vibrancy, depth, and sheen. Oiling out will revive your painting."

After

Once the oil mix has dried, the inconsistencies in the finish have been corrected and the colours have more depth - in line with the rest of the painting.

Colour is

restored

Painting has a

glossy finish

more consistent,

Paint has a glossier finish

Colour is restored

more depth

Glazing

USING TRANSPARENT PAINT

You can use glazes of transparent paint to adjust tone, colour, definition, and mood. Glazing can create a sense of depth as light passes through the transparent layers for a glowing effect. Whether you apply glazes during your painting or on your finished work, follow the fat-over-lean rule (see pp.224–25) due to their high oil content.

Making glazes

There are two main types of glaze in oil painting: neat, semi-transparent paints (thick glazes) and paints thinned with a medium to become transparent (thin glazes). Thin glazes must be mixed with an oil-based medium to prevent cracking. You can buy prepared glazing medium or mix your own using 5 parts turpentine, 1 part stand oil, and 1 part dammar varnish. Layers applied over a glaze must be "fatter" than the glaze.

PUTTING IT INTO PRACTICE

The original painting of this sunset looked disjointed and lifeless. Several types of glazes were applied to transform it into a scene with vibrancy, light, and warmth.

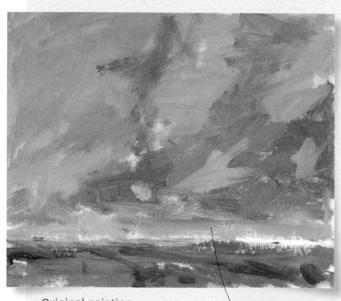

Original painting
This painting lacks drama and
depth because the colours don't
have enough tonal variation and
are too light overall.

Sunset colours look too pastel

You will need Adding the property of the prop

- Glazing medium
 25 x 30cm (10 x 12in) medium-grain canvas board

1 Glazing the middle ground
Use a thick glaze of French
ultramarine and alizarin crimson to
deepen the shadows in the middle
ground. Apply a warm-toned thin glaze
of cadmium red, alizarin crimson, and
French ultramarine at the horizon to
imply the influence of the sun.

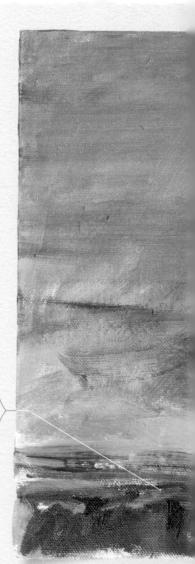

Neat paint

Thin glaze

French

ultramarine

Alizarin crimson Burnt sienna

Thin glazing

Mix your colour first, then add it to a glazing medium to make it transparent. Apply thin glazes with a soft, synthetic brush for smooth brushmarks.

Thick glazing

Semi-transparent pigments, such as thuse shown here, don't need to be diluted. You can apply them neat as denser glazes that show brushmarks.

Adjusting tone

You can use glazes to adjust tone in an area or in a whole painting. In this example, the underpainting is visible but has been darkened by a glaze.

Adjusting colour

Coloured glazes affect the existing colour as if they have been mixed. Here, a yellow glaze makes blue look green, red look orange, and yellow look intense.

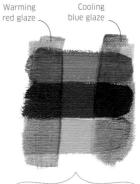

Warm and cool colours

You can alter the visual temperature of a painting with glazes of warm or cool colours. For example, a blue glaze can make a snowy scene feel cooler.

2 Glazing the sky
Apply a thin glaze of cadmium yellow and alizarin crimson to boost the sunset colours. Pastel colours will reflect and glow beneath the light, warm glaze. Harmonize the blue sky by applying the same glaze over it. Darken the top of the sky with a cooler, thin glaze of French ultramarine and burnt sienna.

3 Glazing the foreground Increase the contrast in the foreground area by

applying a thick glaze of burnt sienna and French ultramarine with lively brushstrokes.

Re-evaluating and correcting

REWORKING AREAS OF PAINT

When re-evaluating a painting, you may notice some inconsistencies that need correcting. There are several techniques you can use to amend your work, whether it is still wet or has fully dried.

Manipulating wet and dry paint

You can wipe off areas of wet paint with a rag or your finger, or scrape off thicker paint with a palette knife. Use a firm palette knife or razor blade to shave off dried paint, or sand it back with sandpaper. You can also correct colour or tone by adding a glaze.

1 - Dry paint

1 - Wet paint

1 - Wet paint

2 - Rubbing out

2 - Applying glaze

2 - Scraping off

2 - Wiping off

3 - Amended area

3 - Amended area

3 - Re-painted area

3 - Re-painted area

Adjusting sgraffito

You can adjust areas of sgraffito or impasto with your finger or the handle of a brush several days after painting.

Adjusting colour

You can adjust the colour or tone of dried paint with a glaze. This lets the original brushwork show through.

Scraping off

Scrape off thick, wet paint with a palette knife, leaving the area free of brushstrokes and ready to repaint.

Wiping off

You can also wipe off wet paint with your finger or a rag. This gives you more control and creates softer edges.

PUTTING IT INTO PRACTICE

Several amendments were made to this completed painting of boats at a river's edge. Areas of wet paint were manipulated and remoulded, while sections of dry paint were removed and repainted.

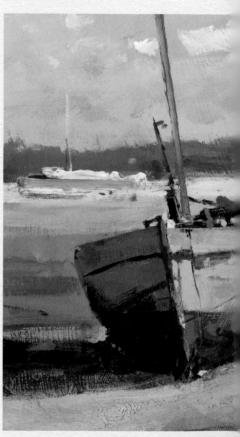

"Re-evaluating is part of the painting process; correcting mistakes will improve your work."

Amending sgraffito edges

While an area of thick paint is still wet, you can erase sgraffito marks by gently smoothing the furrows with your fingertip. You can then make a new mark (in this case, one at a better angle) with the tip of a palette knife.

Smoothing out

Making new mark /

Scraping off

Remove a mast painted in thick impasto by scraping off the paint with a palette knife. The area is now smooth and you can easily repaint the sky.

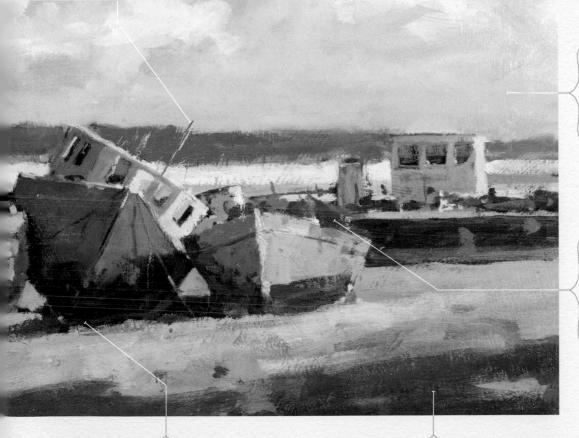

Sanding back

Sand back the dry red paint on the boat to reduce its saturation and intensity. This softens the brushistrokes in the area and prevents it being too dominant.

Wiping off

With a wet cloth, wipe off areas of the wet shadow layer where it has been painted too close to the boat. This will improve the composition.

Applying a glaze

Using a medium flat synthetic brush, apply a glaze of sienna over the dry paint in the foreground. This gives the area warmth and helps bring it forward.

Finding your style

CREATING A SERIES AND EXPERIMENTING WITH TECHNIQUES

If you want to take your painting further, it is important to be able to express what you see in your own way. Finding a subject that inspires you is a great starting point – if you are excited about something, you are more likely to want to express yourself and share your feelings with others. Oil paint is an ideal medium for experimentation, as you can create a wide range of effects, and the long drying times involved allow you to develop your work over time.

CREATING A SERIES

Producing a series of similar paintings enables you to develop your own style across multiple pieces of work. Once you have decided on the colour and tone, you are free to explore the subject.

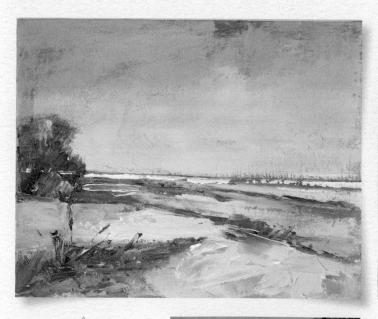

You will need

Titanium white Cadmium yellow Alizarin crimson Cerulean Cerulean Burnt sienna

- No. 4 flat bristle, no. 2 filbert bristle, and no. 6 round synthetic brushes
- 25 x 30cm (10 x 12in) medium-grain canvas board

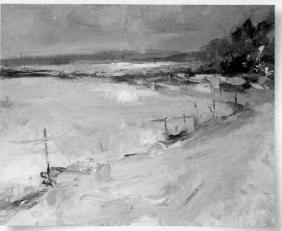

Painting 1

Inspired by a snowy landscape, the first painting in the series focuses on colour and tone. Confirm the palette and choose a coloured ground – in this case, sienna.

Painting 2

Now that you have set the colours, you can create another painting. This one focusing on the trees, introduces a distant light that was missing from the first painting.

Painting 3

Heavier clouds and a higher horizon line give the third painting in the series a different dynamic, while staying true to the palette and tone used in the first two.

STYLISTIC APPROACHES

Approach the same subject in different ways, experimenting with mark-making, tone, glazes, and coloured grounds. Create individual works until you find a way of painting that suits you, which you want to develop.

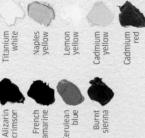

- No. 4 flat bristle, no. 6 filbert hristle, and no. 6 round synthetic brushes
- 20 x 25cm (8 x 10in) medium-grain canvas board

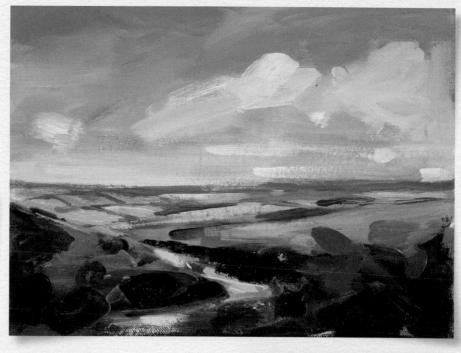

Mood and atmosphere

Here, mood and atmosphere have been created with blending and glazing. Brushstrokes were blended out and a glaze applied to create a painting with a great sense of light.

Light and warmth

This painting focuses on the light in the scene, making use of a coloured ground and exaggerating the warm colours to create a painting with a strong identity.

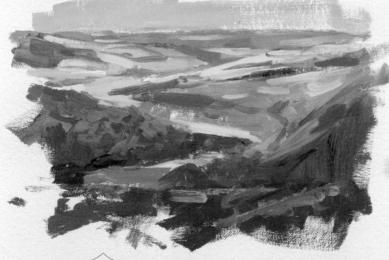

Opaque and softly blended

This painting was created using wet-in-wet techniques to softly blend each area of the scene in a single layer. This helps create an opaque effect.

Loose and simple

Here, a loose and simplified approach was taken. The emphasis is on markmaking and a simple yet bold composition.

Varnishing

PROTECTING AND ENHANCING

Once you have finished your painting, you will need to leave it to dry thoroughly before applying a varnish. Varnishing has several advantages: it protects the surface of the paint from light damage and atmospheric conditions, deepens rich colours, and enhances the overall appearance. Varnishes are available in matt or gloss finishes, and you can create a satin finish by mixing the two.

When to start varnishing

Oil paint can take from two to twelve days to dry, but you should wait at least six months before varnishing – and even longer for very thick paint. Paint dries from the outside in, so although it may feel dry to the touch, it could still be wet underneath. Use white spirit to test that it is completely dry first.

Testing painting

Applying white spirit Dip a lint-free cloth in a little white spirit and gently rub it over the surface. If the painting is still wet, some colour will come off on the cloth. If the cloth remains clean, the painting is fully

dry and ready to varnish.

Painting still wet

Painting fully dry

PUTTING IT INTO PRACTICE

Applying varnish to this beach scene has enhanced the colours and made the surface finish more consistent. Always varnish in a well-ventilated, dust-free area, using a clean, dry brush.

You will need:

- White spirit and lint-free cloth
- Gloss varnish
- Large, soft, synthetic brush

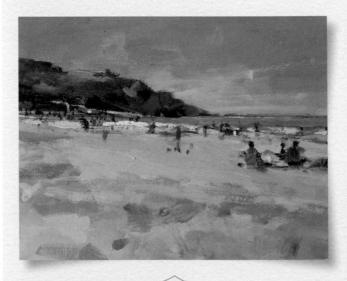

1 Finished dry painting

After several months, when the painting seems dry, test a small area with a lint-free cloth and a little white spirit (see left). If it is completely dry, rest the painting flat on a table.

2 Applying varnish
Dip a large brush into
the varnish and drain the
excess against the side of
the vessel. Apply one thin
coat in a long, continuous
stroke across the canvas.
Continue with the second
stroke, overlapping slightly,
and work down the
painting. Once the varnish
is dry, apply a second coat.

One continuous stroke

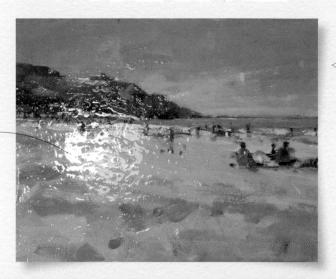

Protect the wet surface from dust

Wet varnish

The varnish will take about 24 hours to fully dry. Keep the painting free from dust while it dries. If possible, shield it with a piece of rigid board, such as foam board. Rest the board on household tile spacers so it doesn't come into contact with the varnished surface.

4 Dried varnished painting
After the varnish has dried, the surface should have a consistent finish. Darks will also appear richer.

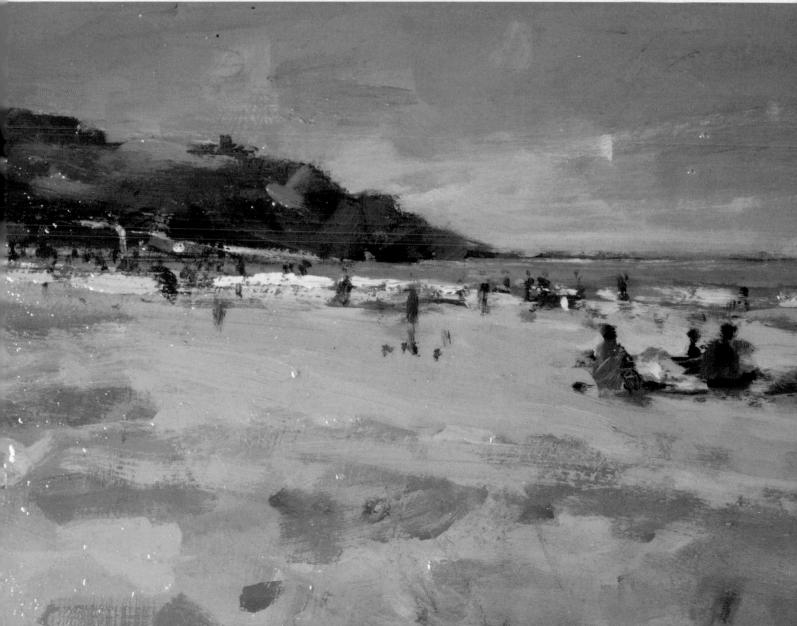

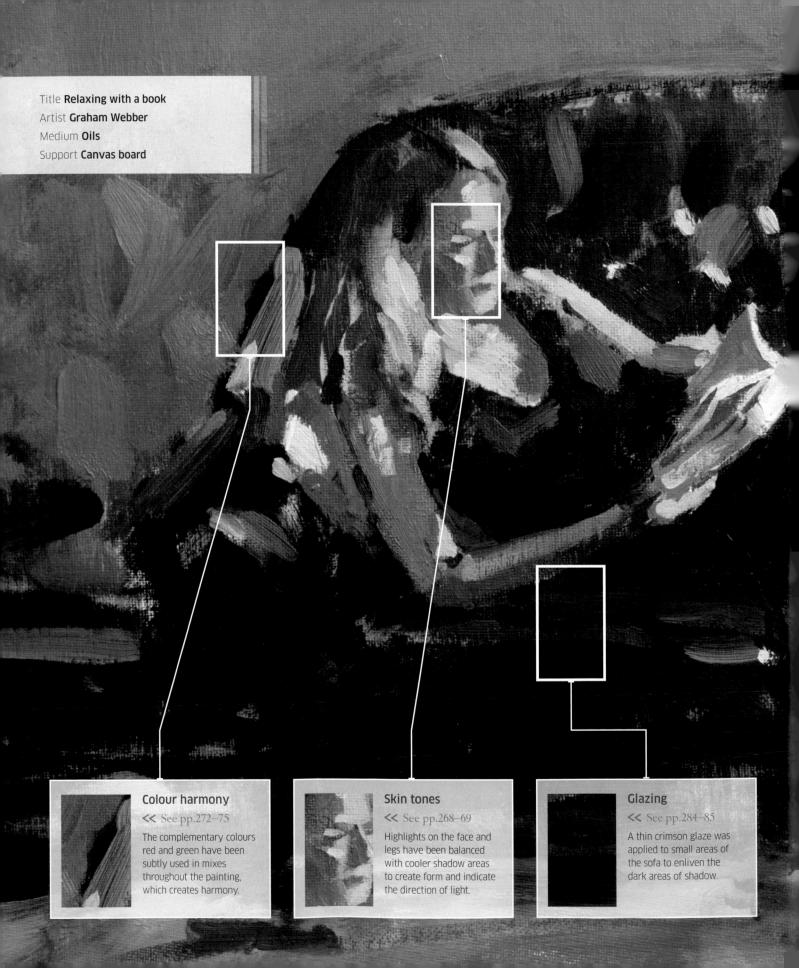

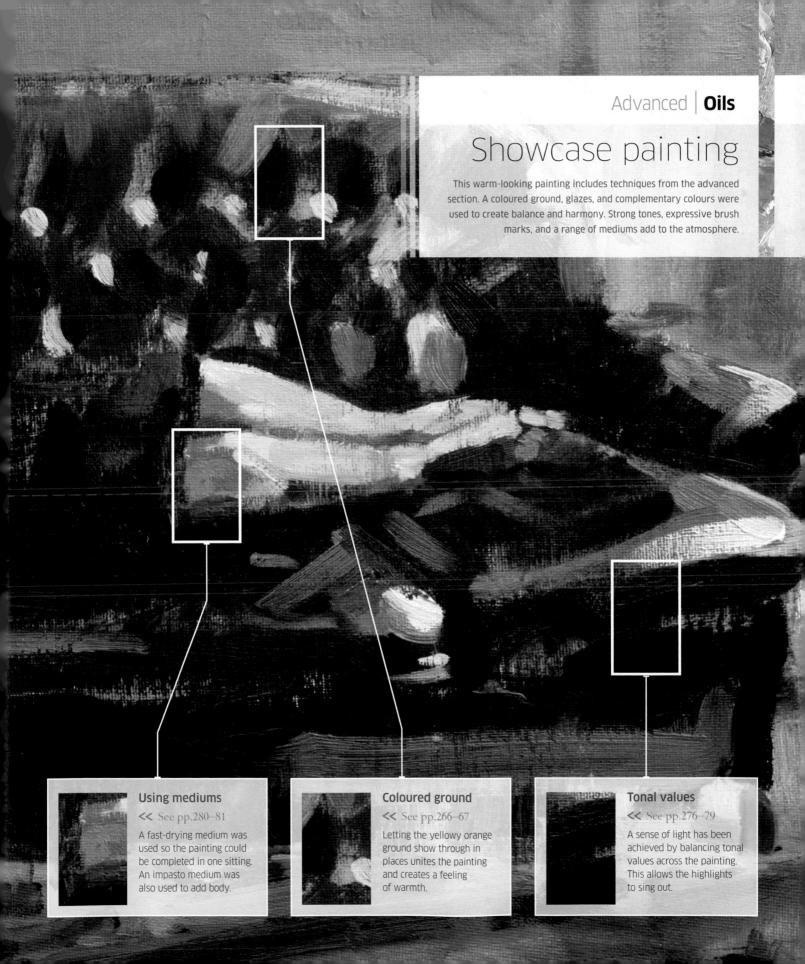

Glossary

Terms with their own entry are given in **bold** type.

Aerial perspective

Where objects in the foreground appear warmer, more detailed, and more focused than those in the background, creating an illusion of depth. Also called atmospheric perspective.

Alla prima

Italian for "at first attempt", this term describes a painting finished in one sitting.

Analogous colours

Colours that are next to each other on the **colour wheel** – such as yellow and orange.

Blending

A way of letting two colours merge gradually with each other in a painting.

Body colour

Opaque paint, such as gouache, which will obscure underlying areas of paint.

Cockling

Wrinkling or buckling in paper supports, caused by applying washes onto an improperly stretched surface.

Colour wheel

A visual device for showing the relationship between **primary**, **secondary**, **tertiary**, and **complementary colours**.

Complementary colours

Colours that are located directly opposite each other on the colour wheel: yellow and purple, red and green, blue and orange. Complementary colours used next to each other make each other look brighter.

Composition

The way in which the various components of a painting,

including the main area of focus, are arranged to create a harmonious whole.

Cool colours

Colours with a bluish tone. They tend to appear to recede in a picture, so can be used to create aerial perspective.

Crosshatching

Criss-crossing parallel lines to create tone. The closer the lines, the denser the tone.

Dry brushwork

Virtually dry paint dragged across the paper or canvas to produce textured marks.

Fat over lean

An important rule of oil painting whereby thick paint, which has more oil in it, should be painted over thinned paint, to avoid the surface layer cracking.

Flat wash

A wash produced in watercolour by painting overlapping bands of the same colour to create a smooth layer of uniform colour.

Focal points

Points of interest that the eye is drawn to immediately, whether because of the **perspective**, the colour, or an intricate shape.

Form

The solid, three-dimensional shape of an object.

Glazing

The application of a transparent layer of paint over a layer of paint that has completely dried.

Graduated wash

A wash laid down in bands that are progressively diluted so that the wash is graded smoothly from dark to light.

Granulated wash

A wash in which watercolour pigments separate from the binder and water, creating a grainy texture when dry.

Highlight

The lightest tone in a composition, occurring on the most brightly lit parts of a subject.

Hot-pressed paper

Paper with a very smooth surface that has been pressed between hot rollers.

Hue

Another word for colour, generally used to mean the strength or lightness of a particular colour.

Impasto

A technique in which paint is applied thickly to create a textured surface.

Key

The overall tone of a painting: a predominantly light painting is said to have a high key.

Layering

Painting one colour over another that has been allowed to dry.

Lifting out

Removing paint from the surface of the paper after it has dried, often to create soft highlights.

Linear perspective

A way of portraying three dimensions by showing how parallel lines appear to converge in the distance.

Masking fluid

A latex fluid that is painted onto paper and resists any watercolour paint put over it.

Medium

A substance used to modify the fluidity or thickness of oil or acrylic paints. Also describes the painting materials used, such as oil, acrylic, or watercolour.

Mid tones

All the variations of tone between the darkest and the lightest.

Modelling

Using light and dark tone to create a three-dimensional impression of an object.

Monochrome

Working in any single colour.

Negative space

The gaps between objects. Negative space is as important as positive **form** in creating a satisfying composition.

NOT paper

Meaning "not hot-pressed", this is paper with a slightly textured surface that has been pressed by cold rollers during its manufacture. It is sometimes called cold-pressed paper.

Opaque colour

Colour that is impervious to light and which obscures anything underneath; the opposite of transparent.

Palette

Any suitable mixing surface for paint. The word is also used to describe colours used by a particular painter or on a particular occasion.

Pan

A small block of solid watercolour paint that can be slotted into a paint box.

Perspective

The method of creating a sense of depth on a flat surface through the use of modelling, linear, and aerial perspective.

Pigment

Particles with inherent colour that can be used in paints.

Plein air

Meaning "open air" in French. Describes a painting created outdoors.

Positive shape

The outline shape of an object.

Primary colours

There are three primary colours – yellow, red, and blue – that cannot be made by mixing any other colours. Any two primaries can be mixed together to make a secondary colour.

Recession

Moving from the near distance to the far distance. Colour recession is the use of warm and cool colours to create a sense of depth.

Resist

A method of preserving highlights by applying a material that repels paint, such as **masking fluid**.

Rigger

A long, fine brush used for detailed work.

Rough paper

Paper with a highly textured surface that has been left to dry naturally, without pressing.

Rule of thirds

An aid to composition that divides a picture into thirds horizontally and vertically to make a grid of nine squares. Points of interest are placed on the "thirds" lines, and focal points on the intersections, for visual effect.

Runbacks

Irregular shapes, sometimes called blooms or cauliflowers, caused when watercolour paint in one colour flows into a different one that hasn't fully dried.

Sable

Sable fur is used in the finestquality paintbrushes. The long, dark brown hairs have a great capacity for holding paint and create a fine point.

Scraping back

Using a sharp blade to remove layers of dry watercolour paint in order to reveal the white paper below and create highlights.

Scratching in

Any action whereby marks are scratched into applied paint to give added texture.

Scumbling

Applying a thin, irregular layer of paint over a previously painted surface, allowing patches of the colour underneath to show through.

Secondary colours

Colours made by mixing two primary colours together. They dre: green (mlxed from blue and yellow), orange (mixed from red and yellow), and purple (mixed from blue and red).

Sgraffito

A technique in which the surface layer is scratched away to reveal a contrasting colour underneath.

Shade

A colour darkened with black.

Shadow

The darkness cast when light is obscured, either on an object or by it.

Softening

In watercolour, blending the edges of a paint stroke with a brush loaded with clean water to prevent the paint from drying with a hard edge.

Spattering

Flicking paint from a loaded paintbrush or toothbrush to produce texture.

Stand oil

A medium added to oil paint, usually consisting of linseed oil, which thickens it and makes it easier to apply to the surface.

Stay-wet palette

A manufactured palette designed specifically for use with acrylic paints. It has a damp layer under the main mixing surface to keep paints moist while being used.

Stippling

The application of relatively neat dots to form a colour field, or to create shading.

Stretching

A method of taping paper down, wetting it with a damp sponge, and letting it dry flat. Stretching paper helps to prevent it from cockling.

Structure gel

A painting medium added to thicken acrylic paint in order to bulld up heavy **impasto** textures.

Support

Any surface onto which paint is laid, such as paper or canvas.

Tertiary colours

The colours between the primary and secondary colours on a colour wheel. They are created by mixing a greater proportion of the primary colour into the secondary colour.

Tint

A colour lightened with white.

Tone

The relative lightness or darkness of a colour. The tone of a paint can be altered by diluting it with water (in watercolour), mixing it with white paint or with a darker pigment, or surrounding it with other colours.

Turpentine (or turps)

A flammable solvent with a strong smell used as a painting medium to thin oil paints. Also used to clean brushes and hands.

Underpainting

An initial layer of (often monochrome) paint that serves as a base for composition.

Value

The tonal position of colours on a scale from light to dark.

Varnish

A protective resin that is applied to a painting that has thoroughly dried.

Warm colours

Colours with a reddish or orange tone. Warm colours appear to come forward in a picture and can be used to create aerial perspective.

Wax resist

A method of using candle wax to prevent the surface of the paper from accepting paint. Once applied, the wax cannot be removed.

Wet-in-wet

In watercolour, adding layers of paint onto wet paper or paint that is still wet.

Wet-on-dry

Adding layers of paint on top of colour that has already dried. Painting in this way produces vivid colours with strong edges.

Α
acrylics 118-205
adding a base layer to the
canvas 156-57
adding texture in 152-55, 178
aerial perspective 148-49
balancing colour temperature
168-71
black and white 122-23
blending 158-61
brushes and palette knives
124-25
care of brushes and paint 123,
125, 127
colours and colour mixing 121,
122, 128-33
creating focal points 180-81,
204
drawing with a brush 134-37
drying times 121
durability 122
glazing 162-63
history of 121
impasto 120
mediums and enhancers 158,
294, 295
mounting and displaying 28
neat acrylics 142-43
negative space 172-75, 179
optical colour mixing 128,
182-85
painting clouds and skies
192-93
painting fur 190-91, 204
painting movement 200-203, 205
painting people simply 194-95,
204
painting rain 186-89
painting reflections 176-77, 178
painting shapes in 144-45, 150
painting skin tones 170, 196-99,

205

painting transitions of colour 158-61 painting with dabs to make colour sparkle 182-85 pigments 121, 122 properties of acrylic paints 122-23 pros and cons 22-23 refining your painting 24 spray painting 125 supports and other materials 126-27 temperature and atmosphere in acrylics 164-65 tints, tones, and shades 138-39, 151 using cool colours 166-67. 168-71 using ground colours 156-57. 179 using a limited palette 132-33, 151 using warm colours 164-65. 168-71, 178 washes 140-41, 150 white subjects 146-47 aerial perspective 16, 108, 294, 295 and acrylics 148-49 and glazing 104 and line and wash 84 and oils 242-43, 265 and watercolours 68-69, 88 Akib. Hashim Boats at Pont-l'Abbé, France 178-79 Chinatown, London 204-05 Vibrant still life 150-51 alkyd driers 215 alkyd impastos 280 alkyd liquid 281

alkyd oil paints 210

alla prima 234-39, 256-57, 294 Allbrook, Colin, Sheep market 88-89 analogous colours 15, 182, 272, 273, 294 animal hair brushes 36, 124, 125. 212 animals, painting fur in acrylics 190-91, 204 art shows 28 art societies 28 artistic licence 12, 13, 92 artwork, mounting and displaying 28-29 atmosphere 68 atmosphere colour 48, 94-97. 272, 275 creating in watercolour 46-47, 48, 68, 94-97, 117 experimenting with in oils 252-53, 272, 275, 289 scumbling 252-53 temperature and atmosphere in acrylics 164-65 atmospheric perspective (aerial perspective) 16, 108, 294, 295 and acrylics 148-49 and glazing 104 and line and wash 84 and oils 242-43, 265 and watercolours 68-69, 88 backgrounds blending two graduated colours

266-67, 293 backpacks, camera 27 balance 93, 272-75, 292 base layers, adding to canvases 156-57 base measurement 12-13 bias, colour 15, 216 black paint adding to acrylics 129, 138 adding to create shades 138, 295 adding to create tones 138 darkening colours with 15 oil paints 211 black lava texture gel 152 blades 286 correcting mistakes in watercolours 78, 80 creating tonal effects with 20, 21 bleeds, correcting 78-79 blending 294 in acrylics 158-61, 192 in oils 244-45, 259, 264, 289 in pencil 21 in watercolours 52, 295 blending stumps 19, 21 blobs, correcting 78-79 blooms 295 blotting 54, 55, 78 boards 126, 214-15 body colour 294 brightness, creating 182 broad shading 18 broken colour 254-55, 264 brown skin tones 196 brushes 10, 36 and acrylic paints 124-25, 129 animal hair 36, 124, 125, 212 care of 125, 211, 213 coarse brushes 220 drawing with a brush 134-37

fan brushes 212

painting in oils 229, 246,

B

98-99 colour and contrast 242 creating form with 238 glazing 104-05 impasto 246 laying a flat wash 62-63 painting movement in 200, 201, 204

comparing tones in colour 276 filbert brushes 212 Chinese white, correcting and tone 15, 138-39, 151, 295 complementary colours 15, 42, altering watercolours 112 flat brushes 37, 124, 212 holding your brush 37, Chisnall, John, Bruges 116-17 130, 182, 205, 218, 272, 274, 294 124-25, 213 clingfilm 86 cool colours 48-49, 166-71. 151 and oil paints 124, 209, 212-13 clouds 179, 216, 242, 294, 295 in acrylics 192-93 paddle brushes 125, 186 rigger brushes 37, 50, 55, 212, in oils 244-45 creating energy through colour 295 in watercolours 52-53 coarse brushes 220 creating grainy effects 100-101 round brushes 36, 37, 124, 212 cockling 38, 294 creating illusion of volume 56-57 sable brushes 36, 295 earth colours 272, 273 shapes 36-37 cold-pressed paper 76, 294 emphasizing areas of interest sizes 37 collage 152 180-81 for sketching 134 colour acrylics 121, 122-23, 140-43, emphasizing through scumbling for special effects 124, 125, 186 158-61, 168-71, 182-85 splatter brushes 124, 125, 186 glazing in acrylics 162-63 swordliners 37 analogous colours 15, 182, 272, glazing in oils 284-85, 292 273, 294 synthetic 36, 124, 212 glazing in watercolours 104-05 applying even colour 62-63 wash brushes 36, 37 and watercolours 36-37, 50-51. applying graduated colour ground colours 156-57, 179, 64-65 266-67, 293 74-75, 124 hues 14, 40, 44, 52, 294, 295 brushstrokes 10, 13 atmosphere colour 48, 94-97, layering 294 272, 275 in acrylics 190-91, 192, avoiding flat, dull colour 66-67 lightening watercolours 42 200-203 marbling effects in oils 254-55, blending in acrylics 158-61 creating characterful skies 192 blending in oils 244-45, 264 264 impasto 246 blending in watercolours 98-99 mixing greens 45 textural brushstrokes 190-91. body colour 294 monochrome 294 muted colours 130, 217 using brushstrokes to create broken colour 254-55, 264 oils 210-11, 234, 258-59, 286 contrast colour and contrast 242 effects in oils 220-21, 246 colour and distance 148-49. opaque colour 294 in watercolours 37 242-43, 265 optical colour mixing 128, bubble wrap 86 66 colour bias 15 182-85 colour gradation 148-49 painting rain 186-89 painting white using colour in 238 camera backpack 27 colour harmony 48, 272-75, 292 acrylics 146-47 colour mixing acrylics 128-33 candle wax 86, 295 pigment 14, 35, 44, 52, 295 colour mixing oils 216-19, 240 canvases revealing contrasts with colour mixing watercolours

transparency 211 using a limited palette 132-33. vibrant colours 130 warm colours 48-49, 164-65, 168-71, 178, 216, 242, 295 watercolours 34-35, 44-45 see also primary colours; secondary colours; tertiary colours complementary colours 15, 294 acrylics 130, 182, 205 oils 218, 272, 274 watercolours 42 composition 10, 17, 294 and colour harmony 272 creating 58, 91, 234 creating focal points 92, 180-81, 204 negative space 172-75 rule of thirds 17, 295 scaling up 17 simplifying 144-45, 150 connection, making a 10-11 considered-line technique 220, 221, 241 colour and contrast in oils 242 creating contrast in watercolours creating form with contrast emphasizing areas of interest 180-81 and highlights 73 revealing contrasts with sgraffito 250 tonal contrast 46, 103 using ground colours 157 cool colours 294, 295 in acrylics 166-71, 179 in oils 216, 242 subduing through scumbling 253 in watercolours 48-9

tints 14, 295

C

canvas grain 126 for oils 214 stretched canvases 126-27 "cauliflowers" 54, 78, 295 chalk 260 characteristics, identifying people's 195, 197 children, painting people simply in acrylics 194-95

40-45

168-71

colour recession 295

colour theory 14-15 colour vs tone 102

colour temperature 10, 15, 48-9,

colour wheels 14-15, 40-42,

128, 216, 294, 295

sgraffito 250 saturation 14, 34, 35, 219

sgraffito 295

205

shades 15, 295

skin tones in acrylic 196-99,

skin tones in oil 268-71, 292

adding in acrylics 180-81

232-33

adding in oil paints 226-27.

cool glazes 104-05, 162 adding in watercolours 55. 78-81, 112-13 flat brushes 37, 124, 212 correcting oils 286-87 74-75, 92, 108-09, 116 re-evaluating and correcting oils flesh colours crosshatching 294 emphasizing areas of interest 286-87 in acrylic 170, 196-99, 205 in acrylics 158, 159, 160 180-81 in oils 268-71, 292 exhibiting artwork 28 in oils 250 recalling details 92 expressive marks 222, 223 in watercolours 114-15 pencil drawing 18 diffusion 52 eye, leading the 294 fluorescent acrylic paint 123 in watercolours 84 diluting mediums 140-41, 162 in acrylics 180-81, 204 focal points 12, 294 crowds 25 displaying artwork 28-29 in watercolours 92 creating in acrylics 180-81, curved lines 19 distance 16 eyes, painting 114 182, 204 cutting in 234 depicting in acrylics 148-49 creating in watercolours 93, depicting in oils 242-43, 265 108-09 D depicting in watercolours 68-69 fabric 260 optical colour mixing 182 dabbing, in acrylics 158 drawing with oils 228-31 faces foreground dabs, painting with to make colour dry-brush technique 294 establishing form of 134 colour and contrast 242, 243 sparkle 182-85 in acrylics 192, 200 skin tones in acrylics 170 glazing 104-05, 285 dammar varnish 284 creating movement 200 skin tones in watercolours form 12, 13, 294 dark, working from light to 106-07 in oils 220, 241, 252 114-15 blending in oils 244-45 dark colours scumbling 252 fan brushes 212 creating in oils 238-39 lively darks in watercolours dynamism, creating in acrylics 165, fat over lean 224-25, 228, 240, creating in watercolours 46-47, 66-67 177, 200-203, 205 246, 284, 294 56-57 mixing complementary colours fat paint 224-25 modelling form 56-57 E to create darks in feathering in acrylics 158 tonal value 15 watercolours 42 earth colours 210, 272, 273 feathers 254-55 foundations, laving in oils 228-31 mixing primary colours to create easels 26, 27, 127, 215 features, creating in watercolours frames 28 darks in oils 218 edges 88, 295 108-09 fur, painting in acrylics dark skin tones 114, 197, 269 in watercolours 70-71 fibre pens 190-91, 204 decreasing stages 232-33 ellipses, drawing in acrylic 134, adding detail 109 G definition 52 line and wash 84-85 135 evoking atmosphere and emotion, evoking 10, 11, figure drawing 25 galleries, approaching 28 emotion 94-97 94-97, 117, 164-65 emphasizing areas of interest gels 152, 154-55, 295 glazing oils 284-85 energy 180 gesso mixture 214 depth creating energy through colour establishing form of 134 glass beads texture gel 152 adding through scumbling 252 201 painting movement 200, 201, glazing 294 creating in acrylics 148-49, 167, creating in acrylics 201 202-03 acrylics 162-63 192. 193 creating in oils 239 painting people simply in oils 284-85, 287, 292 creating in oil paints 226-27, 252 energetic moods 94, 96-97 acrylics 194-95, 204 watercolours 104-05 creating in watercolours 66, enhancing oil paintings 290-91 skin tones in acrylic 170, gouache 294 68-69, 104-05, 106-07 equipment 196-99, 205 adding detail to watercolours glazing 104-05 easels 26, 27, 127, 215 skin tones in oils 268-71, 292 109 using cool colours to create pencil drawing 19 skin tones in watercolours correcting and altering depth 167 see also brushes; paper, etc 114-15 watercolours 112 details erasers 19 filbert brushes 212 gradation, colour 148-49

using to create tone 20, 21

correcting in watercolours

errors

filling knives 250-51

fine lines, pencil 19

fixative 19

graduated washes 64-65,

98-99 116 294

grain, canvas 126

grainy effects, creating in	scumbling with an impasto	and skin tones 268	depicting in watercolours
watercolours 100-101	medium 252	working from light to dark	110-11, 112, 117
granulation, laying a granulated	using oil mediums 280, 281, 293	106-07	mist 186-89
wash 100-101, 294	indoor painting 26, 27	light skin tones 115, 198, 269	and evoking atmosphere and
green paint, mixing 45	interest, emphasizing areas of	lightfastness 122	emotion 94-95
grey paint	180-81, 204, 295	linear perspective 16, 294, 295	mitre cutters 28
adding to acrylics 129, 138	interpretation of subject matter 12,	linen canvas 214	modelling 294
creating in acrylics 138, 182	13, 92	lines	modelling paste 152
mixing complementary colours		curved lines 19	modelling perspective 295
to create in oils 218	K	drawing in acrylic 134, 135	monochrome 294
ground colours	key 294	fine lines 19	in watercolours 102-03, 104
acrylics 156-57, 179	knives	line and wash 84-85	mood
oils 266-67, 293	filling knives 250-51	linseed oil 210, 280, 294	in acrylics 157, 165, 166-67
	palette knives 124-25, 212-13,	oiling out 282-83	and colour temperature 48, 165
H	222-23, 241, 244, 246, 256,	lips 114	166-67
nands 114, 115	261, 264, 286	location sketches 90	energetic moods 94, 96-97
hardboard 214	kolinsky sable brushes 36	luminosity, creating 106-07	form and mood 46
harmony			glazing 104-05, 284-85
colour harmony in acrylics 165	L	M	in oils 220-21, 284-85, 289
colour harmony in oils 272-75,	L-shaped compositions 17	marbling	and planning a painting 91
292	landscapes 17, 25	marbling effects in oils 254-55,	quiet moods 94-95
colour harmony in watercolours	aerial perspective 148-49	264	using ground colours 15/
48	layering 294, 295	marbling patterns in	in watercolours 46, 91, 94-97,
harmonious glazes 162	acrylic glazing 162-63	acrylics 152	104-05, 117
harmonious ground colours 157	building layers in watercolours	mark-making	mottling 54
hatching 18	106-07, 117	hrushstrokes in oils 220-21	mounting artwork 28-29
neavy structure gel 152, 153,	decreasing stages 232-33	knives with oils 222-23, 241	mouths 114
154-55	neat acrylics 142-43	pencils 18-19	movement
highlights 294, 295	oil paints 224-25, 226-27, 228,	masking fluid 82-83, 86, 294, 295	creating in acrylics 165, 177,
adding in acrylics 193	232-33, 240, 258-59	materials, choosing 11	200-03, 205
adding in watercolours 46,	scumbling 252-53	MDF 214	creating in oils 239, 250,
72-73, 74, 86, 89, 109	lean oil paint 224-55, 228	measurements	252-53
and contrast 73	lifting out 294	base measurements 12-13	creating with sgraffito 250
creating in pencil 20-21	in acrylics 162	measuring from life 13	muted colours 130, 217
staining pigments 43	in watercolours 78, 79	mediums 294, 295	
using tone to create form 46	light 12	for acrylic paints 158, 162	N
horizons 16	creating illusion of volume	oil mediums 211, 215, 224, 252,	negative spaces 12, 294
hot-pressed paper 38, 294	56-57	280-81, 293, 295	in acrylics 172-75, 179
hue 14, 40, 44, 294, 295	creating light areas 82-83	see also acrylics; oils;	in oils 238
	experimenting with in oils 289	watercolours	neutrality, using ground colours
	mixing "light" 219	metallic acrylic paint 123	157
impasto 294	and mood 94	mid tones 294	neutrals, creating in acrylics 182
and acrylics 120, 152,	painting light and shade in oils	milky glazes 162	newspaper 262
178. 295	276-79. 293	mirror images 259	NOT paper 38, 76, 294

showing the direction of 72-73

and oils 246-49, 265

depicting in acrylics 176-77, 178

0	
objects	
creating form in oils 238-39,	
244-45	
establishing basic shapes in	
acrylics 134-37, 151	
painting white objects using	
colour in acrylics 146-47	
portraying distant objects in	
watercolours 68	
using tone to distinguish in	
watercolours 70, 102-03	
observational skills 12-13	
oils 142, 206-93	
aerial perspective 242-43, 265	
alla prima 234-37, 238-39,	
256-57	
blending 244-45, 264	
brushes and palette knives	
212-13	
canvases 214	
choosing oils 210-11	
colour harmony in oils 272-75,	
292	
colour mixing in 216-19, 234,	
240	
colours 210-11	
consistency of 211	
creating forms 238-39	
decreasing stages 232-33	
drawing and underpainting 226,	
228-31, 241	
drying times 209, 210, 211,	
280, 281, 282	
durability 122	
fat over lean 224-25, 228, 240,	
246, 284, 294	
finding your style 288-89	
glazing 284-85, 287, 292, 294	
ground colour 266-67, 293	
history of 33, 209	olo
impasto 246-49, 265, 294	oli
layering 226-27, 240	or
manipulating wet and dry paint	op
286-87	

marbling effects in oils
254-55, 264
mark making 220-21
mediums 211, 215, 224, 252,
280-81, 293, 295
mounting and displaying 28
oiling out 282-83
opacity of 211
painting outdoors 26
palette knives 222-23, 241
palettes 215
paper 215
pigments 210
properties of oils 210-11
pros and cons 22-23
protecting and enhancing
290-91
re-evaluating and correcting
286-87
refining your painting 24
reworking wet paint 256-57,
264
scumbling 252-53, 295
sgraffito 250-51, 265, 286, 287,
295
skin tones 268-71, 292
stand oils 215, 280, 281, 282-3,
284, 294
sunken paint 282-83
supports and other materials
214-15
texture 260-61
thinning oil paint 280-81
tonal values 276-79, 293
tonking 262-63
varnishing 290-91, 295
wet-in-wet 234, 258-59
wiping and scraping back
256-57, 264
wooden boards 214-15
older faces 198
olive skin tones 115, 268
one-point perspective 16
opaque paints 294

acrylics 142

oils 211, 289 watercolours 43, 112-13, 116 optical colour mixing 128, 182-85 outdoor painting 26-27, 294 alla prima 234-39, 256-57, 294 oils 215, 234-39, 256-57, 294 plein air 295 watercolours 39 outlines creating initial outlines with paint 134-37, 151 hard and soft outlines 70-71 overworked paint 259, 262 P paddle brushes 125, 186 paint how to choose watercolours 34-35 properties of acrylics 122-23 properties of oils 210-11 quality 34, 35 removing excess 262-63 see also hue; pigment paintings, elements of 10-11 palette (colour) 294 acrylic 123 skin tones 114, 170, 196, 268-69 warm and cool 168 palette (mixing surface) 294 field palettes 27 for acrylics 127, 129 for oils 215 for watercolours 35, 39, 40-41 stay-wet palettes 127, 295 palette knives and impasto 246 scraping back 256, 264 use with acrylics 124-25, 129 use with oils 212-13, 222-23, 241, 244, 246, 256, 261, 264, 286 pan paints, watercolour 34, 35, 294 paper 152

acrylics 126

cockling 294 effect of texture and wetness 76-77 hot-pressed paper 38, 294 NOT paper 38, 76, 294 oils 214, 215 paper surfaces 76-77 pencil-drawing 19 rough paper 38, 295 sizes and weights 39 sketch books 38 stretching 39, 295 tone effects of paper mask 21 toned papers 38 watercolour 33, 38-39, 52-53. 76-77, 126, 215 wet-in-wet and wet-on-dry 52-53 pastel colours acrylics 138 oils 219 watercolours 42, 109 pastes, modelling 152 patterns 17 creating in watercolours 86-87.89 peace, evoking sense of 166 pencil sharpeners 19 pencils line and wash 84-85 mark-making 18-19 pencil-drawing basics 18-19 types of pencils 18 using to create tone 20-21 pens adding detail with 109 adding texture in watercolours with 74-75 line and wash 84-85 people 25 emphasizing areas of interest 180 establishing form of 134 painting movement 200, 201,

202-03

shimmer on water 112

painting people simply in	skin tones in watercolours	ripples on water 110-11, 177	sculptural effects in oils 246-49,
acrylics 194-95, 204	114-15	rock salt 86	265
skin tones in acrylics 170,	positive shapes 295	rollers 125	scumbling 252-53, 295
196-99, 205	pouring mediums 152	rough textures	secondary colours 14, 294, 295
skin tones in oils 268-71, 292	primary colours 14, 295	rough paper 38	acrylics 128, 132, 133, 139
skin tones in watercolours	acrylics 128, 130, 132-33, 139,	using brushes and pens 74-75	mixing 217
114-15	151	see also impasto	oils 217
perspective 16, 294-95	colour harmony 272, 273	round brushes 36, 37, 124, 212	watercolour paints 40
aerial perspective 16, 68-69,	mixing to create darks 42, 218	rule of thirds 17, 295	seeing, art of 12-13
84, 88, 104, 108, 148-49,	oils 218, 272, 273	runs 54-55	series, creating a 288
242-43, 265, 294, 295	using a limited palette 132-33,	runbacks 54, 78, 295	sgraffito 250-51, 265, 295
and composition 17	151		adjusting 286, 287
linear perspective 16, 294, 295	watercolours 40, 41, 42	S	shade (of colour) 15, 295
modelling perspective 295	priming supports 126, 214	S-shaped compositions 17	in acrylic 129, 138-39, 151
photographs, reference 91	proportions 13	sable brushes 36, 295	and mood 94
photorealism 220	painting people simply 194	salt 86	shading 295
pigments 14, 295	scaling up 17	sand 152, 153, 154-55, 260, 261	blending in oils 244-45
acrylic paints 121, 122, 158	protecting oil paintings 290-91	sand texture gel 152	broad shading 18
creating grainy effects with		sandpaper 286, 287	creating in pencil 20-21
100-01	Q	sanding back oils 287	shadows 295
oil paints 210	quiet moods 94-5	saturation 14, 34, 35	adding in impasto 249
pigment staining and		using saturated colours 219	creating form with 46, 56, 57,
transparency 43	R	sawdust 260, 261	238, 239
watercolour paints 33, 35, 43,	rags 127, 256, 286	scale 16	hatching 84
44, 52, 100-01	rain, painting in acrylics 186-89	optical mixing and 128	painting light and shade in oils
and wet-on-dry 52	razor blades 286	painting people simply in	276-79, 293
planning paintings 10, 58-59,	recession 295	acrylics 194	softening in oils 229
90-93	re-evaluating and correcting oils	scaling up 17	using cool tones to create 167
plastic wrap 86	286-87	scalpels	shapes 10, 12, 13
olein air 295	reference sketches and	correcting mistakes in	combined shapes 58
plywood 214	photographs 27, 90-91	watercolours 78, 80	creating three-dimensional
pochade boxes 26, 27, 215	refining your painting 24-25	creating tonal effects with 20, 21	shapes in watercolours
points of interest 180-81, 204,	reflections	scenes, simplifying 58-59	56-57
295	in acrylics 176-77, 178	scraping	exploring shapes around a
portraits 25	in oils 259	scraping back oil paints 256-57,	subject 172-75, 179
emphasizing areas of	in watercolours 110-11, 112,	264	identifying basic shapes 144
interest 180	117	scraping back watercolour paints	isolated shapes 58
establishing form of 134	reinterpreting scenes 12, 13, 92	295	painting around a shape 234
painting movement 200, 201,	resists 295	scraping off oil paints 286, 287	painting in acrylics 134-37,
202-03	candle wax 86, 295	scratching in 295	144-45, 150, 151, 172-75,
painting people simply in	masking fluid 82-83, 86, 294,	scratching the surface (sgraffito)	179
acrylics 194-95, 204	295	250-51, 265	painting in oils 234
skin tones in acrylics 170,	retarder 158, 159	scribbling 19	positive shapes 295
196-99 205	reworking wet paint 256-57, 264	in oils 250	tonal value 15

rigger brushes 37, 50, 55, 212, 295 scrubbing 66, 78, 79

skin tones in oils 268-71, 292

shiny surfaces, depicting in acrylics 176-77 sketch books 38, 39 sketching 24 and acrylics 134, 135, 151 brushes for 134, 151 and watercolour paints 84, 90 string gel 152 skies blending 244-45 blending two graduated colours 98-99 glazing oils 285 granulated washes 100-101 laying a flat wash 62-63 painting rain 188 painting skies in acrylics 167, 188, 192-93 painting skies in oils 244-45, 258-59, 285 painting skies in watercolour paints 62-63, 98-99. sunlight 146 100-101 using cool tones to create 167 skin tones in acrylics 170, 196-99, 205 in oils 268-71, 292 in watercolours 114-15 smooth textures, in watercolours 74-75 softening 295 solvents 211, 213, 215 Т spaces negative spaces 172-75, 179. teeth 114 294 painting people simply in acrylics 194 spiky coats 190 splatter brushes 124, 125, 186 splatter marks 86, 87, 295 painting rain 186-89 216 sponges 78, 79, 124, 125 tertiary colours 14, 294, 295 spray painting acrylics 125 acrylics 128, 132, 133 staining pigments 43 watercolour paints 40 stand oils 215, 280, 281, 284, 294 texture oiling out 282-83 adding in acrylics 152-55, 178.

stay-wet palettes 127, 295 still-life paintings 25 stippling 19, 247, 295 streaks, painting rain 186-89 stretched canvases 126-27, 214 stretching paper 39, 295 strokes, watercolour 50-51 structure gel 295 studio painting 26, 27, 215 style, finding your 288-89 subdued moods 94-95 subject matter 10, 12 choosing 24-25 exploring shapes around a subject 172-75, 179 indoor painting 27 outdoor painting 26 substance, giving objects 238-39 sunken oil paint 282-83 evoking atmosphere and emotion 94, 96-97, 117 supports 10, 295 acrylics 126-27 oils 214-15 watercolour 38-39 surfaces, and reflections 110-11 swordliners 37 synthetic brushes 36, 124, 212 temperature 15 colour temperature in acrylics 164-65, 166-67, 168-71 colour temperature in watercolour paints 48-49 oil colour temperature and bias

wetness 76-77 impasto 246-49, 265, 294, 295 mark-making with knives 222-23, 241 and mood 94 paint texture 10 painting fur 190-91, 204 paper texture 38 spattering 295 textural brushstrokes 190-91 tonking 262 using oil mediums 280 wiping and scraping back 256-57, 264 texture gels 152 thinners 211 oil paint 280-81 three-dimensional effect 16, 294 creating forms in oil 238-39 creating in watercolours 56-57. 72-73 exploring tonal range in acrylics 138-39 highlights in watercolours 72-73 texture in oils 260-61 tints 14, 295 in acrylics 129, 130, 138-39, 151 adding tints to an underpainting 104-05 tone 10, 12, 15, 295

190-91, 204

265, 280

94. 108-09

dry brushwork 294

adding in oils 222-23, 238, 239,

256-57, 260-61, 262, 264,

adding in watercolours 56-57,

adding through scumbling 252

creating illusion of volume 56-57

creating with sgraffito 250, 265

creating form with 238, 239

effect of paper texture and

74-75, 76-77, 86-87, 88, 89,

241, 246-49, 250, 252,

and acrylics 129, 138-39, 145, 151, 166-67, 182, 192-93 blending 245 broad shading 18 colour vs tone 102 creating atmosphere and form 46-47 creating form with 238 creating illusion of volume 56-57 creating tonal blends 182 creating tone effects 21 dramatic skies in acrylics 192-93 evoking atmosphere and emotion 94-97, 117 glazing oils 284-85, 292 hatching and crosshatching 18 mid tones 294 and oils 238, 245, 276-79, 284-85, 292, 293 planning a painting 91, 92 scribbling 19 simplifying composition 145 stippling 19 using pencils to create 20-21 using tone to distinguish objects 102-03 and watercolours 46-47, 56-57, 91, 92, 94-97, 102-03, 106-07, 117 working from light to dark 106-07 tonking 262-63 tools see brushes; paper; etc toothbrushes 8, 87, 124, 125 trees adding texture in watercolours 74-75

conveying motion 201

68-69

evoking depth and distance

negative space 172, 174-75

temperature and atmosphere

in acrylics 164-65

watercolours 64-65, 294 tonking 262-63 tripod easels 27 laving a granulated wash 100-101.294 turpentine 211, 215, 224, 225, line and wash 84-85 228, 280, 281, 282, 284, 295 manipulating runs in washes 54 twigs 152 two-dimensional shapes 56 overlapping washes 106-07 wash brushes 36, 37 two-point perspective 16 watercolours 38, 50, 54, 62-65, U 76-77, 84-87, 89, 98-99, underpainting 295 100-101, 106-07, 116, 140, adding tints to 104-05 294 with oils 226, 228-31, 241 water creating effects with 54-55 depicting in acrylics 167. 176-77, 178, 186-89 V-shaped compositions 17 depicting in oils 220, 258-59 value 295 depicting in watercolours 54-55, vanishing point 16 110-11, 112, 117, 259 varnishing 290-91, 295 painting rain 186-89 vibrant colours 130, 217 reflections 110-11, 112, 117, vibrant moods 94, 96-97 viewpoint 16. 17 259 shimmer on 112, 220 volume, giving objects 238-39 using cool tones to create 167 W wet-in-wet and oils 258-59 watercolours 11, 30-117 warm colours 295 adding details 108 00, 116 in acrylics 164-65, 168-71, 178 in oils 216, 242 adding texture 74-75 adding tints to an underpainting in watercolours 48-49 104-05 warmth experimenting with in oils 289 aerial perspective 68-69, 88 avoiding flat, dull colour 66-67 warm glazes 104-05, 162-63 balancing colour temperature washes acrylic washes 140-41, 150. 48-49 162-63 brushes 36-37, 50-51 building layers 106-07, 117 creating pattern and texture in colour mixes 40-45 watercolours 86-87, 89 effect of paper texture and correcting errors 78-81, 112-13 correcting mistakes with opaque wetness 76-77

white 80-81

46-47

86-87, 89

creating atmosphere and form

creating light areas 82-83

creating pattern and texture

drier strokes and detail 50

glazing 104-05 holding your brush 37

98-99, 116

laying a flat wash in

laying a double graduated wash

watercolours 62-63, 294

laving a graduated wash in

edges 70-71, 88 effect of paper texture and wetness 76-77 evoking atmosphere and emotion 94-97, 117 glazing 104-05 highlights 72-73, 89 history of 33 how to choose paints 34-35 laving a double graduated wash 98-99.116 laying a flat wash 62-63 laying a graduated wash 64-65, laving a granulated wash 100-101, 294 lifting out 78, 79 lightening watercolour paints 42 line and wash 84-85 masking fluid 82-83, 86, 294 modelling form 56-57 monochrome 102-03 mood 94-97, 117 mounting and displaying 28 opaque whites 112-13, 116 outdoor painting 27 pan paints 34, 35, 294 paper 38-39, 76-77, 126, 215 pigments 33, 43 planning a painting 90-93 pros and cons 22-23 refining your painting 24-25 reflections 110-11, 112, 117 reserving whites 82-83, 89 runbacks 295 scraping back 80, 295 scrubbing 78, 79 simplifying a scene 58-59 skin tones 114-15 softening 295 supports 38-39 texture 88 using runs 54-55 washes 38, 50, 54, 62-65, 76-77, 84-87, 89, 98-99, 100-101,

106-07, 116, 140, 294 watercolour blocks 39 wet-in-wet 33, 41, 44, 45, 52-53, 295 wet-on-dry 33, 44, 52-53, 295 wax, candle 86, 295 Webber, Graham Beach scene 264-65 Relaxing with a book 292-93 Vase of flowers 240-41 wet-in-wet 295 acrylic washes 140-41 oils 234, 258-59 watercolours 33, 41, 44, 45, 52-53 wet-on-dry 295 acrylic washes 140-41 watercolours 33, 44, 52-53, 295 white paint acrylic glazes 162 acrylics 129, 130, 138, 146-47 adding detail with 109 adding to create depth and contrast 66 adding to create tones 138 correcting mistakes with 78, 80-81 highlights 73, 74 lightening colours with 14, 42 oils 219, 266 opaque whites 78, 80-81, 112-13, 116 painting white using colour in acrylics 146-47 reserving whites 82-83, 89 tints 295 watercolours 35, 42, 66, 73, 74, 78, 80-81, 82-83, 89, 109, 112-13, 116 white ground 266 white spirit 211, 213, 228, 290 wiping oils 256-57, 286, 287 painting over wiped areas 234

wooden boards 214-15

About the artists

Hashim Akib worked as an illustrator for over 15 years before switching to fine arts full time. His paintings have earned him numerous awards, including the Society for All Artists Artist of the Year (2009). He is the author of Vibrant Acrylics (2012) and is a regular feature writer for Artists & Illustrators magazine. He is represented by multiple galleries in the UK and features in society shows at the Mall Galleries in London, including the Royal Institute of Oil Painters Annual exhibition.

Hashim developed the content for the Acrylics chapter, wrote the introductory topics, and contributed the three showcase paintings in that chapter. He also created artworks for, and wrote, the Acrylics techniques on pages 132–33, 138–39, 140–41, 142–43, 144–45, 152–55, 158–61, 162–63, 168–71, 172–75, 182–85, 186–89, and 196–99.

Colin Allbrook, RI RSMA HSEA, has worked as a painter and illustrator since leaving school. He has won several prizes, among them the Turner Watercolour Prize at the Royal Institute of Painters in Watercolours. He exhibits regularly at the Mall Galleries, London, and widely throughout the UK. His work is held in several private and public collections. Colin is an elected member of several national societies, including the Royal Institute of Painters in Watercolours and the Royal Society of Marine Artists.

Colin contributed the intermediate showcase painting in the Watercolours chapter, and created artworks for, and wrote, the Watercolours techniques on pages 50–51, 52–53, 56–57, 72–73, 76–77, 82–83, 86–87, 106–07, and 112–13.

Marie Antoniou is an artist and tutor who works primarily in acrylics, a medium that allows her to explore traditional subject matter with a contemporary approach. She is well known for her unique depiction of wildlife, which has earned her numerous awards and accolades. She is represented by several galleries and her paintings are part of many private collections. Her work features in Complete Guide to Painting in Acrylics (2014).

Marie created artworks for, and wrote, the Acrylics techniques on pages 128-31, 134-37, 146-47, 148-49, 156-57, 164-65, 166-67, 173, 190-91, and 200-03.

Grahame Booth is a watercolour painter and tutor. A former president of the Ulster Watercolour Society, he exhibits widely and has won numerous major exhibition awards. He holds workshops throughout Europe and provides tutorials online via his website (grahamebooth.com) and YouTube channel. He has produced two DVDs and is a regular contributor to Artists & Illustrators magazine.

Grahame contributed the beginner showcase painting in the Watercolours chapter, and created artworks for, and wrote, the Watercolour techniques on pages 40–43, 54–55, 58–59, 66–67, 68–69, 70–71, 94–97, 102–03, 104–05, and 110–11.

John Chisnall is a watercolour artist who enjoys travelling and painting subjects around the world; his main interests are landscapes, architecture, and portraiture. He has exhibited at galleries in the UK and USA, including one-man shows, and his paintings are found in collections internationally. He teaches painting and drawing to groups and on a one-to-one basis

John developed the content for the Watercolours chapter, wrote the introductory topics, and contributed the advanced showcase painting in that chapter. He also created artworks for, and wrote, the techniques on pages 44-45, 46-47, 48-49, 62-63, 64-65, 74-75, 78-81, 84-85, 90-93, 98-99, 100-01, 108-09, and 114-15.

Graham Webber, ROI IEA EAGMA, has won numerous awards for oil painting and exhibits with the Royal Society of Marine Artists and the Royal Society of British Artists in London, as well as galleries around the UK. He shares his passion for oil painting at workshops and demonstrations for art groups and societies.

Graham developed the content for, wrote, and created all the artworks in the Oils chapter. He also wrote The Basics chapter, and contributed the artworks and text for the Acrylics techniques on pages 176–77, 180–81, 192–93, and 194–95.

Acknowledgments

The publisher would like to thank Mr and Mrs K Francis for their kind permission to reproduce the painting on pages 92-93, and to Mr and Mrs R Lankester for their kind permission to reproduce the portrait on page 115 (top right).

We are also grateful to Louise Diggle for her help and advice during the planning stages of this book; Gary Ombler for additional photography; Alice Horne at the DK Picture Library; Tom Morse for creative technical support; Karen Constanti and Kathryn Wilding for design assistance; Corinne Masciocchi for proofreading; and Vanessa Bird for indexing.